The
Arch
Conspirator

by
Len Bracken

The Arch Conspirator

First Printing

ISBN 0-932813-72-0

Printed in the United States of America

Published by
Adventures Unlimited Press
One Adventure Place
Kempton, Illinois 60946 USA
auphq@frontiernet.net
www.adventuresunlimited.co.nz
www.wexclub.com

Dedicated to the memory of Jim Keith

The author can be contacted at:
PO Box 5585
Arlington, VA 22205

The author would like to acknowledge with gratitude the editorial assistance of Samuel Appelbaum, Ben Bacon, Gabriel Thy, Alex Trotter, and Jennifer M. Wang.

Hidden actions are the most admirable
When I see so many of them in history
I like them a lot
They have not been completely hidden
They have become known
And this bit by which they have become known
Increases their merit
Their finest quality of all
Is that they wouldn't remain hidden
The charm of death only exists for the brave

Lautréamont

Contents

Foreword

Kenn Thomas
Steamshovel Press

Extranationalism and psychogeography - a form of anarchy and the psychological dimension of geography - best describe the substance of Bracken's approach. His means, as he defines them, are his ends: to drift through the world like a psychogeographer injected with the excess joy and sense of play implied by the prefix extra in the title of his zine, *Extraphile*, where many of these essays first appeared, and to reach out to people from other places with the cosmopolitan ethics of an extranationalist.

Bracken projects his will, emotion, and thought over the hues of the established world and its values of sacrifice and pain, and he invites his co-conspirators, his readers, to do so as well. Bracken's world slips through a strange passageway into an ambiance where anything could happen. He writes about one of our adventures in chapter five, when we were shunned from an all-black conspiracy discussion at Howard University. Since then, similar events have taken on the character of propaganda actions for me. For instance, I gave Lech Walesa a copy of Bracken's "Open Letter to the Citizens of Poland" when the electrician-turned-politician recently came to St. Louis. The Pope, in his swing through town, reminded me how necessary debt relief has become in his third millennium proclamation, but he didn't go nearly as far as Bracken's universal cancelation of debt in his "Neo-Catiline Conspiracy" essay. I would have liked to have been there when Bracken distributed this pamphlet to World Bankers last year at their annual discussions in Washington to see the

expressions on their faces. Bracken may be guilty of many things, but he isn't looking for an alibi. He just wants an answer.

When I first met Bracken, he was known as a novelist, author of the ironic porn novel called *Stasi Slut* published by a Playgirl subsidiary, a Berlin-based book that the volatile critic G.J. Krupey calls "a leering, Rabelasian refusal to accept defeat, a libertine call for a cheerful gang bang on the body politic of alienation." Bracken was in the company of foreboding anti-work ideologue Bob Black and Feral House publisher Adam Parfrey in an Atlanta hotel bar. Popular conspiracy author Jim Keith describes Bracken's antics that night as fluidly shifting from "demoniacally possessed table surfing" to a "reasoned discussion of Wilhelm Reich when two hotel security guards ambled by." It was like that.

Keith knew Bracken from his first novel, *Freeplay*, about a group of global gamesters like the Washington-based Finders. What did Keith want to know when he met Bracken face to face? What was it like to live in the embassy in Moscow? Did he hear voices? Bracken's response about Bakhtinian inner speech may have been an obfuscation, but he was willing to share what he calls his earliest "conspiracy-minded suspicions." At age seventeen, while waiting in Dover, Delaware for a military flight to Frankfurt, two Air Force personnel took him into the hangar where the bodies from Jonestown were strewn across the floor. They told him of hangars in the Midwest concealing UFOs. As the first essay demonstrates, Bracken returned to Moscow and became embroiled in a conspiracy of his own.

Now Bracken is best known for his biography, *Guy Debord - Revolutionary*, about the central figure in the Situationist International, a French avant-garde movement that exerted an enormous influence on certain Beats and the French revolution in 1968. Shortly after publication of his Debord biography, Flatland published Bracken's translation of *The Real Report on the Last Chance to Save Capitalism in Italy*. This work by Gianfranco Sanguinetti explains much more than the Italian version of the strategy of tension that Bracken objectively chronicles in "From the Egg to the Apples." Sanguinetti's *Report* also provides an

illuminating backdrop to the post-Oklahoma City bomb political landscape in the United States. The *Report* also looms large in Bracken's would-be master's thesis "A Zerowork Theory of Revolution and the General Theory of Civil War" that reads like it was written by a cross between the Peter Gibbons character in the film *Office Space* and Albert Einstein with his special and general theories.

Although Bracken brings unique qualities to these essays and actions, he doesn't consider himself the arch conspirator in the sense of the ultimate Batman-inspired villain, except ironically. The reader should instead think of the author as arch in the sense of "mischievous," "saucy," or "marked by a deliberate and often forced irony, brashness or impudence." This might be just what Bracken's native Washington, DC needs with its proud, cruel men who sell their souls for scraps of power. Unable to escape the plague of ambition ravaging the city, Bracken turns ambition toward the pursuit of pleasure and the affairs of his time. As historical as his perspective is, he knows that the current conspiracy culture is unique in time, space and content. Participation in this culture endows it with more to see, hear, and touch.

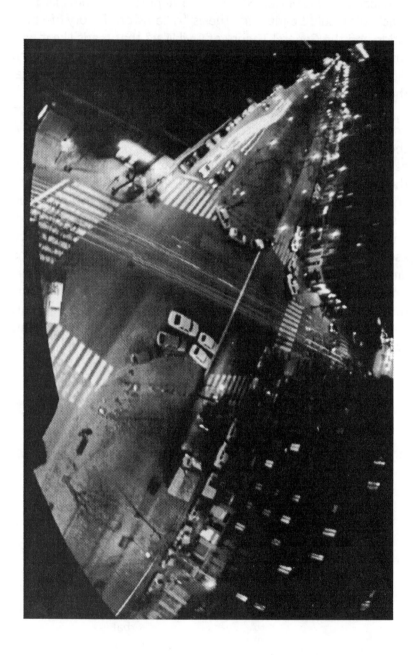

Chapter One

A Russian Conspiracy

I'm an eighteen-year-old American with a diplomatic passport in my pocket and a wealth of time to squander. Moscow's snow-covered streets guide my drifts in search of amusement, adventure and, more than anything, foreign affairs. It's the late Seventies; the Shah's regime has fallen and I'd like to pull the plug on the Soviet empire, or at least bring it to the breaking point. I'm fearless and tend to get away with everything. But I'm also idealistically jazzed-up enough to write about some one-world association or another, even though I know it's a stupid thing to do. The wind-blown desires of youth and the early signs of derangement.

With one university semester under my belt, I know there's so much more to know that I spend my days reading history books and devouring newspapers and magazines - anything I can find with provocative ideas, such as my western civilization textbooks or *Foreign Affairs*. Why? I don't know, but I'm given the job of clipping and collating the AP and TASS wire service reports every morning, and this keeps me well informed on the nuances of the latest verbal assaults between Cold War superpowers. I'd read *One Day in the Life...* in high school

1

and now several more books by dissidents come my way. I wake up early, clip the wire services, study Russian with and without my tutor and spend day after day reading books trying to come up with ways to hasten the State's rotting away.

I know my way around bars much too well for a young man my age. I was working the Marine Bar as a sixteen-year-old barback as the microwave shack across the street went up in flames to the tune "Burn baby burn, disco inferno." And now, with a few more years' experience, I'm meeting dangerous women there and in the Intourist basement bar, or across town, at the Belgrade Hotel bar, or elsewhere in the big drunken city. My first girlfriend, and perhaps the main reason I came back to Moscow, is Janna, a perfect Finnish angel with a perfect twin sister. Her would-be Marine boyfriend doesn't like this development, but he can't do anything other than try to psych me out. Along comes Jacinta Lee, from Malaysia, eventual runner-up Miss Universe and soft porn actress in Hong Kong. Others fill my days and nights, mostly Scandinavians and even a few Americans. But at the precise time I become involved with the dissident circle, I'm seeing Maria, a cute, curvaceous German student at Moscow State University who may have been a spy and who gives me what I really need in exchange for the benefits of dating a black market trader in military-goods with plenty of cash from money-trading schemes and, what is more, embassy connections to everything.

So here I am, a drink-soaked teenager drifting with the fog that invariably accompanies Moscow winters. Elsewhere - in jeans, light-blue down jacket and waterproof leather boots - I look like any other student; here I must seem American, except for my long, angular face that passes as native. Unfortunately my Russian isn't good enough to fool anyone, but after being lost and speechless a few too many times for comfort (one terrifying time when coming home from a gym in the fringes of town in the dead of winter), the language comes to me and I can read signs and converse to a limited extent.

One weekday afternoon, I find my way to a cinema and fall into line with the rest of the film-going public. Not to betray the novel

version of the tale (*Freeplay*), I ask a tall guy in a trench coat, whom I'll call Dimitri, to, if not explain the complicated wall-sized schedule, just tell me what's playing now. The screening of a film based on Chekhov, only with another title - something strange like "The Features of a Mechanical Piano" - is about to begin, but I still don't understand. A pretty blue-eyed redhead pipes in with excellent English, introducing herself as Olga, a philology student, and she introduces Dimitri as a psychology graduate student. When he hears that I'm American, Yuri, the third member of their band, a broad-shouldered, burly man, slightly on the short side, rushes up to me in a friendly, but suspiciously agitated state. Most of us relax in the cinema, feeding our eyes with countryside, except Yuri, who's excited and urges us to leave before the sunny film ends.

Back in the cold, and then at a nearby tea shop, we talk about meeting again, which we do - several times. As we become increasingly familiar with each other, I find out more about Yuri's life as a merchant marine. He has protested in public and in print with guerrilla texts against what he saw as the injustices of a system created by the worst people ganging together to make money, a system that didn't adequately feed its people and that victimized its best sons and daughters. He was punished for this. A few years in a psychiatric prison-hospital and the change becomes irrevocable. No longer a naive cadet. No going back. No stopping a determined man of action like this bundle of nerves gone slightly awry.

We meet with others in the woods where he's recognized as a leader and he even meets with me and my father on a foggy, snow-covered patch of road on Lenin Hills. Naturally, he produces his scribbling, convinced that if published, he'll win the Nobel Prize. Ostentatiously flashing Napoleon cigarettes, he comically assumes an imperial pose. He is arguably paranoid, but I like to think he's justifiably afraid of people in cafeterias he may or may not know. When discussing how to stab a militia man and steal his gun, or whether to continue armed resistance when arrested, we break off and make separate exits.

On a cold, pitch-dark night we're walking across campus when

Yuri suddenly stops and tells us to meet him later. Where is he going? To the science faculty. We wait at one of the palatial subway stations. Time passes slowly. Dimitri and Olga's discussion of resistance factions, the shrinking of various circles and other rumors, is shortened by passing militia. Semi-conspirators wait in silence, censoring ourselves. Meanwhile Yuri, with his slightly limping walk, trudges away from the bomb workshop in the science lab run by people we don't want to know. But in Russia at this time, even propagandists get trials and punishments. Their goal is recognized as being the same as those who prefer faster, bloodier methods.

In the aura of white columns, Olga seems even paler than usual. She makes ironic little smiles in my direction, smiles that cause the corners of her lips to twitch. I stand next to her and think good thoughts. Soviet women are taboo. I'm tempted by taboos. Displaying his usual cool composure, Dimitri looks at me with an all-comprehending, sympathetic expression. Finally, Yuri arrives, chain-smoking and treading heavily in thick-soled boots. He's talking, it seems to me, like an idiot, too fast for natives to catch every word. I make out a few expressions here and there, but don't know what's going on.

His ruthless side surfaces as he orders us to the train platform; and then, in an act of boldness, he shows us two neatly riveted metal boxes.

"What are they?" I ask Yuri.

An icy horror shoots up my spine when I realize, by his silence, he has bombs. Olga and I step into the train; Dimitri and Yuri are headed the other way, but at the last moment Yuri hops on our train and signals through the window that he will come back to Dimitri. Tobacco smoke fills the car as he stamps out his cig.

"What is it?" I whisper, pointing to his bag. "A bomb?"

The previously invulnerable ringleader turns red and feigns vengeance while hissing for me to be quiet. My blood freezes and I feel a numbing sense of loss, but I also feel a sense of relief knowing that everything will be decided the next day. It happens that I've arranged, with my father's help, to have Yuri discuss his emigration possibilities

4

with an American consular official. He laughs in a savage way and I know he's willing to die for some vague notion of freedom he associates with the Statue of Liberty and the United States. At least I'm forewarned. The last glance we share is unpleasantly vicious - a piercing, half-crazy glance from the depths of his soul.

We leave Yuri, the revolutionary outcast in internal exile, on a station suspended over the river. I see him there now wrapped in a shroud of fatalism. It makes me laugh to think of the deceptions or mystique he cultivated with his exaggerations and facades designed to make people tremble. As he pushes his way back to Dimitri and on to some secret address, Olga tells me not to worry, adding that Yuri likes to play with transformers and electronic gear like that. Her inviting eyes and nervous white face are promising, but I don't want to sully this affair with sex. She bids me farewell with a copy of Lermontov's *Hero of Our Time* and a conspiratorial half-smile. Simmering with distrust, I go back to roaming recklessly around the city, drinking in bars, mixing with friends and strangers and eventually running into my lovely Maria. Everything now seems darker, more sinister.

The next day, drawing on my vast funds of impudence, I say nothing. Yuri approaches in circles, not in a straight line, and at a set time meets the consular officer on the sidewalk outside the embassy. They greet one another and pass right by the Soviet guards. Once inside, Yuri unexpectedly states that he has a bomb (perhaps two bombs in a bundle) wrapped around his waist and tied to his fingers. He wants political asylum - nothing less will suffice. Six floors above Yuri and his occupation (no hostages are taken), I get a call from my father in which our anguish is masked by the need to get the facts. Could Yuri have a bomb? Yes.

Standing at my window looking out over the city I think of my friends, of Bill McNary who blew himself up with salvage Navy chemicals four years ago. I think of Bill Stevens and David Nakoa who, less than a year ago, attempted to set off fire bombs at a rival high school. And then, in the best possible denial, I run off to a hotel bar.

I drink in a daze, wearing my best inexpressive face. This goes

on for hours as I silently weigh my second-rate role in the affair and then remind myself to forget. Wanting nothing more than to fade out of the picture, I keep my mouth shut and half-listen to a few Lumumba students at the next table. Maria eventually shows up, ravishing as always. With her sharp little eyes she sees I'm troubled. I decide to tell her what's happening. Her English is impeccable and she instantly understands because of her beautiful fascination for exploits like this. Later still, my father - envious of me for Maria as soon as he sees her - finds me at the bar solemnly smoking a cigarette.

It wasn't anything like Semtex, my father tells me, just sliced razor blades and gunpowder. We walk into the damp cold climate; my knees shake. After a long stand-off, Yuri was ready to give up. As he exited the toilet, Soviet marksmen shot him through the window. Aiming for his heart, they hit his shoulder and the instinctive action to cover the wound triggered the bomb. I imagine the blast echo off the walls as the explosive rips him apart - his eyes blaze with the fires set off by the bomb, and his last fleeting sensation is of his clothes, skin and hair going up in flames. Weak, rasping breaths indicate he's barely alive as Marines shovel his smoldering remains onto a stretcher. In a figurative sense he dies standing, and he does so for freedom and his invisible conspirators.

Chapter Two

Considerations on Conspiracies

Hidden Actions Are the Most Admirable

Let's dispose with the ivory-tinted argument against conspiracy theories of history. A few age-old examples suffice. Just don't fall for the twisted morality displayed in Shakespeare's treatment of the republican conspirators - led by the perfectly virtuous Brutus - who put an end to Julius Caesar's monarchistic leanings and dictatorial behavior.

Herodotus

My first example establishes the earliest historical precedent for conspiracies and demonstrates the primacy of lust and instinct for life. *The Histories* by Herodotus (484-circa 425 BC) ranks as the earliest masterpiece of European prose. The first story of the first chapter opens *The English Patient*, a recent film starring Kristin Scott Thomas.

Imagine her reading Herodotus in the glow of a desert campfire. She tells the tale of Candaules, the king of Lydia, roughly what is now Turkey. Candaules conspires to reveal his wife's nude form to his

bodyguard, Gyges (circa 675-650 BC).

When bedtime comes, Gyges spies the queen taking off her garments and placing them on a chair. She turns toward her bed and glimpses his clandestine exit. The outraged queen saves her sharp reaction for the following day, when she summons Gyges.

"Either kill Candaules and seize the throne with me as your wife, or prepare to die."

He chooses life, and that night, knife in hand, attacks the sleeping king. Bed or deathbed - the ancients remind us that a thin line separates sleep and death. More to the point, Herodotus, the father of history, sums up the conspiracy: "Thus Gyges usurped the throne and married the queen."

Spartacus

I accept Nietzsche's definition of slaves: those lacking the freedom to spend two-thirds of their day as they please. With this in mind, Spartacus sets an excellent example of a courageous conspirator responding to slavery.

The slave revolt against the Roman Republic begins in 73 BC. In a gladiator school in Capua, the sound of chains dies down suspiciously and the conspiracy of around two hundred slaves comes to light. But a small group of slaves - about eighty - manages to escape. They make camp on Mount Vesuvius, the volcano in the bay of Naples, and choose Spartacus as their leader because of his military experience and other qualities - he served in the Roman auxiliary forces before being sold into slavery for desertion. At first, little importance is attached to this conspiracy and the escape of a few dozen gladiators, but it eventually commands enough respect that Hollywood makes a movie about it starring Kirk Douglas.

I laugh because so little is taught in schools about the history of people conspiring for their freedom. At Vesuvius, for example, the slave army faces a Roman detachment of three thousand men blocking the sole descent. The slaves use vine tendril ropes and the cover of

night to encircle the enemy and mount a stunning rout. Spartacus' army quickly grows and conquers most of southern Italy. National divisions within the ranks cause two detachments to split away; they soon go down to defeat. But Spartacus moves north, and with his victory near Mutina his army swells to over one hundred and twenty thousand men. As this mighty army marches on Rome, the Senate sends the slave-owning politician Marcus Crassus (circa 112-53 BC) and several legions into battle against the slaves.

Bypassing Rome, Spartacus marches south. He plans to sail to Sicily where the memory of the slave revolts of 136-132 BC and 104-99 BC lingers on. Unfortunately he can't organize the crossing due to a lack of ships; washed about by violent waves, the slaves' rafts wreck in a storm. Before his fateful battle with Crassus in 71 BC, his men present Spartacus with a horse. He draws his sword and kills the beast with the brave but cruel observation that should they win there will be an abundance of fine horses for everyone, and should they lose, he won't need a horse. The losses are high on both sides and Spartacus dies a hero's death in the field. As revenge, Crassus crucifies six thousand slaves along the road from Capua to Rome.

Catiline

My third example, the Catiline conspiracy to abolish debts, directly relates to the current epoch's crushing financial crisis in chapter six. The historian Sallust (86-circa 35 BC) is no longer widely read; this synopsis makes the case that Catiline belongs next to Brutus, Gyges and Spartacus as one of the great conspirators in history.

Lucius Sergius Catiline (circa 108-62 BC), member of an obscure patrician family, keeps bad company and sleeps with many women, including a maiden of noble birth and a priestess. When his beautiful but dishonorable fiancée hesitates - she fears his grown son from another marriage - Catiline kills his son, or so the story goes. Despite this malevolence he wins election to govern Africa in 68 BC. This ambitious aristocrat rules the province, roughly equivalent to

11

modern Tunisia, from Utica, a port city thirty miles northwest of Carthage that had been settled by influential Roman citizens. From this vantage point he follows the news in Rome, weighing the fortunes of friends and foes at a disturbing distance. He hungers to rise from relative obscurity, flex his strength and display his subtle intellect in the exercise of political power. Yet he loses election to consul (the coveted supreme magistracy of the Roman Republic with both civic and military power, namely *imperium*) in 66 and 65 because of a prosecution against him for extortion in Africa.

In 64 BC Catiline speaks with Cicero (106-43 BC), his future enemy, about mutual support for their candidacies. Cicero considers defending him against the extortion charge and, at this point, he actually admires Catiline's energy, bravery, popularity, loyalty and generosity, but the alliance never fully materializes because of certain misgivings. Indeed, as the election nears, Cicero utters dire warnings about what might happen should Catiline be elected and his evil personality gain power. With Caesar behind him and Crassus' bribe money in his pocket, Catiline verges on victory. By only a few votes, Catiline fails as Cicero succeeds in becoming the first new man elected to consul in thirty years. Bitter in defeat, Catiline tries again in 63, this time campaigning on a policy of debt cancellation while making vague threats against the rich. Again he fails, due to a loss of support from Crassus and Caesar, as well as Cicero's fear-mongering speeches about him.

After numerous overtures and soundings, Catiline hosts a meeting of potential co-conspirators. The guest list is composed of a dozen or so senators, members of the local nobility from the Italian colonies and towns, several high-standing Roman men who have influence but no position, and the rest of his debauched gang of faithful followers including numerous aging prostitutes who have every reason to cancel all debts. The beautiful mother of Brutus, Caesar's future assassin, allies with them, threatening to display her fierce sexual passion (she already stands accused of being an accessory to murder). Catiline flatters his guests and identifies with them while making flowery statements about reclaiming their liberty from the oligarches who

12

rule. "How long," he asks, "can you endure this misery and dishonor as the playthings of other men's insolence? How long?" In light of their destitution, Catiline enumerates the senseless projects and extravagant waste of the wealthy. He then transforms this wealth into booty ready to be won by masters of life who throw off their chains, cancel debts and proscribe the rich.

Although the coup d'état plot is discovered by the wife of one of the conspirators, Catiline remains in Rome and is a candidate for consulship in 62; Machiavelli writes about this in his *Discourses*:

> Catiline attended the Senate where he made opprobrious remarks about the Senate and about the consuls, so great was the respect which this city had for its citizens. Nor, when he had left Rome and was already in touch with the armies, would Lentulus and others have been arrested if they had not had in their possession letters in their own hand which plainly showed their complicity.

Catiline and his men, all armed, organize arson and occupy strategic points in Rome while Catiline issues threats in the Senate about putting out the fire that consumes his fortunes, "not with water, but by demolition." The letter Machiavelli refers to emerges later, when Catiline has already contacted his ally Gaius Manlius' revolutionary army in Etruria that has also been petitioning the Senate for debt relief. Rewards are offered for information about the conspiracy as rumors spread of civil war, but no-one deserts Catiline's camp - in fact, many more conspire against the oligarches living in prosperous ease.

Lentulus, one of Catiline's lieutenants, had been consul in 71, and although he was expelled from the Senate by the censors, he is elected praetor, for a second time, in 63. Nonetheless he carries out Catiline's orders and even exceeds them by enlisting men of many classes in the conspiracy - Catiline would have done well to adopt Lentulus' suggestion that they enlist slaves. Alas, Catiline declines on the grounds that he wants a citizens' movement.... Seizure of one of Lentulus' conspiratorial letters, taken from a Gallic envoy, leads this

once-respected patrician to resign his position and remain under arrest until his execution, strangled by a noose.

By refusing the help of the runaway slaves flocking to him, Catiline openly counts on support from Rome; when news arrives about the execution of Lentulus and other conspirators, the majority of Catiline's followers disperse in all directions. He contemplates retreat to Gaul, but he finds himself low on supplies and trapped on all sides. On a cold day in January, 62 BC, he tells his troops:

> Wherever we decide to go, we must use our swords to cut a way through. I counsel you to be brave and resolute, and when you go into battle remember that riches, honor, glory, and, what is more, your liberty and the future of your country lie in your hands. [...] If Fortune robs your valor of its just reward, see that you do not sell your lives cheaply. Do not be taken and slaughtered like cattle. Fight like men: let bloodshed and mourning be the price that the enemy will have paid for his victory.

Catiline then orders the trumpet call for battle and forms ranks. He sends away the horses - including his own - so that the danger is shared equally by all. As soon as the government army nears them in the mountains near Pistoia, the two armies charge together like swarms of pests. Spears become useless as swords flail at close distance. Catiline fights valiantly beside his men until he suddenly looks around and sees his army completely routed. He plunges into the enemy's thickest line and fights on until pierced from head to toe. His body lies behind enemy lines among lifeless government troops. His dead face wears its characteristic expression of haughty defiance. The government troops take no prisoners.

Machiavelli

The relevant details of Machiavelli's eventful life (AD 1469-1527) tell us much about his experience with conspiracies and con-

spirators. His negotiations, on behalf of Florence, with Cesare Borgia (1475-1507) or Duke Valention (or the Duke of Romagna as he liked to be called), come to mind. Machiavelli admires Cesare Borgia for his cool cruelty, and both Machiavelli and Leonardo da Vinci are with Borgia in Senigallia in 1502 when Cesare slaughters his would-be assassins at a dinner party. Accusations of conspiracy hit Machiavelli in February 1513. The false accusation of conspiracy results in bone-breaking torture and imprisonment, which demonstrates how governments often respond to the threat of conspiracies.

Released in the amnesty granted by the Medici return to power, he retires to Sant'Andrea and writes *The Prince*, where he argues for *virtù* - cunning, courage and force - as the way to succeed while cast about in the sea of Fortune that is a prince's life. And later, after meetings with a group composed of other outcast republicans (the Orti Oricellari) in suburban gardens outside Florence, he writes *The Discourses on the First Decade of Titus Livius*, commenting upon the first ten books of the history of Rome by Livy (59 BC-AD 17). He now makes the argument for the liberties of a republic as the best way to increase a city's power.

In 1522, Machiavelli receives a commission from the current Medici in power, Giulio, to write the history of Florence; while at work on the project, a republican plot to assassinate the Medici Cardinal emerges. Machiavelli and the other members of the Orti Oricellari circle face real danger; one is executed, many go into exile. In 1527, when a republic once again takes shape in Florence, Machiavelli's republican credentials don't stand up to his defense. Heartbroken, he dies the following year after a short illness.

Enough melodrama - I'm more interested in the sixth discourse of book three of *The Discourses*, explicitly entitled "On Conspiracies." Machiavelli speaks of conspiracies with perfect familiarity and makes noteworthy distinctions among several types. What concerns Machiavelli in a more general sense is how to impose oneself on the world and play the game of history. Elites do their best to inhibit an active historical consciousness, yet history affects us all - both those

15

who undertake historical operations and those who do nothing (who are by no means innocent, as they simply allow the past to dominate the present). What I take from Machiavelli is that history is the greatest and most beautiful enterprise; it requires one to seize the opportunities and turn them to one's advantage in a calm way as if they were foreseen and desired, and to change as circumstances change.

The world, after all, looks like those who conquer it, those who know how to take the conditions inherited from the past and the conditions of the present and mold them to their aims. This is no small feat since existing reality usually speaks against those who fight for themselves, those who weaken the enemy with disorder, a state that many find distasteful. My experience tells me that only by completely breaking with the existing order does one learn what one can and can't do, and who one's allies really are. And when I look around I see misfortune befall those who play the games of their adversaries; many fail to recognize the enemy and opt for an orderly existence.

The minimum requirements to play the game of history are to mount a conspiratorial operation and communicate the example; requirements mount if one wants a successful operation and not a glorious defeat after Spartacus and Catiline. But like them, one must not put the entire operation in doubt when the first mishap inevitably arises, rather redouble one's efforts. Most importantly, projects that impose themselves on the world must go to the core of everyday life.

Until now, I've spoken of history and strategic generalities to give a context to the refusal of wage slavery and for the cancellation of debt. What is more worth fighting for than the freedom to spend one's days as one pleases, and to achieve freedom from onerous debts? People rarely fight for a cause beyond their existence or an abstract ideal, rather for personal issues so narrow as to not change anything in a truly historical sense. Think about it: our society has allowed many forms of rights-oriented protesters to win their claims, but as soon as a practical refusal rises, such as the refusal to fight an unjust war, hatred spreads like wildfire. As I imply in my introduction to Spartacus, the refusal of work is the refusal of slavery; likewise my introduction to Catiline's

16

debt cancellation project draws a line in the sand against the current financial elite who have been ruining the world. I'm not being cynical, rather intensely critical when I assert that we live in a work-oriented consumer society that intensifies exploitation of the masses through its use of credit. All forms of tyranny smell, but nothing gives me such a bad taste as domination by the economy of social life. While the harsh attacks on my cohorts and me elicited by our critique are proof of its success, those who dismiss it may one day find, as Machiavelli puts it in his *Art of War*, "Nothing is easier than a project that the enemy believes is beyond attempting; it is from the side that they have the least to fear that men are most often hit."

Machiavelli's Typology of Conspiracies

1. One-man conspiracies (rather a one-man plot, not technically a conspiracy because, in the etymological sense, conspiracy denotes breathing together)
2. Conspiracies formed by the weak (made by "sheer lunatics")
3. Conspiracies formed by the strong (prudence is the only requirement for certain success; avarice and a lust for power, the motives)
4. Unpremeditated assassination (necessity may sometimes require it - the kill or be killed dilemma)
5. Conspiracies directed against more than one prince (difficult, especially in Machiavelli's time given limitations in communications)
6. Conspiracies against one's country (less dangerous than most)

Machiavelli refutes the argument that all historical plans are decided upon in the light of day - those who dare to be the ungrateful subjects of princes who take all they can, should make of these words

what they will and conquer empires. Nothing less is expected in the night before your most brilliant days.

Gondi

My fifth example, Jean-François-Paul de Gondi (AD 1613-1679), is a conspirator par excellence whose playful role in the riotous period of the Fronde continues to inspire. Born into a family with ties to the Médicis and powerful positions in the ecclesiastic realms of Paris, the young Gondi attends a Jesuit college in Paris where he quickly acquires a reputation for academic brilliance and rebellious behavior. In the warm, dry days of August 1624, Cardinal de Richelieu (1585-1642), a Jesuit and possibly *the* prototypical bureaucrat, becomes prime minister. He will keep a suspicious eye on Gondi in the near future. The following year Gondi's mother dies, and his father retires from his position as general of the galleys of France to live a contemplative life. This leaves Gondi, if we can believe him, free to pursue love affairs and duels along with his prize-winning studies.

As a teenager in 1626, Gondi follows the stories about Chalais' conspiracy against Richelieu and the conspirator's subsequent execution. Then, at age twenty-five (he claims eighteen), he acquires a copy of Mascardi's *The Fieschi Conspiracy* while touring Italy and writes his own version. This document reaches French Prime Minister Cardinal de Richelieu, who becomes increasingly suspicious of the young abbey: "This is a dangerous genius." Although his possible role in earlier conspiracies remains obscure, at twenty-seven, Gondi certainly plays a minor part in a failed aristocratic rebellion in Soissons against Richelieu.

Richelieu dies in 1642 and is followed to the grave by Louis XIII the next year. Little Louis XIV (1638-1715), *le Grand* future Sun King, is only five years old, so Queen Anne of Austria (1601-1666) is appointed Regent; she nominates Cardinal Mazarin (1602-1661), an Italian diplomat living in France, as her prime minister. In 1643, Queen Anne, whom Gondi characterizes as "more show than substance," ap-

points Gondi as Coadjutor to his uncle, the Archbishop of Paris. Gondi's zeal as a preacher makes him popular with some, but he is disliked by Mazarin and the Court.

High military expenditures lead to higher taxes; when the young King Louis XIV announces new fiscal measures in 1648, protests break out. The Day of the Barricades (August 26-27) finds Gondi, the astute reader of Plutarch's *Lives* who has always hoped to head a faction, trying to pacify the mob, and then explaining the events to the Court. In a legendary passage in his memoirs, Gondi describes the scene: "We had no other reply from the Cardinal than a malicious sneer, but the Queen lifted up her shrill voice to the highest note of indignation, and expressed herself to this effect: 'It is a sign of disaffection to imagine that the people are capable of revolting.'" The Court ultimately accuses him of intrigue, which inspires him to take revenge: "Our circumstances are not so bad as you imagine, gentlemen," Gondi tells his cohorts, "and before twelve o'clock tomorrow I shall be master of Paris."

These protests earn the name Fronde after the slingshot used by barefoot urchins to hurl rocks at passing carriages. The plot thickens as Gondi and others wear these slingshots on their hats as an expression of the power of the mob that these clergymen could rouse with a wag of their tongues and a wave of their arms. The city is waiting to be wooed and won and everyone knows it.

At the beginning of 1649, the Court leaves Paris. The entourage includes Gaston d'Orleans (1608-1660) and Prince Condé (1621-1686), *le Grand Condé* whom Gondi characterizes as having "the heart of Alexander." Facing so many angry mouths, the royal army blockades the capital. Gondi quickly raises a regiment of troops and resists the blockade by preaching inflammatory sermons. Behind the scenes he negotiates with Spanish emissaries (France was then at war with Spain) to foster an alliance. The Parisians can't hold out long; a peace treaty is signed in April without Gondi's participation. Amazingly, Gondi later reconciles with Mazarin, who promises Gondi nomination as cardinal. The prime minister then arrests Prince Condé and his brothers Conti, "a second Zeno," according to Gondi, and Longueville, whose

"ideas were infinitely above his capacity." These arrests spark rebellions in Normandy, Burgundy and Guyenne. Meanwhile, the Court stalls on Gondi's nomination, and by the end of 1650 his relations with Mazarin, "a complete trickster," deteriorate.

Gondi exercises increasing influence over Gaston d'Orléans, a Duke from a family of kings, whom Gondi admires for his "incredible easiness of behavior." The next year, a secret treaty is signed between the Old Fronde (Gondi and his people) and a New Fronde (Prince Condé's party). The deal promises to elevate Gondi to cardinal, and assures the marriage of his mistress to Prince de Conti in return for Gondi's active support for the prince's release from prison. Gaston d'Orléans openly breaks with Mazarin, who, inexplicably, releases the imprisoned princes and flees the country. Gondi persuades Gaston d'Orléans to mobilize the city militia, and Gondi himself organizes a siege of the Royal Palace that prevents the queen and her son from leaving Paris. When Condé returns, triumphant, from prison, Gondi stages a party in the streets of Paris with bonfires and plenty of wine to celebrate the freedom of his fellow Frondeur, but the joyous union of the two factions doesn't last long.

After failing to have the general estates summoned in 1651, Gondi enters into serious negotiations with Mazarin. The result is a treaty that offers him the cardinal hat in return for support against Condé, with whom Gondi is now in conflict. At one point, the famous writer of maxims Duke La Rochefoucauld (1613-1680) squeezes Gondi between heavy double doors in what Gondi called an attempted murder that he later exploits by appearing as a defenseless man of the cloth - Gondi also claims that Condé tried to kidnap him. Condé, by then in open rebellion, is deemed guilty of treason by the Court. As Mazarin returns to Paris from self-imposed exile, Gondi declares himself against the New Fronde; in 1652 he becomes Cardinal de Retz.

Retz remains behind the scenes when Condé storms and occupies Paris because the prince is pursuing his opponents with vengeance. His troops account for some of the worst vigilante aspects of the Fronde; in addition to attacking specific enemies, Condé's troops favor indis-

criminate violence and random pillaging. When Condé leaves Paris in September 1652, Gondi initiates unsuccessful negotiations with the government. The Court eventually returns to Paris in October, and although Mazarin doesn't return until 1653, the Parliament must submit to royal will. Condé continues his resistance in Bordeaux, only to eventually side with the Spanish. The disgraced Cardinal de Retz spends a year in prison at Vincennes. In March of 1654, Retz's uncle, Archbishop of Paris, dies; Retz is quickly installed by proxy as successor. This Ecclesiastic Fronde begins with Gondi, still in prison, signing a promise to resign as Archbishop and retire to Rome. When transferred to the Chateau de Nantes, he makes a daring escape. His travels lead him to Rome, where Pope Innocent X promises his support against Mazarin.

As chance has it, Innocent X soon dies and his successor grows disenchanted with Retz, advising him to resign as archbishop of Paris. Retz pursues a propaganda campaign against Mazarin, first from Rome with the help of proxies in Paris, and then from numerous countries in five years of nomadic exile. Mazarin and Cromwell's alliance against the Spanish lead to the Treaty of the Pyrenees in 1659, which grants amnesty to Condé, but says nothing of Retz. Even after Mazarin's death, Louis XIV insists on Retz's resignation as the condition for his return from exile. Retz accepts these terms around the time Louis XIV assumes his legendary absolute authority as Sun King. Although Gondi would play helpful diplomatic roles for Paris in Rome, the king makes it clear that he never forgot the conspiring prelate's role in the Fronde by withholding rewards for these missions, and by ordering that Gondi's coffin have no inscription so that we might forget his playful and imaginative historical sensibilities.

JFK

Like Bruce "Gemstone" Roberts' letters, Torbitt's *Nomenclature of an Assassination Cabal* was one of those texts that I'd heard a great deal about among marginals over the years, but never read. Evidently even well-informed researchers missed this pseudonymous document

because of its limited availability, now rectified by Adventures Unlimited Press. Jim Martin of *Flatland* read it and, responding to *Lobster*'s accusation that it's a CIA fake, suggests that it is Soviet disinformation. This immediately reminds me of how awkward the original title seemed when I first heard it.

I've always understood *nomenclature* to be the system of names used in a specialized field such as biology, and *nomenklatura* in Soviet Russian to be the key positions in the state bureaucracies - administration, judiciary, industry, agriculture and education. Torbitt, whom we're led to believe was actually a Texas lawyer named Copeland once close to LBJ, employs a usage closer to the Soviet meaning when he names the cabal that assassinated Kennedy: Hoover, Johnson, Connally and others, even foreigners such as Ferenc Nagy, ex-premier of Hungary, and Werner Von Braun, "whom Hitler personally decorated for his work slaughtering seven thousand allies during World War II." I say that Torbitt's usage is closer to the Soviet's because he is naming people in positions of power rather than employing a system of names used in a branch of learning. This document is valuable precisely because it names names and doesn't merely hint at what is possible. The usage seems odd, although it may be nothing more than the author's stab at a grandiloquent title.

While I don't know if this is Soviet disinformation, or disinformation dressed up to look like it came from the other side, some of Torbitt's syntax and the anti-Nazi, anti-White Russian content could lend support to this reading. In any case, just as there is disinformation in all information, there is information in good disinformation. And if the Torbitt document is disinformation, it's the best I've seen because it assiduously puts the conspiracy into stark terms by identifying the Kennedy assassination as a Nazi coup d'état. If proven, this theory might compel citizens to do more than merely spit bile at the conspirators. Jim Keith, whom I refer to below for his compelling expansion of Torbitt's Nazi-fascist theme in *Casebook on Alternative Three*, doesn't think the Torbitt text is Soviet disinformation because it was originally distributed by photocopy among conspiracy researchers in 1970 - what

might be called American *samizdat*. It isn't inconceivable that the Soviets would submerge a document like this knowing that its argument would be taken up by others and eventually float to the surface. I like to keep the possibility in mind as I look at what Torbitt says.

Torbitt mounts an eyebrow-raising argument against Division Five of the FBI, a small department "whose duties are espionage and counter-espionage," and against the Defense Intelligence Agency (DIA). These two entities control their own "secret police agency," the Defense Industrial Security Command (DISC). DISC grows out of J. Edgar Hoover's Tennessee Valley Authority (TVA) police force that evolved into security for the Atomic Energy Commission. Later, as DISC, this same police force becomes the unofficial police agency for NASA, USIA and military-industrial corporations. Shaw, Bannister, Ferrie, Oswald and Ruby, according to Torbitt, are DISC agents.

Using Swiss-based corporate cover, a company called Permindex, DISC controls entities such as the Solidarists, a group of powerful, purportedly anti-Semitic White Russians who befriend Oswald when he returns from the USSR. The fact that White Russians, such as the Solidarists or their agent George DeMohrenschildt, turn up throughout Torbitt is noteworthy because it indicates that Copeland, aka Torbitt, was himself interested in a Russian connection. Recall that Stalinists in Moscow share a mutual hatred with White Russians, hence Moscow might want to cast aspersion on fascist White Russians and other Eastern European anti-communists in the United States. Or else the CIA, or whoever authored or edited the text, may have included this element to throw researchers off the trail. Or Copeland was calling it accurately and few people listened because of Cold War anti-communist hysteria.

The NASA headquarters historian claims that DISC never existed as part of NASA. Following a lead supplied by comedian and researcher Bob Harris, I asked a public affairs person at Goddard Space Flight Center about DISC and DISCO, the O standing for organization. The Goddard man checks his phone book, and as we're talking, the acronym DISCO rings a bell but he can't elaborate. While directing me

23

to the NASA facility in Huntsville, Alabama, the Marshall Space Flight Center, he begins speaking noticeably louder, as if to send me a signal not to pursue this lead. He even gives me the wrong area code, which he is sure to know because he'd worked for nine years at Marshall. All the NASA people I speak to direct me to the Department of Defense with its like-sounding Defense Information Systems Agency or, closer to the mark, Defense Intelligence Agency. Huntsville never returns my call.

In his letter to Kenn Thomas on the subject of DISC, columnist Bob Harris reports that he tracked down the Columbus, Ohio address given in the Torbitt Document as the location of DISC - still a federal building, but of no particular significance. His tip on DISCO includes the clue to look in Huntsville, and he goes on to say that Oswald may indeed have been an internal security dangle for DISCO, which was created to comply with regulations requiring NASA contractors to run internal anti-communist surveillance. Many Nazi scientists who came to the United States after World War II, the Paperclip exiles, went to work in anti-communist security. Harris follows this fact with the observation that Oswald's first attempt to get a job in Dallas-Forth Worth was with Max Clark, "a former anti-communist security officer at General Dynamics," which makes sense if Oswald is "a free-lance Disco dangle." And as Kenn Thomas notes in his introduction to *NASA, NAZIS & JFK: The Torbitt Document & the JFK Assassination,* when fired from Reilly Coffee, Oswald tells the manager of a garage that NASA in New Orleans will hire him. Instead, Oswald goes to work for the School Book Depository, but four of his colleagues at Reilly Coffee did switch to New Orleans NASA weeks after Oswald's departure. Ominously, the legal counsel to General Dynamics, Albert Jenner, was responsible for the conspiracy segment of the Warren Report.

Does, or did, DISC exist? Some doubt has been cast on these claims since we discovered that Copeland, aka Torbitt, reportedly represented as an attorney, Penn Jones - Jones' *Midlothian Mirror* is the only other source on DISC. Other doubts? The often-noted theory in assassination lore that the man standing on the north side of Elm Street

24

with an umbrella shot Kennedy, figures here. Louis Witt asserts that he showed the umbrella to JFK to protest Joe Kennedy's support for appeasement. But Fletcher Prouty compares the spoke-counts on Witt's umbrella with the one in the Zapruder film and finds a mismatch. The other U-man candidate is Gordon Novel whom Copeland mentions many times. The Torbitt document makes the wild claim that the man with the umbrella is Ferenc Nagy, ex-premier of Hungary from 1946 to 1947, who was in power when Hungary experienced the worst inflation in world history.[1] Ferenc Nagy was a resident of Dallas in 1963, and he was on the board of Permindex with Clay Shaw. We may never know what no-one knows, but speaking of Clay Shaw, we now suspect that Torbitt misspoke when he said that Von Braun surrendered to Shaw in May 1945. He had orders to return from the western front to the United States, and records through June indicate he was not sent back to Europe. However, Clay Shaw may have participated in Operation Paperclip on the US side.

Ruby is alleged by Torbitt to be a DISC-controlled Solidarist, even though he is certainly Jewish and beholden to the Sam Giancana mob. Nonetheless we should recall Ruby's prison claims that there will be pogroms against Jews and that fascists and Nazis killed JFK. No surprise White Russians and other Eastern Europeans with fascist tendencies are beholden to Hoover, and vice versa.

As anyone who has taken the tour of the Scottish Rite Temple on 16th Street in Washington, DC (WDC) knows, Hoover didn't hide his Masonic ties - his office at the FBI is now in the basement of this temple serving "the southern states and NATO." Masonic ties to fascism are nowhere more apparent than in Italy. The infamous P2 Lodge, an anti-communist security organization that funded right-wing regimes in Latin America with the help of the Vatican bank, links the far-Right in Europe and Latin America. The Lodge is considered to be a touchstone of NATO allegiance for Italians, which is strange if one considers that the entire upper echelon of the Italian secret services is P2. The "Worshipful" Master of P2, Licio Gelli, once a wanted wartime fascist who rendered his services to Peron in Argentina, has been the

25

guest of US presidents. He has operational ties to the Black Orchestra, or Nazi International. A chronology of the strategy of tension appears later in this book and my analysis of the implications of this fascist strategy is in my Open Letter to the Citizens of Poland. For now, recall the moment when authorities search Gelli's daughter as she enters Italy and find incriminating P2 documents about the formation of a military government - documents with heavy implications for the US military bases in Italy. Many P2 members have been involved in right-wing coup plots and right-wing terrorism in the Seventies. In Italy, right-wing and left-wing terrorists were often the same and linked, in corroborating testimony, to Gelli. It is often assumed that Gelli was a CIA asset, but the FBI allegedly contacted him. Many surmise that he sent a US Army Field Manual into the country with his daughter deliberately to signal that the DIA played a destabilizing role in the country. In this light, bear in mind that according to Torbitt, De Gaulle's assassination attempt was traceable to Division Five of the FBI working with NATO in Brussels. As Philip Willan points out in *Puppetmasters*, the Italian example reveals the high stakes involved when international fascism comes together to control a country through coup attempts and its role in the Aldo Moro assassination. Italy also suggests that the CIA could be more dovish than the FBI and DIA.

Through its corporations, the Sixties incarnation of DISC allegedly controls the Syndicate, a political-mob nexus, and the anti-Castro Cubans in the Free Cuba Committee. But the prize possession of DISC is the Security Division of NASA, although ownership may have been reversed if one considers the fact that Werner Von Braun was the head of the Security Division of NASA. This troubles me given Werner Von Braun's history and the disgraceful lack of denazification carried out by the United States. Although guilty of this insufficiency themselves, the Soviets naturally acted irate when, at the end of the war, arrested scientists and rocket experts quickly integrated with the US military. In *Blowback*, Christopher Simpson points out that many of these people once accused of brutality to slave laborers and murderous medical experiments on humans were later said to have had nomi-

nal or opportunistic motives to join the Nazi party - no longer ardent Nazis. However, Von Braun became an SS Sturmbannfuhrer in 1937 and clearly had responsibility for rocket works such as Nordhausen where twenty thousand Jewish slave workers died from starvation, disease or execution. Von Braun's emigration snags on a denazificaion hearing - he was thought to be a security threat to the United States and the State Department and Justice should balk at his application. Instead, he is cleared by a sanitized dossier.

As the photo on the cover of *NASA, Nazis and JFK* proves, old Nazis like Von Braun end up in high places, such as riding in a parade car with JFK. Recall the recruitment of SS General Reinhard Gehlen into the OSS (subsequently the CIA) and the grafting of the Nazi intelligence operation onto the OSS - this facilitated the recuperation of Nazi scientists in the United States while enabling the creation of the Nazi International and possibly even allowing Gehlen to set up Nazi Werewolf groups in Germany. After all, by 1951, Nazi administrators are reinstated by German legislation, and by the Seventies 176 of West Germany's generals had once served under Hitler. Americans scoff at the suggestion that Nazis and fascists infiltrated every department of the US government, but in this atmosphere it's hard not to agree with the European intellectuals who considered Truman a fascist. Many more high-ranking political and military officials in the US are said to have been members of the Nazi International, or members of the SS, than simply those mentioned in Russ Bellant's *Old Nazis, the New Right, and the Republican Party*. In 1988, six fascists serve on thirty-third degree Mason and former CIA director George Bush's campaign staff. As Governor of California, Ronald "Knight-of-Malta" Reagan employs a German secretary with an SS-tainted past; back in the Forties, he lives with Gestapo agent Errol Flynn.

Jim Keith puts this scenario in a broader context in "The Fourth Reich" chapter of *Casebook for Alternative Three*:

> In retrospect, it would be a mistake to see the grafting of German spydom and the Nazi International onto American intelligence as an

entirely alien 'virus' contaminating the morality and lofty purposes of the American establishment. As can be seen by the activities of U.S. and British business, statecraft, occult groups, and 'aristocracy' in their role in promoting Hitler to power, and the orientation and alliances of such men as the Dulles brothers and the world-spanning banking and industrialist alliances they represented, the Nazis were no isolated phenomenon, only one expression of a multi-faceted and murderous worldwide game.

We may never know the degree to which these organizations - the FBI, CIA, NASA and Pentagon - were composed of, or intimately tied to, Nazi-fascist elements. We know they battled each other in their little adventures at home and abroad like mastiffs fighting over a dead duck. FBI, CIA, DIA, Nazi, Ally - who's on whose side? Torbitt claims that Gehlen works for the FBI and the Solidarists as well as the CIA, and he puts JFK's head on the FBI-DIA alliance, adding that when Garrison gets too close to discovering Division Five of the FBI, the DIA is sent in to handle the job of confusing and disrupting everyone.

According to Torbitt, Von Braun befriends Hoover and Johnson as soon as he moves to the United States; the German first works with Hoover on the TVA security project that eventually becomes DISC. As the controller of Nagy and of the head of the assassination team assembled in Mexico, Torbitt portrays Von Braun as practically pulling the trigger himself.

Does domestic fascism or the original import version lay behind the crime of the century?

Is Torbitt Soviet *tamizdat* (published *tam*, or 'over there'), or native - even CIA - *samizdat*?

Do the facts check out?

This document begs many questions about the fate of the country; naive questions to many about the demise of democracy that echo Garrison. I'm reminded here of a letter by Jack Ruby, reported by Lincoln Lawrence in *Were We Controlled?* (now in print as *Mind Control, Oswald & JFK* - Adventures Unlimited Press): "The old war lords are

going to come back. SA [South America] is full of these Nazis! [...] They will know that [there] is only one kind of people that would do such a thing... that would have to be the Nazis and that is who is in power."

Let's say Torbitt and Lawrence have it right, and so do the Collier brothers in regard to their votescam thesis.[2] What would it mean to the defenders of democracy to know that shortly after Johnson's fascist coup d'état, their votes were systematically stolen in the votescam collaboration between the media and the government? Kennedy is ready to pull out of Vietnam and warm relations with Moscow, but the fascists of DISC want to keep their war machine running and anti-communism on the airwaves. These theories may be right or wrong, or somewhere in between. Even if half-true, it's too much fascism to endure. World War II never ended, it was obscured by the masquerade with Moscow. The fight against fascism continues in the creative intelligence of conspiracy theorists like Torbitt and Lawrence.

Quigley

One of my bases in Washington, DC (WDC) is the Georgetown University (GU) library; it has the best collection with easy access to the stacks in the city. I drift along walls of row houses, under a green canopy - the sun-dappled leaves in the trees and the leaves rippling in my mind. Cobblestones, then patterned brick, now pre-fab sidewalk slabs lead me to the unimpressive post-modern tower that looks better inside out. The major works of one-time GU professor and Bill Clinton mentor Carroll Quigley share shelf space with lesser gems. As I consult students in foreign affairs as their ghost writer, I come across books from Quigley's personal collection donated to this library that he publicly complains is inadequate. The ideas of Quigley, author of *The Anglo-American Establishment* about the conspiratorial designs of the "secret society of Cecil Rhodes," form the foundation of Clinton's political philosophy. On a hot summer day, I listen to a speech he made a decade after Clinton left Georgetown.

In 1976, the recently retired professor returns to campus to

29

deliver three lectures covering the years AD 976-1976 under the sweeping title *Public Authority and the State in the Western Tradition: A Thousand Years of Growth*. Quigley's primary unit of study, Western Civilization, begins in AD 550 but exists with little public authority until 1050.[3] As I listen to the tape in the cool library basement, I imagine young Bill Clinton at Quigley's feet as the professor divides civilizations into Class A (individual-based) and Class B (community-based) types. His point is that after years of struggle, the political stage has been reduced to the individual against the corporation.

The arrogant Princeton tone and references to Harvard scorn his present listeners, who are under the mistaken impression that they're free - these and other rhetorical devices once mesmerized his students, but he no longer sounds like the imbecile Clinton would have him be. "America is the greatest country," Clinton quotes Quigley without the slightest wink, "in the history of the world."

On the contrary, in plotting the growth of the State, first by looking at the State of Communities (976-1576), Quigley has nothing but contempt for Charlemagne's urge to conquer the world and the very notion of attempting to do so. Quigley prefers the Dark Age (888-988) when Western Civilization borders the Mediterranean Sea in the south and arcs from the Atlantic across the Baltic to Russia. Numerous self-sufficient peasant villages are ruled by mounted spearmen, an environment that fosters significant technological advances. These three lectures amount to his contribution - based on his unpublished doctoral dissertation (he's still bitter) and subsequent research - to the history of the growth of the State. At times, Quigley sounds like an anarchist:

> Out of the Dark Age that followed the collapse of the Carolingian Empire came the most magnificent thing we have in our society: the recognition that the people can have a society without having a State. In other words, this experience wiped away the assumption that is found throughout Classical Antiquity, except among unorthodox and heretical thinkers, that the State and the society are identical, and therefore

30

you can desire nothing more than to be a citizen.

The recent corollary to this lesson might be the Sixties, when the masses engage in society-based movement politics and don't think much about the electoral politics of the State. At the end of the above quote, Quigley makes another severe statement, as if addressing anarchists directly - this one omitted from the pamphlet version of his speech: "And if you want to go down in a ghetto, or catacomb and be with your cozy co-believers and so forth and so forth, you are an enemy because you are violating a fundamental assumption."

Again, the assumption is that the State and society are identical, an idea with origins in understanding the *polis* as a community, not in one man alone - even though this community spirit always experiences limits and definite reversals. The *imperium* implies still more factionalism. According to Quigley, we mimic Antiquity because we identify the State as the community. The consequence of this is that our lives are public and we must die for the State. Mass culture atomizes us to the point where we can't stand apart in idiosyncratic communities, which is precisely his prescription at the end of this series of lectures: "If a civilization crashes," he says, "it deserves to. When Rome fell, the Christian answer was, 'Create our own communities.'"

In plotting the State of communities, Quigley first gives an enthusiastic account of Viking conquests, as a drum roll for his point that they are the first to tax land and hire standing mercenary armies. Next he points to Hugh Capet, a "microscopic lord," and his adoption of a royal, essentially religious, title. Capet gets the crown because he is weakest relative to the lords around him. Laws bind the king more than his subjects because he is the arbiter of justice and because his role supplies moral support to the kingdom. In executing his role, he protects property rights, which in medieval times were specific individual rights of *dominia*, as opposed to the broader property rights in Antiquity, *proprietas*. In this patchwork of customs and hierarchies, members of each community internalize the rules of controls and rewards. Religious and emotional controls rule. After 1000, the Capetians

31

begin to coin money, muster soldiers in emergencies, regulate exports and perform other aspects of administrative power. Quigley isn't worried about this period so much as the next, when France is immured in several periods of legal rigidity that prevent necessary reforms.

The second phase of the reign of Charles VII (1422-1461) is significant to Quigley for several reasons, but primarily for the Montils-le-Tours edict that required localities to codify local customs as local law. This system, or lack thereof, results in the administrative disunity and paralysis that leads to the Revolution of 1789. France is unified under one king in 1500, but taxes, tolls and measures are different everywhere and the king is impossibly weak; only with Church of France help (and loss of still more sovereignty) does the king acquire loans from the city of Paris. Out of this inefficient bureaucracy grew the activities we associate with public authority and a State.

In his State of Estates 1576-1776 lecture, Quigley marks the development of the concept of sovereignty, which he defines by eight aspects: (1) defense, (2) settling internal disputes, (3) administrative power, (4) taxing power, (5) legislative power, (6) executive enforcement of law, (7) money control, and (8) incorporating power. He calls this period the Age of Estates because estate actions in four regional zones in Europe shape, in different ways, monarchy and State power in each zone. England and Germany have more estate holdings than France and Russia, where family farms are the rule. Quigley makes the incredible observation that during this period, no peasant has to worry about royal interference in his affairs. In England, the serf stops being a serf when he gives up land rights by paying rent instead of working a portion of the lord's land. This transformation increases estate power to the point where estates control the courts and Parliament. Reformation Germany's implementation of Roman law leads to decentralized principalities that Quigley cherishes; Eastern Europe, as he describes it, has a system of nepotistic gentry administration vulnerable to advancements in military technology and the commercial expertise of city-based Jews. In France, taxes lost in barter deals over local tolls and other schemes engender corruption, such as selling offices. Quigley is

comical when speaking about the endless litigation among charterless corporations, prolonged to serve the interests of lawyers and judges, as is the case today. In 1776, the attempt to abolish guilds fails because of their legal debts. Only revolution wipes out all debt and ushers in the Napoleonic Code. After the Revolution, all the gaps and cracks disappear; State power becomes absolute and in perfect opposition to the individual.

Quigley begins his State of Individuals (1776-1976) lecture with a discussion of a society's ability to supply needs: military, political, social, emotional, religious and intellectual, which, he notes in passing, are arranged in "evolutionary sequence." One of his first points is that Sirhan Sirhan killed Robert Kennedy to manifest his existence. It couldn't be psychic-driving, the likely form of mind control that made Sirhan do it, rather the desperate social need to show off that motivates these otherwise pointless assassinations. As for intellectual needs, look no further than Marilyn Monroe marrying Arthur Miller, whom Quigley nonetheless implies is not an intellectual. The retired professor speaks of the need to love children in communities and thus socialize them in terms reminiscent of Hillary Rodham Clinton. He then levels all needs to their role as the basis for power.

Power, Quigley proclaims, and this is a point that I explore in the General Theory of Civil War, is best administered by legitimate power accepted by the people. Wars and revolutions demonstrate the illegitimacy of a given regime's rule over a society. A "revolutionary situation" Quigley tells us, "is one in which the structure of power - real power - is not reflected in the structure of law, institutions and conventional arrangements." By 1776, we have isolated individuals confronted with a powerful State apparatus - the economic expansion or commercialization process sputters and by now rewards and controls have been externalized. This promotes instability. Politicization and then militarization sets in. Quigley gives America a century or two, but he remains skeptical when contemplating the increased rate of change and the way everyday relationships are no longer between people but with power, wealth or organized force. Quigley disdains

33

the way everything is now commercialized - religion, education, politics - yet he firmly believes that an expanding society requires not just the continuation of commercialization, but increased output per capita (although later he backs qualitative change). Once politicization takes place and raw power animates a society, we face a crisis prone to militarization.

He disputes the myth promoted by the French Revolution that a nation can be both a State and a community. Independence movements, to take one example, reveal the weakness of the nation-state concept. Moreover, the exceptional amount of behavior regulated by internalized controls - he says eighty percent - indicates how ineffective external controls are in creating a stable society. Indeed, we no longer have the weaponry needed to control the individual behavior of those who don't have internal control. Instead, we recruit mercenaries from the same twenty percent of the population that doesn't have internal controls. Communities are required for stability and any illusions of American stability in the XIXth-century seem silly. Greed and competition never create communities, nor do litigation-obsessed bureaucracies Quigley tells us, nor modern-day, capital-obsessed corporations that enjoy all the rights of citizens - a source of outrage for the ex-professor. Nothing works well, he tells us, beginning with the industrial production of medicine and food and ending with the Constitution and Supreme Court. In a derisive aside, he adds, "We would have to have someone supreme." The State is powerless before the might of corporations, and for this reason the only way out, adopted by millions, is to cop out. Carroll Quigley dies a few months after this lecture, on January 5, 1977.

Notes

1. Note well that Ferenc Nagy is not to be confused with Imre Nagy, who occupies a significant place in Hungarian history and in the history of the XXth-century. But Imre doesn't merit the hero's honors and martyr status now bestowed on him by the post-communist regime. As minister of agriculture and later as minister of interior, he survives the Stalin era's worst purges and becomes prime minister in 1953. While implementing Moscow's reforms, Nagy lets up on the toll exacted from the population in meeting increased production goals. He goes so far as to call for the abolition of special police tribunals - he goes too far. Relieved of his post in 1955, he will later be expelled from the party as "an incorrigible right-wing deviationist." In February 1956, Krushchev gives his famous speech to the XXth Congress of the Russian Communist Party. Later that year significant protests break out, first in Poland, then in Hungary. Amid calls for "genuine workers' self-government" Nagy gets a new Party card. In the wake of the October 23 demonstration and massacre, crowds occupy Budapest city streets. Nagy takes over as prime minister and soon allows Russian tanks to restore order. He may have been betrayed into appeasing Moscow, but he certainly doesn't stand his ground as workers and students stage a country-wide general strike with revolutionary councils in permanent session. Nagy gives a quit-your-strike-or-else speech before sending the Russian tanks into full battle with the population. Amazingly, the barricades hold and councils grow stronger. Land is redistributed and peasants supply the rebels with food. The councils are prepared to give Nagy their support if he supports them. Despite his denials about calling in the Russians, it's apparent that he sold out to the USSR. The defense mounted by the workers' councils of Hungary against the Second Russian Intervention remains one of the most glorious defeats in history. Nagy is executed in Romania and workers' councils are outlawed in Hungary.

2. Collier James and Kenneth Collier, *Votescam: The Stealing of America* (Victoria House Press, 67 Wall Street, New York, NY 10005 - I give the address here because Borders once refused to order this 1992 publication for me - also *see* chapter fourteen, end of section 2.1)

3. Quigley's Civilizations:

First Chinese Civilization (1800 BC to AD 400)
Classical Civilization (1200 BC to AD 300)
Byzantine Civilization (330-1453)
Islamic Civilization (630-1922)
Russian Civilization (800-present)
Western Civilization (550-present)

Chapter Three

"The sea sent it to me"
interview with
Joaquin Gutierrez

San Jose, Costa Rica.

I ring the bell of a small bungalow on the outskirts of town.

A dog barks; a child cries.

The legend opens the door with a smile. He's tall, and still standing perfectly erect despite his advanced age. A plume of white hair crowns his noble-looking head.

"So you're a journalist?" he asks with a smile. "I was a journalist, so we're colleagues."

I step into the vestibule adorned with photos of him with Lenin's secretary in Moscow and with Ho Chi Minh in Hanoi.

"Yes, Don Joaquin, but you're a communist and I'm more of an anarchist so -"

He cuts me off with the wave of his hand: "What's important is the struggle."

We move into a large room overlooking his garden and take

armchairs beneath a large painting of the silvery rain of Puerto Limon: with his white hair and beige skin, he almost looks as if he's right there on the beach.

I start the tape.

Can you tell me a little about your novel *Puerto Limon*?

It's about my youth in Limon. My father had a banana farm during the crisis of '29-'33. We Ticos grew bananas on contract for the United Fruit Company, and they paid us with vouchers that could only be used in their commissary so we couldn't send any money back to our families. In those days the banana trees grew much taller. It was bestial work to cut the stalk and catch the bananas on the back - hours and hours getting hit on the spine with bananas. But the good thing about Limon is that it enabled me to understand ethnicity. In Limon there were blacks, whites, mulattos, indians, mestizos, Chinese, gringos - all the races living together. So I learned that the heart of the man is the same regardless of the color of skin. We are a big human family.

I understand that Luis Fallas, the popular communist author of *Mamita Yunai* [about United Fruit], fought against Jose Figueres, the social democrat and devotee of Fourier, during the civil war in 1948.

This was a very complicated war. It produced confusing alliances - many of us were much closer to those on the other side. And when the country changed, it was very good for the poor people. Figueres' group of social democrats was much more advanced than the neo-liberals we had before. Who thought Figueres would nationalize the banks?

What side were you on?

I was always with my party, but at the time I was in Chile.

During the time of Allende?

I was in all four electoral campaigns that finally resulted in Allende's election. Four. Elections were every six years. The first time he got fifty thousand votes. The second, three hundred thousand. The third, three hundred eighty thousand. The fourth, one million votes, and he won. It was a long march. But let me tell you something about

Figueres, Don Pepe; he saved my life. After the Pinochet coup I was imprisoned. Don Pepe sent Pinochet cable after cable telling him to free Joaquin Gutierrez. He didn't know me, but if not for the cables from Don Pepe, I wouldn't be having this conversation with you.

When you were in Moscow in the Sixties, did you happen to meet Mikhail Bakhtin?

No, but I read his book on Dostoyevsky, which is undoubtedly one of the greatest works of philology and philosophy of art. He was the most important Russian esthetician, but theory can't die, it's destined to continue. The biggest contradiction is to believe that the dialectic is something fixed, static - there is a dialectical evolution of the dialectic. If you don't understand that, you don't understand anything. The Chinese had their yin and yang, which is dialectical, and they had the good fortune to miss the interpretation given to Aristotle, whereas it took us in the West a long time to get back on the path of the dialectic. But even my colleagues at the Foreign Language Publishing House in Beijing would ask me, 'Who was this Jesus Christ?' This was right before the Cultural Revolution when I was translating Mao. Of course many people in the United States have no idea who Buddha was.

[The phone and doorbell ring simultaneously. After a moment of confusion, a young girl answers both.]

What was the question? Oh yes, the point I want to make is that the most absurd problem is the division between the two worlds, capitalist and socialist - or better said, the contradiction between the two systems of production that coincide on the same planet. There must be an interpenetration of the two systems. We have given excessive importance to fighting and not enough to unity.

If the dialectic is between capitalism and communism, might not cooperatives be a synthesis? Their proponents say the cooperative worker is a proprietor of the means of production rather than a proletarian.

The cooperative is a political mattress that puts the workers to sleep..., even though some cooperatives have produced good results.

41

It depends on the product, the region, the fertility, the capacity of the peasant, etc. As far as the means of production are concerned you can look at coffee. The peasant has the means to produce coffee, but the processors and traders are the beneficiaries. These industrial and commercial processes are in the hands of foreigners and coffee is the most Tico product of all.

I'm reading *Cocori* and enjoying it very much.

Cocori is a book for children, but adults read it too. It had an eight-year run as a play in Berlin. Would you like a drink?

He pours tall glasses full of rum.
We toast each other with incredibly smooth rum.
I stop the tape.

"You see this?" He points to a stone figure on a nearby shelf. "The first nations used this to press cacao. Picasso considered it an impressive work of art."

We sip our rum.

Suddenly, Joaquin gets up and grabs a knobby piece of wood and holds it like a cane.

"One cloudy day, not so long ago, I was sitting on the beach in Limon and the sea sent it to me."

Our conversation drifts from the bars of Sofia to the latest project of Gabriel Garcia Marquez as we drift around his house taking in his souvenirs. He looks almost Biblical with his wooden staff. I'm getting drunk, but I remember to ask about his translation of the collected works of Shakespeare.

"It was very difficult for two reasons - there were many archaic words, and the sentences were constructed with the words in an illogical order, which I call 'pig tails.' My method was to take out one of every three flips and to use modern language so people could understand a little easier. It was very rigorous, and it took me five years - an immense, monstrous undertaking, but it helped me as a writer. Even though I was fifty years old, I looked at the task as an education on

how to use words and language. Ah, the precious plays on words, the audacity."

I take my leave. A little drunk and disoriented, I climb the sidewalk out of the subdivision. The sun is setting, and as I gain on the road heading into town, a vista of the sunset opens for me that is almost as beautiful as the smiling faces of the Ticos passing in their cars and cycles. I sway over to the bus stop and stand there feeling very free and alone, yet also much closer to Spanish-speaking peoples of the Americas. Thinking of the great humanist writers of Central and South America who, for better or worse, had a stake in the history of their times - Bolivar, Marti, Gallegos - I'm reminded how most North American writers stay disengaged. A truck rumbles by in a cloud of dust and my thoughts turn to my dinner date that night. A thought nags me: *What have I done to change this world?*

43

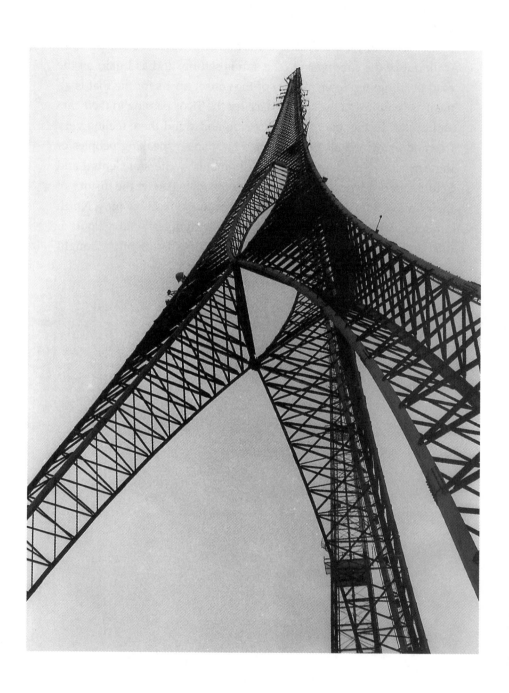

Chapter Four

Anti-Labor Day 1997
with selected
Aphorisms Against Work

On the End of Work

In my polemical response to the French academic Robert Castel and his notion that the end of work is a demobilizing myth,[1] I remind him that when we speak about a utopian end of work, we're referring to the end of *alienated* labor - domestic labor and autonomous activity are by definition exempt from abolition. It's healthy to keep a paradise in mind, and this is especially true given the increasing severity of workplace conditions, even in places like France where dear S writes of her most recent horror: she's forced to run in heels at her receptionist job even though she has severely strained ankle ligaments.

For activists in the zerowork or slacker movement, "the myth" of the end of work, as Castel accurately calls it in communications terms, is explicitly used in hyperbolic and propagandistic ways following the sublime example, save the distasteful anti-Semitic insults, of Paul Lafargue's hilarious *The Right to Be Lazy* (1880). We're not so naive as to say that work will suddenly end tomorrow, and to say so aims a tinny voice at a straw man.

While we dream of the end of alienated labor for everyone, what we practice is the refusal of work, which is a more accurate expression to describe our movement. We either quit or strike over issues such as mandatory overtime, or just call in sick in the German

Saint Monday tradition. These activities, regardless of how momentary, represent the realization, not of utopia, but *eu*topia (not "no place" rather "a good place"). And while this momentary end of work may not affect the labor market in a positive way, it amounts to a personal victory in the war against reproducing one's exploitation.

Most labor remains a cheap commodity as long as it is a commodity and as long as the accumulation of labor leads to the accumulation of capital. Only workers prepared to refuse work can mount effective resistance on the job using slowdowns, give-away strikes, sitdown strikes, sick-ins, ignoring the boss, monkey-wrenching, etc. These Wobbly tactics are, in part, what the Indian group Kammunist Kranti calls routine resistance - more effective tactics than unifocal struggles such as union-sponsored strikes with their low expectations, predetermined outcomes and tendency to peter out. The small steps of routine resistance often work better than contracts, which, when seen in the light of a resistance strategy, amount to concessions to management, not a worker benefit as Castel assumes.

So you can see how activists use the end of work as a dream, a lofty aspiration that responds to real pains and needs and as a lure for the very concrete refusal of work movement. What I'm saying is that this myth of the end of work doesn't demobilize people, rather it mobilizes them in ways that may be under Castel's radar. I recently met a Sorbonne management professor who, when I asked if she had read Michael Seidman's *Workers Against Work: Labor in Paris and Barcelona During the Popular Fronts*, responded: "I haven't just read it, I teach it." The other side knows the real worker threat, which is why business institutes incredible surveillance and eradication measures. I doubt the academic Left has fully contemplated the refusal of work and calculated its potential power and range as a revolutionary weapon to gradually wear down the enemy. But then again neither have most workers, even if they have practiced some form of refusal.

Moreover, I'm not convinced by Castel's booming assessment about the world of wage work because he uses French, not global, figures. And he makes no qualitative distinction between productive and

46

non-productive labor. Include the rest of the world - Korea, for example, in the current financial crisis - and discount people outside of the production of goods and you'll get another picture. There is simply no denying that low-skilled people are being unemployed by technology and that considerable work-loss is hidden by narrow statistical categories. Downsizing, in its various forms, including what the Japanese now call bullying-downsizing, has abolished many mid-level jobs. But even if total global work hours are going up faster than people are becoming eligible to work, this only proves that the situation is getting worse for overworked wage slaves. The phenomenon of overproduction is well-known in the business press, the auto industry being the most obvious example. I think we're drastically underestimating the role of decades of overproduction in the current Asian financial crisis. We should consider immediately putting an end to certain forms of work, from CEO to board member to many banking and finance positions as was the case in the Middle Ages. Freedom begins where work ends.

Anti-Labor Day, 1997

On August 30, I produce the layout and cover for my heretical *Aphorisms Against Work* and hastily make late night copies of the eight-page pamphlet. Ready. Set. The news breaks: Lady Di, Di, Di says "Stick it in your eye" to the photographers who'd done so much to make her such a royal celebrity-commodity as her chauffeur-driven, armor-plated Mercedes rattles off the walls of an underpass on the banks of the Seine. To perish at thirty-six, my age, is tragic, even for one whose life is nothing but the beautiful experience of luxury villas as large as many towns. Blow out the candle and pull a white sheet over her porcelain body - a cold reminder that a bed or deathbed is only a question of degrees. Not to be too compassionate about the death of anyone who would have the conceit to consider herself royal. Better to sing songs of criminality and sensuality in the graveyard at night to remember the proximity of life and death to love and sleep.

47

Any hopes for a slow news day on this Sunday before Labor Day fade as the image of the dead princess rises like a phoenix in the spectacle that had created and then killed her. Her bleached white bones and these already wilting flowers come to mind - knowing that her coffin will thoroughly dominate in a fetishistic way, I go ahead and test the terrain rather than garner any serious media attention. First stop, Fox News, 8:00 AM - NPR's Mara Liasson gets out of a white Cadillac and sees me wave to her as I pull up. Smiling, I flash the pamphlets and she pauses long enough for me to give her a few: "You want me to give these to the other people on the show? I can do that." Very gracious of her, if she does in fact do it. Contemplating the reaction of the likes of Tony Snow and Brit Hume to the aphorisms, I make my way to ABC where, outside, an obviously overworked ABC Radio worker takes a copy with a friendly smile. I leave five copies for Sam Donaldson. Next stop CBS - a couple of copies for those who *Face the Nation*.

Secretary of Labor Alexis Herman will appear on CNN so I go over there, just off Psychology Plaza, and talk to a limo driver. I tell him what I'm up to and he gets a kick out of it, agreeing with me that limo drivers the world over are overworked. I think of my month-long stint behind the wheel last summer - after expenses I made less than minimum wage. It's outrageous and I'm lucky that I didn't crash when overworked day after day. I go into the CNN building. The guard calls up for me - someone is coming down. While waiting, I turn to an ABC reporter who also waits in what might be called an intraspectacle stakeout:

"I'm a dissident celebrating Anti-Labor Day."

She puts her arm up in protest: "I've been up all night covering Princess Di and I don't want to hear about it."

"If you hadn't worked so much, you wouldn't be in such a bad mood."

The laugh of solidarity from the guard lifts my spirits because it tells me my protest resonates with his everyday life - a sane response to an insane situation. Before you question my sanity any more than

you already have, try not to think of this laughter at the expense of work as mean-spirited, rather as a gift. The guard's laughter, in the opinion of many doctors, adds time to his life.

A producer comes down and accepts my pamphlet for the secretary of slavery, as I would've called her if she weren't black. On my way back to the business district, I stop by Fox, located in the Hall of States where the governors have their offices, but the CNN stakeout won't cover my gentle protest. Back uptown, I gas up and head over to CBS. A cynical cameraman comes and goes. Martin Walker, the British journalist, walks up so I give him my thoughts on Labor Day. He smiles, perhaps reminded of London pamphleteers, and a Salvadoran janitor who sees the exchange asks what I have:

"It's too bad that you have to work Labor Day weekend," I say in Spanish.

"I suffer. For me, life here is bad."

Sensing a potential ally, I tell him that I'm making a revolution against work. He takes the pamphlet.

"You know," he says, "when I first came here and saw the wind blowing in the trees I thought that this place was paradise. Now I know it's modern slavery." And as I'm leaving he speaks to me with gravity in his voice: "If you're making a revolution against work, I'm with you."

For a moment I know that at least two of us no longer support the tyranny of work. We're ready to revoke its power over us, power that we give to work as long as we want to endure it. By publicly contradicting the general will to suffer untold indignities at the hands of work, a passageway emerges leading away from economic misery. If we take victories over work where we can get them and strengthen ourselves to endure a long struggle, we will succeed.

To kill a little time, I cruise back to ABC to see if there is much of a stakeout: the reporter who had been at CNN - the butt of my joke - is outside smoking. She scowls as I roll by. Her driver, the guy I'd spoken to, stands by his car down the building a little ways. He grins and waves in what I like to think is solidarity. I circle back to CBS -

nothing going on - then head up to the National Cathedral. Passing the British embassy, I'm negatively impressed by the camera crews and the beginning of the memorial to Di. To think we still have princesses at this point in the XXth-century and that so many girls still buy into that shit. All I can tell you about Charles is that when he showed up in Coronado, CA, to try to surf in the Seventies, we got a big kick watching him paddle out. Charlie don't surf, and his daily life must've been abominable or else Di probably would've fought for him and not run around with a long list of men, ending up with a rich Egyptian playboy. Anyway, none of the camera crews want to hear about my critique of work, or my commentaries on the commodification of Di. They want to talk to the people who think that life really takes place on TV, that the dead images of Di are alive and that they're missing out on life. To make this story short, I'll skip over the details of my donations of pamphlets to slacker kids, reporters and to more than a few pretty young women strolling the Cathedral grounds.

I go inside as the secretary is giving her speech. When it's over, I ask her press people for a copy of it. What did she say? Work is a source of dignity? Where is the dignity in working for $5.15 when someone has you do something you don't want to do? At forty hours per week, this $5.15 amounts to an annual salary of $11,000, which still amounts to poverty in my book. Where is the dignity in working for crumbs like that? What we once called chump change. She claims that unemployment has dropped to a twenty-four-year low, but only experts can demystify these figures and count marginally attached workers or discouraged workers or ones that haven't worked in many years. Of course she ignores the serious crisis of overproduction, which is only superficially discussed by the business press:

> [...] On some estimates the industry will by 2000 have the capacity to produce twenty-two million more vehicles a year than the world wants. In other words, every car plant in America could close, and the world would still have too many cars.[2]

50

With advanced automation techniques, there really isn't need for us to work the hours we now work. Yes, the deflationary macro-economics are currently good for the *rentiers*. But even the secretary makes the point, in an indirect way, that not everyone makes out like Wall Street bandits - this is "morally troubling" and "economically unsustainable." The new minimum wage is a "matter of social justice and economic necessity," but it is still not a living wage. Look where we've come since 1968 - in 1997 dollars, the minimum wage in 1968 was seven dollars per hour. Where is the dignity in watching this already meager compensation drop to five dollars over the last thirty years? The same work, in increasingly unfavorable conditions, receives less pay. Go figure. We may not have had to do it, as she argues, but we have indeed robbed Peter to pay Paul. And the secretary knows it. She speaks of going on a tour of coal mines, but glosses over the disaster of that industry to workers and the ecology.

Finally, she comes around to the UPS strike, which is what I was thinking of in my fourth aphorism: "The ugly brown dye of work spills across this miserable civilization, saturating the fabric of everyday life, day after back-breaking day." My idea of hell on earth is the life of a UPS driver endlessly delivering packages. And to think that the mafia-ruled Teamsters are against part-time work and for full-time jobs. The union should've taken a position that the drivers could really stand behind, like full-time pay for part-time work.

While waiting outside the cathedral for the event to unfold (the Secretary will speak for CNN), I talk with many people - reporters, the Department of Labor sound man, tourists. A small group from Wisconsin, where the dreaded Wisconsin Works program is now going into effect, are right with me:

"I can't imagine going to work on Tuesday, can you?" one middle-aged woman asks another.

"No, you're right, I don't want to work," she says with a laugh.

It's strange standing with reporters who would rather be at the British embassy around the corner. I chat with a Labor press woman who complains that I'm making her work, which enables me to point

out that her presence here isn't the result of an autonomous decision - she has every right to be indignant. The secretary emerges and speaks first to CNN, as planned, then to the gallery of reporters (one of her goons stands in front of me because I'm "too close to the cameras"). And she has a few words for the Labor Department soundman who will put her recorded message (with church bells in the background) on an eight hundred number for radio stations to call up and use. At this point she greets people from the press, turns toward me and takes my *Aphorisms* with what sounds like a polite "Thank you." She may never have read them, but I know that my truths ride away with her in her limo. No way she could miss the cover quote: "Prepare for the coming inaction - be lazy."

As I walk away, a Cathedral guard chuckles as if he knows what's up. I make my way to the other side of Wisconsin Avenue. It's a fine, sunny day. While I'm getting in the car, a GSA cop in battle gear trots out the alley to make sure that I see him in my rearview mirror. I'm not followed back to Virginia. The lesson of this action isn't so much my audacity in giving *Aphorisms Against Work* to the person least likely to want to receive it, rather the spontaneous expressions of solidarity I receive from so many bad workers. A general strike without leaders and without end seems more possible to me today than ever. These notes have been compiled, with ease, on Monday, September 1, 1997. Lazily yours....

Selected Aphorisms Against Work

1. Everything that requires effort and supports the market - shopping, cleaning, watching television - has become work, albeit invisible work.

2. Work surrounds us and lays siege to our souls.

3. Going to work is like hurling yourself into an abyss.

4. Slaves feel tired just thinking of all the work they've yet to do.

5. Many waters cannot quench our thirst for laziness, nor floods drown it.

6. Creativity constrains the return of work; be creative and put severe constraints on work.

7. Laziness is a comedy in which we can all play a part, a veritable field of sunblown flowers where the unruly colors of the universe dance with the wind.

8. Fling your work schedule into the river of time.

9. The legends of paradise teach us to curse work, reminding us that laziness is the essential goal of humanity.

10 All power to zeroworker councils - impose a strict regime of laziness!

11. The right to work is the right to misery and always implies the possibility of the right not to work.

12. Now more than ever, we must fight the measures designed to make those who refuse to work, work.

13. Work is the graveyard of bad intentions.

14. Authentic humans feel degraded by those who preach the religion of work.

15. Pay your debts with an effigy of your boss.

16. Wage labor perpetuates the archaic system whereby armies and courts consume the profits of overproduction.

17. In a ton of work, there's not an ounce of love.

18. A life of labor always diminishes one's love of life.

19. Become a verb like Bucky Fuller and cease to be the lowly noun spoken of so fondly, once a year, on Labor Day.

20. Take your victories over work where you can get them.

21. Waiting for the Waterloo of work...

22. Work for full unemployment.

23. Work is long; the boss a beast.

24. Death to Malthus, religion and the dogma of work.

25. Laziness is the religion of the XXIst-century.

26. Worship the oracle of laziness.

27. Every prison is built with work.

28. Desire frees itself from work by consuming commodities in the fires of South Central Los Angeles.

29. Work dies on the comfy pillory of laziness, putting a momentary end to the system that sublimates sex with work.

30. Between wages and salaries flows a river of tears.

31. Laziness is my food, love my wine.

32. Work is to life as a wall is to the wind.

33. Laziness and hedonism prevail over productivism and puritanism.

34. Work sits, as the saying goes, at the brave rider's back.

35. Freedom begins where work ends.

Notes

1. An excerpt from Robert Castel's "The End of Work, A Demobilizing Myth" from *The World of Work* (*Le Monde du travail*, Kergoat and Lienart eds., La Découverte, 1998) in *Le Monde diplomatique*, September, 1998 pp 24-25.

2. No author, "Car Firms Head for a Crash," *The Economist* May 10, 1997 cover story.

Chapter Five

A Psychogeographic Map into the Third Millennium

Sending Our Souls to Search the City

Drifting advances the progress of hedonism through the process of creating more life. By taking pleasure in the sensation of movement and simultaneously responding to the immediate impressions created by everything around you, you in turn create a moment of poetry. This lyrical passage may take place in the space of a few yards - follow the nearby pedestrian alley between buildings, for example, not really knowing where it goes - but mile-spanning vistas are just as likely to lead to the Northwest Passage, as conduits out of the ordinary were called by the first psychogeographers (see my biography *Guy Debord - Revolutionary* for the early history).

Knowing, intuitively, that to form habits is to fail, you criss-cross the smooth footsteps of the first hedonists drifting on the sand-stone cliffs of what is now Libya. You recall from your youth how you instinctively sought pleasure and direct your present actions towards obtaining new pleasures. Your impressions are created by your imme-

diate relations to everything around you, relations informed by the constant reminder that historical consciousness is consciousness of everyday life. Why is it abstract or egotistical to recognize something of yourself in all the human endeavors that have come before you? A pleasurably human response, indeed, the ultra-human response. You recognize the things around you as the cause of your impressions and you perceive the human touch in all of these things. And then, at decisive moments, you possess the creations of your fellow humans and use them for your hedonistic ends, ends at odds with the current mindless reproduction of daily life. You laugh to yourself that a hedonistic act is now a historical event because it's true.

For an instant, you feel what it means to be human - the sensation of the earth under foot and the shifting angles of the urban landscape that surrounds you. You know that as long as you're human, as long as you are you, you'll never escape human subjectivity. You exalt in this subjectivity. After all, you have your grievances, your great and small pains without which you wouldn't know pleasure. As these grievances accumulate on a grand scale, your knowledge of history tells you to anticipate and foment a transformation in which you could play a part in the passage of this civilization of pain and economic utility into its opposite.

Orwell puts it nicely in *Homage to Catalonia*: "When you are taking part in events like these you are, I suppose, in a small way, making history, and you ought by rights to feel like an historical character. But you never do, because at such times the physical details always outweigh everything else." For us now, class war infiltrates daily life by the sheer superabundance of commodities and spectacles of commodities in the human ecology - a colonization manifesting such vast power that most of its subjects are afraid to whisper that the emperor wears flammable pajamas. The dialectical moment transforms us from neatly dressed citizens into graffiti-writing vandals, all too ready to express our skepticism to fellow pedestrians about the captains of industry who dictate what people buy, and what junk fills the world.

Drifting through this maze of commodities, like work, requires

effort, but the same is true of all movement. If I were to assure you that without effort you would never experience pleasure, would you consider looking at work for what it is? Otherwise, work will always be lead in your feet as you shuffle like a bored man towards the yes and the no that you don't see. Ignore the dialectical relationship between work and life and see where it gets you; you quickly lose touch with the living soul inside you and identify with the commodities around you as a commodity.

It's time to revive and modernize the debates about pleasure that raged in IVth-century Athens. Are you a partisan or adversary of pleasure? Moreover, we don't want a calm sense of pleasure that has more to do with the absence of pain and reminds us of sleep. We want the positive enjoyment of sensual pleasures found in movement, the pleasures we attempt to snatch from fate the same way - guided by nature - we snatch a purse, figuratively speaking, or otherwise behave in sacrilegious ways.

The material conditions of existence here in the capital city create maladies of the soul that defy psychoanalysis. The overbearing ways and insulting tone adopted by Washington bureaucrats - political, administrative, corporate - underscore the barrenness of their souls. Recall that the soul expresses the spirit, the deepest inner core of a being. Spirit can never be known save through soul, and soul is always other-oriented - in other words, you can only catch a glimpse of your inner spirit through other people because soul depends on the other for expression. With the reckless inner power that comes from truth and flexibility of soul, we sometimes transform the essence of bureaucrats by compelling them to cultivate habitats of inhibition.

Their burnt-out eyes meet our blazing eyes. We in turn give them looks that burst into flames and burn. Like deafness or gout, the morbid over-cautiousness of most Washingtonians hints at senility or depression. With our vast fund of impudence we infect the philistines of WDC with a wild thirst for life as an antidote to the spite and bitterness of our times. We have a therapeutic technique for those disillusioned with careers and hurl at the prospect of a future spent at false

occupations. Psychogeography enhances our experience of the world by listening to the cries of the material world that speak to us in our language.

"Welcome," we tell them, welcome to an adventure involving what certain highbrow theorists euphemistically call "the withdrawal of obedience." Yet we explicitly obey the laws of pleasure by moistening our souls and moving around only half-knowing where we're going. To catch my drift, you must cross the intellectual equator into the realm of dialectical hedonism where delightful scents and tastes and emancipatory sensations are themselves and their opposites. For many years, my friends and I have practiced these psychogeographic techniques that boil down to putting pleasure into action as we drift and don't drift, through the city's kaleidoscopic topography. We experience particular pleasures and increase happiness, which is the sum of all pleasures that ever have, and ever will, come into existence. Without pain, we would never know pleasure; regardless of its source, however bad or even painful, all pleasure is good. The road to and from the beer store is the same and different depending on whether it's day or night.

We often begin our Dionysian processions in Dante's shadow near 15th Street, NW. With bumpers of beer in hand, the abyss between our hemispheres quivers and, to paraphrase the great poet, renews itself in chaos. Who benefits from chaos? We benefit because we don't have hierarchies to defend. The wet soul displays wisdom in this neighborhood where each step can indeed be a veritable descent into hell. Sirens, gun shots and screams of pain accompany us as we navigate the rapids of addiction. We know that every step and non-step can end in death. So where do we go? Further, mostly further....

But when we come to the door of eternal pain, we turn away because pain and its reasons (Dante's rhetorical tortures) make us small, and because eternity doesn't exist. Conversely, as indifferent and instinctive as pleasure may be, it creates brief moments of greatness. I'm not thinking of the expansive dimensions of my eleventh finger, although this certainly qualifies as pleasure unchained. Our march in

line with grapevines is itself a clock that marks dazzlingly pleasurable moments, and by coming together as city-rangers at war with notions of absolute utility and with commodities and the psychology of isolation (and a few other things), we experience the living deed. This city of ours, so meretriciously dressed in advertisements, is redressed with the subversive flicks of our magic markers. I remind my cohorts that no matter how small an operation may be, it remains unique at its particular point in history and therefore has qualitative significance. Our drift may go down in the history of hedonism as we drown ourselves and our delusions on land as others do at sea. Walking in the magic city....

Who are we kidding? We're only kidding ourselves into thinking that unlike those whose minds are perverted by custom or bad morals into choosing pain over pleasure, we don't need excuses to celebrate the stupidity of work. Instead, we paint skeletons on our cups to remind us that time is fleeting and to get from it all we can. As dawn breaks, a young woman goes picking flowers reflected in water, blue-gray water rippling in a soft breeze. I point to the clouds as they drift by, and with a word or two about love, I'm picking youth's garden on the banks of the Potomac.

This may indeed be useful, but no-one is absolutely useful. They, the bureaucrats in their prison-offices, see us and wonder how we wander day after day in the sun-drenched parks dotted throughout our elegant city. Why should we behave like humble slaves when we're freed or runaway slaves? For a moment we can walk on dreams and devour vast distances. This is how we sketch the cartography of our desires - with the immediate impressions we have of what we see. And if we're moved to do so, we think nothing of stealing, committing adultery or being sacrilegious. We insist on having near absolute freedom of speech with everyone. We know that words expressing evil are destined to take on a more positive meaning. We live to repulse those who want to die and risk our lives in the process. To paraphrase Heraclitus, we step in mud and wash ourselves in it.

Our perceptions of the micro-environments of WDC have been

altered, sometimes even enchanted by these techniques. Given the degraded state of everyday life in the capital of the United States of America, continuous reenchantment is no small feat. As we drift by the horizontal skyscrapers, we witness the shabby lives of human worker-bees in their hives. After work, their paths cross on the street, but they remain disconnected. At night, we drift by their residential windows and observe withering, human forms bathed in flickering blue light: a strange mass-fusion with televisions. The dispossession and isolation induced by these torturous conditions has driven many people out of WDC, and some to early deaths.

The finest psychogeographic practices condemn the complacency and overbearing uniformity of WDC by demonstrating, through experimental behavior and radical interventions, just how open-to-question these restrictions on life have become. For example, the flat roofs of many town houses offer impassioned psychogeographers an ideal place to display their passion. The sight of two sexually intertwined bodies on a clear spring day can have far-reaching affects - for the unsuspecting viewer it can be a turning point, a gift that inspires her to unite with the world. From the cradle to the grave most Washingtonians wander in the labyrinth of office buildings built on a murky southern swamp. Iron enters their souls. We anticipate your objections to these assertions and simply remind the reader that the phonemes at the root of most nouns refer back to sounds originally used to describe human body parts. It is perfectly natural to be your path by simultaneously reading and rewriting it, superseding it by making it you. Living life as a lie - detached and disconnected from everything - only leads to anguish.

"Mysterious Assassinations and the New World Order"

When Steve Cokely announces on Jessie McDade's weekly radio show that he will speak about the death of Ron Brown and others, I figure it might interest *Steamshovel* editor Kenn Thomas when he vis-

its neo-Rome. The event is billed "Free and open to the public" on the local Pacifica station. So on a Tuesday in September, Kenn and I drift over to the Georgia Avenue Cafe and the Howard University Hotel. The end of a cool, hazy day - my eyes scan the vacant skyline over the playing fields through poison-laced smog, stopping, for an instant, on the Wonder Plaza sign that echoes the Wonder Bread sign at the cafe's service entrance.

I'm debating whether this space is worthy of my affection when a sexy blonde waves to me. Naturally, I wave back.

"Why did you stick your tongue out at me?" she asks.

"Involuntary response."

She introduces herself as Christina, from Germany, over the wail of a car alarm. Kenn drums his fingers on the brick wall, thinking that I'll have this strumpet play my trumpet on the other side of the wall. I introduce her to Kenn who gazes back at her with beer-stained eyes - she suddenly throws her arms around his neck and announces: "I'm Barbie." I doubt she's Christina, German or as broke as she claims to be but I like the organic motion of her hips and the way it puts a few waves in the waters of stagnation that engulf this unpoetic space. Leaving her in our wake, we cross the street and step into the shadows of a hotel arcade.

We attempt to harmonize with this architectural form and get into the flow of the place, but we're waiting and our invisibility cloaks don't function in this all-black zone. Eventually, the cafe opens and we go on in - our conversation and laughter ruptures the anxious silence that surrounds us. A guy with gray dreadlocks sets up a video camera while another guy wearing a hearing-aid works the tapedeck. I quietly comment to Kenn that they're worshipping machines like the others; he's oblivious and wants to tell me UFO gossip. The cafe fills with an upscale black crowd as the tape-recorded words of Cokely on Jews blare from the speakers. I don't believe my ears. Kenn and I quitely continue to converse.

"Is there anything to all this?" I ask, adding, "Cokely said on the radio that he had information about Mickey Leland's plane crash."

63

"There's talk that the plane may have been shot down by the space shuttle."

Needless to say, Kenn has a very open mind, which is more than can be said for Cokely. As soon as he shows up in his red plastic warm-up suit, this would-be black messiah has a pitifully obese guy ask us (the only whites) to leave this supposedly public event. Kenn reminds him that this was the treatment blacks were given in the Fifties. With a sheepish look, the guy insists that the discussion is private. Because less would be a bore, I yell "Racism sucks!" as we leave, intent on marking this rupture with a few words to foul their habitat. The program director at WPFW agrees with me - Cokely is banned from their airwaves and McDade won't do his show this week. WDC is repressive enough without building racist Chinese Walls that cut off conduits to more informed conspiracy theories and still greater conspiracies.

Millenarian Anxieties

From Babylonian times to the present, prophets claim to have discovered the ultimate truths about the universe in omens and visions. In calm, confident voices, the more pessimistic seers sound a false alert about the end. The millennium - *l'an mille*, or 'thousandth year' - is one of the preferred explosion points. Given the uncertainties of everyday life, it comforts many to have an end fixed at a certain point in time. Those worn to a shadow from work don't know where they are in history or in life, and they grasp at these spurious predictions as if they were life rafts jettisoned from the shipwreck of civilization. The adherents of apocalyptic myths swoon upon hearing the certainty of prophetic voices such as Nostradamus: "The year 1999, seven months/From the sky will come a great King of Terror."

Visions of a millenarian Last Judgment actually induced incidents of mass hysteria in 999, which serve as a poignant reminder that no-one knows the future. With the millennium, it behooves us to re-examine chiliastic prophesies with a healthy dose of skepticism, lest

we be visited with the same mass psychosis. The hard truth is that all eschatological thinking is a lie. With the Cold War fast becoming distant history, the children of Washington and Moscow are no longer haunted by the nightmarish image of mushroom clouds (even though the risks of a nuclear accident may actually be greater). The question asked with great seriousness halfway through the XXth-century - "Will we get out of this century alive?" - now appears ridiculous. One of the merits of cyberpunk literature is that it abandons apocalyptic visions in favor of a dialectical continuation of current trends. The cyberpunkers' realistic form, patterned on the XIXth-century novel, corresponds to the decomposition of monumentalized architectural realms and the massive buildup of a hyper-technological infrastructure. We are not drawn to these currents; rather, we map their influence.

Babylon on the Potomac for us to Enjoy Whereas psychogeographers look for omens in the billboards and shop windows of WDC, seeking signs of the verities of commodities, the millenarian prophets traditionally rely on biblical history and astronomy to predict the end of the world. A Babylonian seer in IIIrd-century BC, a certain Berosus, heralds the end in terms more astrological than astronomical. But his present-day followers point to scientific studies on the effect Jupiter has on the sun to support their far-fetched claim. According to adherents of Berosus' prophecy, increased sunspot activity caused by Jupiter has triggered earthquakes, and a conjunction of five planets on May 5, 2000, will have profound gravitational effects on the earth. Time nonetheless flows, and the earth revolves around the sun - a demystified view of contemporary history points to the likelihood of revolution rather than some end-time scenario. In the meantime, the perverse desire of the urbanists of WDC to re-create the milestones of history might be encouraged, so that the wondrous Hanging Gardens of Babylon find their place on the shores of the Potomac for our drifts. One doesn't have to be a Daniel to read the writing on the wall when there are psychogeographers to translate it for our times:

65

All prophets have been judged and found wanting.

"Spoil the Egyptians" The pyramid at Giza and its prestige as one of the great wonders of the ancient world serve a Victorian brand of millenarian prophecy. In 1864, the Royal Astronomer of Scotland used biblical history and his measurements of the pyramid to conclude that the dimensions were based on the sacred cubit used by Moses to build the tabernacle. The astronomer's fellow Victorians hijacked his method to predict the second coming of Christ. End-time dates generated by pyramid prophecy come and go without earth-shattering catastrophes - a few of these dates are clustered around the millennium, but a safe bet is that the pyramid will survive these predictions. We live in a material world, as did the Egyptian slaves who staked their lives on the creation of this cultural artifact. The negation of life, exemplified by Egyptian slaves, continues to this day because negation has been suppressed by the slaves who govern. If the millennium is a prophetic date, it's prophetic because the lucid spirit of negation will be applied to the remnants of Victorian values, and passion creates a licentious festival that breaks all chains - a groundbreaking festival for a new, XXIst-century civilization.

Gnostic Heresies for Those in the Know? At the time of Christ, numerous sects flourished around the Mediterranean. The Gnostics are particularly significant and, to a certain extent, admirable for their cultivation of intuition. Active in Alexandria, then under Roman rule, the Gnostics borrowed ideas from numerous traditions - Christian, Greek, Egyptian. Philo of Alexandria, the classic Gnostic figure, knows Hebrew scripture and Plato. From these he creates the doctrine of the *logos*, 'word' in Greek, expressed by St. John: "In the beginning was the word." The various Gnostic sects have divergent practices, but all strive for mystical attainment of knowledge. Even fragments of the Gnostic scriptures are suppressed by the Catholic Church until the XIXth-century. Then, in 1945, two Arab peasants drift into a cave in Nag Hammadi, Egypt, and find amphorae sealed with lead. Inside the jars

they discover ancient Gnostic texts (unpublished in English translation until 1977) with new prophesies such as the Apocalypses of Peter, James and Adam. The Gnostics are too intelligent to fix a potentially erroneous date-certain to their apocalypses. The Gnostic Simon Magus, a rival of Jesus mentioned in the Bible, and Apollonius of Tyana, a pagan miracle worker, are later associated with the apocalyptic Beast, the infamous 666, by early Christians. The spread of secret Gnostic sects fail to keep their notions of apocalypse alive. However the Gnostics provide a valuable example of heresy that inspires later heretics. Psychogeographers are, likewise, heretics. The difference is that we dissent from the most profound theory of political economy and radical subjectivity of all time. Like the Gnostics, the various psychogeographic sects engage in divergent practices, but we all strive for the illuminating moment of oneness when we become both the subject and object of history.

Revolution v Revelation St. John's vision: a beast with multiple heads and horns seen through lightning and surrounded by a rainbow, spirits and angels - a vision that inspires apocalyptic prophesies and corresponds to most people's idea of biblical apocalypse. Speculation has it that John experienced this vision on the Greek island of Patmos during a volcanic eruption. But there may be another, more likely, explanation. Biblical scholars agree that he is writing in the tradition of Daniel and Ezekiel, which is to say John "eats a little book" (Revelations 10:10) before making his prophesy. This coded phrase and the exaggerated imagery lead skeptics to posit that he has eaten a psychedelic book - the visions are drug-induced. Psychogeographers tend to be too experienced with drugs to lend much credence to visions associated with altered states of mind. Drugs can be a tool to increase the psycho aspect of psychogeography, but we by no means run the risk of becoming a mushroom cult like the Christians. Alcohol is the drug of choice for drifts. Yet psychogeographers naturally avail themselves of everything in the world fit for human consumption. We like certain aspects of the early Christian sects, particularly the celebrated

love feasts and the gender equality borrowed from the Gnostics, later forgone, that brought many fallen women into the ranks - no drug has the desired unifying effect so much as love. No visions are more compelling than millenarian images depicting the earth and human bodies as gardens of delight.

The Year 999 v 1999 No moment to date has experienced as much millenarian furor as 999. The tribes of Europe have been preached to by wandering monks long enough for pessimistic messages to sink into the public consciousness. The apocalypse rumor is so strong that not even the Catholic Church can deny its existence. The impending millennium lends a sense of urgency to the utopian myth of an end-time scenario. Many people fear the worst. Monasteries and churches swell with people during the Fall. They bring their land deeds, jewels, manuscripts, etc. in hopes of being in good grace on Judgment Day. Other pilgrims go to the Holy Land and skeptics buy their land at ridiculously low prices. Debts are forgiven and people stop working. Fields go fallow and livestock roam free. Although some millenarian sects constitute revolutionary millenarianism, many of these sects are notoriously anti-Semitic. The poor rise up, but they irrationally target the ungodly. Prophets preach that history will culminate on December 31, 999. The Pope is Sylvester II, a man accused of having learned the black arts in Spain, which adds a little luster to his Last Mass at St. Peter's.

At the appointed hour, nothing happens. The lords and peasants, down on their knees together, marvel in astonishment that the world doesn't end. Time flows more in the manner described in Ecclesiastes than Revelations. The real problem with these millenarian sects is that they look for salvation from above rather than use the biological force in their numbers to create heaven on earth. In 1999, we anticipate the same hysterics, and we hope to deflect them into global civil war whereby psychogeographers, with their intimate knowledge of the terrain, can point out the hideouts of the rich, along with a few exits, defenses, axes of passage and the exact location of

68

psychogeographic pivotal points such as 1333 16th Street, NW and the intersection of Wisconsin Avenue and M Street. We have a democratic right to know who has accumulated the most capital, because the accumulation of capital invariably leads to the accumulation of the proletariat in more run-down sectors of the city. Eschatology will be superseded by revolutionary ideologies based on ultra-democratic principles, such as decision-making in open assemblies by delegates revocable by the base at any time. As psychogeographic surveyors, we scout and mark the terrain.

Reconstruct the Temple of the Sun? As Ivan Chtcheglov, the grandfather of psychogeography, was well aware, the Aztecs think that the universe operates in great solar cycles. The priests teach their fellow Aztecs of four cycles or suns since the creation of the human race. The millennium is actually foretold in the Aztec sun stone of Axayactl, XIth emperor of the royal dynasty. This huge monolith, hewn from sold basalt in AD 1479, states that the world has already passed through four epochs. The representation of the fifth sun, our current epoch, is the face of the sun god himself, Tonatiuh. His knifelike tongue symbolizes his hunger and thirst for human hearts and blood. The Mayan calendar claims that the fifth sun will come to an end on December 23, 2012, close enough to the millennium for adherents who fail to recognize the sop of the Mayan priests for what it is: "...there will be a movement of the earth and from this we shall all perish." Reassuring words for those standing in line to be sacrificed.

Nostradamus Was Not One of Us This doctor who dabbled in Delphic rites, this contemptible Nostradamus (1503-1566), wrote many verses - around 1000 of them, as millenarians like to point out. We can almost see him now in his study in Solon, France, looking for visions in the water rippling in a brass bowl. Because most of us are reformed poets, we have no patience for the likes of a Nostradamus writing in Greek, Latin and archaic French. But his *Centuries* has never been out of print, which lends credibility to the claim that he is the world's most

69

popular prophet. As mentioned above, he explicitly states that the King of Terror will come in 1999, which is easy for him to say knowing full well that he won't be around when proven wrong. If Mars is to reign as the doctor prescribes in stanza 10:72, then let the god of war be appeased with the likes of poets and false prophets such as Nostradamus. The real disaster is that people still need to believe that the end is near rather than drift around like Eros in search of Psyche in WDC's Valley of the Dolls (Connecticut Avenue, near the Zoo) or have drinks under the volcano of Capitol Hill. *Que será será.*

The newcomers to this millenarian parade marching over the cliff of time include Jehovah's Witnesses, Mormons, Aleister Crowley, Edgar Cayce, and the tragic case of two Portuguese children who thought they were visited by the Virgin Mary in 1917. The terrors of war go a long way in explaining how this Portuguese fantasy takes hold among believers, just as the weed smoked by Rastafarians might account for their fantasies of Armageddon. Look no further than the wackos from Waco to see where this apocalyptic thinking leads.

Rather than trace signs of the end, we use the power of psychogeography to explore the psychogeography of power here in WDC. We pass through the varied ambiances of the city that reflect the poverty and wealth of its inhabitants, and bring with us the historical consciousness of how the city was reduced to its current state. With every step, this historical consciousness informs our consciousness of daily life, and vice versa. As we drink a cup of tea, for example, we're staggered by the way this simple act brings us into direct contact with thousands of workers around the world - the tea plantation workers in Africa, the sugar plantation workers in the West Indies, the refinery workers in South America, the workers in paper mills in North America. Workers at packaging plants. Workers who make the coffee machine that heats the water. Workers who extract iron ore and bauxite. Workers who smelt steel, drill oil and refine it. Workers who transport the raw materials and the parts across oceans and continents. Clerks, typists and communications workers who coordinate production and

70

transportation. When we consider this direct relationship with all the workers who produce all the other things we use, we see all partial group identities fading into insignificance. These people - confined to limited roles in the global spectacle of production and consumption - could greatly enrich our lives with their creativity if they drifted into contact with wobblies and anarchists and not simply other alienated workers. In the millions of potential allies we find ourselves.

Psychogeographers

Who are we? Don't be put off by our sometimes slovenly, nihilist appearance - the red, wintered faces that come from spending most of our days in the open like tramps or wandering drunks. We're always changing, always going somewhere, always turning into something else, living like Diogenes the cynic, or like Arristipus (the first hedonist, who found pleasure exclusively in movement). Although we have numerous impressive exploits to our credit, we must, due to their somewhat transgressive nature, be slightly vague about what we do. Of our most charming pranks, not a word. We aren't braggarts, we prefer to be evasive, to keep out of sight and act disingenuously when the situation calls for it. We are the great unknowns, the outcasts of the capital discovering the fastest ways to create a revolutionary atmosphere. We're an invisible band who has already caught the eyes of the world, but the world doesn't know it. Every time the government seems disorganized, you should ask yourselves if the Washington Psychogeographic Association isn't at work reshaping the world. We won't accept a third-rate role in the spectacle, and our numbers don't matter. We have connections in other cities and abroad, and we're waiting for lots of people to join our struggle to unify cities, so that people can afford to live and play everywhere, not just in predetermined areas. For now we're content to perpetrate TAZs (Temporary Autonomous Zones) here and there, always looking for a new way to spend the day. Psychogeographic drifts take people along divergent routes, but they all have the same destination: revolution.

71

Psychogeography is a way to open the cage and mock the zookeepers as you strut out of captivity.

Psychogeography is about drifting around the city and disabusing oneself of all the skim-milk precepts of one's time.

Psychogeography is about allowing alcohol to remove some of the machinelike precision of your movements and taking on a slightly more animal form.

Psychogeography is molding the city to our purposes.

Psychogeography is the matching of actions, gestures and phrases to the environment.

Psychogeography is the ability to exaggerate, frighten and create a facade.

Psychogeography is the creation of a widespread sense of imminent transformation.

Psychogeography is intentionally vague, like a new sensation of joy that overcomes you as you walk in the street, pushing through crowds, reading the minds of passersby: "I'd better stay clear of that maniac."

Psychogeography is like snow, it covers everything and then disappears.

Psychogeography is using police observation techniques on the police over an extended period of time, in a specific zone.

Psychogeography is the outlook of the lookout, an inspection of the spectacle.

Psychogeography seeks the passageways for the return of the repressed.

Psychogeography is a vaporous assault.

Psychogeography is finding exile within walking distance.

The Gun Smokes

A red light rotates outside the door to the Oval Office. The clapstick snaps shut - scene one, take one. Whispered rumors waft from the wings about the president and his intern. The camera films his world-weary reflection in a mirror while he lolls on his sofa. A patch of silver backing is missing around the reflection of his crotch and a scene emerges through transparent glass: tones change quickly from light to dark as her long dark hair bobs back and forth. A publicity still of the president's face in ecstasy as the nation crumbles in the background. Murder on Ruby Ridge. Transshipment scenes from Mena. Cut to a montage of the young, barefoot boy coming to Washington with a hayseed in his mouth and a saxophone around his neck; then to the icing expert with such a winning smile who is all too willing to throw her weight around - a screwball comedy in the works, one that calls for a new style of acting in which people from the worlds of politics, culture and business play themselves, like Howard Stern and his retinue in *Private Parts*.

These rumors about the most decisive person in the most delicate affairs of American political life give the West Wing an illusory quality. And these powers of illusion are so great the cast frequently loses their heads and becomes confused with other protagonists: Dick Clinton and Bill "call girl" Morris, for example, or Janet Hamrod and The Hillary We Know, as lesbians call her when she gives in to sadistic urges. Paula Dumbski, Monica Jones - opportunists separated at birth?

A glorious pubic feud erupts in the trailer park on Pennsylvania Avenue between Dick and his Starr-struck prosecutor, a judge intent on determining if the president would risk the world for a piece of pie.

For all we know, this infamy is precious to the president. He has assassins for friends or assassinates his friends when they become unworthy accomplices. Rumor has it he came to power thanks to a coalition of prostitutes and an appetite for glory that affords no patience for morality. An affable, even gregarious man dances on the stage of the world historic with a harem in tow. He bluffs the public about everything, including his health. And for a while he brilliantly camouflages his Casanova past and delinquent inspirations. Some see the ruin of the presidency expressed in his personal ruin; others judge him on abstract ideas about morality rather than concrete examples of injustice. Still others smile because Clinton has an epicurean side to go with his insane ambition. His cult of charm is constrained by his foibles and a web of laws he only half believes. What emerges isn't the thief in tricky Dick, rather the con man, now with a big red nose - a clown who would be king. With his face in place, he openly speculates on the ignorance of the American people and its taste for scandal.

Only the latest and widest range of cinematic techniques can capture these rumors as they're transmitted around the globe like points of light from a mirror ball. But the effort and expense is justified because Washington rumors are more significant than other equally truthful and malicious rumors. The first rumors scream into view on a missile-tracking camera, as if on a magic carpet, and explode in the veritable center of the universe.[1] Critics of future generations will debate the symbolism involved here, and it's true, it's not what you'd think. A bomb falls on the American psyche and the lever of war goes up for grabs. Mobile production units appear on the scene to assess, and inevitably add to, the damage. Puppets with exchangeable heads swallow dictionaries and let out the story like so much gas: the pyrotechnists among them execute fireworks; those with a tendency for bombing shit their pants.

Meanwhile, rumors surface about obscure organizations in the

deepest shadows of recent events. Will we have to wait for the screen credits to find out about the North American News Alliance? Rumor has it the founder of this small and obscure news agency was a high-level member of the OSS. Rumor also has it that NANA became, under Sidney Goldberg (husband of Lucy, agent to Linda Tripp), a media infiltration instrument of the CIA. And what about the tabloids' ties to the CIA? Where else would one get access to Oswald's widow? What about the direct CIA ties to a financier of *The American Spectator*? a journal that has whipped the president with its anathema from day one. And what about this journal's Ted Olson and his close friendship with Ken Starr. Of course all sense of fair play is abandoned with Starr's appointment to Independent Counsel; the same magazine financier with a pedigree going back to the OSS, the eccentric Richard Mellon Scaife, once paid Starr through his Landmark Legal Foundation to support Miss Jones in her case against the president. She also found inspiration in the words of Ambrose Evans-Pritchard, a crony of the crown who, like most British agents, knows how to create a sex scandal to divert attention from the most pressing issues of the day. The reaction shot of the press is priceless: blank stares accompanied by plaintive chords on the violin. The production assistants are restless as this awkward moment passes; then it's back to business as usual for reporters with the humility required to chase celebrity-commodities and stick microphones under their double chins. This is what the sponsors want - a spot news check to tell everyone what to think and feel.

What were once whispered rumors have become an alarming noise. We should recall the maternity of these rumors - Linda Tripp, whose name and appearance refuse to be confused with anyone, a high-ranking civilian with Delta Force experience, a possible Bush mole and ally of Gary Aldrich, the FBI agent who made a few scandalous claims of his own about Clinton sexual misconduct. Tripp also made an accusation about a Bush extramarital affair and another about Clinton sexually harassing Kathleen Willey. As the story goes, she trips her pawn with a wire at the Pentagon City Ritz-Carlton, an apparently shrewd betrayal designed to get a book deal (a book that gives every indica-

75

tion of having pages stuck together). Whereas many women would rather fondle Clinton's stainless-steel testicles than tattle, this is not an option for the Tripp who looks too fucked even for Dick and who knows all the gossip or invents her own. As Master of Obscene Arts she unravels a thread going from FBI-military intelligence connections to Nixon's plumbers and back to the CIA. It may not appear in their training manuals in exactly these words, but all of the those mentioned above know that rumors make the least expensive poison. Washington is not Whitman's invincible city of friends, rather the center of a society founded on deceit and perpetual illusion.

In his prime-time State of the Union speech, Clinton passes the personality test by demonstrating that as individually corrupt as Americans may be, they're suckers for mass spectacles that profess respect for virtue. With slogans about surplus for social security he is the ultimate Democrat giving expression to noble sentiments about care for the elderly. The way spectators enjoy being duped is one of those little truths most people avoid telling themselves and don't want to hear from others. Clinton shares pains with his people and with future glory-seekers who are sure to imitate the Clinton bluff, which he executes with tremendous powers of suggestion and no trace of irony. It's enough to make a general cry. And like so much of what Clinton is able to do, this encounter is more illusory than real.

Indeed, the film chronicles the illusion of encounters from Monica's first White House fantasies to the moment they became all too real; from Dick's very real dreams to the illusions, no less real, crafted by the office of the president. Will these powers of illusion be enough to cover his character flaw? Not likely. We're all destined to wage war with our weaknesses, but temptresses are especially difficult - as one poll put it: "Most men go for it." Yes, Dick is oblivious, reckless.... For him sexual misconduct might be premature ejaculation. In this sense, the pair - the celebrity and his face artist - is not incongruous at all, but the script stipulates that only archival footage of them together be used. We hear them on new White House tapes as the screen splits between shots of him at the beach in the Virgin Islands, and Monica, dear Monica,

in a *Vanity Fair* spread. The actors are still on good terms and therefore might have wanted to reenact these scenes. But they accept, however reluctantly, every nuance of the script. Meanwhile, Clinton pushes his agenda through the assembly of mercenaries on the Hill and has Gingrich act as his valet at the State of the Union. The stage managers and Starr system make it seem as if Clinton uses his disasters as opportunities to mistreat his opponents, but he isn't the first glory-hound to fill the capital with scandal and still get his way. Whereas adultery once again saves Clinton's marriage, Dick no longer hangs out in West Wing hot-spots and lays women by the dozen. What were you thinking, Mr. President? If you can't love your wife, and only your wife, you shouldn't marry! Learn fidelity from your dog and have Hillary beat both of you when you stray. She's right, after all, if she's pointing to a vast right-wing conspiracy that coalesced in Iran-Contra operations and never demobilized or purged itself of fascists. She is obviously the most brilliant protagonist, and very brave to call these dirty tricks by their proper name. A drum roll and gunfire as prophets speak of darkness and the ghost of Jacqueline.

Note

1. Location scouts from the Washington Psychogeography Association identify a point on 16th Street NW (between Meridian Hill Park and the Diplomat condos) as the center of the city.

Chapter Six

The Neo-Catiline Conspiracy

Introduction

The history of this conspiracy coincides with many marginal jobs; two come to mind. As a chauffeur - a few years ago - I'm talking to bigshots in my black car about the universal cancellation of debt. Meanwhile, between calls, I translate Gianfranco Sanguinetti's *The Real Report on the Last Chance to Save Capitalism in Italy*, the superlative lefty hoax perpetrated in the name of a pseudonymous conservative. On our way to the airport, a young woman financier and I converse while stuck in traffic. I let it slip that I'm an economist looking for work at the International Monetary Fund (IMF), but not for the money. I'll only take the job to initiate my cancellation of debt conspiracy that wins me so many friends everywhere I go. She laughs and assures me she'll mention it at her bank board meeting in Manhattan. I'm confident enlightened minds readily warm to the idea, and when it catches fire, lava erupts and ashes of invoices float in the air.

 More recently, I'm line-standing on Capitol Hill for $18 an hour. Sipping green tea and calmly melting rice crackers on my tongue, I decide if I'll read for an hour or talk, staple pamphlets or wander away

with a sign in my place. On a hot summer day, after several low-sleep nights, I cut across the asphalt expanse on the east side of the capitol. Tourist women attempt to photograph the dome, backlit by the setting sun. I suggest they try from the other side and leave them with a neo-Catiline conspiracy pamphlet. Hundreds of cars idle at the base of the House-side steps. I harass a few of these insane drivers in a mock reenactment of Steppenwolf's hallucinogenic dreams. Motorized slaves collapse as I move away from the smoke and noise. And I tell a congressman about it in stinging terms. We cross Independence Avenue. He's for letting people do what they want, the ecology be damned.

"You probably like the $2.35 minimum wage in the 'competitive sector.'"

"Let the free market rule."

"You're on the side of slavery."

A tall redhead walks by with a dog on a leash.

"Is he yours?"

Blue eyes, love alive.

"Isn't he something, he must be very old."

"He's on his way to the vet," she says.

"I've seen you here before."

The dog pulls her away; she doesn't resist. Even these temples frozen in time melt in our wake. The vet will wait.... As cherry blossoms fall around us, I imagine the occupation of this quasi-Grecian space by delegates from zeroworker councils world-wide, in open assembly on the issue of what work may and may not be - now that all debt has vanished. Wine spills and her lips speak of passion without words. Egoist versus collectivist arguments rage with festive abandon, but the major moral force is directed at supporters of domination by the economic machine. Red pubes unite, a brother-sister commando unit turning tears into joy in ways that resonate with many others. A new social ethic blossoms whereby management's cross-training programs become self-directed, or else subversive. Pleasure assumes its proper place at the center of our lives as Dionysus tunnels under the volcano, dancing to a love ballad. He's always on the lookout for out-

80

posts, staging areas and places to leave pamphlets and marks. WE WON signs in the windows, but not political party softball. Liberating the Christian young women's home across from the Hart building - lace panties and quivering flesh in the shadowplay of spherical lamps and the sun appearing and disappearing through passing clouds. I turn to the left as our tangled paths cross in ways that make our activity appear to the enemy as a knot of hair, seen from afar. Extramedia figures paint over the lenses of security cameras and the interactive mapping begins. Persistence, becoming, realization - chaos comes to life and the existing order, wrapped so tightly, splits at the seams. We've said something by transforming the most powerful city in the world into an ungovernable vortex.

The last job I'll mention wasn't a job at all, rather a pose, assuming the journalist role for future historians looking back at the week October 5, 1989, to the ninth, when the fifty-third World Bank and IMF meetings coincide with disputatious budget negotiations between the White House and Congress. These historians will first focus on the major issue of the day: the vote in the House of Representatives to launch an open-ended impeachment inquiry into President Clinton's representations of his extramarital affair. What these future historians might ignore is how improbably IMF funding and the polishing of Clinton's knob by a young Polish-American femme fatale are connected by Representative Sunny Callahan, chairman of the powerful House Foreign Operations Subcommittee of the Appropriations Committee. Reporters ask this soft-spoken Alabaman about *The Starr Report*'s revelation that Clinton allegedly spoke with him on the telephone while Monica performed her unmentionable act sometime around the 1995 budget impasse: "I had no knowledge I was sharing the president's time or attention with anyone else." In this budget battle, Callahan laments that the president gets too much press, and the House not enough. He doesn't complain when this small piece of the scandal draws attention to the importance of his subcommittee.

Foreign Operations actually has more real power - the power of the purse - than the House International Relations Committee and

its sometimes explosive hearings on topical issues. In the bill passed in September 1998 for fiscal year 1999, Mr. Callahan appropriates only $3.4 billion of the $18 billion requested by the president in his budget, but suggests that the rest might be forthcoming if Treasury and Federal Reserve officials win agreement with the IMF on significant reforms, particularly transparency of its decision-making process. As this key congressman sees it, repayment of IMF loans has been generally successful, but he mentions the practice of transferring IMF loans to the World Bank, where they are forgiven, as a process in obvious need of light.

Mr. Callahan goes on to say that "the concerns of Congress revolve around the history of the IMF with respect to their demands on countries prior to their release of funds." Pointing to Indonesia, he sympathizes with the view that the IMF-mandated reforms caused that country's current financial problems. Ignoring, for now, the possible implications of this conservative Southern congressman's sympathies for the regime in Jakarta, consider for a moment his blunt assessment of the forthcoming battle:

> We put up the largest percentage of any country, we put up eighteen percent of the assets of the IMF and it's beginning to grow more and more. The US Congress is simply not willing to say that the source of assets for the IMF is a bottomless pit. I don't think there is enough money to bail out everybody for every reason without some stronger indications of success. We can't dictate to the IMF, but we do hold the purse strings on our contributions. So we're going to make strong requests to the secretary of the Treasury saying "Look, if we put up this $18 billion you're requesting, you're going to have to come back with a report telling us that things are going to be different.

The administration case for funding the IMF mentions that the money is like a deposit in a credit union, fully backed by IMF gold reserves. Because US participation is treated as an exchange of financial assets, the transfer of funds is not scored as a budgetary outlay.

Clinton's budget request proposes US participation in an expanded IMF emergency fund called New Arrangements to Borrow (NAB) to cope with crises like the current one, and seeks authorization of participation in periodic increases in IMF quotas, so as to grow with the world economy. When the United States approves its share of the 45 percent increase in quotas for the IMF, the Fund will have roughly $90 billion more in resources. The US delay in turn holds up the entire increase, and the administration says it can only go so far in forcing reform on the 182-member IMF.

The Senate, where purportedly greater wisdom prevails, has its own Foreign Operations Subcommittee, led by Kentucky Senator Mitch McConnell. Better known for supporting the campaigns of Republican Senate candidates, McConnell is best known for his outspoken opposition to campaign finance reform. After a year of hearings featuring the likes of Treasury Secretary Robert Rubin and Federal Reserve Chairman Alan Greenspan, McConnell's Foreign Operations Subcommittee votes, in September, to approve its appropriations bill containing Title VI, Multilateral Economic Assistance, which explicitly prefers to be cited as the "International Monetary Fund Appropriations Act of 1998" so that there is no ambiguity about what is at stake. The Senate will give Clinton the full $18 billion he wants, but not without reforms, and certainly not without recognizing the current crisis in its own terms, by the use of phrases such as moral hazard and the real economy.

During the week prior to the annual World Bank and IMF discussions, Washington fills up with bankers in charcoal suits; limousines keep their engines running for the industry's most lucrative ten days of the year. Oxfam International uses the discussions as an opportunity to denounce the IMF and Bank review of their heavily indebted poor country initiative and to brief the world on how the East Asian "'recovery' leaves the poor sinking." IMF Managing Director Michel Camdessus steals some of Oxfam's thunder by issuing a report advocating, in the wake of Russia's mid-August loan defaults, the use of "debt moratoria" in exceptional circumstances. But make no mis-

take, everyone courts private bankers and investors, not non-governmental organizations seeking a little social compensation for IMF austerity programs. The aquifers dry up and not much can be done about it.

Over the weekend prior to the discussions, opponents of the IMF from many places around the world attend the Fifty Years Is Enough Sado-Monetarism Conference that climaxes in a lively march from the White House, up Pennsylvania Avenue a few blocks, to the World Bank's new horizontal skyscraper. On Monday, Clinton meets with central bankers and economic ministers at the IMF in the morning. He then appears with Democratic Representative Gephardt and Senator Daschle at his side, calling for the Republican Congress to appropriate the full $18 billion to the IMF; even progressive Democrats agree to IMF funding as long as the Administration doesn't press for so-called fast track authority to negotiate trade deals with limited congressional intervention. And then later, on the eve of annual discussions, the most exalted bankers attend a performance of Ottorino Respighi's *Roman Carnival* at the Kennedy Center where World Bank chief James Wolfensohn was formerly chairman.

At this point, everyone at the annual discussions is closely following the negotiations between the White House and Congress, lest the dreaded contagion (no longer merely the Asian contagion) spreads, and the doctors be denied their remedy. Loans are being called in around the world, but even *The Economist* questions the financial contagion phrase. Call it what you will, Japanese banks burn and the annual discussions take place in the most pessimistic atmosphere in thirty years. On Tuesday, thirty minutes before President Clinton is due to address the opening session of the discussions, Senate Majority Leader Trent Lott, the conservative Republican from Mississippi, holds a press conference in which he says that the administration hasn't spoken to him about IMF funding since the beginning of the summer and has made "little effort to indicate they want it."

The level of trust between the White House and Congress has diminished since the already very contentious days of the 1995 budget

stand-off when the president used his veto power to out-fox the Republican Congress. Clinton holds his cards tightly and speaks with his adversaries through press conferences and other public forums. In his press conference, Lott calls for an end to "propping-up cronyism," which is another economistic buzzword that sounds strange when spoken by someone from the Deep South. Skirting the conferee system designed to reconcile the Senate and House Foreign Operations bills, Lott says that the language will have to be stronger than that of the Senate bill, which implies that the House leads the negotiations.

Marilyn Monroe gazes through her lashes from the side of a building onto Connecticut Avenue as Clinton approaches the hotel where the discussions are held; her ghost witnesses the slow assassination of his character. And yet he continues. The Wardman Park Marriott, formerly the Woodley Park Sheraton, sits on a hill, and from this perch Clinton delivers a sermon exhorting bankers to hunker down and save the global economy. Slim on details, he makes the case for the equivalent of the United States Securities and Exchange Commission for other countries, and talks up various reforms. When addressing his negotiations with Congress over IMF funding, Clinton speaks to the American people, as if to children: "I have told Congress we can debate how to reform the operations of the fire department, but there is no excuse for refusing to supply the fire department with water while the fire is burning." One reads in this metaphor a politically brilliant perspective on what the president implies is also a moral hazard.

Later that day, House Republican Majority Leader Dick Armey holds a press conference. He is "very gratified" to hear Clinton urge IMF reforms. His specific demands for one-year loans, above-market rates and greater transparency indicate that he sees himself as a principal who will be in the room when the final negotiations take place. Armey, a hard-line conservative from Texas, is undecided (and possibly misinformed) about how to handle anti-abortion language tenuously tied to the Foreign Operations bill, and whether or not to link it with IMF funding; this wrinkle adds to the public drama. The impresssion he wants to give is that Dick "One Man" Armey is in the

thick of things, following the strategy implied by the cowboy poster in his office: "If you don't make dust, you eat it." As the holder of a Ph.D. in economics from the University of Oklahoma, this former power pole lineman considers himself qualified to take on all comers on economic questions, and is himself a proponent of a 17 percent flat tax. Majority Leader Armey chairs no committees, but he once served on the Joint Economic Committee in the early Nineties where he honed his debating skills in an effort "to rebut congressional liberals' attacks on the Reagan economic record." He has a well-deserved reputation for confrontation and several punk rock bands named after him. He is an ardent foe of the IMF.

On Wednesday, the city wakes up to a depressing front-page story of a successful suicide pact by three failed Japanese businessmen in *The Washington Post*. And as the discussions are under way, complete with multimedia displays such as a demonstration of the IMF web site on fiscal transparency, the Congressional Joint Economic Committee holds hearings broadcast on C-SPAN. The primary mandate of this committee is now to submit an economic evaluation of the president's budget proposals to the budget committees, but the chairman, Representative Jim Saxton, a Republican from New Jersey, makes it his business to hound the IMF, which he describes as "a powerful, arrogant and often counterproductive bureaucracy whose operations are cloaked in excessive secrecy." In a recent *Wall Street Journal* article Saxton suggests that the IMF has access to $86 billion in capital and that it can raise money by selling bonds - he explicitly defines moral hazard as expectations of bailouts that engender riskier lending strategies.

The Joint Economic Committee's guru on creating "Blueprints for a New Global Financial Architecture" is Charles Calomiris, a Columbia Business School economics and finance professor and the director of the American Enterprise Institute Project on Financial Deregulation. The fact that a man like this calls for stricter regulation for IMF membership and for greater regulation of the IMF itself suggests that the Reagan-Thatcher era of financial deregulation is over, despite ada-

mant denials (peppered with more buzzwords: illiquidity, credibility, free entry) to the contrary.

The cool-headed banker is personified in these hearings by Dr. Jacob Frenkel, governor of the Bank of Israel and former IMF research director. He insists that the clock is ticking - the $18 billion may have no effect on such an enormous liquidity crunch unless quickly used. Frenkel draws a distinction between moral hazard within one country and international moral hazard, whereby the IMF "induces governments to drive recklessly." But he rejects Calomiris' recommendation to tighten IMF membership requirements on the grounds that the problems are global and their solutions require a global framework. The suggestion that the IMF only grant short-term loans inevitably leads to what Frenkel calls short-termism, a danger to be avoided at all costs.

Speaking of short-term funding, over the course of its negotiations with the White House on IMF funding and other issues, the Congress passes, and the president signs, several continuing resolutions to prevent the government from shutting down for lack of funds. Part of the problem stems from the fact that no House-Senate budget resolution was achieved: this serious lack of responsibility, which hasn't happened in twenty-four years, is attributable to Republican infighting over proposed House tax cuts designed to stir up the Republican voter base. Because of tight deadlines imposed by the end of the fiscal year and the beginning of the campaign season, separate appropriations bills roll into an omnibus spending package, forcing negotiators to adopt all-or-nothing strategies in which Clinton, given his veto power, has the most leverage. The situation is muddied by the historic House vote on Thursday, October 8, 1998, to approve presidential impeachment hearings, and by violent swings in global stock, bond and currency markets.

The Bank and Fund discussions conclude Thursday with the directors' final press conferences. They put a brave face on the situation - the delegates have obviously failed to achieve a unified strategy to forestall a global recession or a possible general depression. Circumstances are perceived to be so dire that serious consideration is given

to the Group of Twenty-Two (G22) proposal to provide IMF funding to countries that have already defaulted on their private sector debts. But proposals like these don't do much to inspire investor confidence in emerging market countries for whom credit is now impossibly tight. After what has happened to them in Asia and Russia, bankers and investors are indiscriminately risk-averse; Congress shares this aversion.

Over the Columbus Day weekend, the legislative and executive branches of the US government near agreement on IMF funding, but the House holds out for broad agreement on other issues. At this point, Senator Lott tells reporters that disagreements remain over "one phrase and one word" (the word being the use of shall or should in the transparency conditions). The careful reader understands the implications of both words. The final negotiations require Treasury Secretary Robert Rubin to shuttle between Representatives Gingrich and Armey, with Callahan and Democrats such as Representative David Obey from Wisconsin remaining closely involved. As is often the case in Washington, the solution to thorny issues is to create a commission - in this instance, two commissions. The commission demanded by Democrats, composed of business, labor, finance and non-governmental groups, resembles the advisory committee proposed in the original Senate bill. The Republicans insist on an eleven-member commission with three seats reserved for former US Treasury secretaries to study the Fund's operations over the next two years.

Rubin and Federal Reserve Chairman Alan Greenspan must certify agreement by other Group of Seven (G7) countries to these reforms: (1) publishing summaries of IMF board meetings, letters of intent and policy papers, (2) raising loan costs to three percentage points above market rates and requiring repayment within two and a half years, (3) liberalizing trade policies, stopping government-directed lending on preferential terms and ceasing favoritism in bankruptcy proceedings. Although explicitly forbidden by their leaders from using the word *caved* to describe these negotiations, several Republicans maintain that their leaders in fact bowed to the White House to avoid

the charges of irresponsibility. The end result of the IMF funding battle is best described by Armey when, mixing metaphors in a way that hints at how much the Lewinsky scandal dominates his mind, he emphatically assures the American public there will be "no more moral contagion." The unprecedented mid-term election a month later, exceptional because the president's party gains ground, results in Newt Gingrich resigning as speaker. As humanity approaches various limits, rapid reversals of Fortune increasingly come into play.

The Neo-Catiline Conspiracy
for the Universal Cancellation of Debt

1

Often the wicked prosper, while the righteous starve;
Yet I would never exchange my state for theirs,
My virtue for their gold. For mine endures,
While riches change owners every day.

Solon

Although Solon (circa 630-circa 560 BC) lived a luxurious life, we read in this verse that he considered himself to be one of the poor. This consciousness of misery gave the philosopher-king of Athens the courage to discharge, as he liked to put it, all debts. Most people seek authority in a higher source, which is one reason we cite this shadow from the past. This cancellation of debts created the conditions that led to the prosperity of Vth-century Greece - we argue that the great works of this Golden Age would not have been realized if Solon had not effected this radical, but favorable measure.

In our opinion, Solon didn't go far enough when he decided not to redistribute property. Those with whom he'd confided his plans

89

borrowed money and bought land. This tarnished his otherwise courageous operation with corruption - an early example of free enterprise. One might take Solon at his word and contend that he liked being one of the poor, and was thus at heart a slave. In this case, Solon's institution of a rigid class structure in Athens is based on the best intentions. We're a little too cynical for such a naive interpretation, but by cancelling all debts, Solon ushers in the prosperity that accounts for the glorious works of classical Greece. Western Civilization would not be what it is today without the initial use of this now unavowable economic policy of the cancellation of debt.

The millennium, that period of one thousand years some foresee as an epoch of great happiness was merely four years away when we began this enterprise. We have no time for an academic or bureaucratic analysis of the situation. Everywhere we go, we hear proclamations of the impending apocalypse based on omens like the simultaneous collapse of commodity prices, Japanese banks, massive hedge funds and the near-collapse of too many currencies to mention here. Claims of millenarian apocalypse lack credibility (see chapter five), but people succumb to this idea of tragedy because their lives are empty, and they no longer see the spreading misery of places like Mozambique where 25 percent of children die before age five from infectious disease, and where the State spends twice as much on debt payments as it does on health and education. As we see it, even in the United States, the richest country in the world, tens of millions citizens live in poverty.

We refuse to debate any point we raise below, and certainly not this one: to really live, life must be directed toward some glorious project, such as the creation of a new, XXIst-century civilization that surpasses the glory of the ancient Greeks. Implementation of this debt cancellation policy requires a metamorphosis of the mass of humanity from its present state of diffidence into a collectivity fully conscious of its decisive role in the unfolding of universal history (universal history having been a novel idea in Polybius' time, but no longer). We live in dangerous times, but the real danger is that resignation reigns over

90

courage.

<div align="center">2</div>

We don't cite the Romans at every turn - to compare their times to ours is like expecting "a jackass to race like a horse," as Guiccardini put it. However, the Catiline conspiracy has the merit of mounting a revolutionary operation that attempts to remove one of the causes of our complaints. Catiline shook the foundations of Rome in 63 BC when he announced his program to cancel all debts and proscribe the rich. With his neediest and most reckless supporters behind him - the gamblers, whores and other scum of the Eternal City - Catiline obstinately pressed on, despite the odds. The unjust portraits of Catiline that come down to us from Cicero and Sallust mask the insane courage of a man who died in battle, defiant to the end. Both of these writers had reasons to exaggerate the depravity of this character. And nothing is ever said of the brilliance of his revolutionary plot - perhaps it takes an extremely bad man to have such a good idea. Ours is not one of Cicero's Catilinarian orations, rather the remarks of people who respect the fact that Catiline died in battle, defiant to the end. The very portrait of bravery, according to Samuel Johnson.

The flaw in Catiline's strategy? He only enlisted citizens. By excluding slaves and foreigners he excluded the true partisans of revolution. The slaves who suffered such a victorious defeat fighting beside Spartacus in 73 BC had once been battle-hardened masters of life. The memory of that event still transmits the spirit of revolution to us today - it has been conveyed down through the generations by the very name Spartacus. Recall that the history of the Roman Empire is also the history of the extranational masses rising up and taking over. By virtue of their sheer biological force, the masses are the only historical force capable of surpassing every previous epoch. History demonstrates that when confronted with a present and certain danger, the masses respond with all their power - power is a question of will, and will of appetite. As history shows, the savage appetite of the masses

makes the universe its prey.

3

Who are we? A little dissolute from living in one intercontinental hotel after another like decadent little Catilines, we are a cadre of co-conspirators whose global perspective of the economy motivates us to act. Far from being puppetmasters, we resemble those aristocrats who welcomed the French Revolution - they marched alongside each successively more radical faction until their heads were finally cut off. We share the hope of these aristocrats for a universal republic to advance to the next stage in the progress of freedom on earth. But above all, we are humans who haven't failed to notice the teeming masses from our chauffeur-driven sedans as we're shuttled to and from the Ministry of Economics of developing countries.

We go *everywhere* on our World Bank, IMF, IADB, etc, missions - the exotic East, romantic Africa and all points in between (you haven't lived until you've experienced nightfall in Mogadishu). And everywhere we go we see the forsaken people of this world. They could easily be motivated to create a new civilization if this civilization were only worthy of the word. With this little programmatic analysis we raise the flag of a quality life that we intend to pass along to the professional agitators who lead the cry: "Take the streets and feed the people, shout it from the highest steeple." The reason you haven't heard about the sealing of our pact to conspire with the poor is that employees are forbidden from commenting about issues relevant to the World Bank in public. The president of the Bank should be reassured to know that we approve of this ban only because we relish breaking it.

Our silence can't be bought with cushy jobs. Over the years we have cultivated ethics in ourselves that enable us to enjoy egalitarian interactions with the poor and with people from other places. These cosmopolitan ethics must sometimes be suspended when we are confronted, as we often are in the course of our affairs, with imbeciles. We are thinking here of the likes of Brahmins droning "we are not respon-

sible" for little industrial mishaps such as the Union Carbide explosion. Our consciences are clean because, like Solon, our consciousness is with the poor. Everywhere we go we see slaves and displaced, abandoned people: of the five billion people in the world, one billion live on one dollar per day, or less. Most of the rest live worse than they could or should. These massive surplus populations know that the economy is a tyrant. We're not in the habit of quoting Shakespeare, but it's irresistible not to paraphrase his axiom that to really live is to stomp on the heads of kings.

4

Our plan for the universal cancellation of debt in the year 2000 recalls the biblical jubilees of the past. Did you know that these jubilees didn't promise relief of sins, rather debt relief and suspension of all work? We are by no means an anti-Semitic clique bent on the destruction of some imagined Jewish world banking conspiracy. Many of us are Jews who recognize the moral imperative of the jubilee because a festival for the faithful to set slaves free and remit debts is long overdue. Failure to act is to act - as was the case with King Agrippa II who advised his fellow Jews not to revolt even though Rome was in such disarray: "The man who has submitted and then revolts is a refractory slave, not a lover of liberty." The best efforts of Jewish revolutionaries couldn't overcome this servile leadership and prevent the demise of the kingdom of Jerusalem. The Christian jubilees, taking their name from the 'rejoicing' denoted in *jubilatio*, transformed the universal pardon of the Hebrews into pilgrimages to visit basilicas in Rome and elsewhere. We're reminded here of the mission of Petrarch, the poet of Vaucluse, to Boniface VIII in Avignon in 1300.

Our millenarian jubilee must surpass all jubilees of the past. This wake for the death of debt must have enough glory to do justice to all those whose lives were crushed by work, debts or some other fact of life imposed on them by the tyrannical economy. We can't expect our religious figureheads to lead this procession because they don't

even have the moral courage to denounce the shameful disparities of wealth that exist everywhere, but especially in the United States where these disparities are higher than anywhere else. The Pope may find himself faced with flocks that read their bibles and decide to "spoil the Egyptians" - in other words, loot and pillage. The debt system of one class lending and another paying can't last forever. The universal cancellation of debt is a rational solution to millenarian anxieties stemming from apocalyptic myths, and to the anxieties stemming from very real conditions and uncertainties.

<p style="text-align:center">5</p>

The history of debt - not simply our ongoing personal debt history, but the world history of debt - remains a fact of our daily lives. To pick one example among many, we wouldn't be in Washington, and certainly not in August, if it weren't for the Jefferson-Hamilton dispute over Revolutionary War debts. The capital of the most extensive empire in world history was situated here as a concession to Jefferson so that Hamilton could use debts and deficit spending. This pattern repeated itself following the American Civil War when wage slaves paid back three million in war debt. Meanwhile robber barons skimmed assets, floated loans, sank funds and watered stocks. Perhaps this is what is meant when the economy is said to work on a system of supply and demand. A euphemism as crisp and clean as the laundering of money would have to wait for a time when the powers of illusion were so great that speculation could, however briefly, attain a squeaky-clean image.

The United States is only a particular case, but a decisive one with planetary implications. The slippery financial dealings mentioned above precipitate the Panic of 1873, followed by the Great Upheaval of 1877. This great American experiment in worker self-management proves that a strike committee can govern a city the size of St. Louis. And the first May Day, in 1886, proves that a general strike is possible in the United States when workers eschew blind acceptance of the ad-

age, "A fair day's work for a fair day's pay." The words *free labor* ring as hollow now as they did then. "We can always hire one half of the working class to kill the other half," industrialist Jay Gould said of his Pinkerton mercenaries. The economic elite would have us forget the ensuing police raids and Haymarket explosion, and they would have us forget the monopolies and trusts. While the media is willing to make vague allusions to the Populist Revolt to explain the current militia movement, they make no mention of the anti-bank, anti-business platform of the People's Party.

Palmer Raids, anti-immigrant hysteria, corruption and light taxes on the rich, as Andrew Mellon liked to advocate - have we revisited this bygone era? The racist and avaricious powers of domination who take us down this path might recall that it was precisely these conditions that created Marcus "we were the original fascists" Garvey and his Black Nationalism movement. The elite make the risky calculation that racial harmony - a prerequisite for collective action on the scale required for our plan - is undesirable. The promotion of separatist ideologies could backfire and lead to a world no longer worth inhabiting. A universal general strike could realize our plan for the global cancellation of debt, which would require new levels of unity and solidarity. Police raids and so-called parallel tactics should be anticipated, but we must remain true to our cosmopolitan ethics and not scapegoat other races and immigrants, because debt must remain the immediate target. Separation remains our enemy, especially separatist ideologies such as the one-two punch of capitalism coupled with nationalism, or the redneck racists of the KKK. Rather than implementing enlightened policies and promoting harmony, the economic and political elites of the last century - with the laissez-faire of Pareto, the racism of Gobineau and the elitism of Mosca rattling around in their brains - delivered us two world wars separated by a depression. It's true. You read it here first.

You remember the Great Depression, don't you? Black Tuesday, October 29, 1929. A crisis induced by massive debt and over-production. Wages plummeted because of anti-union polices, driving down demand for commodities. Stocks soared right up to the panic. Then businesses fold. Prices fall. Banks fail. The government does little to help all those standing in private bread lines. Hoover tells everyone, "Prosperity is just around the corner."

We're now faced with record levels of debt. From the overvalued stock prices of transnational corporations (TNCs in our lingo), to national debt, to individual debt - debt threatens meltdown of the entire financial system. The bankruptcy of so many banks underscores this threat. Over-production is never reported as such, but observed in overstocked stores that, with every little blip of the weather or slight economic downturn, go bankrupt. We don't doubt that enough people would continue to buy beyond their needs, and beyond their desires, to keep the system going, but they can't because there aren't enough jobs to support the required level of consumption. Global unemployment, now in the billions, is perhaps the most decisive factor in our call for the universal cancellation of debt. But even most of those who do work are deprived as real wages drop and working conditions deteriorate. As one employee stocking retail shelves says to the other, "How do they expect us to buy this crap if they don't pay us anything?" Of course the dailies and magazines and the companies themselves want everyone to believe that we're just one big happy family.

7

The globalization of production and subsidizing of industry has pitted workers against workers and driven down wages everywhere. In case you haven't noticed, the poverty rate is increasing. The poor compete with the super-poor while global corporations and bankers impose their elitist ideology on the world. But as the poor grow in

number, their importance grows right along with their aspirations. Knowing this, companies now build excess capacity into their facilities so that operations can be shifted in the event of labor unrest. Incessant reorganization and foreign outsourcing increase the hours people work, but at lower wages. In the United States, for example, over the last twenty years young families and workers at the bottom of the wage-scale have suffered the equivalent of the Great Depression. The bottom-fifth has lost seven percent of its income while the top-fifth has gained 25 percent. The income of this top-fifth is now ten times greater than the bottom-fifth, and American CEOs make one hundred and forty times the wages of their workers. Of course it's harder at the top than it looks, harder to lay off so many formerly indispensable employees.

Many blame FDR for allowing unions to bloom, but they fail to realize how unions divide workers, and how unions, by their mistakes and sheer repugnance, lead this nation of clerks into mistaking their low-paid, non-union jobs in factorylike conditions for middle-class status. The Teamster strike in Minneapolis in 1934 and the West Coast Longshoreman strike of the same year, which became a general strike in San Francisco, could never happen today, or so we might like to think. Those of you whose eyes glimmer with hope for a revolutionary situation should remember the *Freikorps*. The fascist deck is stacked against you, but as impossible as it sounds, these ditto-headed clerks must be turned into allies. Then again, the situation might be more readily susceptible to revolution than first meets the eye. The current crop of managers has not been tested with a total, global crisis. Unlike the proprietary class of the past, these managers don't have much at stake - once they are shown their real position in society, they might acquiesce.

8

Before turning our attention back to the lending class and its managers, let's glance at the resolve of the liberal democracies during a decisive point in their history. When confronted with Japan's Manchurian adventure in 1931 and Italy's invasion of Ethiopia in 1935, the

liberal democracies did little. Were another Hitler to arise again (a real Hitler, not just another failed artist like that notorious poet-psychiatrist Radovan Karadzic, scorned by the literary salons of Sarajevo), how would these democracies respond? Shopping-mall democracies based on religious faith, genetic science and tribalism. In the particular case of the United States, its scientists responded to the Soviet threat by feeding cereal laced with nuclear material to retarded children. Sounding like Franco, Nixon rode the communist issue into Congress, although in the United States those "conspiring to teach" Marxism were merely incarcerated; in Spain they were executed with the blessing of Opus Dei. Should history be brought back into play, it will be because the ruse of reason was present in those episodes. This reason was even more evident in the strikes of 1946 and 1947, the largest in US history. History might be given a shove if people ask what led the House Unamerican Activities Committee to stage a bureaucratic inquisition: "Are you now or have you ever been a member of the Communist Party?" Party affiliation only hinders radicals in this land where even liberals like Hubert Humphrey declare communism a "criminal conspiracy." Legality must always be put in historical context. Who, for example, would have the gall to question the legality of another Shay's Rebellion (the revolt of farmers unjustly saddled with debt) after the devastation of the American farm over the last thirty years?

9

Management has control of the automated workplace, but by hiring scabs and temp workers for the lending class, managers build their coffins. The economic elite insists on a low-wage, low-growth, high-profit economy. Who knows how it will turn out? In the event of a severe crisis, management will probably form *zaibatsu*-style cliques and look for support from the middle and lower middle classes in a fascist takeover - that is, a fascist takeover aside from the one already presided over by Eisenhower and Johnson. These two have been described by us as the Pétains of their time because of their apparent

willingness to allow America to become German. The corporatist State became so deeply entrenched that it easily absorbed the civil rights movement following the infamous takeover in 1963, an operation that prevented withdrawal from Vietnam and served as revenge for the Bay of Pigs. Kennedy was nothing, the State was everything. This was confirmed by Richard "I'm not a crook" Nixon, who put US forces on full nuclear alert and sent his FBI *falange* to crush subversives.

In the event of a severe crisis, the lending class will face severe problems. They position themselves so far from their investments, they'll be irrelevant during our reversal of economic injustice. They're oblivious because they've been told the end of history has arrived. On the contrary, the incredible docility of consumers is waning - consumers are no longer willing to buy anything for any price so long as they can pay tomorrow. The lending class hasn't read the articles that circulate in the underground press that describe the way life has become unbelievable and empty precisely because of the commodity-driven economy.

The shareholders have lived through the same horrific haze of cults, drugs, mass murders and assassinations of the Sixties and Seventies, but the only thing they've been brainwashed to do is to transform everything into money. In their history blindness, OPEC means nothing more than the genesis of Eurodollars. The fall of Saigon, or the choice of Pinochet over Allende, means nothing to them. The Eighties were their nirvana, the grand years of junk-bond trading, Ronald "October Surprise" Reagan's Savings and Loan deregulation and record deficits due to tax cuts and increased military spending on ridiculous projects like Star Wars and Lebanon. The shareholders have since refined their tastes. They don't want physical capital that needs to be defended on numerous fronts, they want liquid, mobile capital with which to speculate - the stuff that now accounts for most of the activity of the American economy. Above all, they don't want us to know who has all this money.

The massive quantitative shift from physical and human capital to financial capital eclipses all the technological changes that have taken place over the last twenty years. The financial sector has exploited new computer and communications technologies, and these two factors - the shift to financial capital and the new communications technology - have empowered the financial sector to the point where it has attained the dominant position in the global economy. Paris Clubs and their like come and go with greater or lesser degrees of success, always finding a way to turn losses into victories. The Mexican peso bailout demonstrates how inadequate something like the G7 is for the tasks it faces. No-one could deny foreign investors and their politican-lawyers, not even the governments of Germany, France, England, etc.

Every day, a trillion dollars is traded through New York computer wires linked to the far reaches of the globe. The new technologies and globalization of the financial sector constitute an auto-deregulation of banking, which bankers have exploited by demanding still more sovereignty. This computerized trading has been strong enough to diffuse crises and create adjustments, such as using debt-induced depressions in developing nations to make the poor ease the pains of the rich. All the Latin American "debt crisis" loans of the Eighties were, after all, paid. But somehow paid loans turned into a multi-trillion-dollar unregulated trading market in debt with numerous bankers taking their cut. We tend to forget how the banks of the North cash in on the undocumented capital flight from the South that is reinvested in their banks. This hot money impoverishes nations ruled by corrupt, loan-skimming bureaucrats while the IMF collects the despots' debts from the poor.

In the particular case of the United States, the Savings and Loan crisis was induced by bankers who paid high rates on deposits to grant unsecured, risky loans to well-connected friends. Taxpayers pay for this fiasco, and they pay for the $900 million in Egyptian debt that Bush canceled for support of the Gulf War. The banks have stopped

complaining about much of anything because over the last twenty years the federal tax paid by American banks has been cut in half. Consumer fees have increased right along with bank profits. All the subsidies and tax breaks that went to big business thirty years ago now go to the financial sector. Those who doubt the sovereignty of the financial sector ignore how obvious it is that Goldman Sachs names the tune Clinton plays on his saxophone.

11

Investment isn't based on vital necessity, rather on prejudices for parasites who produce nothing but black holes. Viewed from this perspective, we find that the financial class relies on the extreme, global exploitation of the wealth that could be invested in communal, regional economies. Our data confirm what we've known for years - each region of the world has the natural resources to satisfy the extravagant needs of the people who live there. Regional markets could be coordinated in ways that lessen the work done by all. If work were focused exclusively on necessities, the ten-hour work week would become the golden rule. In this light, we'd like to remind you that the nation-state is only a relatively recent development that may soon be destined for the landfill of history.

There are two possible futures - favorable and unfavorable. If allowed to develop along current corporate organizational imperatives, the global economic arrangement (the wage-slave system) and its political counterpart (the nation-state) will negate all spontaneous historical action. But in the long run this negation will impel human destiny even further through the negation of negation. If we really want to live together in favorable conditions, we should reexamine the city-states that survived for so long in Italy because they provide the only administrative model we have to oppose the nation-state, and, by extension, the nationalism that divides us. Incidentally, destruction of the nation-state will effectively destroy treasury bonds. But the main point is that a total conception of humanity is required if we're to mount

101

a global operation like the cancellation of debt, which amounts to the destruction of a peculiar form of money and the lucrative reasoning that creates it.

12

This lucrative reasoning has become increasingly irrational of late. For example, the first action taken by Gingrich's 104th Congress was, after twenty minutes' debate, to raise the majority required to pass a tax increase to three-fifths, potentially precluding all future tax hikes. Historic cuts in public expenditures for the poor are being effected at the behest of a minority - anything to brake inflation. Whether induced by rapid economic growth or deficit spending, or both, inflation devalues the money paid back to lenders, which is favorable for the poor. The lenders would like to see deflation, perhaps even a fall in prices equivalent to the Great Depression - they want to build anew on the ashes. The depressions of the Eighties were enormously profitable for American companies, and American banks made out like bandits as well.

In the United States, the Revolt of the Haves has been so staggering to the poor that all property rights must now be openly contested. We readily acknowledge that this is a minority position at present, but we anticipate a mass of adherents once the message spreads. Humans transformed into consumers may fight to regain their humanity, sensing that in the fight itself they find what's missing in their empty lives. People are beginning to want more than to buy what's on sale, or what's sold on credit. They want autonomy, yes, but not the autonomous isolation of the highway. They want community, but not a community of dull shoppers and hamburger eaters. The accumulation of debt is really the accumulation of wealth, and as corollary, the accumulation of the proletariat. The time is at hand to infuse a little life into these historical forces.

We can easily imagine a scenario in which a run on banks spreads to the point where banks can't pay their major creditors. And no longer being able to collect from failing companies, even banks will have every reason to cancel their debts. Now that the welfare State has vanished before our eyes, can it be restored in time to compensate for the havoc wrought by financial capital? Capitalism is an amazing enterprise that has, time and again, saved itself from itself, but it remains to be seen if the financial elite is savvy enough to make the necessary reforms to stave off the organized, political refusal to pay debts. Doug Henwood, the author of *Wall Street*, reminds us that the opponents of apartheid effectively used this refusal strategy in the final assault against the racist South African regime.

Those rebels with a little historical imagination might want to simultaneously revive democratic assemblies directed by delegates who are revocable at any time by the base - delegates who decide nothing in secret, rather in open debate before the assembly. And those who have the audacity to form an alliance of workers and consumers (so that no dangerous toxins are used in production, hence nothing toxic is consumed), might remember what the Germans call *räte*, that is, councils (*soviets* for those of you astute enough to recognize the Bolshevik seizure of State power as instituting a regressive mutation of capitalism - State capitalism, not communism). Assemblies and councils function much the same way. We should add that the most effective worker's council is an assembly that decides what work must be done, and what work must not be done.

13

The cancellation of debt has been a demand of revolutionaries as diverse as the *ciompi* or 'muckers' (see the "Twilight of Humanity" essay linked to our Access Five recordings on the RealAudio website) and the Zapatistas. Resistance to debt is particularly widespread in Mexico, where interest rates soared after the December 1995 peso devaluation. The middle-class Barzon or 'yoke' movement was formed

to protest foreclosures, and to threaten US investors. The Barzonistas tar and feather repo men, which is something to consider when you get a little behind in your credit card payments. A small farm is nothing to die for, but when a dispossessed man suffers a fatal heart attack, the Barzonistas deliver his corpse to the bank. As they link up with others and the whole country becomes Barzon, they might remember what Stalin did to his economists and set a few examples. Reason and justice must dictate the use of political violence, not the generalized, irrational violence constantly perpetrated on us by the toxic dregs of the political economy.

14

The aristocratic minority, those who purport to rule the world, can no longer mask their moral inertia, their intellectual sterility and barbarism. Our theory of history is more just, cogent and elegant. Only two eras have existed prior to the modern era, namely Antiquity and the Germano-Christian era. The theofascists of the Christian Right would have us live on the remnants of Germano-Christian culture despite the widespread evidence that we're living in a new era of praxis; they spout paranoid theories about end-time scenarios and scapegoat minorities. While we obviously draw inspiration from dynamic figures of Antiquity, such as Solon and Catiline, we acknowledge that a few signs of life were manifest around year 1000. But this chiliastic urge was scarred by the same repellent racism and improbable eschatological thinking as the theofascists of our time.

The age of praxis is characterized by acts of negation, such as those perpetrated by teens in Florida who demolished a vacant house. Acts of vandalism such as this are indirect expressions of the terror people feel as they look out and see nothing but life at hard labor at false occupations on the horizon. Out of sheer boredom they're beginning to attain a sense of historic destiny and act directly, outside the law, imposing their desires and aspirations on the world. This rabble refutes the cardboard culture imposed on them, and begins to create a

new civilization in the process. But if this mass of slackers and refugees is to transform itself into an unassumingly noble class, and thereby obliterate all classes, it will be because it has the courage and intelligence to overthrow the economy that excludes or marginalizes them, and then constitute revolutionary democracies everywhere in the world.

Many of today's so-called slackers already have the values needed to pull off a revolution. They don't believe in alienating ideologies, and while they're aware of the wealth of the world, they know better than to be nationalistic. They're cynical about governments and politics, almost to the point of subversion. They're not greedy or servile, nor are they usually sexist, racist or homophobic. They have a sense of solidarity with low-wage immigrants because they work the same dismal jobs. These post-punk slackers pick up their guitars, brushes and pens and revel in their amateur glory, eschewing any sense of dreaded professionalism. The Eighties came and went, and the cold, clear perspective of that decade has been softened with a little more awareness of what it means to be human. More than anything, these slackers have seen what the spectacle has done with the most radical adventures of modern art. They're sick of having protest sold to them as fashion and all the other lies. Like Indonesian students and workers they're ready to become their own art directors and designers and rewrite the year of living dangerously. If they can radicalize themselves, and then make the right interventions while simultaneously aligning with sub-proletarian elements everywhere, they can reclaim the world and shape it to their designs.

15

To make history is to wage war, a total war with a total objective, as slaves destroying our masters. To this end we've decided to mimic the technocrats who have a quasi-monopoly on everything and who impose their solutions on our bureaucratic societies of programmed consumption. The secret society known by the code words Federal Open Market Committee speaks in Delphic phrases when it

105

meets to decide interest rates, so we see ourselves as those who make the Olympian decision to cancel all debt. Once we have made this donation, nothing more than an irrefutable suggestion, we leave it to the impassioned masses to ally with us, and supersede us by a general lockout of managers and their police.

Most workers will strike on the job, but others, who don't have jobs, can be brought into key productive sectors so that everyone works less. Managers and the credit class will have to do their fair share of real labor, but no more than anyone else, no more than ten hours a week. Between now and the year 2000 we should experiment with factory-, industry- and city-wide strikes so that the general strike can be effectively organized and consumption can continue at high levels. We might look to the Argentine example of *ollas populares* or 'popular waves' of festive protest that take it upon themselves to occupy public squares and feed the poor and unemployed - here we need to read the books of Pantagruel to prepare our imaginations for the jubilee year. An effective general strike is one that impedes the feeding, supplying and transportation of the mercenaries who oppose it, while simultaneously creating such a seductive vision that mutiny becomes a viable option for the soldiers of fascism. Strikers can bring the jubilee spirit of a festival to the reconstruction of the devastated world and win converts to their cause. Cities can be repainted and replanted. The unemployed hordes can cast aside their drugs and crime with natural therapies and jobs fixing up their own homes. Most prisons can progressively turn into correction facilities that show the way back to society. Life can grow with the force that comes with breaking all chains, not tolerating anything that suppresses it: racism, nationalism, pollution, torture, murder, fear, guilt.... With life on the offensive, victory by general strike is more likely than victory by bullets or ballots.

16

We will apply our reckless minds to the task of global currency unification, ending the travesty of currency speculation, and to

the creation of a new system of zero-interest mutual banking that creates wealth for projects corresponding to real needs. We think we can do better than the current generation of bankers who, over the last fifteen years, have suffered banking crises in 75 percent of the world, including the leading industrialized nations. As with the Revolutionary War debt and Civil War debt, right up to Cold War debt and Savings and Loan debt, the poor here and abroad have paid them all.

We're physically tough enough to take on the monstrous task of the universal cancellation of debt by general strike. We have no respect for the lending by banks that creates most of the money supply. We've seen the way the boom-bust cycle of banking has been masked from the population - the rise of the Eurocurrency market, the use of syndicated loans to spread the risks and international transmission of crises. We've also seen the way banks have been waging and winning a war against the productive sectors of the economy. We hold our banking colleagues accountable for their disasters.

We may sound desperate with our call for the universal cancellation of debt by general strike, but we aren't half as desperate as the people afflicted with the economic hardships resulting from irresponsible lending. The world could be transformed into a gigantic Mexican *maquiladora* - factories where workers average $35 per week and babies are born without brains due to toxic waste dumping, where workers construct their homes with trash from poisonous industrial parks and the government union is a complete sham. We must respect the rights of all workers, or better said, of all humanity. The problem is, we don't exist.

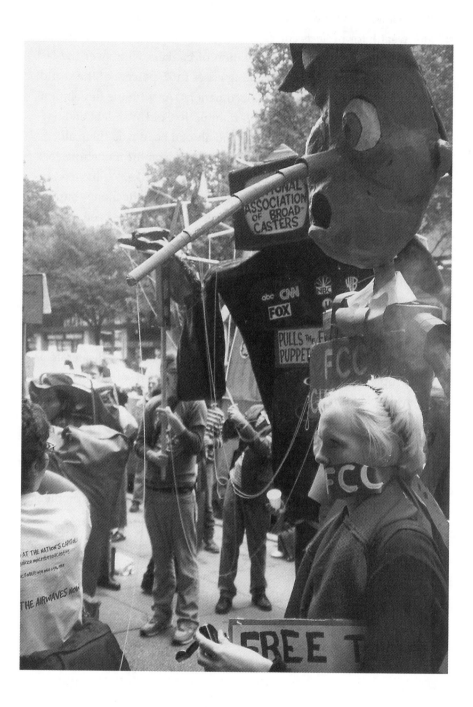

Chapter Seven

We Read You Loud and Clear: Micro-Radio Protesters Storm DC

On October 5, 1998, an eloquent and highly diverse contingent of broadcasters converges on the capital in the first national mobilization for pirate radio: the over one thousand unlicensed, low-powered FM radio stations nationwide currently at war with the Federal Communications Commission (FCC). These gung-ho community radio stations constitute the veritable free speech movement of the Nineties and today they're looking for a showdown.

Late in the cloud-covered morning a patchily broadcast show emanates from Dupont Circle. Feigning nervousness at being the focus of so many cameras, DJ Toxic Cloud, a pirate hat on his head, half-yells into a hand-held microphone: "We want to say what we want to say, when we want to say it, even if we don't have anything to say." These words issue from a score of nearby boom boxes and are met with a rousing chorus of cheers and hoots.

With his disarming smile and manic energy, Toxic Cloud buzzes from Ocean, a young guy from the punk rock station Free Radio Ashville that recently forced the FCC to abandon the enforcement of its rules, to soft-spoken Mara from embattled Radio Gainesville, who expresses

the widely held opinion that micro-radio is a First Amendment right. Meanwhile, a formation of massive puppets and festive protesters gathers on the edge of the circle eliciting curious looks from motorcycle cops and passersby.

Toxic Cloud moves on to Jesse Walker, who recounts the Freedom Forum debate earlier that day: "We had three pirates and the establishment point of view, along with a guy from *Broadcasting and Cable Magazine*. We wiped the floor with them. The crowd was clearly with us and we may even have made a few converts who will come down and march with us. That's all I have to say."

Next it's Flint Jones, dressed in pirate garb and casually resting the Baltimore IWW (Industrial Workers of the World) flag on his shoulder - he tells Toxic Cloud and everyone who is tuned in to 97.5 about Wobblies of yore storming small towns, about the hundreds of singing workers demanding and often getting better working conditions: "Wobblies were involved with independent radio in the Thirties when organizing auto workers in Detroit and now they're involved in the whole micro-radio movement - Gainesville, Miami, Philadelphia and soon Baltimore and DC. Micro-radio gives us a way to say how we, as working people, are going to organize. We're here to protest the fact that in the last year alone fifteen stations have been busted by the FCC using back door tactics, which simply ensures continued corporate domination of the airwaves. If you challenge corporate America, you don't get heard; the more of us there are, the more we cut into their advertising revenues because listeners tune in to us."

Conspiracy researchers should note well that the *c*-word is often associated with the Wobblies, both for their highly engaged actions (need I say more) and the US government's tactics against the group for its resistance to World War I. Toxic Cloud moves on and asks a man wearing a pointed silver hat and a TRI ANG U L8R backpack: "Who are you?"

"I'm a secret FCC agent."

Actually it's WDC Wobbly Chuck Munson.

"How do you sleep at night?"

"I don't. I can't sleep at night with all these micro-radio waves around, but I'm thinking about defecting to the other side because they seem to have more fun."

"I'd like to encourage you to do so as soon as possible."

"Excuse me please, I need to triangulate something...."

A pack of similarly outfitted would-be agents is waiting in the wings.

And as the march is about to begin, a man in a yellow National Association of Broadcasters shirt emblazoned IF WE DIDN'T PROTECT THE INTERESTS OF CORPORATE BROADCASTING, WHO WOULD? makes the point that in their FOIA (Freedom of Information Act) search of FAA (Federal Aviation Administration) records his friends could only find one case in which the FAA claimed a hazard was caused by a micro-radio transmitter. This was in Sacramento, and rather than requiring the usual arm-twisting, the station voluntarily shut down. He then mentions an ominous case in Puerto Rico in which the FBI, not federal marshals who should have jurisdiction, cracked down on a pirate station.

To the rattle of drums, and somewhat disjointedly at first, the march begins. Toxic Cloud is back at the microphone, walking backwards, urging everyone on with the chant: "Yo ho, ho and a bottle of rum, pirate radio's time has come." Traffic at the circle backs up and pedestrians stop to take in the procession as camera-snapping reporters swirl in and around the small mass of protesters. Emerging from the semi-obscurity of the tree-lined park, the puppets attract the most attention, and none so much as the gigantic green obelisk with big gnashing teeth and four blood-shot eyes rolling around in their sockets as it negotiates awkward turns. This is Corporate America on wheels; its massive green arms and hands control the ostentatiously orange strings to the deadly TV-headed monster representing the National Association of Broadcasters (NAB). Plastered with corporate logos, this twelve-foot-tall black NAB creature in turn controls Kennardio, a crude but effective morphing of FCC Chairman William Kennard onto the legendary folk tale character with an elastic nose.

111

As the mostly rag-tag marchers stretch down posh Connecticut Avenue, it's easy to see that this protest to bring down the barriers to airwave access is, in large part, a women's issue. The drummers are women, as are those directing traffic, such as local organizer Amanda Huron and many other women, handing out fliers to passersby or playing FCC Nerds in pointed hats and triangulator backpacks. Philadelphia's Condom Lady, exceptionally well dressed in a suit, is speaking into her tape player about pirate radio as "the voice of people who don't have a voice in a society divided by racism, sexism, classism," adding, "with everything going on here, DC is obviously in need of sexual information." Mara smiles as she holds a sign with the tips of her fingers: THE FCC CAN KISS MY BILL OF RIGHTS. A woman in a wheelchair wearing a red bandana rolls by blasting her boom box, followed by Kate, from the strong Philadelphia contingent, sporting another National Association of Broadcasters t-shirt, this one asking: IF IT WASN'T FOR COMMERCIAL RADIO, HOW WOULD WE KNOW WHAT TO BUY? Another woman wheels by on a tricycle; two friendly young women tell me they've come all the way from Texas to represent their station....

We make the right turn west onto M Street, into a concentrated segment of the city's business district. It's a one-way street but we stay in the two right lanes, hemmed-in by motorcycle cops and the cars they fail to block. The sickly seductive scents of restaurant cooking and the stench of a homeless drunk who joins us are rightly overpowered by the sound of people not afraid of their own voices: "Radio for you and me; tell it to the FCC" switching to "FCC, NAB: Enemies of liberty." The caravan covers half a block by the time the head of it closes in on the FCC - somewhere near the middle of the procession Kate and the guy who spoke about Puerto Rico start singing "Solidarity forever," and a few others join it to finish off the refrain, "for the union makes us strong." Thousands of people press against the windows of their sealed offices looking down on us, people who may never know what this means.

The insistent chant "Free Our Airwaves" begins in the street and moves into the hollows of the FCC entrance, where it echos. And with the radios amplifying the endlessly repeated demand "Free Our Airwaves," and other protests shouted into the chorus (such as "Corporate America creates radio that teaches people that the only way to be happy is to buy more stuff" followed by "We can't afford it!") and the heavy drum beat, well, with all of this noise we are creating quite a disturbance on what is usually a sleepy Washington street.

Much smaller than the others, hence unnoticed until now, a silver puppet is carried to center stage by burly guys wearing gags emblazoned with the letters FCC. Pete triDish takes the microphone and points to this oversized switch. Surrounded by cameras and dwarfed by the silver-painted cardboard structure, the young Philadelphian from Radio Mutiny stares back at the crowd through large horn-rimmed glasses and smiles behind a long beard strangely incongruous with his close-cropped hair. The chants "Free Our Airwaves" eventually die down. And when he announces on the doorstep of the FCC "We will throw the Free Speech Switch," his voice, worn from all the chanting, breaks on the last word. Amid the friendly laughter, Pete triDish repeats himself with a comically deep voice, and then he and Condom Lady flamboyantly flip the Free Speech Switch.

Maintaining his poise, Pete triDish questions the FCC commissioner's claim that he wants to open the airwaves to more diverse voices and challenges him to come down and arrest us if what we're doing is so wrong. Ending raids on micro-radio stations is the most pressing demand, followed closely by expedited approval of rules for legalized micro-power radio. To considerable laughter someone chants "Hey, hey, ho, ho, classic rock has got to go" as Pete gathers himself to introduce characters in a radio play - Kennardio is a "lifeless marionette" Pete tells us, and NAB is a "gorilla" of a lobbying organization; both, along with Corporate America, get the boos and hisses from the audience they deserve. The play is read with gusto by Joe Ptak and Zeal Stefanoff from San Marcos, Texas' Radio Kind. This theatrical reprise serves the dual purposes of entertaining us by ridicul-

113

ing our enemies and giving us an excuse to hold our ground for twenty minutes while continuing to broadcast.

While the play is under way, I speak with David Fiske, the FCC's smiling spokesman on the scene, who assures me that the FCC is considering several petitions to license micro-radio. He neglects to mention that these considerations mark a recent change in the FCC's hard-line against low-power broadcasts. The Skinner petition calls for a tripartite classification based on wattage and, in the case of the lowest class, time-based event radio; the Leggett proposal uses wattage and antenna height criteria and stipulates that owners live near the station; the Deieso petition proposes very low power event broadcast stations. The FCC claims that their hundred-watt minimum power level is designed to maximize airwave diversity and serve the widest possible audience - claims that seem mutually exclusive in light of micro-radio's ability to truly maximize diversity by enabling so many more people to become broadcasters. In a letter to *USA Today*, FCC Chair Kennard felt compelled to respond to charges that his policies only benefit rich corporations. His defense rests on the number of stations licensed nationwide, a defense immediately followed by the concession that recent media consolidation trends adversely impact the diversity of voices in the media. (As I write this, CSPAN Radio reads an October 10, 1998, news report on a merger that brings four hundred stations in 101 markets under Clear Channel's umbrella.) The FCC justifies its harsh enforcement tactics on the grounds that they're protecting the public from interference - micro-radio makes planes fall from the sky.

The response of the protesters:

What it took to get the FCC to consider legalizing LPFM was thousands of people committing electronic civil disobedience, by defying their unreasonable rules and demonstrating that low-power FM works, that it is an asset to communities, and doesn't cause undue interference with anything. As long as the campaign of harassment and disinformation against micro-broadcasters continues, the proposals for legalization would seem to be no more than a public relations ploy. Until

114

twenty years ago the FCC issued class D licenses for noncommercial stations operating at a minimum of ten watts, but abolished them under pressure from NPR [National Public Radio] and the CPB [Corporation for Public Broadcasting], who sought to consolidate control of noncommercial broadcasting and what public money was available to support it. The FCC already licenses repeaters at power levels of less than 100 watts. These stations are not permitted to originate programming, but only to rebroadcast the signal of another station. There is no technical reason why the class D license, or something even less restrictive, couldn't be reinstated. What looked like chaos to a bureaucrat who preferred to have fewer, larger stations to regulate, looks like greater opportunity for expression and communications for local writers, musicians, teachers and activists.

The radio play continues, now over kazoos to the tune "God Bless America." I turn to a man in a jacket and tie; he speaks with a British accent.

"What's the name of your station?"

"Radio Free Lao. We're broadcasting in the Lao language to the Lao people. At the moment we're broadcasting from a conventional station in Falls Church, Virginia, and on the Internet. We're hoping to open our own station in the future. But the problem is that small stations are not allowed a license, so we're campaigning to change the rules to give the airwaves back to the community. The Lao community, for example, is completely unserved by the radio industry. Almost half a million Lao live in the United States and corporate media is simply not interested. So we need to have our own voice to reach our community."

The radio play winds up and a few shouts of "Hey, ho it's not that hard; We want to talk to Bill Kennard" are hurled at the FCC before we move on to the NAB's gleaming, tinted-glass structure a mere three blocks away. By now we've picked up confidence and move into the circular drive with a full head of steam - at the head of the brigade, a band of young people holding the sign: WHO ARE THE *REAL* PI-

115

RATE RADIO STATIONS. Some guy yells, "What you do is wipe your ass with your lies and your lousy fucking commercials." As Jesse Walker mentions to me that this is what it's really all about ("Bringing down barriers to entry to get on the air and compete with these corporate bozos") his voice is partially drowned out by the disappointingly stale chant: "Hey, hey, ho, ho, NAB has got to go."

Kennardio, the lifeless marionette whose strings are pulled by the media elite - gaping mouth, crossed eyes, asymmetrical ears and a nose that grows with the tug of a string - has been pushed to the back of the procession. Now it's NAB (the TV-headed black monster with FOX, CBS, NBC, CNN and UPN logos on it) and Corporate America (the teeth-gnashing obelisk, four blood-shot eyes peering from its wobbling apex) that move toward the office door. Older white men with temporary name tags, obviously taking a break from a seminar or luncheon, mill around not knowing what to make of this NAB-Corporate America duo and the rest us. Someone, possibly Condom Lady, begins to shout "Who are the fucking broadcasters? We're the fucking broadcasters" and it turns into a chant. I look up and notice that a Jolly Roger is flying on the flagpole next to the US flag.

Lyn, a red-haired woman from Los Angeles, perhaps a little older than most of the others, spins around and addresses her fellow protesters in a defiant voice: "The First Amendment doesn't say that airwaves are for millionaires. There are communities without voices, without food. We are here to broadcast to the public, to reclaim what belongs to us." She turns toward the NAB building. "What you have is an advertising revenue machine of no value. Bill's zipper is down. OJ is guilty or innocent. These issues are trivial when compared with the misery and poverty in this society."

I can no longer quote her directly, except somewhat roughly. At some point in her lucid denunciation she asks, "Why should any one entity have over three hundred broadcasting stations across the country?" Finally she makes the accusation: "Boy do you like your property, don't you? But you don't want it for anyone else." Others join in as she points: "Shame on you. Shame on you." By now the mo-

116

torcycle cops and a few others in unrecognizable uniforms are attempting to get the crowd to back off and bring down the pirate flag. The NAB flag is missing, which leads to a standoff. Someone - I don't know who - points to a striking sixteen-year-old woman, dressed in a black coat and red scarf, her short blond hair stylishly swept away from her pretty face. Boni Ramey from Gainesville touched the sacred NAB flag and for this cops twice her size handcuff her and press her so tightly against the wall that she turns her head to prevent her face from being squashed. She's worried-looking, but also speaking in her own defense. A "Free the hostage" chant begins and someone yells "This is bullshit." By the time the chant to free the hostage is transformed into the simple refrain "frame-up, frame-up," the cops are signing time out with their hands and trying to get a male protester to tell everyone to back up. A young male professor who has been manning one of the puppets is cuffed along with the young woman.

To the tune of "God Bless America" on kazoos, the protest disperses up 18th Street, blocking traffic with Corporate America on three rather weak wheels. We leave two comrades in cuffs with IWW experts in this sort of thing to follow them to the juvenile and adult police stations for routine arrests. "From every mountainside let freedom ring" a few sweet voices sing along with the kazoos, belying the "I'm going to take a piss on this building every time I come to this town" sentiment we all feel.

Back at Dupont Circle, a short block or so away, Pete triDish tells us about the GANGPLANK sign on a seventh-floor door of the FCC. Behind this door lay trophies of captured pirate radios waiting to be liberated. But contrary to Pete's confrontational quote about ten stations popping up for every one the FCC shuts down that NPR chose to feature, Pete now speaks about how forthcoming FCC bureaucrats are when someone is interested in what they do. He seems to see them as potential allies who can be won over in a soft-sell approach. These micro-radio people are savvy, and one way or another, they will undoubtedly get their way. The NAB flag was never found, although a few hours later it, or another, was flying.

117

Chapter Eight

Open Letter to the Citizens of Poland

Search every land, from Cadiz to the dawn-streaked shores
Of Ganges, and you'll find few men who can distinguish
A false from a worthwhile objective, or slash their way
Through fogs of deception

Since when were our fears or desires
Ever dictated by reason? What project goes so smoothly
That you never regret the idea, let alone its realization?
What you ask for, you get

Juvenal

This message cautions you regarding a likely consequence of NATO expansion into your country - the parallel expansion of clandestine, psychological warfare operations that are detrimental to flourishing civil societies. I could address this to Hungarians and Czechs, but Poland is the prize of the East, the land of long ashes and diamonds in the rough. You might instead cherish living in Europe's extra-imperial gray

zone, a zone that could be extended by Poland casting a shadow of independence into the European Union (EU). I've been touched by the beauty of your all-too-human spirit and would hate to see it crushed yet again. Fascists (Nazis, Polish Stalinists, National Communists and others) can't resist dragging beauty in all forms, particularly in defiant art and people, through blood-soaked mud. Even if some of you have lost your taste for freedom over the course of a century of humiliation, your thirst for beauty will never be quenched. And for this reason, if for no other, you must allow your indignation to be roused and oppose those who live by the ugly credo, Long Live Death.

Am I implying what you're thinking? Yes. It may not look like its historical antecedents, but no word, other than fascism, describes the viciously manipulative form of domination favored by military police spies in the United States and elsewhere in NATO. Everything these partisans of the military-industrial-entertainment complex touch turns into a sickening spectacle of greed, violence and filth. The CIA's Nazi origins in the person of Hitler's Eastern front intelligence guru Reinhard Gehlen are well-known, not to mention the founder of the pro-Nazi America First Committee Allen Dulles, who brags in his *Operation Sunrise* about his OSS operation to save Nazi soldiers from Allied vengeance. CIA misdeeds in support of absolute power by means of guile and force constitute a list of scandals too long to enumerate here, but are understood by astute students of post-war history and anyone who bothers to read the agency's ghastly training manual, *A Study of Assassination*, or the Pentagon's fascistic guides to waging low-intensity warfare, *Counterintelligence* and *Combat Intelligence*.[1]

If one asks, as Chomsky does, *What Uncle Sam Really Wants*, one can only respond that he wants to create obstacles to any resurgence or emergence of a power capable of rivaling him - in your neck of the woods: Russia, Germany or integrated Europe. Don't let the US troop reductions in Europe fool you; Washington is more engaged than ever. The most impressive raw political power the world has ever seen, which is to say Uncle Sam, uses the Security Council to approve the military occupation of Bosnia-Herzegovina. The star-spangled recruit-

ment clown rules very imperiously, against the wishes of France and Italy, by delaying Romania and Slovenia's consideration for entry in NATO. Washington publicly discounts the risk of conflict in the Baltic States but may, one day, provoke wars where many Russians still live and where an American with an intelligence pedigree was recently elected president. Any crisis will serve as a pretext for foreign troops to again occupy Poland - when the relentless beast sinks its claws into your skin there's no going back. As you move, it moves with you. The CIA and Pentagon are merely two tentacles among many issuing from a hideous octopus capable of writing its own history in poison ink. If the phrase "the mighty Wurlitzer" means nothing to you, you might want to read Daniel Brandt's indisputable articles on journalism's ties to the CIA - check his *NameBase* website (www.pir.org), as hundreds of journalists do, to see if someone you suspect has been publicly exposed in the thousands of books, journals and newspapers Brandt has been combing for decades.

At the moment, a shallow little book is making the rounds of the publicity circuit: *Conspiracy: How the Paranoid Style Flourishes and Where It Comes From* by Daniel Pipes, Ivy League professor, member of the Council on Foreign Relations and son of a former National Security Council employee. In his *Washington Monthly* review of *Conspiracy*, Christopher (son of William) Buckley paints a disturbing family portrait of his intelligence ties, then dismisses this tableau as an irrelevant joke. The technique is tried and true: tell the truth then scoff at it. Should we trust these frat boys of the spy establishment not to use loaded dice? To my mind, the editors of *The Economist* are being more objective when they chastise Pipes for his condescension in their eloquently entitled review "Not Reliably False."

I recall Pipes' WAMU radio appearance. He feigns ignorance of details regarding the CIA's role in the distribution of crack cocaine and is corrected by both the host and callers on specific points. He nonetheless accepts at face value the spy agency's conclusions in its then unreleased report on the affair, which we now know is full of admissions. He is not alone.

Public opinion has been softened up so much by perpetual apologies for the regime that citizens did nothing when the House committee looking into October Surprise issued a report in 1993 that whitewashed the scandal. Remember? President Carter's negotiations with Iran for the release of US hostages in Tehran were broken off as Casey, Bush and other Republicans met with Iranians in Europe to orchestrate the resolution of the 1980 hostage crisis, for their own political ends. Ex-Iranian president Bani-Sadr supports the allegations, as does Arafat who was himself approached by Republicans. Others who have gone on record are French spy-master deMarenches, ex-Israeli spy Ben-Menashe, who once operated in Poland, and the US-Iranian arms merchant Jamshid Hashemi. Two bogus alibis were reported for Casey's whereabouts on the last weekend of July 1980, when Casey met Hashemi in Madrid. In exchange for US arms, the hostage release was delayed until Reagan's inauguration.

The chief council of the House Foreign Affairs Committee, Spencer Oliver, issued a report that questions the Secret Service's records and the Republican attack on his investigation. Oliver has gone so far as to accuse the Secret Service supervisors of lying about the whereabouts of George and Barbara Bush on the morning of October 19; these accusations are backed up by the person with whom the first family was said to have brunched. George Bush's afternoon alibi crumbled as well, and several witnesses have him in Paris that day, meeting with Iranian representatives.[2] You Poles may be more civilized, intelligent, cultivated and even better informed than us provincial Americans who are so easily duped. But you are just as likely to serve our master as your old one. The West is no less a wolf than the East and you have yet to shed your wool.

If I had bothered to call Pipes' radio show I would've asked if there was anything conspiratorial about the cover-up of the exposure of millions of US citizens to radioactive fallout from nuclear tests, either directly or as downwinders, or in macabre experiments, such as exposing prisoners' testicles to cancer-causing radiation. I would've mentioned the neo-Nazi movement in the United States military, par-

122

ticularly the Christian Identity strain of fascism that propagates vague ideas about Aryan supermen; a group with close ties to the Klu Klux Klan. Are cross burnings and Nazi salutes indicative of conspiracies? I would say so.

The thing to remember about the Patriots and Aryan Nation types is that they all mix with spies. Many - Mark Koernke, Bill Cooper, Bo Gritz, Linda Thompson and others - have military intelligence backgrounds to go along with their supremacist ideology. People like Gritz may have transformed themselves from Rambos into something else, but in my humble opinion, the connection between the alphabet soup of intelligence agencies and neo-Nazi violence goes to the heart of the Oklahoma City bombing and other nefarious acts of terror. It may sound as if I'm speculating wildly, but I'm simply making a subjective interpretation informed by numerous mysterious facts, such as the fact that two explosions in Oklahoma suddenly became one in the media and the courts.

And if I'd gotten through to Pipes, I would have asked him for you, the citizens of Poland, if there isn't an ongoing conspiracy to make the accession of Poland to NATO seem like a done deal, an inside the Beltway *fait accompli*. I would have asked Professor Pipes if he doesn't think industrialists in the military-industrial-entertainment complex are conspiring in ways we will never know, conspiring to turn Poland into a market for US arms. Who got to Clinton in October 1996 and convinced him to ditch his anti-expansionist Partnership For Peace? We still have no explanation for the abrupt reversal on the issue. The more obvious question is: How many F-18 fighters will go to Poland?

People like Pipes tell you, the way he tells us, that black helicopters are laughable, when in fact *The Washington Post* reported on Special Operations exercises with unmarked choppers in dozens of US cities.[3] One doesn't need to be a conspiracy theorist to know that the Pentagon violated the Nuremburg code when it used experimental vaccines on Gulf War soldiers, the Geneva Convention on germ warfare when it sold certain chemical products to Iraq, or the US constitution when it obscured damaging facts about the use of unapproved

drugs by soldiers in the desert. The major media finally disclosed the cover-up, but neglected to mention the poisonous depleted uranium exposure resulting from tank rounds. The atrocious "bomb them to the Stone Age" mentality that swept the ranks during the war did its damage, much of it unintended and self-inflicted.

I'd like to draw attention to Pipes' treatment of *The Protocols of the Elders of Zion* because he holds it up as a key to demystifying conspiracy theories. In a limited sense, Pipes is correct - the *Protocols* present a fake image of a Judeo-Masonic conspiracy for world domination based, in part, on the good Communard Maurice Joly's *Dialogue in Hell*, which I can't resist quoting here, from the epilogue:

> Machiavelli: "If I weren't a tyrant, I'd be nothing."
> Montesquieu: "It's a good word."

Neither the false origin nor their amusing, enlightened source absolve the nasty *Protocols* of conspiracy charges. Quite the contrary. The Russian Tsar's notorious secret police, the Okhrana, initially conspired to create and distribute the *Protocols* for deceitful ends. I'm confident that many of you detest, as much as I, this abuse of writing as an instrument of political power, an instrument of separation.

This false key opens a double-bottomed box concealing the beveled cards of *agents provocateurs*. Does Pipes dispute the Okhrana's use of agents such as the infamous Azef, the head of the Combat Organization of the Socialist Revolutionary Party? If so, perhaps he should take a few Russian history lessons from his father or read the last chapter of Boris Savinkov's *Memoirs of a Terrorist*. And lest this example be dismissed as something that happened long ago and far away, Pipes might consult Ward Churchill's work on the infiltration and militarization of the Black Panthers by the FBI in its COINTEL operation. And how can we forget the revelations in April 1974, when revolutionaries uncovered the archives of the Portuguese equivalent of the Gestapo, and its most shameful annex, The Aginter Press, a covert espionage office and mercenary recruitment center for its international fascist

organization, Order and Tradition, and its grim-sounding military wing, Organization of Action Against International Communism. Aginter Press published the infamous Italian text *Our Political Action* (1969), extolling political and economic chaos to legitimize a military seizure of power. This brings us to the best-kept secret in Europe: the Gladio (*glaive* in Italian, named after the Roman short-sword *gladius*) conspiracy.

Because of the tumultuous events taking place in the East, many close observers of current events missed the admissions, in 1990, by the Christian Democrat elephant and then Prime Minister, Giulio Andreotti, in a report to the Stragi commission, the parliamentary commission charged with investigating numerous terrorist massacres that took place in the Eighties. What, precisely, were those admissions? Andreotti disclosed the existence of a super-secret intelligence organization under the auspices of NATO but financed and controlled by the CIA. Designed in the post-war era to counter an Eastern Bloc invasion of Italy and domestic communist subversion, the "gladiators," primarily fascist veterans, enrolled in courses - sabotage, propaganda, infiltration - taught by the Training Division of the British Intelligence Service. Andreotti had previously denied the existence of such an operation many times, and NATO's denials continued for a short period after Andreotti's report. The CIA has still not declassified documents regarding its role in this apparently still ongoing affair.

At the time, Andreotti and President Cossiga insist that the operation is legitimate, although the president later orders the Supreme Council of Justice not to discuss the issue and not to question this censorship. The president even threatens to resign if his view on the Gladio affair is not supported by his cabinet; he is otherwise so vehement that newspapers question his sanity. We now know why. For years he censored reports on coup attempts, eliminated information and edited tapes. Moreover, the Italian military intelligence agency SIFAR certainly has the goods, real or improvised, to blackmail President Kossiga (in far-Left orthography) and any other politician. The Socialists abstain when the legitimacy of the Gladio comes to a vote, but the Italian Com-

munist Party organizes mass protests against Gladio and the failure to get to the bottom of right-wing bombings. In defiance of this opposition, Cossiga publicly praises a right-wing coup plotter and is seen around Rome paying his respects to generals of the secret service and to associates of P2 Master Licio Gelli.[4] Needless to say, Cossiga is not impeached for treason as certain minor political parties would have liked. Andreotti is much more sanguine about these revelations and partially succeeds in convincing Italians that the Gladio conspiracy is nothing extraordinary.

We now know that the CIA and NATO were hand in glove in Italy, and many Italian military officers, bureaucrats and politicians joined P2 to demonstrate their pro-NATO stand. Despite the ostensible independence of the Italian intelligence services, according to Andreotti's report, they were coordinated by the CIA. Whether or not one accepts the idea that during the Cold War there was a reciprocal CIA-KGB agreement regarding the ideological purities of Italy and Poland, the average Pole might consider the implications of the CIA pulling the strings in Polish society. This is, after all, the CIA of Operation CHAOS (an illegal operation in which the CIA, in liaison with local police, spies on domestic dissidents with break-ins and wiretaps, no-knock searches and selective assassinations by special intelligence units which have been privatized in the wake of Watergate) and the CIA of MKULTRA (mind or behavior control experiments on unsuspecting victims using radiation, electric shocks, electrode implants, microwaves and drugs such as LSD). And this expansion of NATO would inevitably inspire the new KGB, the Russian Federal Security Agency, to increase its practice of the black arts of intelligence in Poland.

I'll never forget the publication of *The Black Book of Polish Censorship* here, in 1984 no less. The orchestration of political events was heavy-handed in Poland, but the government and KGB used a light touch compared to the sledgehammer tactics used by the CIA in Italy - direct support of attempted coups d'états and artificial terror perpetrated by government infiltrators of both left-wing and right-wing

groups, in a strategy of tension designed to push the country to the right. To this list of CIA-inspired atrocities I would add, and I am not alone here, the kidnapping and assassination of the president of the major political party in the country: Aldo Moro.

How can I make this accusation? Kissinger made public threats, reported in the *New York Times*, regarding the use of covert operations in Italy at the time of Moro's 1974 visit to the United States. The Secretary of State who had once played such a helpful role assisting Nazis to emigrate from post-war Germany to the United States was irrationally concerned with Moro's historic compromise between the CIA-funded Christian Democrats and the Italian Communist Party. According to his wife, Moro was told by an unnamed intelligence official during his US visit: "You must abandon your policy of bringing all the political forces in your country into direct collaboration. Either you give this up or you will pay dearly for it." After becoming ill at New York's St. Patrick's Cathedral, Moro returns to Italy and tells one of his close collaborators that he plans to withdraw from politics. The CIA later refuses to participate in the manhunt for him.

For those who still insist that the CIA was not involved in the Moro assassination, I raise the problem of the 1976 arms deals between the PLO and the Red Brigades, based on an accord between the PLO and the CIA's Hyperion Language School in Paris mediated by Colonel Stefano Giovannone of the Italian Military Security Information Service. More to the point, it seems that Mario Moretti, the man in charge of the Moro kidnapping was, despite his denials, a government infiltrator. Moretti's transformation into an extreme revolutionary militant came after a religious youth, and a surprising transformation only one year after having made an impassioned speech against trade unions at the Siemens factory where he worked. Moreover, his rise in the Red Brigades was a consequence of the arrest of two main leaders, an arrest that can reasonably be pinned on Moretti because he failed to relay a warning to his comrades. When many others were caught in dragnets, Moretti escaped time and again. He left and returned to the country at will, and was, at key moments, the only Red Brigade contact

127

with the Hyperion Language School, whose luxurious Parisian offices Italian police say housed the most important CIA office in Europe.

This school was founded in 1976 by Corrado Simioni, Vanni Mulinaris and Duccio Berio, former members of the ultra-left Metropolitian Political Collective (MPC) in Milan. Renato Curcio had been a member of MPC prior to organizing the Red Brigades. When the founders of the Hyperion Language School set up their own terrorist organization, Curcio and Alberto Franceschini dubbed them the Superclan or Superclandestini because of their obsession with secrecy. Superclansman Simioni was identified in press reports at the time as a CIA agent who had worked for the United States Information Agency and Radio Free Europe. Moretti was, likewise, a former member of the ultra-militant Superclan, a group whose expressed mission was to infiltrate all the organizations of the extreme Left. Even the Red Brigades founders were suspicious of Superclan members; Francheschini actually issued a warning to that effect from jail. Too little, too late. Moretti took over, continuously escalated Red Brigade military operations and personally led the via Fani attack on Moro. This same Moretti was responsible for not releasing Moro's scandalous disclosures about the Christian Democrat party as an authentic revolutionary would certainly have done. The briefcases taken from Moro during the kidnapping, thought to contain sensitive information, are still reportedly missing although someone certainly has them. When Moretti was finally arrested, Giovanni Senzani, another suspected infiltrator, became the Red Brigade contact with the Hyperion Language School. When asked about a false communiqué released during Moro's imprisonment, as Philip Willan describes it in *Puppetmasters*, Moretti inadvertently showed his cards regarding secret service manipulation of the Red Brigades.[5] As he makes his denials, we hear Moretti, as Italians say, laughing under his moustache. Even his ex-comrades now admit they were misled and used by him.

And why would a man known to have such long arms, Licio Gelli, the Venerable Master of P2, the Propaganda Due Masonic lodge, be on such close terms with ex-CIA director George Bush? They re-

portedly spent most of the week of Reagan's first inauguration together. No connection between the Italian P2 and the CIA? You must be joking. Gelli began work for American intelligence as early as October 1944 as an informer and spy of questionable loyalties. A friend of Peron, an economic advisor to the Argentinian Embassy in Rome, a coup plotter in 1970 - Gelli, it must be remembered, was convicted of financing terrorists in deadly train bombings, only to have this and other convictions reversed by complex legal maneuvers. Abundant testimony and other evidence exists to support the claim that the CIA actually funded P2-orchestrated terrorism - a few reports claim that drugs factor into the mix, which comes as no surprise in the wake of CIA support for drug smugglers who were part of the agency's Nicaraguan contra support network. One of the most authoritative statements on the subject comes from the Christian Democrat chairwoman of the P2 Commission investigation; she publicly claims P2 was involved in Moro's assassination. Not only were a majority of the Committee of Coordination dealing with the Moro crisis P2 members, many were right-wing military men and intelligence operatives who hated communist-accommodating Aldo Moro's guts. Their goal was not their stated goal of finding Moro and obtaining his release.

As Machiavelli remarks in the sixth of his *Discourses*, "On Conspiracies," many more princes have lost their lives and their States through conspiracies than by open war. On the surface, the Moro assassination appears to be an example of what Machiavelli calls conspiracies formed by the weak, which are made only by "sheer lunatics." The case also has the superficial aspect of the conspiracies against one's country variety - the Red Brigades conspired to bring down the fragile Italian state, a conspiracy "less dangerous than most." No, the Brigades did not advance a program as revolutionary as Catiline's cancellation of debt nor, in the end, were they particularly red. They were part - perhaps unwillingly, but never really unwittingly - of what Machiavelli called "conspiracies formed by the strong" that only require a little prudence to succeed. As Dante says, when people sing while the organ plays, "sometimes the words are heard, and some-

129

times lost."

Say what you want about the man, but in his June 26, 1938 journal entry, the controversial psychologist Wilhelm Reich accurately defines fascism as humanity's fear of pleasure, which turns into romantic impotence in the wake of lies, deception and taking advantage of others. He goes on to show that the fascist mentality lurks in many unsuspecting places, "like a cat waiting for victims." It could happen anywhere, and without notice. I don't need to remind you that Hitler didn't bother to declare war in 1939 when he occupied your country with fifty-four divisions. Never again? We now know that after World War II, the CIA, State Department and US Army Intelligence created programs for the specific purpose of bringing select former Nazis to work in the United States. Many were experts in propaganda and psychological warfare; as Christopher Simpson demonstrates in *Blowback*, "hundreds, and perhaps thousands, of such recruits were SS veterans." Then keep in mind that George Bush's 1988 presidential campaign was forced to dismiss numerous anti-Semites, holocaust revisionists and Nazi apologists and collaborators, many of whom would later return to work for the Republican Party as they had for decades prior to the scandal. Bush's son is currently the Republican front-runner for the presidential election in 2000.

Ex-president Bush, in case you didn't know, is a member of Yale University's Order of Skull and Bones, the influential secret society of WASP families: Taft, Stimson, Pillsbury, Weyerhaeuser, Harriman, Rockefeller, Bundy, Lord and others. This Brotherhood of Death is linked with the Oxford University-based Cecil Rhodes group known as The Group, which Carroll Quigley (see the Quigley section in chapter one) writes so convincingly about in his *The Anglo-American Establishment*. The point is that both The Group and The Order share a penchant for secrecy and coercion in acquiring immense power in every aspect of society - from politics to history, medicine, the media and transportation.

Perhaps the most intriguing revelation in Anthony Sutton's

130

book on Skull and Bones[6] is The Order's philosophical underpinnings. Those wearing the badge of death are Hegelians - not so much followers of Hegel as sublime author of *Logic* (although the logic certainly applies in a perverse way), rather the proponent of the absolutist state who penned *The Philosophy of Right*. It seems members of The Order imported Hegel from Germany in the XIXth-century and have successfully applied his dialectics in the clash of opposites for over a century now: "Today this process can be identified in the literature of the Trilateral Commission," Sutton writes, "where 'change' is promoted and 'conflict management' is termed the means to bring about this change." This seems a little too facile to my mind because it ignores the confluence of both systems around monopoly ownership by bureaucrats, that is corporate or ministry technocrats. And this abstraction ignores the real movement of negation in the global rising that peaked in 1968, which was in its best moments anti-hierarchical and anti-bureaucratic. The domination imposed on us now, what the French strategist Guy Debord calls the integrated spectacle, is the negation of this negation and perfectly comprehensible in Hegelian terms other than those posited by Sutton, and others, who rail against the new world order. I should add that it's too easy to discount the power of the nation-state, the definition of which is the monopoly of force, which isn't to say that world government doesn't have its advocates, including Zbigniew Brzezinski, or even its realities outside of any State structure.

Hegel followed Heraclitus' contention, supported by countless barroom brawlers, that nothing comes into being without conflict - he agreed in spirit with the French poet who says "those who live are those who fight." One requires only a very short leap of faith to ascribe Bush's irrational decision to wage war on Iraq to his fundamentally Hegelian worldview. After all, Saddam Hussein was clearly ready to negotiate when the United States launched the first missiles. Bush and his acolytes wanted a war more than they needed one (other than to dispose of excess weapons), but they certainly needed, and continue to need, a bogeyman like Saddam. To illustrate his point that the elite

131

needs to pretend there is a real conflict between the Left and the Right, Sutton quotes Quigley at length: "The associations between Wall Street and the Left (...) are really survivals of the associations between the Morgan Bank and the Left. To Morgan all political parties were simply organizations to be used, and the firm always was careful to keep a foot in all camps."

Far be it for me to pose as a prophet and suggest, with absolute certainty, that Hegelian elites in the United States would manipulate the internal affairs of Poland any more than they already have. All I'm saying is that the powerful have always used coercion to create their own realities. You can't expect powerful Americans to reckon half is more than the whole. In other words, and I don't mean this in a condescending way, you should consider the value of preserving the independence you have.

Let's take this further and recall the great Polish left-Hegelian August von Cieszkowski and his dialectical interpretation of history. Antiquity is the stage of beauty, characterized by being; the Germano-Christian era is the stage of truth, characterized by thought. Cieszkowski's third stage is the epoch of praxis that reconciles thought with being in action. This age of action realizes beauty and truth in a society where "being and thought must disappear in action; art and philosophy in social life."

To my mind, the closest Poland comes to this sort of realization of philosophy is the workers' riot at Poznan on June 28, 1956. These workers were not dragged by the nose of socialist propaganda, nor were the Polish soldiers who, during the October Days of 1956, threatened the Soviets with reminders of 1919-20. And at the very least, which is already saying a great deal, you Poles inspired the Hungarians to go much further and put a nail in Stalin's coffin. If the subsequently legalized workers councils were dismissed by Gomulka, the man who made strikes illegal, as anarchist utopianism, then he showed his true colors long before the massacres in Gdansk, Gdynia and Szczecin, and the assassination of adventurers and hooligans who were precisely the Poles most capable of realizing the poetry of Cieszkowski's teleology

of universal history. All this might sound strange to you, but consider this: (1) it sometimes helps preserve one's sanity to have a vision of paradise, even a realizable one like the chaotic beauty of open and transparent ultra-democracy; and (2) upon replacing Gomulka, Gierek tells you, with the crocodile tears characteristic of politicians, "The only solution is, believe me, painful. It's difficult to say, but the solution is for you to continue to work, and always work more."[7]

Jaruzelski's martial peace should be comprehensible to everyone who has a little common sense, or, if you prefer, everyone who understands Hobbes when he writes that "peace" must be maintained at all costs. What is more painful to think about, if not as difficult to understand, is why Walesa supported Jaruzelski's Brumaire on December 13, 1981. We laughed when your man of steel told *Playboy* he was a "democratic dictator." Unfortunately vice-Premier Radowski wasn't joking when he told Oriana Fallaci: "Poland needs Solidarity. Not just as a union, but as a force of control opposite government power. Even angels can become prostitutes when they get a taste of power." Meanwhile, Walesa, the so-called fireman, puts out wildcat strikes and soldiers take up positions in factories and mines. As I understand it, during many heroic moments Solidarity is on the wrong side, allied with Communist Party reformers against the union's left wing, against those who don't agree with the accords. Walesa even goes so far as to say he will help the party "as soon as it begins to discredit itself or disappear." This pro-party line is disputed by many, which is why the Solidarity bureaucracy fears open assemblies. Ultimately the Stalinist bureaucracy plays Walesa for all he is worth when it accepts a few words of support from the bankers of Opus Dei, delivered by their convenient Polish poster boy, John Paul II: "Human work takes one to God the creator. Work for redemption."

Now Zbigniew Brzezinski says Poland, which he concedes is the most important potential Central European member of NATO and the European Union, only has one option. In other words, no options. I presume to remind you that Western integration has its costs, not the least of which is the enhancement of German influence east, into Po-

land. I recall that Brzezinski was, as Carter's National Security Advisor, in favor of a polycentric approach to Italian communism, which suggests that he understood Censor's *Real Report* on what Communist Party types really are in Italy, and what realistic politicos must do with them. Perhaps Zbigniew was able to convince others that reformed communists are the best communists - more willing than others to serve their new prince, thus allowed to win back at the ballot, in 1997, some of the immense power they lost in the suffocating struggle with Solidarity and the Church, only to lose it again. Brzezinski comes off as the salesman of his grandiloquent book *The Grand Chessboard: American Primacy and its Geostrategic Imperatives* in which he's selling the idea of German-Polish reconciliation. In reality, Germany was reluctant both to recognize the Oder-Neisse border and to sponsor Polish membership into NATO (in contrast to a very insistent United States). Brzezinski's predicted Franco-Polish alliance may never materialize because the French are justifiably skeptical; it could end up looking like a Canadian-Mexican alliance to contain and encapsulate the United States.

I would like to suggest that as a once-removed "geopolitical pivot" (after Ukraine falls) Poland has many options - neutrality being one, a vacuum you could conceivably fill with lively democracy. The Russians are much too far away from reintegrating Poland into their empire for you to worry about them. But if you want peace, as Thucydides said, you must prepare for war, even if it is nothing more than a war of wills. Why not fight the good fight to maintain your neutrality by playing one side off the other? If Russia re-emerges as a threat you will have your EU security ties to protect you from being attacked, and the fact that you are not in NATO would be an advantage in relations with Russia, giving you more flexibility than you would otherwise have. Russians view NATO expansion so badly that its separation from an expanded NATO militates against long-term friendship and stability in Europe. In effect, NATO membership militarizes Polish relations with Russia at a moment when Russian nationalism is being expressed in bellicose statements about the advent of World War

III over Iraq. Even NATO members such as France have serious questions about the United States' intentions in bombing Baghdad. Why would you want to get caught in knots that are sure to remain tangled as long as the United States and Europe have different ideas about NATO's role in the world? The division of labor in NATO is indicative of these differing conceptions - to play the peacekeeper is a noble role, but it isn't one I'd relish. The potential militarization of Polish society also raises questions about tradeoffs and costs: will you be able to improve your armed forces to meet NATO standards *and* keep on track for the European monetary union? The risk that NATO could price you out of Europe is a more serious security consideration than even the long-term threat from Russia. Besides, both NATO and the CIA are fronts for transnational capital and a culture that will cause you to yearn for the underground art of the Seventies and Eighties.

While many of your best artists have already gone abroad in droves, where they feel appreciated, many more are rediscovering Poland. But those who choose to stay and live among you are being corrupted by corporate sponsorship, which is intolerant of all real defiance. I've recently read reports that your taste for film directors like Andrzej Wajda and Krzysztof Kieslowski has waned in favor of thrillers and Hollywood comedies. And you've even cultivated, although I'm not sure that is the right word, an appetite for the ideologically and otherwise vapid spy novels of Tom Clancy. Please, don't allow yourselves to be buttered up like the American public with this drivel.

Lest you consider Italy an anomalous case of spies pulling the strings of power, consider this: South Korea's newly elected president (December, 1997) Kim Dae Jung, DJ as he's called, is a former dissident turned opposition party candidate, the first opposition party candidate to win since the nation was formed in 1948. Now he's anything but the once-feared red. At seventy-three, DJ has no problem forming an alliance with conservative Kim Jong Pil, founder of the national intelligence agency, the KCIA - a man who once tried to murder DJ! This time DJ miraculously wins. What gives? Perhaps some secret protocol, like the protocols De Gaulle refused to sign, has already been

signed in Seoul, or Warsaw or Washington, or in Berlin for that matter.

So you can see why I would hesitate to criticize Jacek Saryusz Wolski's stubbornness with Brussels' demands for entry into the European Union. Perhaps he feels something of the sovereignty of a real citizen. He not only faces the global financial aristocracy, but also the knights of the European Roundtable of Industrialists with all of their wealth and power to lobby for what they want. Things are bad enough without having NATO put you further in debt to the West; not even Clinton could escape the Pentagon and its sex spies, the hideous Linda Tripp and her Nixon dirty trickster literary agent. You see the extent of military intelligence in our civilian affairs? I write to you, the Polish citizens who take part in your cities, as a citizen of the world who knows that scandals always happen after the deed is done; in the end everyone simply submits to the spectacle-commodity tyranny of post-modern democracy.

Besides, I have other reasons for disclosing this information to you. Having taken a stroll down New World Avenue with Konwicki, I'm impressed by your culture and have even gone so far to once use a Polish pseudonym in my own anti-literary endeavors. But this letter isn't political science fiction. I've found myself staring at the feminine charms of the Polish bartenders in New York's East Village, falling on every word murmured in endearing accents. Gazing into my friend Marek's paper and ink structures in his Paris studio, my mind drifts into an Ubu moment "when we have all the treasures of Poland in our hands." What I meant to say is, any of you good Poles out there who haven't been scared off by the gravity of the themes under discussion here, and who happen to visit Washington, should look me up and I'll take you on a tour of the re-creation of J. Edgar Hoover's FBI office in the catacombs of the Scottish Rite Temple - the Masonic Headquarters for the Southern States and NATO. It's just up 16th Street NW from the White House.

I'll leave you with a few extra thoughts (as if you haven't already heard enough) - a rhetorical question and a fable about morals and the law of unintended consequences. Do you think you will be

able to defend your sovereignty any better than Italians who lost theirs in a thick veil of stinging smoke? I'm sure that some of you are dying to display your valor and become gladiators, but the full significance of this historical analogy is lost on you. I won't talk about lions, rather suggest that in your eagerness to join this military alliance, you could end up like the frog nation that, bored with the struggle for democracy, asks for a king and receives a frog-eating crane.

Notes

1. Haugaard, Lisa. "Textbook Repression: US Training Manuals Declassified" *Covert Action Quarterly Summer*, 1997 pp. 29-45. Also InTERRORgation: The CIA's Secret Manual on Coercive Questioning edited by Jon Elliston and Charles Overbeck (parascope.com).

2. Parry, Robert. "The 1980 'October Surprise' Revisited" *IF Magazine* November 1997, pp. 15-25.

3. Priest, Dana. "The Army's Urban Obstacle Course" *The Washington Post* pp. A1 and A6.

4. Willan, Philip. *Puppetmasters: The Political Use of Terrorism in Italy* (London: Constable, 1991) Willan is a sincere journalist who has written an invaluable history, but I think he may have it wrong in regard to Toni Negri. Willan reports on views espoused by Robert Kupperman from Georgetown University's Center for Strategic and International Studies, a place that once employed Claire Sterling, notorious for her disinformation on Italian terrorism. Willan drops his guard on page 347 when he allows Kupperman to echo CIA master spy James Angleton's charge that Negri became an FBI asset when he visited the United States and later worked for them in Italy, which would normally be CIA turf. After all, Angleton's goals are those of the strategy of tension: to discredit or criminalize the Left. In a prison interview in *L'Humanité* (July 24, 1997), Negri stated that he returned to Italy to face charges that he was the secret leader of the Red Brigades to "regain contact with the realities of Italy."

You may recall that Negri was first imprisoned in 1979, and after four years of preventive detention, he was elected parliamentary deputy. Using his parliamentary immunity, he went into exile in Paris for fourteen years.

5. ibid., pp. 272, 293, 295, 345.

6. Sutton, Antony. *America's Secret Establishment* (Billings: Liberty House, 1986).

7. Martos, Jean-François. *La Contre-révolution polonaise* (Paris: Champ Libre, 1983). Also see Simon, Henri. *Poland 1980-82 Class Struggle and the Crisis of Capital* (Detroit: Black and Red, 1985).

(This essay was first circulated as a supplement to *Extraphile* and at places like the Polish Film Club and offices likely not to want it. Copies were sent to addresses in Jim Haynes' *People to People Poland* guide and they will be distributed around NATO's fiftieth anniversary ceremonies in Washington, 1999.)

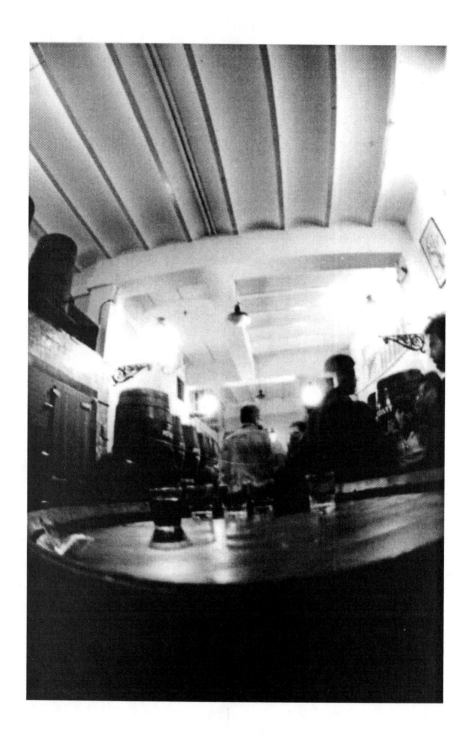

Chapter Nine

From the Egg to the Apples

The Combined Chronologies of the Strategy of Tension in Italy and of the Italian Section of the Situationist International (revised, second edition)

June 1943 - Preparations for mutual support by the Vatican and fascists who plan to redeem themselves in the 1948 general elections.

July 9, 1943 - Allies land in Sicily and drive the Germans north of Naples. Bill Donovan, then head of US secret services in Italy, enlists the Sicilian Mafia to arrange the landing operation and install a government on the island to serve as a model for the peninsula as a whole. American anti-communist influence increases in the Research and Analysis section of the OSS, which works with the Anglo-American Psychological Warfare Branch troops seeking to penetrate and divide the Italian syndicalist movement.

July 1943 - Hitler and Mussolini meet at Feltre. King Victor Emmanuel accepts an invitation to assume command. Mussolini's arrest.

July 28, 1943 - Otto Skorzeny frees Mussolini, who then assumes leadership of the Republica Sociale Italiana - the Salo Republic.

June 4, 1944 - The Allies occupy Rome. James Jesus Angleton, who now heads OSS special ops in Rome, enlists recruits from fascist contacts to ensure the rebirth of neo-fascism. The explicit goal of the OSS is to eliminate all communists from Italian political life. The plan calls for professional fascist killers to fight against members of government and the civilian population - then pin the blame on communists.

1944 - Palmiro Togliatti, founder of the Italian Communist Party, returns to Rome from his war-time refuge in Moscow.

December 8, 1944 - British and US military sign an accord to support anti-communists. MI6 and OSS work closely on this.

December 27, 1944 - Founding of *The Common Man* newspaper, appealing to fascist sympathizers, reactionaries, monarchists and Salo republicans.

March 21, 1945 - Report issued by the Confidential Affairs section of the Interior Ministry of Mussolini's Salo Republic on the establishment of espionage in occupied Italy - the report calls for infiltration of the Communist Party and the Committee of National Liberation. The goal remains to foment divisions and provocations that will destabilize progressive forces. The report underscores ties between Italian fascists and the Roman Catholic Church.

April 25, 1945 - The communist resistance movement crushes the last Mussolini loyalists in Lombardy.

April 29, 1945 - Angleton rescues Prince Borghese, a wartime fascist,

from his hiding place in Milan and escorts him to Rome dressed as a US officer.

August 8, 1945 - Christian Democrats - mostly fascists or sympathizers, with a few exceptions - take political power in Italy.

September 20, 1945 - US President Truman disbands the OSS, but Angleton remains in place in Italy.

March 31, 1946 - Dissolution of sanctions against fascists by the High Commission studying the question.

1946 - General Gerardi attempts a monarchist coup d'état and by 1948 he presides over the commission for the advancement of superior officers.

June 1946 - The Italian populace rejects monarchy by 54 percent of the vote, in favor of a republic - a result that goes against the wishes of Christian Democrats and the Catholic Church.

June 8, 1946 - Communist Minister of Justice Togliatti (in a coalition government) proclaims general amnesty, with very few exceptions.

December 26, 1946 - Foundation of the neo-fascist Italian Social Movement (MSI) in Rome.

November 14, 1947 - US National Security Council document 1/1: "The Position of the United States with Respect to Italy."

1948 - Covert CIA operations against leftists in Italian elections.

February 1948 - Right-wing victory leads to rapid purge of socialist and pro-Resistance elements in the Italian administration.

July 1948 - Anti-anarchist and anti-communist repression swings into

gear - people are tried, convicted and jailed for anti-fascist activity. The MSI expands.

1948 - Over the course of the last four years, 90 percent of the personnel of the fascist state have resumed their former positions, including people in positions of power in the so-called forces of order and the army. The army pursues a vast campaign against the Communist Party, accusing its members of fomenting insurrection in northern Italy. Between 1948 and 1953 anti-communist repression claims 62 deaths and 3,126 injured persons; 92,169 people are arrested, 73,870 of them members of the Communist Party.

1949 - Italy signs secret NATO protocols agreeing to prevent communists from gaining political power.

July 1951 - Premier de Gasperi authorizes the formation of a civil defense corps to assist police and *carabinieri*.

May 14, 1952 - US Joint Chiefs of Staff top-secret memo on a plan codenamed "Demagnetize" to reduce communism in Italy and France using "political, paramilitary and psychological operations." The governments of Italy and France are not informed of the plan, which is carried out in Italy by General Giovanni De Lorenzo, then head of military intelligence and later accused of having plotted a military coup in the summer of 1964.

1956 - Ordine Nuovo founded by Pino Rauti - its members sentenced in 1973 for reconstituting the banned Fascist Party: the prosecutor in the case is killed by the group that year.

1959 - Military intelligence (SIFAR) begins collecting dossiers on Italian citizens; copies forwarded to the CIA.

1960 - Fascist and anti-Semitic slogans painted on the walls of Jewish buildings and Socialist Party offices.

1961 - The notorious soldier of fascism, Stefano Delle Chaie, is arrested for removing the flag of the Resistance from the Tomb of the Unknown Soldier in Rome.

1961 - Right-wing Italian journalist, Ordine Nuovo founder and future secretary of MSI, Pino Rauti gives a lecture at the US Marine College in Annapolis on "Techniques and Possibilities of a Coup d'État in Europe."

1963 - The super-secret Operation Gladio begins - the SIFAR and CIA secret network that will stay behind in the event of Eastern Bloc invasion of Italy or communist subversion. The operation is financed and controlled by the CIA. It will be revealed later that arms caches were buried around Italy for use by Gladio members. P2 master Licio Gelli will eventually admit that Gladio members were fascist members of Mussolini's last stand.

1964 - Secret plan called Piano Solo created for the paramilitary police to intervene to restore public order in a coup - the plan is exposed in May 1967 by *L'Espresso*. General De Lorenzo of the *carabinieri* and others plot the assassination of Premier Aldo Moro who promises an opening to the Left. The coup is called off at the final moment by a compromise between the Socialists and right-wing Christian Democrats. De Lorenzo goes on to create La Rosa Dei Venti, a secret organization maintaining officer loyalties to De Lorenzo and his plan.

May 3-5, 1965 - Conference of fascists and conservatives sponsored by the Alberto Pollio Institute at Rome's Parco dei Principi Hotel on "Revolutionary War" - considered by many to be the *momento zero* of the strategy of tension.

1966 - De Gaulle denounces, as an infringement of national sovereignty, the previously secret NATO protocols committing the signatory countries to prevent communists from assuming political power.

April 21, 1967 - CIA-inspired military coup in Greece - the junta now in power is visited immediately by Pino Rauti.

June 5, 1967 - NATO decides to move its Mediterranean naval command to Naples and its Defense College from Paris to Rome. The US Sixth Fleet base changes to Gaeta, Italy due to de Gaulle's decision to withdraw from full membership in the Atlantic Alliance.

1968 - Student and worker protests amid explosive attacks by Maoists and fascists.

January 1969 - Constitution of the Italian Section of the Situationist International (SI).

April 25, 1969 - Milan trade fair bombing injures twenty people - investigations center on anarchist and left-wing circles, but it turns out that they had been infiltrated by the extreme right, which was in contact with the secret services. Two right-wing publishers and booksellers (Franco Freda, author of *The Disintegration of the System*, and Giovanni Ventura) were responsible for the blast. They were said to have met with Pino Rauit and another right-wing journalist, Guido Giannetti on April 18 - the latter two were linked to eight hundred thousand dollar payments from the US embassy for what was called a propaganda effort.

July 1969 - Publication of *Internazionale situazionista* #1 in a four thousand copy print run - edited by Claudio Pavan, Paolo Salvadori and Gianfranco Sanguinetti in the middle of the hot summer.

September 1969 - Venice Conference of the SI. The Italian section represented by Pavan, Rothe, Salvadori, Sanguinetti. Sabotage of FIAT factories in Turin and the Pirelli plant in Milan.

November 1969 - Publication of the anonymous Italian document *Our Political Action* by the Lisbon-based Aginter Press infamous for giving cover to extremist political activity throughout Europe. The document recommends the promotion of political and economic chaos: "This will lead to a situation of strong political tension, of fear in the industrial world, of hostility towards the government and all the parties. In our opinion the first action to be embarked upon is the destruction of the structures of the state, which should appear to be the action of the communists and the pro-Chinese." The goal is to make it seem as if the armed forces are the only force capable of providing a solution.

November 19, 1969 - Publication of the tract *Advice to the Proletariat* by the Italian Section of the SI for the day-long general strike. Riots erupt in Milan.

December 12, 1969 - Bombs explode in Milan's Piazza Fontana and in Rome. The cover-up of the Piazza Fontana bombing lasts decades and involves secret service officers uninvolved with the bombing itself. General Maletti and Captain Labruna are sentenced for sabotaging the investigation and the main suspects - Freda, Ventura and Giannettini - are acquitted even though two other courts sentenced them to life for carrying out the bombing. The SID, latter renamed SISMI, were undoubtedly involved, with the police playing a minor role. Ventura, who tried to pose as a lefty, later claimed to be working for the CIA. Giannettini was an SID informant since 1967. Politicians such as Moro, who were made aware of the details of the bombing and opposed the strategy of tension, accommodated the plotters rather than expose them publicly.

147

December 19, 1969 - Publication of the tract *Is the Reichstag Burning?*, a tract denouncing the police provocation of the bombings in Milan and Rome on December 12, signed Friends of the International.

January 17-19, 1970 - SI conference in Trier Wolsfeld with Pavan representing the Italian section.

February 20, 1970 - Pavan's resignation from the SI is refused and transformed into an exclusion.

April 21, 1970 - Exclusion of Eduardo Rothe from the SI.

July 27, 1970 - Attempted exclusion from the SI of Sanguinetti by Salvadori.

August 1970 - The Red Brigades convene in Pecorile.

September 18, 1970 - Exclusion of Salvadori from the SI.

October 1970 - Publication of *The Workers of Italy and the Revolt of Reggio de Calabre* by the Italian section of the SI.

December 7, 1970 - Coup attempt by WWII naval commander and founder of right-wing National Front (in '68), Prince Borghese, under the code name Tora Tora (after the Japanese attack on the same date in 1941 that brought the US into WWII).

July 23, 1971 - Expulsion of Sanguinetti from France by the Minister of Interior as he attempts to join the French section of the SI.

April 1972 - Sanguinetti and Debord sign the *Theses on the SI and Its Time* as the act of auto-dissolution of the SI.

May 31, 1972 - Car bombing in Peteano kills three *carabinieri* and injures a fourth. Fascist Vincenzo Vinciguerra collaborates with the police in the case, revealing the way investigations follow wrong leads and generally cover up the strategy of tension by falsely blaming the left.

May 17, 1973 - Self-professed anarchist Gianfranco Bertoli throws a hand-grenade into a crowd outside Milan police headquarters, killing four and injuring twelve. Thought to be revenge for the murder, while under interrogation for the Piazza Fontana bombing, of anarchist railway worker Giuseppe Pinelli. It was later discovered that Bertoli worked for SIFAR (that is, military intelligence) and was a member of the Gladio conspiracy.

1974 - Red Brigade founders Renato Curcio and Alberto Franceschini arrested, paving the way for Mario Moretti, former member of Superclan, and his strategy of constant military escalation. Moretti maintains contacts with CIA front Hyperion Language School in Paris. Moretti is so suspect that even the Red Brigaders put him on trial in prison when he is finally arrested - he wasn't acquitted or convicted by his ex-comrades, rather isolated from them. Note that in 1974, the Brigades had also been infiltrated by Marco Pisetta and then Silvano Girotto. Despite the information they gave to authorities regarding Brigade activity, the group is allowed to carry on.

April 18, 1974 - Red Brigades kidnap Mario Sossi, a right-wing magistrate from Genoa. He is held, then released without any concessions from authorities. It is later revealed that the secret service had planed to kidnap a left-wing lawyer in contact with the Red Brigades to force Sossi's release - note that former counter-espionage chief Giandelio Maletti had reports in 1975 that the Red Brigades were "recruiting terrorists from all sides and the leaders remained in the shadows, but I wouldn't say you could describe them as leftists." Many secret services officers reported that it was wellknown where Sossi was being

held. Maletti agreed that there were Eastern Bloc agents in the Brigades, but that one found "further in, in the most secret compartment, the infiltrators of the Interior Ministry and Western secret services."

May 28, 1974 - A bombing in Brescia during a union and anti-fascist protest kills eight and injures 94. In their May 1987 trial, one of the terrorists stated, "All the bombings had a single purpose: to create social tension and prepare the conditions for intervention by the army."

June 17, 1974 - Killing of neo-fascists by the Red Brigades; speculation that it was an internal right-wing dispute.

August 1974 - Bombing of the Italicus express train. Twelve deaths, 105 injuries. The bombing is linked to the P2 by the courts and the injured parties go on record stating that the accused had been "inspired, armed and financed by freemasonry, which made use of subversion and right-wing terrorism in the framework of the so-called 'strategy of tension' to create the conditions for a possible coup d'état."

August 4, 1974 - Bombing of the Italicus Rome-Munich express train near Bologna. The P2 Commission states that support was given by P2 to the bombers.

September 1974 - As Foreign Minister, Aldo Moro visits the United States. Kissinger opposes Moro's efforts at a historic compromise with the communists and his pro-Arab foreign policy. The next day Moro becomes sick and swears off politics. He is also said to have been warned by US intelligence that his policies would be blocked and that groups on the fringes of the official secret services might be used. His wife recalls his take on the meeting: "You must abandon your policy of bringing all the political forces in your country into direct collaboration," he was told. "Either you give this up or you will pay dearly for it." Press reports in the US carried Kissinger's unabashed intention to use co-

vert action to undermine communism in Italy.

September-October 31, 1974 - General Vito Miceli, then head of Italian military intelligence, testifies that "Now you will no longer hear people talk about black terrorism, now you will only hear them speak about those of others." Miceli is arrested for conspiring to overthrow the government by provoking an armed insurrection in order to provide an excuse for military intervention. He discloses the existence of a Parallel SID (SID being the Defense Information Service) formed in secret agreement with the United States and within the framework of NATO.

June 1975 - Red Brigader Mara Cagol killed in a shoot-out with *carabinieri*.

August 1975 - Sanguinetti publishes his *Real Report on the Last Chance to Save Capitalism in Italy* (available in English from Flatland, POB 2420, Fort Bragg, CA 95437).

1975 - according to court testimony by P2 member Arrigo Molinari, P2 Master Gelli meets with Italian and US secret services in the US embassy in Rome to discuss ways to halt the communist electoral surge in regional elections.

June 8, 1976 - Red Brigades murder Public Prosecutor Francesco Coco and two bodyguards in Genoa, beginning a wave of murder of people chosen for little reason.

1976 - Arms deals take place between the PLO and the Red Brigades based on a secret accord between the PLO and the CIA mediated by Colonel Stefano Giovannone, an Italian SISMI (Military Security Information Service, formerly the SID) officer in Beirut who has previously collaborated with Abu Ayad in a disinformation operation about the Bologna bombing.

January 1978 - Mino Pecorelli, publisher of *Political Observer* (*OP* in Italy) and one-time member of P2, publishes the secret service report that forms the basis for the prosecution of the participants in the 1970 coup attempt led by Prince Valerio Borghese.

March 16, 1978 - Christian Democrat Party leader Aldo Moro kidnapped with military precision on the way to Parliament on the Via Mario Fani - sometimes referred to as the Via Fani attack. His major preoccupation prior to the kidnap, seen in unpublished articles, was US opposition to his historic compromise with the PCI. CIA refuses to help in the manhunt.

April 1978 - Action is taken to block mediation efforts by the International Red Cross and by Pope Paul VI, a personal friend of Moro, who found considerable oppositions to his efforts. Suspicions arise, from Moro and others, that the Americans are advising the Italian government to follow the American policy not to negotiate with terrorists. Moro writes appeals from prison to his political colleagues, reminding them of the many times flexibility was the order of the day. Even the PCI supports an implacable stance, although the Socialist Party was ready to deal with the Red Brigades.

May 9, 1978 - Moro's body found in the trunk of a car on Via Caetani halfway between the headquarters of the Christian Democrat and Communist parties.

January 29, 1979 - Prima Linea gunmen kill Magistrate Emilio Alessandrini, whose murder would have been desirable for the P2 as he was investigating Banco Amrosiano, the Milan bank headed by P2 member Roberto Calvi.

February 1979 - Publication of *Preface to the Fourth Italian Edition of "Society of the Spectacle"* by Guy Debord.

March 1979 - Publication of *On Terrorism and the State* by Gianfranco Sanguinetti and the murder, Mafia-style, of Mino Pecorelli, publisher of *OP*. Pecorelli was scheduled to have an appointment for "dinner Licio" the night after his death - Licio being, quite probably, P2 boss Gelli. The headline of the *OP* published a week before his death: "Assassinations, bombings, coup attempts - the shadow of freemasonry hovered over them all: from Piazza Fontana to the Occorsio murder, from the Borghese coup to kidnappings, to the flight of Sindona from Italy."

August 2, 1980 - Bologna railway station bombing kills eighty-five and injures two hundred. A 1988 conviction of right-wing terrorists for this act is overturned in 1990.

January 1981 - P2 Venerable Master Licio Gelli attends Ronald Reagan's inauguration. Gelli will later report that he spent the entire week with George Bush.

March 1981 - P2 Venerable Master Licio Gelli's home is searched revealing that four cabinet ministers, three under-secretaries and thirty-eight parliamentarians were P2 and helped precipitate the fall of the government of Arnaldo Forlani and appointment of a Prime Minister who was not Christian Democrat for the first time since WWII.

July 4, 1981 - Gelli's daughter, Maria Grazia, is searched at Rome airport upon entering the country. P2 documents are found on her that spell out a right-wing vision of government and the possibilities for civil war.

December 17, 1981 - US General James Lee Dozier is abducted by kidnappers disguised as plumbers. Largest manhunt in Italian history - bigger than for Moro - is successful largely because of the Mafia role. The hostage is released unharmed. Beginning of the end for the Red Brigades.

1983 - Bettino Craxi, a Socialist, becomes leader of a broad coalition government.

1987 - Craxi resigns and the succeeding coalition falls within months.

December 1987 - Gelli sentenced to eight years for financing an armed band responsible for planting bombs on railway lines in Tuscany between 1973 and 1975. This and other convictions later reversed in complex legal maneuvers.

1988 - Christian Democrat leader Ciriaco de Mita establishes a five-party coalition including Socialists.

1989 - De Mita resigns over disagreements within his coalition and loses leadership of his party to Giulio Andreotti. Communists said to form a shadow government.

1990 - Christian Democrat-controlled channel of state-run Italian televisions dares to broadcast allegations by an American who claimed to have worked for the CIA about Gelli's manipulation of Italian terrorism and his relationship with the CIA. He claims that the CIA financed P2 drug trafficking and terrorism.

August 3, 1990 - Prime Minister Giulio Andreotti makes a partial disclosure of Operation Gladio, a secret NATO resistance network sponsored by SIFAR and the CIA since 1963 and armed with Eastern Bloc weapons. They trained for action in the event of an Eastern Bloc invasion of Italy or domestic communist subversion. Andreotti quells the crisis by claiming that Gladio was legitimate. Evidence is destroyed and false information is supplied by President Francesco Cossiga. Demonstrations calling for the truth regarding Gladio and the right-wing bombings. Gladio is linked with the Parallel SID, Piano Solo plan and the Rosa dei Venti conspiracy to plot coups in the Seventies. Gladio may have been involved in the Red Brigades' kidnapping of Aldo Moro

(linked by a photocopier from the secret service ending up with the Red Brigades, and by the fact that Moro's body was left near what had been a gladiator amphitheater, as Mino Pecorelli had predicted before Moro was found: "I read in a book that in those days runaway slaves and prisoners were taken there so that they could fight one another to the death. Who knows what there was in the destiny of Moro that his death should be discovered next to that wall? The blood of yesterday and the blood of today").

1992 - Ruling coalition loses majority in general election; President Cossiga resigns. Oscar Luigi Scalfaro replaces him; Giuliano Amato, deputy leader of the Democratic Party of the Left - half of the renamed Communist Party - becomes premier.

1993 - Investigations reveal mafia ties to Craxi and Andreotti. Craxi resigns from the Socialist Party leadership post; Giorgio Benvenutu replaces him. Amato resigns premiership; Carlo Ciampi succeeds him, and yet another man made of pastry follows him.

Sources

Brozzu-Gentile, Jean-François L'affaire gladio (Paris, Albin Michel)

Christie, Stuart Stefano Delle Chiaie (London, Anarchy)

Drake, Richard The Aldo Moro Murder Case (Cambridge, Harvard)

Italian Section of the SI Internationale Situationiste (Paris, Contre-Moule)

McCarthy, Patrick The Crisis of the Italian State (New York, St. Martin's Griffin)

Willan, Philip Puppetmasters (London, Constable)

Another chronology of interest is Armed Struggle in Italy 1976-78 (Elephant Editions BM Elephant, London WC1N3XX England)

Chapter Ten

False Report Exposes the Dirty Truth About South African Intelligence Services and Begs More Questions

No-one had heard of the FAPLA or Front African People's Liberation Army until news of it surfaced in early 1998. The first accounts of this non-existent organization were plagued by suspicion, because they grouse in connection with a false report given to President Nelson Mandela by the apartheid-era holdover, General George Meiring, then heading the nation's defense forces. The general has since resigned. Questions linger.

> • What was Meiring's motivation when he advanced the tainted military intelligence document to Mandela?

> • Was he too short-sighted to foresee how averse the president would be to the report's coup-plotting accusations?

> • Who persuaded the general to give Mandela the report?

157

• Who, precisely, wrote the report, and what are its sources?

Unnamed sources tell us intelligence reports such as this never name sources, not even when given to the president. What do these sources say? Members of this illusory FAPLA will assassinate the president, murder judges, occupy parliament and broadcast stations, and cause enough general unrest to make the country ungovernable in a way that plays into the hands of this left-wing group. A more plausible scenario holds that the report is designed as a diversion, directing attention away from old-guard intelligence types, many of whom are sympathetic to the growing Afrikaner homeland movement and perpetrate special operations themselves.

One hundred and thirty names are listed as members of this mythical, coup-plotting FAPLA, including Mandela's ex-wife Winnie; the deputy chief of the defense forces, Lt. General Siphiwe Nyanda, and other black soldiers; the controversial diplomat Robert McBride who was apparently framed to lend credibility to the report; and Bantu Holomisa and other former and present African National Congress leaders. Even Michael Jackson is in on the plot.

The shroud of controversy surrounding the report inevitably obligates Mandela to appoint a judiciary inquiry. These judges trash the report as "utterly fantastic."

While explicitly denying any acknowledgment of acting wrongly or with sinister motives, on April 6, 1998, General Meiring announces that he is asking President Mandela to suspend his contract at the end of May and allow him to retire on early pension without prejudice.

Back in February, when the false report was given to him, Mandela might not have given it much thought if its existence hadn't been leaked to the press. Parliament needed reassurances; Mandela was obligated to address the issue. He generally gets high marks for allowing opposition leaders to read the report in his office. But in a

strange twist of fate, Robert McBride keeps the story alive. While in Mozambique investigating gun-running, McBride, a notoriously dangerous man who was once sentenced for bombing a Durban beach bar and killing three women, is himself arrested on March 10, 1998. Accused by local authorities of buying guns to smuggle to South Africa, McBride languishes in a Maputo jail as reports surface about South African Police Superintendent Lappies Labushagne's involvement in framing McBride in concert with his Mozambiqan colleagues. Labuschagne ultimately resigns over the incident.

Another name emerges in connection with these dirty tricks: Hendrik Christoffel Nel - probably not the author, but quite possibly something like the editor, of the Meiring Report. South African papers paint a gruesome portrait of a man who was once a member of the Civil Co-operation Bureau (a secret hit squad that assassinated anti-apartheid activists) and who now heads the Army's counter-intelligence unit. He was reportedly involved in the shooting of an academic named David Webster and has been described as a professional leaker. One doesn't have to be easily swayed by conspiracy-minded suspicions to question the innocence of someone who served in the infamous Directorate of Covert Collection. The Directorate was the veritable headquarters of apartheid-era dirty tricks, the suspected breeding ground for those involved in the more recent shooting of trains and unsubtle stoking of taxi violence.

President Mandela, Deputy President Thabo Mbeki and Deputy Intelligence Minister Joe Nhlanla speak of a third force composed of old-guard security operatives who specialize in provocations - the type of operations that cause communities to fight without knowing why. To support their claims, they point to events such as the strange death of police assistant commissioner Leonard Radu, the most senior former African National Congress member to join the new South African Police Service. According to Justice Malala of the *Financial Mail*, Radu was "alleged to be on the trail of ANC leaders who spied for the National Party government." As unready to fade as these accusations of a third force are, the evidence so far looks more episodic than con-

clusive.

Malala writes convincingly about the faction-ridden conflict resulting from the integration of South Africa's old twelve officially recognized intelligence networks into four new agencies. The National Intelligence Co-ordinating Committee (NICOC) coordinates the four separate agencies and advises the government on intelligence policy. According to Malala, the Meiring Report "should first have gone to NICOC, which would have forwarded it to the relevant Minister for a rigorous examination before it was sent to the Office of the President." Meanwhile, *Business Day* publishes unconfirmed reports that Meiring may have discussed the report with Defense Minister Joe Modise who, the paper alleges, has "deliberately allowed the general to shoot himself in the foot" by recommending that it go to Mandela. Similar logic alleges Mandela used the report as a pretext to appoint Siphiwe Nyanda to Meiring's post.

Third force or no third force, the most plausible scenario is that Meiring took his dirty document to Mandela with the expectation that the president would weaken his party by skewering members in the defense forces and intelligence services named in the report. As fate would have it, it was Meiring who fell on his sword: "My early retirement, therefore, is an effort to restore the trust in and to promote the esprit de corps in the South African National Defence Force."

Questions linger.

• Are the authors of the report still at large?

• If so, what is being done to stop them from perpetrating dirty tricks before their next attempt?

• Will there be more shake-outs in the South African intelligence community?

Tolerance of dissent is a hallmark of democracy, but it is unacceptable when enshrouded in the conspiratorial form of special operations, such as this false report.

Chapter Eleven

Situation Report on the Hacienda Conference

Two inches of snow on the ground and more falling as I make my way by rail from Manchester airport to the city's Piccalilli Station, and then on to the B & B by tram and on foot. To paraphrase the radio: SNAFU - Situation Normal All Fucked Up. My expectations for the conference fall with it, knowing that many people will be daunted by the weather. Manchester dressed in white. A windy snow-swept walk to the hotel, walking in circles a bit. After resting up a bit (seems everthing here is done a bit) I drift through swirls of snow to the bank, and then on to the tourist info center where Sharon gives me an expansive overview of the city, from the tattoo parlors of Afflecks Place to the ruins of a Roman fort around the Canal Basin. Since no-one from the *Manchester Area Psychogeographic* is here to guide my drift, I appreciate her ability to read the map upside-down and show me around. For three quid she sells me the book *Frederick Engels in Manchester: The Search for a Shadow*.

Using my trusty compass and heavily annotated map, I head over to the Corner House to eat and read how Engels fell for a radical young woman who worked in his father's factory, and how he and

Marx studied the work of English economists in Manchester for several weeks in 1845 - the year Engels wrote his celebrated *The Condition of the Working Class in England*. The Corner House, a mini Flatiron Building, is a blend of bar, cafe and cinema screening rooms unlike anything we have in WDC. Andrew Hussey and Gavin Bowd, the organizers, turn up - we have a beer, then move on to have a look at the fabled Hacienda.

They're excited and have every right to be. I share their pleasure of being on the verge of realizing a daydream, and even if our dreams vary, they intersect in precisely the same way our paths are crossing. From the bar across the street, we find ourselves gazing through the snow at the massive, three-story facade of the Hacienda adorned with scaffolding and emblazoned with the sign that it's "still being built." The juke is blaring home-grown Oasis, which really fires their imaginations. While I like progressive music well enough, it's jazz that moves me and matches my moods. As Vaneigem wrote in *Revolution of Everyday Life*, "The consciousness of the present harmonizes with lived experience like an improvisation. This pleasure - impoverished because of its continued isolation, rich because it tends to reach out towards an identical pleasure in other people - must, for me, be assimilated with the pleasure of jazz."

Coming from WDC, I bring this bias for jazz with me to Manchester. At the old Saloon on M Street in Georgetown, and from my perch above the Down on Pennsylvania Avenue, I saw the musicians come and go about their lives with their feet firmly on the ground, and compared to the bluster of the rockers, always in uniform, jazz musicians seem more authentic to me. Contrary to journalist Ben Watson's remarks about situationist theoretician Guy Debord's failure to identify with rock and roll, it can easily be argued that the rock star role is antithetical to the revolution of everyday life. There's a time and place to blow one's horn, say, an improvisational jam session in an out-of-the-way bar. But to take the stage night after night with the same band and play the same songs the same way in stadiums and concert halls with false passion reeks of the reproduction of daily life. Rock is

164

just the most commercial genre of all, with precious little revolutionary about it. In this light, I should mention that we're now led to believe that Debord took a fancy to the disco dance floor in the Seventies. Moreover, Stewart "I-don't-think-the-Sex-Pistols-were-a-punk-band-and-I'll-tell-you-why" Home is persuasive - hard core punk didn't draw on the Situationist International (SI).

The morning of Saturday, January 27. It's still snowing as I go over to the Hacienda. The doors are closed, but I meet two young Frenchmen - one wearing Breton's epitaph *"Je cherche l'or du temps"* on his back. We stop in a cafe around the corner where we happen to meet two older Frenchmen. Lots of good will flows around the table as we discuss where we're from and the Italian Anselm Jappe's monograph *Guy Debord*, now out in French.

As soon as we enter the Hacienda, Bowd tells me that there's a change of schedule and I'm up to speak this morning, which is fine with me. We shuffle down to the Fifth Man Bar where David Bellos (in a fur hat and après-ski clothes) chairs the first session - he replaces Malcom Imrie, translator of Debord's *Comments* (see *Extraphile* #1 p. 44). We guess Dumontier and Tordjman, the big French draws to the con, were either snowed in or had their French Embassy support withdrawn. We guess wrong. Their short speeches on interpretations of the SI and Debord are read in French by a beret-wearing woman: "If the SI is still talked about, if representations are made of it, it is obviously because the very concrete representation of revolution came, in May-June 1968, to prove the situationist conceptions of history" (Dumontier). "There is no situationist balance-sheet, only history that remains to be done" (Tordjman).

To contribute to this session, I read a few prepared remarks in French: (1) while Debord and the SI did make polemical use of ideology, the total ideology of the spectacle implies the possibility of total democracy (verified by the SI's activity in May 1968), and (2) the most laughable interpretation of Debord is Marcus' "reversible connecting factor," which he pretends is Debord's big discovery - the reversible connecting factor as the activation of nazi and situationist archetypes,

and the reversible connecting factor as Debord's interpretation of history, ignoring the fact that for Debord, history isn't reversible, but explicitly "irreversible time." Gus McDonald takes the stage to make a Stirnerian interpretation of the SI, and point out that this sort of project didn't begin and end with the SI, but that it has a historical connection with the Spanish Civil War and English Poll Tax riots and many other historic moments. Suddenly, I'm up, making the case for cosmopolitan and slacker or sub-proletarian ethics, doing a little show and tell with Debord's *Game of War*, and calling for the universal cancellation of debt on January 1, 2000.

We break for lunch in the Hacienda cafeteria in good spirits - a tasty humus sandwich and carrot-curry soup for me - then pick up in the afternoon with *A Film by Brigitte Cornand*. This nostalgic collage of French cinema from the Fifties to the Seventies is followed by her anti-television film on Debord, made with his collaboration, that many of us have already seen. I follow Mike Peters of *Here and Now* outside - he inspired some of my earliest writing on the SI, and I tell him so. As we're walking up the street we run into novelist Stewart Home and Fabian Tompsett (the London Psychogeographical Association) as they pull into town. The sun is out, smiles all around. Home shrugs off the criticism leveled against him by Mike in the latest *Here and Now* (say what you want about Mobile Home, as Michel Prigent of Chronos calls him in his denunciation of the conference, but at least he takes shit in good humor as well as he dishes it out).

As we're standing there, Mike's impassioned friend Jackie shows up - she's just read *The Revolution of Everyday Life* and is impatient for change and the rush of radical subjectivity. I leave them to talk to one another and drift back to the Hacienda's main dance floor where ex-situationist Ralph Rumney's letter to the conference is read to the crowd (he was to have shown a film and level his predictable complaints). Rumney pulled out of the conference due to misrepresentations in the organizers' essay on Debord in *The Independent*. While I too have misgivings about the article (its portrayal of Debord as a paranoid while omitting the *Times'* agent-baiting of him, the smear of

Vaneigem as having taught school in a tutu, the misattributing of the Censor book to Debord), it seems to me that Rumney is himself a pro-situ in the sense that he has made no advance on situationist theory or practice, and he admires the group that excluded him to the point of absurdity - for example, he categorically states that Debord can't be translated. A general discussion ensues regarding Rumney's letter and *The Independent* article. Lucy Forsyth, a translator and friend of Debord, argues quite persuasively against Rumney's insistence that Debord can't be translated; and Jon King of Gang of Four fame makes the point that all that now matters is what's done with situationist tactics.

The afternoon concludes with Jamie Reid's slide-and-video show "Shamanarchy: A Spectacle," which, despite being extraordinarily reductive, does come through with the right messages: unity and democracy. I drift out with Phil Edwards, who is writing a book on Debord, and Lucy and her friend; and only much later, and with some difficulty - three buses - catch up with everyone else at the Alladin restaurant several miles out of town. Simon, a Brit living in Germany, is holding court with a materialist, global analysis of soap operas. I'm down at the end of the table with his friends Stephan and Heidi from Germany, Jean-Jacques and the other Frenchmen. Jean-Noel and I have a long discussion about the proletariat and my conception of the sub-proletariat - he thinks that only the proletariat can be the subject of a revolution, whereas I remind him that the SI weren't proletarians and recognized this problem in their Orientation Debate in 1970. Yvan thinks that the economy will always be big enough to include more people than it excludes - I disagree: the pauperization that Marx wrote of is happening before our eyes. As I jump on the bus, leaving the others behind to talk outside the restaurant, the driver, a real prole, scoffs at the group, mistaking them for students: "I don't know when they have time to study when they're off drinking beer all the time. I hope none of them become prime minister." Back in the center of the city, I realize that I left my sample of Debord's *Kriegspiel* in the Hacienda so I go back to get it. The bouncers can't understand me - nor me them. The manager comes out to let me in, and I follow her through the throb-

bing, cavernous, smoky nightclub packed with people seemingly dressed for Halloween. On the way out, I pull out my camera and shoot two women dancing; they surprise me with very provocative poses. The place is *wild*.

The morning of Sunday, January 28. The con begins today with a panel chaired by the hippie Nikos Papastergiardis. He does a good job keeping things going until, as if wading through glue, Richard Hooker reads a paper on recuperation. I don't want to be accused of child abuse so I withhold my criticism of the fact that Hooker fails to understand that the charge of recuperation always entails taking sides - there's the recuperation of avant-garde tactics by dominant institutions such as the academy, and then there's appropriation to support the partisan struggle of social revolution. Perhaps reflecting the mood cast by the previous speaker, Phil Edwards gives a talk on unitary urbanism that hits most of the right points, but is unduly pessimistic. Lucy Forsyth then delivers her feminist critique of the SI while simultaneously giving us a first-hand account of Debord's life in Arles. Her quote of Debord's comment that men make revolution and women do the dishes, strikes us all as laughably repugnant.

For lunch, I sip a cup of the Hacienda's delicious peanut and paprika soup as the others dig into full-on meals. Patrick French, who looks like McEnroe's twin brother, turns up to read (and I do mean read) a paper on *dérives* or 'drifts.' The paper interests me, but I can't sit through a reading on walking. I regroup with Stephen in the cafeteria to discuss the German radical scene. People drift in and out of Ben Watson's reading and the next discussion between Hacienda owner Tony Wilson and Mark E. Smith, with Stewart "The-only-thing-I-see-drifting-around-here-is-snow" Home and Jon King sitting on the sidelines. At one point Smith asks Wilson, "What's the bloody difference between situationism and Prince Charles?"

King says that for many years he carried the "Work, Family, Country" Vichy coin pictured on the cover of *A Brief History of the Twentieth Century* to remind him of the difference between it and the "Liberty, Equality, Fraternity" of the French Revolution. When I drop in on

his conversation with Bowd later in the day, he boasts of his machine-polished boots and Belgian overcoat. King has the audacity to wear his fetishism for coins and vanity for clothes on his sleeve - truly radical. At one point during the second day, King calls for people to dress up as security guards to sow confusion, reiterating his feelings for uniforms expressed in the catchy Gang of Four song.

Fabian Tompsett of the London Psychogeographical Association has the misfortune of following Home's well-rehearsed discourse on Hegel. After a good beginning, Fabian loses me with his ramblings on the three m's of magic, materialism and the millenarian tradition. At least he didn't put me to sleep like the others who were the nearest things in life to death. Sadie Carnivorous-Plant, as Prigent calls her, doesn't show up, but her partner Nick Land is on hand for the screening of their *Swarmachines* video that suffers from dismal production quality:

"Who are the situationists?"

"No, we must ask ourselves who are the children of the situationists?"

I linger around the bar at the end of the con for a few moments, speaking with Jeremy Stubbs, co-editor of *Aura*, a scholarly journal on the avant-garde, as people make comments on the con to the video camera. Prior to the schedule changes, Stubbs was chair of my panel, and it's a shame he didn't chime in anyway because he could've drawn out my contention that the spectacle corresponds to Sun Tzu's conception of total war, whereby no resistance is mounted against the invader. For the hell of it, I throw a few situationistic lines into the video cacophony, in Russian, then bail out to a nearby bar to quench my thirst with the *Here and Now* crew.

After a lively discussion on nationalism, Gus belies the austere reputation of the Scots by warmly welcoming a few of us to his place. We set off across the icy cityscape. For a few hundred yards, Jackie and I run hand-in-hand to keep up with Gus and Bill. Lindsey has cooked a sublime *cordon vert* meal for us, but there's some misunderstanding. Having just read *Revolution of Everyday Life*, Jackie grows

169

impatient for something more than we can offer and, despite our pro-
testations and best offers, she drifts into the night on her own. Rather
than the comradeship that occasionally flared up at the con, and the
warmth we feel here at McDonald's place over the last drops of Scotch,
Jackie's situation is more indicative of the human experience of our
time - being cold and alone on a brutal winter night.

Chapter Twelve

A Lucid Assessment of Our Chaotic World: A Conversation with Ignacio Ramonet

Unlike most of his American colleagues in the upper echelons of their profession, Ignacio Ramonet, editor of *Le Monde diplomatique*, maintains that "journalism must be combat," adding, "to be a journalist is to resist an oppressive system run by a norm-producing machine, to tear away the veil and reveal what is hidden, and to think and to write against it." The fact that he acts on these words as an incisive writer and talented editor clearly distinguishes Ramonet from the corporate sellouts, advertising agents and celebrity hounds one reads in today's papers. His father fought in the Spanish Civil War, and from his words one gets the sense that the son carries on his father's fight for democracy and social justice.

A few years after his birth in 1943, the family left Franco's Spain for Morocco where his father worked as an artisan and his mother as a factory worker. He won't say how, but from these humble beginnings Ramonet goes on to attain a doctorate in semiotics under Roland Barthes[1] and become the editor, in 1991, of what can only be described as one of the premier intellectual journals in the world. With its seven hundred thousand circulation in eight languages *Le Monde diplomatique* communicates the thoughts of essayists such as Edward Said,

173

Thomas Frank, Herbert Schiller, Benjamin Barber and many others.

I meet Ignacio Ramonet in his Paris office, adjacent to *Le Monde*'s Left Bank complex, not far from the cobblestone streets of rue Mouffetard. The French have just won the World Cup; while many of his compatriots are still on vacation, the editor is hard at work, partially hidden behind his manuscript-stacked desk. I've been following his wide-ranging writing and was particularly struck by his December 1997 call, on the cover of *Le Monde diplomatique*, to "disarm the markets" and institute the Tobin tax: a global tax on securities transactions first proposed by the Nobel-winning American economist James Tobin in 1972. Now, in the summer of 1998, I'm happy to congratulate Mr. Ramonet for being elected as the honorary president of ATTAC (*Action pour une taxe Tobin d'aide aux citoyens*[2]), due to his initiation and crucial support for this project to resist domination by financial capital.

Although the Tobin tax is a perfectly fair-minded and relatively mild reform, Ignacio Ramonet's thoughts and actions make him a radical compared to the silent majority, who prostrate themselves to their masters by never deviating from marketplace mantras, by being agreeable, by pretending to admire what nauseates them. Ramonet speaks about the present state of affairs, and his colleagues, in mordant terms, as if civilization is drying up before us on an archipelago of desert isles.

Ignacio Ramonet:

...After the fall of the Berlin wall, the collapse of the Soviet Union and the Gulf War we find ourselves in another world, and not just from the geopolitical point of view, but from an intellectual point of view. The supremacy of neo-liberalism manifested itself without barriers after these three - what were for us - threshold events. Curiously, these events coincided with the Eighties when many intellectuals were highly publicized and overcome by the superficiality of the epoch; they forgot that the role of the intellectual is to think.

Philippe Sollers, for example?

For example Sollers - and I say this with affection because for us Sollers was such a big influence, especially as the editor of *Tel Quel*[3]

174

and as a materialist thinker deconstructing what exists, and as a novel-
ist he was very important at the time - he was once a Maoist, but he,
and many others, abdicated to the notion that the objective of the intel-
lectual is to become famous in the mass media. We see them in every
country on television making pronouncements about this and that while
forgetting the essential. We were some of the first to say that *now* is the
time to think about the way this magma that envelopes everything
and restricts people from acting and thinking - what we call the sole
philosophy.[4]

Which is?

As we define it, the sole philosophy is primarily two things.
First, the idea that the economy is more important than politics, and
that politics is at the service of the economy. And second that an
economy can only be efficient in one way - neoliberalism, which is to
say monetarism and all the principles that impose competitiveness:
foreign trade, a strong currency, reduction of budgets, etc. This Bible,
this gospel, has created a great consensus now that the Soviet Union
has fallen and there are no longer two schools of thought. We here at *Le
Monde diplomatique* never considered the Soviet Union to be a good
model, and we always said so, but we have given space to those who
have begun to denounce this new totalitarianism - in the sense that it
envelopes everything, the totalitarianism of the market. All human
activity, whatever it may be - culture, sports - must be regulated by the
market.

Everything is commodified.

Yes, that's right, everything is commodified. We're in agree-
ment with the existence of the market, but the market should be *for*
precise sectors of the economy. Other sectors, such as public service,
collective necessities, etc. must not be subject to market pressures. Life
can't be abandoned to the market; the market is no way to build a life
for people, it only builds a life for what is marketable.

We've entered a system in which the elements which permit-
ted the constitution of modern nations - social cohesion, national cohe-
sion - have disappeared. Because the market is so powerful, we're in a

175

system that divides itself into what can be sold and what is non-sellable. Thus we're in a system that, in a structural way, produces inequality. If a system produces inequalities, one can no longer produce national cohesion - there is no longer a national community. All we have is people fighting one another. We've tried to describe this global system, and many intellectuals - economists, sociologists, philosophers - have joined us. For example, an intellectual that we respect a great deal here in France, Pierre Bourdieu, doesn't need us - he could be published elsewhere - but he has chosen to share his ideas with us.

I was just thinking of Bourdieu's article in your March issue, "The Essence of Neoliberalism," when you mentioned national cohesion because Bourdieu looks to what I would consider to be conservative institutions - the State, the church, the family, parties, unions (what he calls the old solidarities and reserves of social capital) - to be the last resistance against pure market hegemony.

I don't know if you read his book *La Misère du monde* (1990)[5] which we admire here because it was the first book in France to reveal the advance of neoliberalism, which is to say, the new misery. But we have also published the economists and sociologists who have proposed alternatives and we have suggested a few alternatives ourselves, such as the Tobin tax. Today, we find ourselves playing an important role in the intellectual debates in France.

And in the rest of the world?

In the rest of Europe, in any case. In Italy we have the same debates; as in Spain. In Germany *Le Monde diplomatique* is important. We are less well-known in the United States because we don't have a supporting paper.

Do you think you'll get one? [PS Now in English through *The Guardian Weekly* 75 Farrington Road, London EC1M 3HQ]

I think so because we have many readers and we publish many American writers, such as Noam Chomsky.

Didn't you write a book with Chomsky?

Actually it was the Barcelona publisher who put the two texts together because they were of the same sensibility - the title, in French,

176

would be *Comment on manipule nos esprits* (*How They Manipulate Our Minds*).[6] We like Chomsky a great deal; he's one of the great intellectuals today not simply because of his linguistic scholarship and his media analysis, but also because of his personal attitude. In Germany we have Jürgen Habermas.... Indeed, in the world today there are a certain number of intransigent intellectuals who tranquilly state that the world doesn't function well and will function less well. Of the six billion people in the world today, one billion live like us and five billion live in distress - in my opinion that won't keep on working. We have to find ways to a better-functioning world; and we must integrate a radical ecological approach because we're in the process of destroying the planet and we're doing it slowly, with full consciousness that we're doing so.

You've recently written that the Spanish Civil War should inspire us. How so? And I ask this with Bosnia and Kosovo - Europe's contemporary civil wars - in mind.

These are Spanish Civil Wars without revolution or revolutionaries. In Spain you had at least two revolutionary programs: anarchist and communist. Sarajevo has nothing like this, but in this edition of *Manière de voir*[7] [a journal edited by Ramonet and published by *Le Monde diplomatique*] we have an article by the Spanish intellectual Juan Goytisolo that compares the two wars. The Spanish Civil War, unfortunately, is a lost war that was nonetheless a moment that marked our century because our century is characterized by the great fascist against anti-fascist confrontation. This great confrontation in defense of liberty and democracy began in Spain, and it lived its greatest moment with the defeat of fascism in 1945. Beyond this, we can be inspired by the fact that the Spanish Civil War was an international reference for all the combatants. The international brigades were very significant; the American Lincoln Brigade being the most well-known. People crossed the Atlantic Ocean to fight, which is rare (with few exceptions such as Lord Byron fighting for Greek independence). Today, we don't pay enough attention to all the young volunteers who fight for NGOs [non-governmental organizations]. These NGOs are internationalist,

they're in Africa, Asia and Latin America building schools, helping the sick and wounded. They don't do it for money; they don't do it for social advancement - they do it, in a certain sense, because they want a better world. It is often said that the young aren't politicized but there are tens of millions of people from the developed world who fight in the NGOs and volunteer in other ways.

To follow up with Spain and the early fight against fascism for a moment, have you read Michael Seidman's *Workers Against Work*?[8]

No.

According to him, the true historical record reveals that workers in Barcelona and Paris under the Popular Front Governments were skeptical toward exhortations by party and union leaders to work hard in the fight against fascism because for workers, managers were fascists and the fight against fascism involved sabotage and other forms of what the Wobblies[9] in the United States called bum work. What do you think of this struggle against work?

Today, I believe that this struggle is coming back strongly because new forms of work are as severe as ever. What was once called piece work in the factories is a category of work for many people. Take the young journalists who are increasingly engaged in piece work. They rewrite news dispatches and don't have the possibility of making a complete investigation. Thus they're alienated by their own work, they must rewrite something others have done. You have the same thing in the insurance and banking sectors, in the academic sector.... Thus what was once called the intelligentsia has been driven into a proletarian situation with a real sense of alienation. Work is no longer guaranteed and we now have the massive phenomenon of precariousness, which is to say people who work without a contract and can be let go any time.

The other day I overheard a young woman say that when she was at work, she was always depressed. Do you think we will ever be able to abolish alienated labor?

While I don't believe in the death of work, I do think that we

178

are redefining certain ways of working. Incidentally, I support the move to a thirty-five-hour week, but this measure is too timid and won't change much. We should go right down to a thirty-hour week and insist that the great technological revolution and its gains in productivity result in a reduction in work-time. Moreover, it is quite evident that one can no longer be content to practice one profession all of one's life. We don't know what tomorrow's activities will be, we will discover them. We stand before vast territories that we must clear - communications, education, culture. If one diminishes work-time, one gains a great deal of free time. This time must be devoted to the social economy, to aid others, or else this time will just be given over to the increasingly large leisure industry. With five billion people to feed, house, clothe, teach and heal, I can assure you that there will be the need for a great deal of work. To think that work will soon disappear is, for me, Western thinking that closes one's eyes to the needs of the rest of the planet. We have to help our human brothers and sisters. This is an incontestable human reality.

I was fascinated by your recent essay[10] concerning the island of Kronstadt because it is a place I've often dreamed of visiting.

At the time, no-one was allowed to enter and I used false papers procured by friends that made it seem as if I were a Russian citizen. This was in 1994, but it was still a closed city on the extremities of Kotlin, an island in the Gulf of Finland, forty kilometers from St. Petersburg. It was built in 1703 and for many years it was the only military port of the Russian empire, but we know it for the primary role Kronstadt sailors played in the 1917 Bolshevik revolution (reminiscent of the Black Sea sailors in 1905-1906 revolt as portrayed by Eisenstein in *Battleship Potemkin*) - the Kronstadt sailors gave the order "All power to the soviets!" raised the anchor of the famous cruiser Aurora and five thousand of them participated in the October insurrection and the seizure of the Winter Palace.

It is a little known fact that the Aurora figured into the Treaty of Portsmouth ending the Sino-Japanese War (1904), negotiated by Teddy Roosevelt. As part of the treaty, the ship was repaired by the

179

United States Navy in the Philippines. Hence it's almost possible that we wouldn't have had the Aurora radio operator's "spark" of the revolution from the Neva River, if it weren't for capitalist America.

Yes, and it was actually their 1921 rebellion *against* the Communist Party and *for* the right of peasants to use their land that makes the Kronstadt sailors so revolutionary. The mutinous Kronstadt Commune only lasted fifteen days but Lenin felt threatened and proposed, in the guise of a concession, his New Economic Policy (NEP). Trotsky ordered the insurrection be crushed, and it was. This idealist and freedom-loving revolt died in a pool of blood on March 5, 1921.

But after the experience of the Portuguese Revolution (1974-1975), wouldn't you say that we must be very apprehensive about military types entering the fray on the side of revolution?

I was in Portugal when they had their carnation revolution. It was a remarkable atmosphere; you had the phenomenon of military people making a revolution when they normally engage in colonial wars and reactionary *coup d'états*, as was the case here in France in 1961. There, in Portugal, it was different - one had the impression that the military taught the revolutionaries how to fight. They quickly redistributed land and created agricultural cooperatives and worker cooperatives. I recall May 1, 1975, a year later, after the beginning of the revolution in April 1974; by then one had the impression that Portugal was a thoroughly, almost flamboyantly socialist country. In reality things were much less clear because you had a very conservative Communist Party that put the brakes on many reforms. In any case, when it fell it was the oldest fascist country in Europe under the reign of Salazar and Caetano (1928-1974), older than Mussolini and Franco. It was extraordinary, and revolutionaries from everywhere in the world came to Portugal at the time.

*

Ignacio Ramonet was covering the Portuguese Revolution for *Le Monde diplomatique*, hence he has been with the journal long enough

to see it though many changes, but none have been as dramatic as those implemented since he has taken charge: circulation has increased from 100,000 in 1990 to 700,000 in 1998, and in 1996, he and his colleagues were able to attain greater financial independence from *Le Monde* thanks to the resources of the financier Gunter Holzman and support from *Les Amis du Monde diplomatique,* 'Friends of *Le Monde diplomatique*'[11]. While ostensibly always enjoying editorial independence since its inception in the Fifties, *Le Monde diplomatique*'s new-found financial autonomy appears to have afforded it extra room to maneuver. What I appreciate the most about recent issues of the journal is the way the ideas presented in its pages often open up spaces for people to come together to think and to act. Every month, one sees a wide array of events: a round table on European-Latin American relations, a documentary on social struggles in Latin America, a book presentation on Palestine, a study session on *négationnism* (a shade of fascism).[12] A general assembly of the Friends of *Le Monde diplomatique* was held this year (1998); and to date, the journal has established 299 collective reading centers (163 in Africa and the Middle East, 42 in Latin America, 83 in East Europe and Russia and 11 in Asia).

I didn't have a chance to ask Mr. Ramonet about the journal's striking appearance but I recalled reading his *Cahiers du cinéma* essays, and now, hearing about his scholarly work under Barthes on images, I suspect that he has a hand in *Le Diplo*'s fascinating mix of contemporary full-color paintings and photography. This artfully presented academic-activist reporting is the form - appreciated even by non-French speakers who spot it on the newsstand - that Ramonet has consciously chosen and developed in a propaganda war with what he calls the PPII System.

Jean Baudrillard has his orders of simulation; Michel Foucault, surveillance; Guy Debord, the spectacle - Ramonet, in turn, explicitly draws on the Frankfurt School and represents our world as the PPII system, characterized by God-like traits that engender submission to, and faith in, the liturgy of a new money-mongering cult. In the recently published English edition of *The Geopolitics of Chaos* (Algora,

181

1998, already translated into Spanish, Italian, Greek, German, Romanian and Serb) Ramonet writes about the PPII System:

> What is the PPII system? That which stimulates all activities (financial, commercial, cultural, media) having four principal qualities: planetary, permanent, immediate and immaterial - four characteristics which recall the four principal attributes of God himself. And, in fact, this system sets itself up as a modern divinity, demanding subservience, faith, worship and new liturgies. Nowadays, everything tends to be organized according to the PPII criteria: stock exchange values, trade, monetary values, information, communication, television programs, multimedia, cyberculture, etc. This is why we talk so much about globalization and one world.
>
> The central model is the financial markets. They present the basic sciences not as natural science, Newtonian mechanics and organic chemistry, but probability, game theory, the theory of chaos, fuzzy logic and the life sciences.

In this PPII system, there are two new paradigms; the first is communication:

> ...Replacing the ideology of progress by that of communication brings upheavals of all kinds, and confuses the very purpose of political power. Thus springs up a central competition, more and more grating, between the powers that be and the mass media. In particular, it drives leaders to openly reject social goals of primary importance, established for the sake of equality and fraternity. This new paradigm is better accomplished, better carried out, better implemented by the media than by executive powers.
>
> The other paradigm is the market. It replaces the machine, the clock, the organization whose mechanisms and operation ensured a system's development. In a clock, no piece is extraneous, and all the elements, all the parts are interdependent. This mechanical metaphor, inherited from the XVIIIth-century (a society is a social clock, and each individual ex-

erts a function useful to the correct operation of the unity), is succeeded by economic and financial metaphors. From now on, everything must be controlled according to the criteria of Master Market, the ultimate panacea. New values take top billing: profit, earnings, return on investment, competition, competitiveness....

The Geopolitics of Chaos is a wide-ranging book that has a slightly hybridized feel to it. In certain respects much of it reads like the cover stories on child labor, the Gulf War, neofascism, corporate mergers, Columbia, Israel, etc. that Ramonet writes on a monthly basis for *Le Diplo* - a blend of reporting and opinion full of sharp, witty observations. As the above passage demonstrates, the book is also theoretical; he expands upon his reporting with theory that is both informed by high-brow thinkers, yet relevant and accessible. Indeed, Ramonet attempts, as a communications professor and journalist, to theorize the world from many perspectives, although the common thread is clearly what was called the sole philosophy above, or the PPII system or simply neoliberalism. From the rise of the irrational to the emergence of what Ramonet calls a world man, devoid of culture, meaning and a sense of the other. In sum, everything about our current situation results from the explosive convergence of economic globalization, the loss of State power and the destruction of cultures.

As convincing as much of this argument is to me, one could protest, as many do, that the economy is not as tyrannical nor as global as Ramonet portrays, that cultures become richer through communication and markets, that the poor will always be with us. But Ramonet refuses to be blind to the fact that markets are blind, and he repeatedly recognizes the absurd degree to which markets force people to obey the law of each for him or herself. Even if a conspiracy of silence has been organized to muffle cries of protest on this subject, it seems rather obvious to me that our post-modern, information era, with its mega-mergers of media giants, coincides with reactionary politics. As Ramonet says:

Groups more powerful than States are raiding the most invaluable asset of democracies: information. Will they impose their law on the whole world or, on the contrary, open a new expanse of freedom for the citizen? Are we astonished that in such circumstances, in the United States in particular, the inequalities of wealth continue to worsen? And that, as the International Herald Tribune noted on April 19, 1995: "One percent of the wealthiest people control approximately forty percent of the national wealth, which is twice as much as in the United Kingdom, the most inegalitarian country in Western Europe."

And skipping down, he makes still darker observations.

...the protests[13] fulminating in European societies could put an end to one of the most reactionary periods of contemporary history; a period in which we lived to see, from 1983 to 1993, social democratic leaders and intellectuals give up any hope of transforming the world and propose, as if it were a brilliant future, only one exhortation drawn from the Darwinian lexicon so dear to ultraliberals: adapt. That is, give up, abdicate, submit.

Even in the blackest part of the Great Depression of 1929, there was not so great a number of outcasts. If one adds to the twenty million unemployed all those who are excluded by every means, that makes a European population of some fifty million people who are reduced to poverty, often adrift in city outskirts in fear of final marginalization. Ten million of them live below the absolute poverty line, with less than sixty francs per day.... Because misery is an insult to human rights, such shredding of the social fabric destroys a certain conception of the republic.

The unemployed, the homeless, those on the edge, and the rejects are the dramatic expression of the sacrifices demanded of European society for two decades without anything given in return. They are the social translation of purely ideological choices founded on strict budgetary policies, hard currency, the reduction of public deficits, relocation of businesses, competitiveness, productivity, etc. People do not want

184

any more of that. And they do not accept calling something a reform when it is, strictly speaking, only a counter-reform, a return to the old social order, to the abominable world described by Dickens and Zola.

Millions of citizens are affronted by the scandal of prosperous societies which, in the name of economism, tolerate pockets of misery that grow larger every day. How can we fail to understand the rancorous opposition to European integration among those who feel threatened by the brutality of the structural adjustment imposed by Brussels and the blind implementation of the criteria of convergence defined by the Treaty of Maastricht?

As I was leaving, I couldn't resist asking the author one last question:

Isn't it true to a certain extent that Fukuyama's thesis about the end of history is proven correct by *The Geopolitics of Chaos'* pronouncements about the awesome powers of domination engendered by globalization and the triumphant expansion of capitalist "democracy"? In my opinion, Fukuyama's thesis can only be disproved by a global, left-wing revolution, because anything less would not affect capitalist production and consumption worldwide, which is the real historical moment of our time.

Ignacio Ramonet:

Democracy expands, but not real democracy; rather democracy in an economic system that weakens it. Neither Ted Turner of CNN, neither Rupert Murdoch of News Corporation, nor Bill Gates of Microsoft, Jeffrey Vinik of Fidelity Investments, Larry Rong of China Trust and International Investment, nor Robert Allen of AT&T, no more than the dozens of other new masters of the universe, has ever submitted his plans to universal vote. Democracy is not for them. They are above these interminable discussions where concepts like public property, social happiness, freedom and equality still make sense. These have no time to lose. Their money, their products and their ideas are crossing the borders of a globalized market without restraint. In their eyes, political power is the third power. First there is economic power,

185

then media power. And when one has those two - as Berlusconi dem-
onstrated in Italy - seizing political power is nothing but a formality.

[The editor gets a call and quickly tells his secretary to have
the person call back the following week.]

I wouldn't say that we're at the end of history because of the
disequilibrium that reigns in this world between the haves and the
have-nots. There will be convulsions, and according to neoliberals, there
are two objectives of the human being: market economies and parlia-
mentary democracies. Whatever happens in these convulsions, in the
end they'll get a market economy and a parliamentary democracy, and
until now Fukuyama is right. Globally, this is what the citizen wants.
And regardless of small wars or revolutions, so long as most countries
have these two objectives nothing will really change. We're in a phase,
however, in which market economics itself has become totalitarian,
alienating, as we said earlier. Thus it becomes an obstacle in its own
realization and everyday it produces dissatisfied rebels who reject this
system. And we remark all the time that parliamentary democracy
doesn't always work very well because of the affections of the citizens,
and the existence of new actors.... Our citizens only seem to want the
politics of Nike and General Motors or IBM and Microsoft; these are
the big players who have large roles in your cultural consumption,
your nutritional consumption, etc. There's something wrong here. To
hold that the two objectives mentioned above have been obtained for
the moment is a natural conclusion to the fall of the Berlin Wall (1989)
and the dissolution of the Soviet Union (1991). The problem is that
history hasn't ended and that human beings haven't made their last
reclamation, they continue to reclaim. The construction of a neoliberal
European Union hasn't deterred many citizens from reclaiming de-
mocracy in the social sense as we understand it. I've never considered
the Maastricht Treaty to be the European Constitution. One day it will
be written and voted on and European citizens will have a word to say
about it. It's true that present social movements are vague; they're

186

against existing society, but they don't have any coherence of thought or unity, and this opens the door to populism. And yet a global project of resistance, a global counter-project, may still emerge. We'll see.

*

In a sense, Ramonet is right: as long as there are humans there will be history. Or, as Barthes put it in what Ramonet described as his professor's deep, serious voice: "In the last instance, all of history rests, on the human body."[14] And in the history of journalism at the end of the millennium, it should be recalled that 474 journalists have been killed in the line of duty in the last decade, many targeted by assassins for exposing crimes and injustice.[15] On the side of these brave professionals, and precisely against the condescending reporters who have attained their popularity by mastering the art of sidestepping obvious questions and gliding by delicate points like matadors, Ramonet is incapable of writing forty column inches without making the slightest stab at the issue. And by giving us more news than we can use in twenty inches, Ignacio Ramonet proves that he is not a friend of silence.

Notes

1. Semiotics is the study of signs - see Roland Barthes' *Elements of Semiology* (1964, trans. 1967).
2. Action For a Tobin Tax to Help Citizens (9 bis, rue de Valence, 75005 Paris, France), which is now independent of Ramonet and *Le Monde diplomatique*.
3. *Tel Quel* was an influential journal that ran essays by Jacques Derrida, Michel Foucault and many others. Sollers may be best known in the United States for his novel *Women* (Columbia, 1990).
4. *La pensée unique*. See also "When Market Journalism Invades the World" by Serge Halimi, *Le Monde diplomatique* August 1998 pp 12-13 (http://www.monde-diplomatique.fr/dossiers/ft/dbserge.html).
5. Not available in English as far as I know.

6. *Como nos venden la moto*, Icaria, Barcelona, 1995

7. "Madrid 1936, Sarajevo 1996" by Juan Goytisolo, *Manière de voir* July-August, 1998 pp 44.

8. Seidman, Michael *Workers Against Work: Labor in Paris in Barcelona During the Popular Fronts* (California, 1991).

9. For the "wobblies" or the decentralized union formally known as Industrial Workers of the World, "bum work" is a threat made in response to bad pay and may involve slowdowns, working in exact accordance with workplace rules, give-away strikes, sitdown strikes, sick-ins, ignoring the boss, monkey-wrenching, etc. IWW 103 W. Michigan Ave. Ypsilanti, MI 48197 USA

10. *"Cronstadt et ses marins libertaires" Manière de voir*, July-August, 1998 pp 74-75.

11. contact: Association des Amis du *Monde diplomatique*, BP 461-07, 75327 Paris Cedex 07 France.

12. See *Nuit et brouillard du révisionnisme* by Louis Janover (Paris-Méditerranée, 1996).

13. Ramonet is referring to events such as the 1995 strikes in France. See *Remarques sur la paralysie de décembre 1995*, L'Encyclopédie des Nuisances, 74 rue de Ménilmontant Cedex 20, Paris, France 1996. For coverage and analysis of the more recent jobless movement (December 1997-February 1998) see *Collective Action Notes* POB 22962 Baltimore, MD 21203 USA, Fall 1998.

14. Barthes, Roland *Michelet par lui-même* Paris, 1954

15. "Journalists in the Firing Line," *The Economist*, July 4, 1998, p 41.

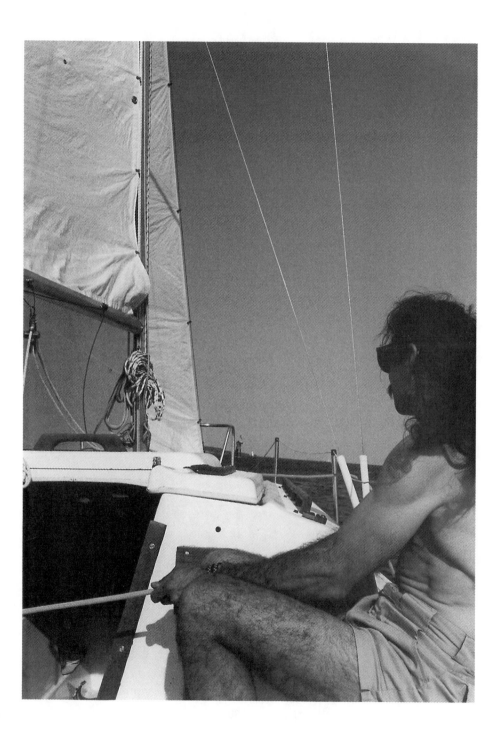

Chapter Thirteen

Solar Economics

It's good to know the best minds of your time, there aren't many. Allow yourself a few moments to follow the movement of Bataille's pineal gland as it forms the embryo of an eye that allows him to see the sun vertically, a celestial eye atop his skull that grants virtual vision of Helios floating in a cup of orange fire on the blue lagoon of noon. We're inclined to say that gold is the blood of the sun, whereas Bjork would have it be its sweat. For the Aztecs, gold was the shit of god; for the Maya gold was the shit of the sun, which is to say the same thing with a slightly different shine. Scatologist that he was, Bataille wrote: "The *solar annulus* is the intact anus of her body at eighteen years to which nothing sufficiently blinding can be compared except the sun, even though the *anus* is the night." He was with Zarathustra who said, "The night is also a sun." Yet of all the bodily fluids, urine comes closest to describing the way the sun endlessly pisses on us from a great height.

All that glitters is gold - a cliché suggesting that economics is one of the most durable lies in history; it continues today without contradiction. In solar economics, energy becomes wealth and the sun rules the earth by its gifts of heat and light, by its effects of chance and surprise. The world's real wealth surpasses what passes for economics by light years. Of the many suns, here are two: one appears small and close, another many times larger than the earth and very far away. Economics draws on the abstraction of all things being equal.

All things are unique in regard to their irrepeatable time and place in the sun. Whereas money can always be replaced, you can't, as Cratylus says, step in the same river once. Like the sun that we recognize by the way it continuously squanders energy, societies and individuals reveal themselves by their waste - the wasted energy of festivals, dance and laughter. The real manifestion of wealth requires engaging human passions in art, eroticism, revolution, war - moments when the idea of a future vanishes like smoke. The solar economy foregrounds these sumptuous activities that have no economic use value, activities which don't figure into the calculations of mainstream economics. Infinitely larger than the restricted economy which it encompasses, solar economics includes all human activity and all life under the sun.

2

The globe spins at an imagination-defying rate like a turbine blowing in solar wind. Life grows at insane rates, and there is such an overabundance of life that we can't accept the economic argument that scarcity is the only obstacle to growth. An immense ocean of solar light washes over the blue planet. This light bathes us with more energy than we need for this insane rate of growth. Solar energy passes through the mass of life and then loses itself. These rays are impeded by organisms that have the power to accumulate them, and then use this excess

energy to grow.

In the economics of life, we understand that growth requires more energy than is needed to survive. We also find that living organisms *always* capture more energy than they need for survival and growth - the evidence appears in every organism's wasted energy. This waste takes innumerable forms, but the basic forms are heat and excrement. The reverse perspective of this phenomenon holds that the sum of energy produced by a living organism is always greater than the amount of energy needed for its production. This is a basic principle of life.

<div align="center">3</div>

In a highly parasitic way, life wants to maximize the use of the energy given to it by the sun. Plants and animals occupy all the space they can, and they acquire all the energy they can. But each organism can only use and invest so much energy. The excess energy acquired by the organism is squandered. Some organisms have more power to waste excess energy than others. Predators kill their prey and leave the excess for scavengers. The limit to this loss of energy delineates problems of acquisition of energy and the organism's powers of destruction. An organism can't waste the energy it can't capture; when an organism succeeds in attaining excess, it grows and multiplies - but only to a limit. Natural history show us that the climax of growth engenders massive losses. A herd attains the limits of growth and becomes, by virtue of its size, prey to deadly viruses, parasites and predators.

Solar economics rests on the principle of loss, or, to put it more precisely, on the disaccumulation of excess vital energy. The fusion of braided magnetic bands of burning gases that we call the sun continually squanders energy. Energy lost by the sun bombards the earth, and the energy that the earth can't swallow up is in turn lost. The same holds for plants and animals - organisms lose the excess energy they acquire. Some calories maintain life; the rest is surplus. The surplus burns in activity that reveals the essence of the organism; or else the

<div align="center">193</div>

surplus turns into fat lost at the time of death, if not sooner. Expenditure reaches its most luxurious form in death because it represents all the wealth that that organism ever acquired, and the energy it can no longer acquire and squander because of this fatal loss.

4

The anatomists who named the solar plexus must've known that this endless appropriation of solar energy brings humans to life. The light and heat of the sun are blazing unilateral gifts that engender all life on the planet. Humans constitute many forms of excess solar energy; they seize and use a considerable amount of planetary energy. Some of this expenditure of energy ensures the growth of the human race; the rest is excess. In all the useless human activity that we love and hate, we can marvel at the human capacity to liberate vast amounts of excess energy.

With so much excess energy in the world, the argument that the earth is poor doesn't make sense. If energy is wealth, wealth is the biggest problem facing the blue planet. Humans exist to expend the energy that accumulates on earth. In the case of some humans, they're fully conscious of how they lose this excess energy, and they do so in glory and still more glory. If scarcity prevails in one place, we should only acknowledge that this reveals an isolated limit to growth and not mistake the part for the whole. The growth of life continues as orgies of energy produce surplus and scarcity. With these principles of solar economics in mind, we realize that we're free to dispose of all the resources we can get our hands on in a debauch of vital energy.

5

The energy accumulated by capitalist rationality, frugality and sobriety that characterizes its early phase was invested in still more accumulation. This accumulation breaks with the sumptuous expenditure of the feudal order. In hindsight, we find that capitalist invest-

ment accelerates the expenditure of energy, but rarely do the losses have qualities of sumptuousness, luxury, majesty.... Human majesty is the image of earthly splendor manifest in humanity. Capitalists can't begin to compare their scanty losses to those of the tribal chief who burns down his village like a force of nature, simply to humiliate a rival chief. Unlike the capitalists' miscarriage of the art of consumption, the Egyptian pyramids, Islamic holy wars, Spanish bullfights, the Roman circus, Bonfires of the Vanities, and even American gang wars correspond to this majestic, glorious waste of energy that engages powerful emotions. In this century nothing corresponds to the grandeur of lightning, forest fires, tidal waves, volcanoes and earthquakes like the majesty of revolution.

Capitalists are afflicted with the lurid compulsion to reinvest and multiply surplus value despite diminishing returns, industrial overproduction and so on. Even the post-bourgeois capitalism of George Gilder (Ronald Reagan's favorite author) fails to consume more than a fraction of the excess. The world contains too much wealth to suffer the stingy mode of consumption of capitalist economies. In defiance of Ben Franklin's virtues of sobriety, frugality and work, we've had the moral licence needed to engage in pseudo-wild, individual consumption for over a century. But we don't come close to consuming what we, as humans, produce. The sacrifice we make for this paltry consumption is the slow death of work.

Shopping is also work in the sense that it serves the economy. Both work and shopping have become less useful on the level of human needs - they increasingly signify service to the economy. Utility is something we take for granted, and many assume the economy is useful. But look around. We have so much more than enough of what is useful and needed to sustain our lives. What concerns us is the luxurious. We agree with Fourier who said that the sun is the body of god, and who ranked luxury as the first passion. The erotic interlude, which is a highly non-productive expenditure of energy, is certainly luxurious, but nothing is so luxurious as human death, the strongest fetish. We're drawn to work the way we are drawn to death, only not so much.

195

Ecological destruction and wage slavery prove that the restricted economy wages war on humanity. Yet, seemingly everyone conspires for this deadly economy. Self-destruction and self-sacrifice are inflated into something they aren't - profit. Fourier was surprised that Smith and Ricardo studied wealth without looking at morals. Their pseudo-scientific theories missed the fact that at behind all economic activity lurks the invisible hand of religion.

Until the dubious knights of industry of the XIXth-century put their blot on history with the perverted idea of continually reinvesting profits, everyone engaged in sacrificial expenditure. This break in non-productive expenditure is best illustrated by the potlatch of the Kwakiutl, ruinous gift-giving feasts outlawed in capitalist-protestant Canada. Potlatch proves that as long as it remains above the plane of commerce and attains a ruinous scale, the gift commits a crime against the restricted economy. Spiritual prestige went to the Kwakiutl person who sacrificed the most to his rivals. Picabia puts it well: "Is it hunger or abundance that inspires the desire to destroy - or is it perhaps both."

Vast stores of energy appear to be wasted on dressing up commodities. As the poet likes to say, "An American apple isn't an apple," but the spectacle of an apple for sale. This apple is unlikely to make it to the eternal feast - it remains in the market ecology only as long as it retains its false shine. Commodities aren't gifts that come to us from symbolic exchange, they're pollution acquired by equivalent exchange using the homogeneous substance of money. Using irrationality as a defense, Reagan's apologist of capitalism, George Gilder, defines feasting and potlatching as traits of entrepreneurs who assemble and distribute wealth. At least Gilder recognizes gifts as the most burning issue in capitalist society, but this paltry giving that is the vital impulse and moral center of capitalism gives less than it gets or else goes out of business. In other words, profit is contrary to the idea of the gift.

Capitalist societies appear to consume more than pre-capitalist societies, but there is a distinct qualitative difference in the modes of consumption. Even the seemingly unproductive forms of consumption of alcohol and tobacco create profit-generating industries. We don't

196

have to be Mandevilles to understand the economic benefits of self-destruction in these limited forms. Self-destruction on the scale of the Kwakiutl has greater benefits - it spreads wealth and levels the playing field. Capitalists practice a deceptive self-destruction that stems from their global monopoly. Losses in New York are gains in Tokyo, and vice versa. The system risks nothing, and for that reason nothing sumptuous is at stake. The players play an empty game.

6

There are active and passive solutions to the acquisition and expenditure of energy, which is to say there are active and passive ways to live. The passive solutions are pleasant or painful for those who engage them - the herbivore, or the worker - depending on the situation. The active solutions are more interesting. As every businessman knows, expenditure is just as important and difficult as acquisition. As every pirate knows, plunder demands risk. Freedom is at the apex of the temple of the sun. To worship the sun, we must simply engage in the anti-economic activity of our choice. The active solutions to sumptuous expenditure are seen as bad by most people. Massive losses of solar energy are made by the few despite the general misery. This is why Bataille referred to this extra as the accursed or guilty share. The superfluous is necessary on a scale that defies most imaginations, yet as hilarious as it seems, the charade is maintained that the earth is poor and that humans must work. Work presents us with the obvious first step towards revolution because we can refuse to do it. Paradoxically, the most apparent form of abundance is the abundance of dispossession. We're dispossessed of our lives by our daily toil.

The solar energy in life flows like electric current with inflows and outflows, movements of heat or light that go from one being to another. These impulses of energy are always communication. Energy is the basis of all production, but it's also the communication of emotions in love, art and festivals. As Dostoyevsky's novels conclusively demonstrate, we sing with joy to the sounds of the sun even in mo-

197

ments of emotional distress and loss. Most people aren't conscious of what they do with their lives and mask their distress. They become fat or they go to work - in America they do both.

Prior to the XIXth-century no-one was considered wealthy if they prostituted themselves for money with work. Accumulation may be far from its limits, but the overproduction of cheap commodities and the underemployment of creativity strike us as passive solutions. Loss, in our time, comes in the form of human courage and life. The illusions of the spectacle force humans to betray their essences as laughers, dancers, and givers of parties. It's human to liberate immense amounts of solar energy. It's human to burn. Revolution entails taking all the risks required to create an experimental civilization of eternal festivals, festivals that bring with them a renewal of greatness in everyday life.

7

The human population will reach its limit. As humanity approaches this limit, it enters the situation of an individual who can't grow any more. The excess energy of this individual finds a way to free itself and show us what he, she or it does with excess energy by manifesting desires. The explosive liberation of sexual energy - from the perspective of life - assures the duration and extension of life. For the individual, this explosion of sexual energy is pure loss. Sex is the sublime expression of the sun on earth. Man gives to woman, who in turn gives by receiving.

All the excess energy at the disposal of humanity won't be absorbed by the human race; the limits of growth engender massive losses. Through the loss of life in plague, war and revolution humanity destructs on a scale large enough to correspond to its excess solar energy. As has been the case so many times throughout history, the rage of the sun expressed by the cowardly submission of humanity to war finds roots in work and its ubiquitous context of nationalism. And even if work were somewhere free of its repugnant nationalism, it still

represents class war. Imperial conquests are often depicted as obeying the logic of a grand economic plan, when in reality they're usually driven by the insane solar-driven passions of the interests.

Luckily, truth rides on the sun's rays. We're reminded of the way Hitler abused the solar symbol of the swastika and was scorched to death like a snake. We must choose between what Bataille called the "morality of laughter at the indecencies of life" or the morality of war, the economy of passion or the economy of submission. We can remain submissive children and go back to work and war, or we can act as adults and press for a revolution of the restricted economy. Judge this tyrannical economy on its own terms, namely by its effects on commerce. Judge solar economics by the miracles of the sun.

Revolution entails the disaccumulation of the excesses of capitalism. This expenditure of energy must be perfectly useless because no matter how glorious something may be, it's not great unless there's no purpose behind it. Humanity will squander the accumulated wealth of the ages on the undeniable passions we all feel as the hot pulse of life that runs through our veins. If we see ourselves as spindles of fire burning with desire, we'll begin to understand what we can do with our passions as we consume ourselves and others. We can allow this maniacal accumulation to continue for a little while, but it will soon attain the limit of growth, as it did in Los Angeles in 1965, and again in 1992.

As capitalism approaches this limit it will begin to experience massive losses. Revolution represents the supreme and extreme potlatch of the proletarian masses offering themselves up to the classes for destruction in a fight to the death. Are the classes capable of returning this gift? At the crossroads, fools choose moderation and the wise go astray. If we take the risk, we can turn the world into a playground for revolution. Everything eventually turns to the advantage of the extranational empire of the children of the sun who recognize its secret logic. The rest of humanity aligns itself with misfortune.

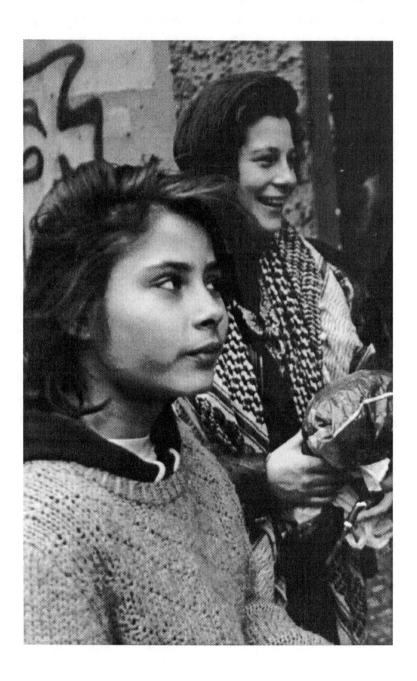

Chapter Fourteen

A Zerowork Theory of Revolution Including the General Theory of Civil War

Outline

A Ghost Writer's Memoir

Part I As Fast and Beautiful as Lightning

1.1 Preface
1.2 Method and Theory
 1.2.1 English Civil War
 1.2.2 On the Definitions of Civil War
 1.2.3 Summary of a Civil War Typology
 1.2.4 Towards a General Theory of Civil War
 1.2.5 Historical Assessment of Civil Wars
1.3 The General Theory of Civil War
 1.3.1 Spanish Civil War
 1.3.2 Historic Moments of Councilism

A Ghost Writer's Memoir

All art is propaganda... on the other hand, not all propaganda is art.
George Orwell

My comrades tell me that the only way for my thoughts on civil war to reach their intended audience is for me to display myself - not so much in the exhibitionistic mode of my novels, but in a more theatrical manner - simply to lend a little human interest to the historical facts, news

203

items and types that make up an otherwise straightforward general theory of civil war. At the risk of sounding academic in the body of this essay that was once a thesis paper, I confine my personal remarks to this introduction.

I became a ghost through the good graces of a long-running Fourier-Taoist sect that once called itself the Divine CIA. The Finders, as the group is known in the national media, were very much the inspiration for the form of my first novel, *Freeplay*. As the story goes, a drifter came though my part of Washington back in 1983, taught the heavy metal band up the street guitar. and took me up to New York when he won a DC 101 contest to see Ozzy Osborne at Madison Square Garden. He was a Finder who shared tales of games, like always being ready to go in any direction and then taking off on wild adventures. Then we lived it. We out-rocked Ozzy and didn't let the April blizzard slow our raging party. With the Finders, it seemed, anything was possible.

Years later, when I finally met the group, they immediately tried to put me in charge of what they call their non-bureaucratic org, but I wouldn't have it; my wants-list consisted of me wanting them as friends. Later I let on that I needed to do some writing or editing work for pay. Miss X played her part by writing technology articles for major papers and ghost-writing school papers on the side - writing constantly, as journalists do. The problem with her operation, as I see it, was that she based it on the gift economy, but didn't like the rich kids she worked for. How she gave as much as she did, I'll never understand. I wouldn't have liked them either if they'd paid me the way they paid her, but I straightened them out right away and tripled the price. Good pay or bum work, as the Wobbly saying goes.

At first, I wrote for a student of international affairs at a local university, Mr. A. We began our conspiracy with a take-home test essay about Nixon's adaptation of containment and his realpolitik - I told the professor what he wanted to hear, but reminded him of Nixon's notorious Operation Duck Hook to end the Vietnam War, the proposed escalation of threats, up to the use of nuclear weapons. In another take-

home test I poked fun at the way National Security Advisor Robert McFarlane admitted his fear of being called a commie for opposing the sending of arms to the Contras. I also made fun of Reagan's storytelling, for example his first inaugural address in which he argued that Vietnam had been a just and honorable war. I even made vague allusions to the October Surprise conspiracy theory by mentioning the arms shipments and the release of the hostages on the day of his inauguration. This wasn't what the professor wanted to hear, but I stated these facts so bluntly that he couldn't argue with them. My most blasphemous phantom opinion? I don't think Reagan's Star Wars spent the Soviet Union into submission. I agree with US experts who were in Russia before, during and after the fall, and with outspoken Russian generals, when they insist that the failure in Afghanistan was the single most important moment in the rapid decomposition of the empire. We now know that many of their missiles were fakes, hollow shells paraded through Red Square. What a joke.

I soon found ghost writing exciting because I learned while double voicing papers on Kant, Hegel, Nietzsche and Arendt - for excellent pay. This form of writing might aid and abet anyone who wants to work their way through the equivalent of a university education. I don't care for Kant much, so it wasn't a surprise that the professor didn't like my paper on Kant's compatibility with this or that society. Moreover, I didn't want the paper to seem artificially flawless, so I planted a few language errors in the text. I hid behind my student's foreign voice. But, no, Mr. A wanted the best grade and would pay extra for it.

I'd just read Hegel's *Philosophy of History* and used the paper as an opportunity to explore themes of historicity, the progress of reason and the ideal and real in Hegel's philosophy of history. In a sense, the Hegelian becoming of knowledge and the continuation of it on a long journey of historical self-realization is what this book is about. As grandiose as it sounds, I'm attempting to comprehend, in the context of civil war, the historical unfolding - through action and struggle - of the world.

My Nietzsche paper treated him as a psychologist of historicity and correlated his monumental, antiquarian and critical senses of history to the id, ego and super ego. After Hegel, it's healthy to listen to Nietzsche's hypocritical contempt for history and his prescription for us to forget more or less history, depending on the type of people we are: "martyrs who want to stir up the swamp" or "anyone who manages to experience the history of humanity as a whole as *his own history.*"

I began charging thirty-five dollars per manuscript page and more for the take-home tests he was sure he would fail. Mr. A harbored his deepest fears for a strategy-related course with a notoriously difficult professor. When called upon in class, he defended himself with a few mumbled buzz words. But on paper, the course allowed us to drop the disinterested academic voice and adopt a strategic perspective closer to that of the French strategist Guy Debord. Why Debord? His life's work moved me to write his biography and translate his Game of War. The martial tone seemed natural because my student was a member of his nation's military. But I may have gone over the top - I'm now looking at an exam in which I made a region-by-region roundup of US foreign relations that, at its core, has a severe tone.

In this course, we brushed up on concepts like compellence and coercive diplomacy and the current phase of non-proliferation - topics I'd studied over a decade earlier at George Washington University. Simultaneously, I developed my parasituationist concepts into a general theory of civil war in outlines and proposals that eventually bloomed into a twenty-five-page paper. It's amazing I lasted as long as I did. Half the time he didn't read my papers for his best, and perhaps most difficult class, on Third World politics.

Who am I to fault him? In 1994, I gave up regular work and began living off unemployment and part-time work in secondhand book shops. This was an attempt to once again realize my refusal-of-work philosophy. Thanks to my lover and benefactor, I could afford to write and hang out with other failed writers in blues bars and warehouses, where old yippies and hippies rule. But, inevitably, she tired of

me coming home late and put her foot down on me to get a job.

Before I became a ghost, I had a stint as a chauffeur - the most dismal job I ever had, though I did translate the Italian situationist Gianfranco Sanguinetti's *The Real Report on the Last Chance to Save Capitalism* between calls. I'll never forget driving Michael Berman, one of Clinton's advisors, to the White House or other places, thinking, after Sanguinetti and Machiavelli, that he should tell the president to be more resolute. George Will and his daughter rode with me on their way to San Diego for the Republican Convention, but I didn't feel like sharing with him any of the thoughts of a true conservative (he passed out as soon as we hit the highway). I'd worked with this *Real Report* for years before I translated it, but it wasn't until later, when I began to write student papers, that I could play around with the double-voicing that takes place in the *Real Report*. I take that back. I did once write a conspiratorial rant as if I were a neo-Catiline World Banker out to cancel all debt, but I didn't fool anyone the way Censor did (although I can still end up with an accurate prediction wrapped in a vague plan). Sanguinetti wrote, with Guy Debord's collaboration, the greatest political fake of all time; he pretended, under the name Censor - as in the mold of Cato the Censor, a military man - to appear as an aristocrat who stepped out of a novel by Manzoni when in fact he was a contemporary prince from the far-Left.

Censor is far too modest in his claims that the *Real Report* will only be of interest to historians. Not only did it create a sensation when it was first published - he was described as a sublime cynic and a genius - the book has stood the test of time very well. I've recently written about this in *Anarchy* magazine, although the know-nothing reviewer had it all wrong. Now the ex-Communist, Democrats of the Left head the government, and together with the Refounded Communists, control Parliament. They do the bidding of the bourgeoisie, just as Censor said they would. They aren't real communists. As for the unions, at least the big three, they're bought off. Censor's warnings about wildcat strikes and the movement politics of the mid-Seventies are still on target if one can appreciate his radical reversal of perspec-

tive for what it is. I'd completed the translation of this cynical text only a few months before I began my ghost career and both the form and the content informed every paper I'd written that fall and spring.

Finally, at the end of the spring semester, 1997, my twenty-five page paper put Mr. A over the top in his bid to graduate and I drafted my student's academic and professional statement of purpose for graduate school, a portion of which appears below:

> My academic interests are focused on strategy, hence I have a profound admiration for the master theorists: Clausewitz, Sun Tzu, Jomini and Liddell Hart. But strategy is a vast field that enables me to follow my inclinations and study history, psychology, sociology, economics, religion and politics in my society and potential enemies. I will not consider my studies to be complete until I have a clear understanding of the major wars in human history and their strategic successes and failures. My intention is to bring this understanding up to date so I can understand present and potential wars everywhere in the world.

The deal, as we parted for summer break, was for me to take a sizeable advance with me to Paris and research the civil war theme, then turn the twenty-five-page paper into a hundred-page master's thesis. With pleasure I met alone with Mrs. A to find out more about the project, never quite forgetting what my friends had told me about Middle Eastern women being bred for large clitori. Blood surging to strategic points.... I was delighted to hear that one of her thesis advisors was a professor I'd taken a class with when I was at XXXX - a good man who never minded a little plagiarism: perhaps he knew, all along, that progress implied it. So I went to France to collect my strategic thoughts and fall in and out of love. As every ruthless vandal poet knows, nothing is worth learning if it can't be learned with pleasure.

Somehow, my student was accepted to graduate school.

I'd only added another twenty-five pages to the project by the time school started in September, and the wife now wanted me to work full-time for her. For one hundred dollars I'd write a few lines about

the reading she was supposed to do for each class, and for a few more dollars I would do her summaries and reports, her computer databases on the possibilities for peace here, there and everywhere. Aye, aye, aye. The hoops they make you jump through in school.

With the lovely wife I studied the theory of conflict. Of my ghost work, Miss X, the Finder, favors the essay for this class about electronic Hypnos and the power of love. Not because she likes love, but because it went so far over the top. Then the wife and I took postmodernism and peace studies. Against better judgment, I decided to be cruel to the professor for asking stupid questions. He was one of her thesis advisors....

True to my word, I wrote the thesis, then helped her defend it through a major rewrite with this just-mentioned advisor. He must've known there was someone like me behind her papers, and the thesis was far too equivocal about war to be an analysis of peace in a peace studies program. In this version, a few traces remain of my peace study feints, such as unkept promises about the mechanisms for the resolution of civil wars.

What follows is a revision of my general theory of civil war (parts I-III) as a basis for my thoughts on a refusal-of-work revolution that appear in part IV. My question to peace-loving people who question how I can speak of war this way: How many propaganda campaigns must we endure before we acknowledge that peace is war by other means? The Cold War proved that psychological warfare is war. And we know that the most effective propaganda campaigns are reinforced by actions. "Nature likes to hide herself," Heraclitus tells us, but in the end he concludes: "War is the father of all and the king of all; some he has marked out to be gods and some to be men, some he has made slaves and some free."

Part I As Fast and Beautiful as Lightning

1.1 Preface

Barbara Ehrenreich concludes her recent book *Blood Rites* with the non-intuitive assertion that it was only through militant peace activism that she felt something of the glories of war. I'll make another paradoxical assertion. Peace and social justice don't inevitably coincide. In general, peace is preferable to war. But how much should we pay, in terms of justice, for peace?

By focusing on civil wars rather than foreign wars, I've discovered that peace tends to serve the established order - the absence of civil peace, namely war, is by far the biggest threat to any regime. War is the just response to despotism, yet most succumb to peace. Why was this discovery non-intuitive? Perhaps I've been conditioned by the American literature on Vietnam, which tends to view what was a civil war (with foreign intervention) as a foreign war, albeit one with serious domestic consequences for the United States. Although I didn't offer any public protestations against the American campaigns of the Eighties - T-shirt slogans weren't for me - I was appalled by these bully-boy tactics. The image of the US as a marauding shark crowded my mind as patriotic hysteria swept the country. This lust for low-intensity conflicts and foreign military occupations was enough to make me averse to war. Realistically speaking, a foreign war may be more or less advantageous to a country - I'm thinking here of the way World War II increased the United States' wealth and power. But civil wars are virtually always disasters for any regime forced to fight one.

The point is that civil peace may or may not be accompanied by social justice. Whereas peace can be imposed by a leviathan, the absence of justice - as in, for example, the brutal imposition of peace - can be a just cause of civil war. The partisans of peace are correct to stump for peace and social justice, but only to a point. Just as Barbara Ehrenreich, in her more activist moments, found herself in the paradoxical position of fighting for peace, social justice is, likewise, worth

fighting for - perceived or real injustices of every possible type are, after all, the ostensible rationales for most civil wars. Yet in the spirit of survival, or of cowardice, most people will choose abject forms of submission over death.

But a vital minority in even the most repressive societies (people such as China's Wei Jingsheng) find freedom and humanity in risking their lives in a fight against injustice and servitude. In short, liberty often requires war. One doesn't have to be a Montesquieu to see the supreme justice in the First Slave War in Sicily under Eunus (136-132 BC) or the Second Slave War (104-99 BC) or again the great revolt of slaves in southern Italy under Spartacus in the Third Slave War (73-71 BC). The questions are: What is the best way to govern to create the conditions that ensure civil peace? and its corollary: What, in contemporary terms, is the best strategy to oppose tyranny? To ask one question without the other is to engage in a fragmentary analysis.

1.2 Method and Theory

To follow this adventure, consider the social and ecnomic conditions that have, in the totality of human history, and may in future, foster civil war - hence my allusion to the Slave Wars in the Roman Republic in the preface and my critique of contemporary wage slavery in the body and culmination of this thesis. Other types of civil war are analyzed from this same perspective, a perspective which is both strategic and dialectical. At present, no threat to civil peace is as intensive, in terms of its intensity in daily life, and simultaneously extensive, in terms of its extension around the globe, as the problem of work.

If you doubt the importance of work's role in civil strife, consider the use of balaclava-clad scabs flown by helicopter across picket lines in Australia's 1998 dockers' strike, revealing how far management and governments will go to defend corporate interests. A zine called *Counter Information* from Glasgow expresses the problem quite well:

211

In the Thirties, Nazis would have you believe work made you free. Religion praises the work ethic as akin to a cleansing of the soul, and present day bosses and politicians hype work as the salvation of the nation, bringing dignity under prosperity to the masses. Work as we know it under capitalism is nothing short of repetitive, routine, disciplined long hours at low pay, and it's usually boring. There are clear-cut times for workers to work, to play and to rest. Work, it appears, is apart from our lives. It is something we do because we have to, not because we want to.

Work as we see it need not be separate from our lives but should be a part of it. It should not involve working long hours, day after day at the same thing. It should involve learning, time to play, and should not have limited goals. It should be expansive and of interest. Not all work is going to be enjoyable, but unenjoyable work should not last a lifetime!

The world's resources belong to everyone. With a system of mutual aid and voluntary co-operation, with no bosses and no profit motive, work could become satisfying and maybe even enjoyable! Capitalism has stolen our humanity and individual self-worth; maybe it's time to steal it back.

I realize that the critique of work may be off the academic radar screen, but that doesn't mean that it isn't real - its expression is found in everything from Mike Judge's mainstream film *Office Space*, to Matt Groening's *Life in Hell* comic on things you can do to waste time at work (making animals out of paperclips, etc.) to the striking increase in murders of managers by workers that attempt to validate a phrase uttered by Radio Werewolf in my Washington novel *Secret City*: "The best gift is a dead boss."

Curtis Price reported on this phenomenon in his article "Smith and Wesson as Shop Steward," in an early issue of the highly recommended *Collective Action Notes*. He demonstrates that violent crime in the workplace is up, much of it by disgruntled employees and directed at management such as the accountant in Connecticut who shot four

lottery executives to death in 1998. The expression "to go postal," like a berserk postal worker, has entered the lexicon after a rash of post office killing sprees.

The National Academy of Sciences' 1999 report *Protecting Youth at Work* finds that work is often physically dangerous for teenagers and that it tends to disrupt their education. The mass of American youth, more overworked than their counterparts in other industrialized countries, finds itself trapped in low-wage, dead end jobs. Many respond by breaking workplace rules and the law - usually within the first year on the job. And in the wake of the subversive film *Office Space*, psychologists have taken to the airwaves warning parents not to express their dread of work in front of children.

I first encountered this total disgust for work, in print form at least, in Bob Black's essay "The Abolition of Work" that appeared in numerous editions and guises in the Eighties and Nineties. But this critique is both older and newer. Like Paul Lafargue in his seminal work on the subject, *The Right to Be Lazy* (1880), today's slackers demand their just rewards as inhabitants of a superabundant planet. Lafargue was writing against those workers and party hacks who demanded the right to work, those afflicted with what he described as an insane passion for work. The importance of Lafargue's best-selling *The Right to Laziness* (a literal translation) for contemporary struggles, such as opposition to workfare, can't be underestimated; it draws a line in the sand, and its libertarian thought rivals and may yet exceed anything his father-in-law, Karl Marx, ever did. Lafargue's 1883 preface, written in prison, to his work of genius:

In a 1849 Commission session on primary education, Mr. Thiers proclaimed:
I want to make the clergy all-powerful because I count on it to disseminate the good philosophy instructing humans that life on earth is for suffering, and not the other philosophy that tells humans: "Enjoy."
Mr. Thiers thus formulated the morality of the bourgeois class, the class whose fierce egoism and narrow intelligence he incarnated to per-

213

fection.

Even as it fought nobility with support from the clergy, the bourgeoisie extolled free thought and atheism. Victory changed its tone and style. Today, the bourgeoisie props up its political and economic supremacy with religion. During the XVth and XVIth centuries, the bourgeoisie rediscovered the pagan tradition glorifying flesh and its passions. The contemporary bourgeois class, stuffed with goods and drowning in pleasures, denies the lessons of its thinkers - Rabelais, Diderot - and preaches abstinence to wage-workers.

Capitalist morality, that pitiful parody of Christian morality, whips workers' flesh with its anathema. The goal is to minimize the needs of producers, and to suppress their joys and passions and to condemn them to the role of a machine. In short: work without respite or thanks.

Revolutionary socialists must recommence the war fought by bourgeois philosophers and pamphleteers and attack the moral arguments and social theories of capitalism.Revolutionary socialists must demolish the ruling class prejudices sown in the minds of the class called to action. Revolutionary socialists must proclaim - right in the faces of hypocritical moralists - that the earth will cease to be a valley of tears for workers. Revolutionary socialists must proclaim that in our future communist society - created "pacifically if possible, violently if not" - human passions will have free reign because they're "all naturally good absent their misuse and excess."

These passions will not be avoided except through the equilibrium established by the harmonious development of the human organism. As Dr. Beddoe says: "only once does a race attain its maximum physical development and reach the summit of its energy and moral vigor." This opinion was shared by the great naturalist, Charles Darwin.

This refutation of the "Right to Work," which I'm republishing with additional notes, first appeared in the weekly L'Égalité in 1880.

P.L.

Prison de Sainte-Pélagie, 1883

214

On the heels of Michael Seidman's *Workers Against Work* (1991), an entirely new labor history is emerging that points to slacker techniques such as absenteeism, sabotage, lateness, theft, feigned illness and indifference to production goals as the real weapons of worker struggles. As Seidman proves with his painstaking research, during the Popular Front years in France and Spain, management and revolutionaries were united against workers who were waging massive, spontaneous resistance to workplace discipline. Contemporary workers should note that managers were considered fascists by most workers, and the struggle against work was the struggle against fascism. At the height of the Spanish Civil War, the anarcho-syndicalist CNT fought against the forty-hour week, to the bitter end, and sent so-called parasites to labor camps. But in France, workers spontaneously occupied factories and otherwise rose against management controls. Good workers were humiliated; strikes flared up across the country, strikes in which management was attacked.

I suppose it isn't too surprising that machine-breaking, boss-badgering workers were both part of, and at times opposed to, more bureaucratic elements in the big union federations, such as the French Confederation Générale du Travail. Then, as now, we have those who push the principle of direct action further than the rest. But the logic still holds considerable sway. What if this increased class conflict, under the right conditions, *did* lead to a general strike? The Industrial Workers of the World (IWW), or Wobblies, still harbor thoughts of one big union, not a trade union, participating in one big strike. And moments such as the nation-wide general strike in Denmark in 1998 for a sixth week of vacation give Wobblies grounds for hope.

I became interested in the IWW when I read about a pamphlet entitled *How to Fire Your Boss - A Worker's Guide to Direct Action*. When I worked at Baltimore's Black Planet Books, I was given the pamphlet about work slowdowns: working in absurdly strict accordance with rules or exceeding the rules allow by providing extra service, sitdown and selective strikes, whistle blowing, ignoring the boss and sick-ins. My colleagues were members, but it was my boss who persuaded me

215

to join the anti-boss IWW with his stories of subverting workplaces.

I was skeptical at first. Why join any organization? The better tactic might be to organize when something needs organizing. I wasn't going to join something simply for the sense of solidarity, was I? What, I asked myself, could this union experience do for me? Then I started reading the books about Wobblies organizing lumberjacks in the Pacific Northwest, about a string of successful strikes in Paterson, Akron and Minnesota, as IWW membership swelled and spread. Opposition to World War One did them in; the government cracked down and they've just hung on over the years. They're rebuilding again, and while I remain skeptical of the syndicalist approach, I'm willing to look for ways to share or bend my anarchistic anti-organizational instincts with others, even in union and council forums, to advance the refusal-of-work movement.

The most amazing fact is that in 1996, the United States surpassed Japan and all other advanced nations in the number of hours workers are compelled to fritter away at senseless jobs, which in part accounts for publications such as the cover story of *Generation Next*, a free news magazine widely distributed throughout the Washington metropolitan area: "Quit Your Job: Why Not? Everyone Else Is Doing It!" This is a logical response to reports such as the front-page article in *The Washington Post* about harried workers toiling through lunch or using this time for domestic chores. The rise in the simplicity movement, in which people choose to work and consume less, is well known but there are numerous other indications of the sizzling pace with which an amorphous anti-work movement advances. Millions are becoming aware of their allergies to work and how work infringes on their lives, although the majority has yet to discover the bad worker lurking in each individual even if they can joke about the privations of work. This issue is important because the anti-work movement - characterized by everything from the refusal of overtime to routine resistance to wildcat strikes - represents the most serious long-term threat to the established order that any of us can imagine.

216

How do I explore this threat?

Over the course of this paper I define civil war and its variables, and I create a typology of civil wars. My definition of civil war is rather broad, my typology a broad classification that identifies one form of civil war, namely left-wing revolutionary civil wars, as far more dangerous to the established order than the others. Unlike other typologies (and there are no adequately nuanced typologies of civil wars that I am aware of), my forms of civil wars are not ideal types, rather forms defined by numerous examples from recent history. In other words, the types of civil wars are the wars themselves, and only loosely fit this broad classification. This typology is deployed more as a way to structure my thesis than as an attempt at a structuralist analysis of civil war - every war is a unique unfolding of events that resists a static, structuralist analysis, which is why the book is comprised of numerous brief civil war chronicles. Nonetheless, my categories are entirely justified, as I make clear in the full presentation of the typology. For now, a brief outline of my three categories and six basic types:

Category I: Conventional Civil Wars

Type A: Single Issue Civil Wars
Type B: Wars of Secession

Category II: Revolutionary Civil Wars

Type C: Left Wing
Type D: Right Wing

Category III: Undefined Civil Wars

Type E: Seizure of State Power
Type F: Molecules of Civil War

My definition of civil wars in the definitions section of this

thesis and the typology - grounded in the major historical moments of civil war - are the basis for my general theory of civil war, which I have chosen to express in strategic rather than strictly academic terms. I shouldn't have to do so, but I've found it necessary in my conversations with the academic community to point out the strategic rationales for the following: (1) preventing civil war by governing in a just way, (2) co-opting the opposition, and (3) the regrettable use of repression. My analysis of civil wars demonstrates that concessions, even seemingly disastrous ones, are usually better for the regime in power than civil war. But at other times, the issues at stake are so great and rouse so much passion, as with the US Civil War, that conflict is as inevitable as the mournful wail of millions. Although I fail to arrive at absolute policy directives for every eventuality of civil war, at crucial points I strip away the historical examples and present my findings, based on strategic logic, in theoretical terms.

My general theory, distinct from the typology, is based on the same basic political commitment as Thomas Hobbes: a commitment to civil peace by whatever means this entails [or so I said to my student, and indirectly, to her king]. To argue otherwise risks sounding something like the absurd Prince Andrew in *War and Peace*: "All the kings, except the Chinese, wear military uniforms, and he who kills most people receives the highest rewards." Hobbes was a monarchist living in the XVIIth-century, but his observation that peace is the goal of the established power is no less true today than it was in his time because he recognized the implicit contract that those who wield power have with the people under their dominion.

The sort of absolute state power based on natural rights that Hobbes favored implies that a state has within its power the use of concessions and, if necessary, power sharing to avoid civil war - the use of these counter-intuitive measures that both ensure peace and the sanctity of state power is supported by select examples from the recent past.

For example, after the breakup of the Soviet Union, Russia has given its numerous ethnic regions genuine self-rule and managed to

maintain what can only be called an empire. Where Russia failed to grant concessions, in Chechnya to cite the most dramatic example, it suffered the disastrous consequences of civil war. Readers who have perceived my anarcho-communist sympathies might wonder how it is that I can assert that the Russian State took a hit in this affair. Easily. I'm not blinded by a simple reversal of perspective to prove my point. Take Ukraine. In giving autonomy to Crimea, Ukraine is maintaining dominion over what might otherwise be a contested peninsula.

Likewise in Germany, where considerable power is granted to the sixteen *Länder*, or states, including five eastern states; paradoxically, the devolution of power can be a unifying factor. France's gravest separatist threat, Corsica, has been placated, somewhat, through subsidies and increased autonomy. In a more general sense, Paris has relinquished power since the Eighties by creating twenty-two mainland regions with their own budgets. Spain has decentralized much the same way (by creating semi-autonomous regions), granting still more power to Basques and Catalans.

Compare these examples with the way Turks have handled their Kurdish minority - the refusal to give Kurds any autonomy has cost the Turks lives and considerable expense in fighting a civil war, and only idiotic leaders, of which the world has known many, sacrifice lives and waste other forms of wealth rather than make a little bow to the other. If Kurds enjoyed greater autonomy, they could have greater respect for, and dependence on, Turkey.

1.2.1 *The English Civil War* To cite another example, this time from the annals of history, I turn to the English Civil War (1642-1646). King Charles I ruled without Parliament for over a decade prior to the war, and consequently suffered anti-royal legislation, namely impeachment of Archbishop Laud and abolition of the House of Lords and the Court of High Commission in 1641. Charles accepted these measures, but then moved to rescind them. Radical members of the House of Commons pushed for the realization of increasingly revolutionary propositions. Faced with rebellious Scots and Irishmen, and denied an

army by Parliament, Charles instigated military action against parliamentary forces using nobles and mercenaries: a measure akin to what I refer to below as ill-advised extra-legal repression. Charles was executed in 1649 on the charge of high treason, and in the process, delivered a severe blow to the source of his power - divine-right monarchy. Had Charles worked with the Parliament, perhaps even granting them the power to wage war on the Scots and Irish, he might not have met such a tragic fate. Charles II worked well with parliament, but eventually dissolved it over the issue of Catholicism, which would send his successor into exile and usher in the so-called Glorious Revolution of 1688 that drove nails into the coffin of divine-right monarchy in England. If the Stuarts hadn't insisted on absolute power, they might've been able to retain some of it. The ascension of William and Mary to the English throne explicitly recognized the supremacy of parliament and formalized the fact that had already been established in the civil war: the king ruled with the consent of the governed.

I've taken the trouble to give this historical example somewhat prematurely because it underscores the way civil struggles tend to work themselves out in the world. To paraphrase John Locke, who was writing at this time, the only way rebellions can be avoided is for governments to respect the rights of their citizens. The debate still rages as to what, exactly, these rights are, but governments do best when they cultivate the consent and perhaps even the strong support of the governed. And today, no less than in his time, Locke's assertion of the natural right of the citizenry to rebel in the face of tyranny, is valid. Hence readers of my thesis should not be surprised to find the strategic perspective of those fighting modern forms of tyranny expressed herein, including those fighting the tyranny of governments who use rebellions to their advantage.

1.2.2 *On the Definitions of Civil War* I opt for a broad definition of civil war because it is the basic form of human conflict. The phrase "civil war" itself has sufficed for writers throughout the ages, from Julius Caesar to Hans Enzensberger - when history books written by

authors as knowledgeable about the subject as the two mentioned above opt for the term "internal" or "intrastate" war, I will follow their lead. I'd also like to point out that nothing about the phrase civil war precludes, by definition, the reality of foreign intervention that is suggested by the terms internal and intrastate.

Because civil wars are tragically costly, and threaten state power in a fundamental way, I argue that from the perspective of the established order, the strategic goal is to avoid civil war. As Cicero put it, "An unjust peace is better than a just war." And because the goal of the established order is prevention of civil war, I follow Enzensberger's *Civil Wars* and bring the molecules of civil war into my definition, which implies that few lives need be lost for a conflict to be classified under the undefined civil war category. I realize that this definition may be excessively broad, but the stakes of civil war are incredibly high. Moreover, a palace revolution or a coup d'état can impose a situation of what Sun Tzu called pure war on the population, a situation in which citizens have no realistic way to fight back. It would be unrealistic for my strategic analysis, focused as it is on prevention, to put a body-count minimum on what constitutes civil war. One could even go so far as to say that all nation-states are continuously in virtual civil war because someone is inevitably at war with the State, or vice versa. As always, Maurice Joly puts it nicely when he says that "society is a state of war regulated by laws."

For more perspective on the body count issue, recall that guerrilla wars can involve very few people on both sides. In the revolutions that swept Europe in 1848-49, or moments such as 1968 and 1969 in France and Italy, moments that pitted the masses against the established order, relatively few people were killed. More than anything else, the Cold War demonstrates the way wars are waged for people's minds - the strategists dream of how a rival's thoughts can be destroyed and the enemy turned into a convert who will work for the cause. Whereas the zerowork movement cultivates defectors from the work camp, the target of commodity economy is to soften up workers with comforts and images, and then persuade them to love voluntary servi-

tude, or worse:

> We shall crush you down to the point from which there is no coming back. Things will happen to you from which you could not recover, if you lived a thousand years. Never again will you be capable of ordinary human feeling. Everything will be dead inside you. Never again will you be capable of love, or friendship, or joy of living, or laughter, or curiosity, or courage, or integrity. You will be hollow. We shall squeeze you empty, and then we shall fill you with ourselves.
> (George Orwell, *1984*)

If war is suddenly inevitable or always already ever-present - as I have suggested above - the strategic goal of the established order becomes to wage its war to govern peacefully, preferably with the support of the population. Autocratic regimes that ignore the desires of their citizens do so at their peril. And as Rousseau put it, "To rule through public opinion, begin by ruling over it." Those who think that the rule they are being subjected to is illegitimate, or those who otherwise want to right the wrongs of social-economic injustice, might try to change public opinion and change the government. If this option is precluded, civil war is one logical course of action. The other options available to disgruntled citizens are to endure indignities and perhaps allow themselves to be bought off, or migrate or go underground or risk torture and detention by vocalizing dissent. These options are not as satisfying as violent opposition because violence transforms humans from objects into subjects. As Alfredo Bonanno puts it in *Armed Joy*:

> Whoever is determined to carry out their deed is not a courageous person; rather a person who has clarified his or her ideas and realized the pointlessness of making so much effort to play a part in the performance assigned by capital. Fully aware, they attack with cool determination. And in doing so, they realize themselves as human beings. Even if they create destruction and terror for the bosses, in their hearts, and in the hearts of the exploited, there is joy and calm.

222

1.2.3 *Summary of a Civil War Typology* I divide civil wars into six types and three basic categories, however these types and categories are often very fluid as one type spills into another.

Category I: Conventional Civil Wars. I divide conventional civil wars into single-issue wars (issues such as ethnicity, race, religion, nationalism - bear in mind that all wars are actually multifaceted), and wars of secession (which may be based on a single-issue, but are defined by their strategic goal). The distinction between these two forms of war is crucial; note the importance that the United States negotiator of the Dayton Accords, Richard Holbrooke, placed on the issue when he returned to Bosnia in August 1997 to assess the goals of Serbian politician Biljana Plavsic: "...she began by saying, 'I am a nationalist but I am also a democrat.' And I said, 'What we really want to know is: Are you a separatist?'"

Category II: Revolutionary Civil Wars. With their left-wing and right-wing types, revolutionary civil wars are marked by mass participation and efforts to effect radical change. The strategic moment of support from the population is of supreme importance as Mao points out in his little red book: "The revolutionary war is a war of the masses; it can be waged only by mobilizing the masses and relying on them." *My thesis is that no form of civil war - other than a left-wing revolutionary war waged on anti-hierarchical refusal-of-work principles - poses any threat to existing global financial and commercial arrangements.* Although disastrously unsuccessful in the past, these revolutions potentially threaten the global economic environment - an example set in one country, such as France's 1998 jobless movement, in which the unemployed unabashedly said that they wanted "full lives, not full employment," could be followed in other countries and, conceivably, generalized the way revolutions spread across Europe in 1848, or again around the world in 1968. Unlike other civil wars, a generalized civil war based on the refusal of work would interrupt the historic moment of our time, namely the

reproduction of daily life on a planetary basis by the capitalist system of production and consumption, more succinctly called the commodity economy, or simply, the spectacle.

Category III: Undefined Civil Wars. Undefined civil wars may entail the seizure of state power (coups, palace revolutions, etc.), or the molecules of civil war (riots, occupations, arson, looting etc.), or a combination of both aspects.

1.2.4 *Towards a General Theory of Civil War* From a rational and humane perspective, the established order does not want to fight its own population, even though it attacks its citizens on a daily basis with psychological warfare. This moral high ground of non-violence (or quasi-legal violence) has proven itself the best way to gain the support of the population; extra-legal violence receives a mixed response at best. Although support created by supervised public opinion, in itself, may not be enough to assure peace or victory in the event of hostilities, the hostility of the population is, for the State, deadly. Over the course of my thesis I will periodically highlight ways in which this support is won and lost, and some of the sources of contemporary tyranny that might justify revolt on the part of the population.

I also analyze the results of the two ends of the spectrum of tactical approaches to deal with civil war situations: repression and concession. The first approach, almost always disastrous, may involve the use of extra-legal paramilitary tactics against opposition forces, or other forms of excessive repression. The second approach, much less risky than appears to be the case as events unfold, is to offer concessions and perhaps even the sharing of power with the representatives of opposition forces. For all practical purposes, concessions and repression represent the two extremes open to the established order - if one wanted to exaggerate, one could speak of capitulation and genocide, but concessions and repression are classic categories used by all regimes on a daily basis. Gurr refers to the use of a mix of concessions, co-option and repression in his *Minorities at Risk*, and he is correct to

224

do so. But I want to highlight what I perceive to be the differences between pursuing these divergent options, and then make historical judgments about them to put my points in higher relief. When discussing opposition forces, the concepts of capitulation and struggle are a more accurate representation of the widest range of options, and concessions are a highly important option as I make clear in my discussion of the Spanish Civil War. While I intend to look at the poles of repression and concession, history dictates that I look at other options and their combinations and make my judgments accordingly.

By fighting a civil war in a way considered fair in the minds of the citizens, the modern prince or princess gives the population an indication that he or she will govern fairly and, by this means, the ruler enlists the support of the population. Even in times of peace, governing elites should bear in mind that the population will not fight to save a civilization unworthy of the name; a civilization of misery, shame, squalor, corruption, etc. By expressing the strategic goal of peace with deeds such as concessions (usually as reforms) and power-sharing, the established order has the best chance of maintaining or regaining the support of the population, without which it will have a difficult time governing.

For now, I cite three examples to illustrate my point. First, recall the way the socialist, Polish regime behind the Iron Curtain gradually ceded power to Solidarity and paved the way for a socialist president to hold power for four years in post-communist Poland (1993-1997). The results of war are never absolute, hence it is sometimes better to concede defeat honorably so as to be able to fight again if one can't successfully co-opt the opposition, or otherwise defend one's position. Poland was not a declared civil war, but it could've been - it was on the verge and went over the brink on several occasions. Only concessions by the Soviet-backed regime prevented it from tumbling into an all-out civil war.

My second example, explored in greater detail in the body of my thesis, is the dirty war waged by the Shah of Iran's SAVAK that precipitated the 1978 right-wing revolution that appears to have ban-

ished monarchy from Iran for good. However, the repression perpetrated by ayatollahs germinates the seeds of future demise.

My third and final example - the killing of Hutu refugees and the repressive restrictions on the activity of opposition forces - will make it impossible for Laurent Kabila to peacefully govern Congo for an extended period of time. He has created too much bad blood to have the support of the entire population. Kabila was correct not to have negotiated with a dictator like Mobutu, but he didn't wage war in a way that would ease his ability to govern. Shoot-outs with rival army factions raised serious questions about the desirability, if not the long-term stability, of President Laurent Kabila's new government, and then escalated into a civil war with foreign interventions.

These tactical considerations in favor of co-option over repressive measures are not absolute and may or may not conform to predicted strategic calculations. At the end of the day, these small civil wars are disasters for the countries that suffer them, but they haven't so much as nicked the reproduction of daily life, the capitalist production-consumption cycle that has held up so admirably despite a few stresses and strains. Shrewd observers recognize the sophisticated, continuous psychological warfare operations aimed at populations by the existing order and the ways people resist this domination. Broad-based movement politics against work, commodities and other hierarchies that lead to generalized civil war, and outrageous demands, such as the universal cancellation of debt, represent the only possibility for historic interventions. Otherwise, the real historical moment will continue to be about putting prices on everything, everywhere, and what follows from this process.

1.2.5 *Historical Assessment of Civil Wars* Throughout my thesis I test and attempt to develop my theory against the major and minor civil wars in world history. Taking a long-term view, I examine the beginnings and effective resolution of the Peloponnesian Wars, the civil wars of the Roman Republic, the Arabic religious civil wars of the VIIth-century, the French wars of religion (1559-1589), the Thirty Years' War

226

(1618-1648), the US Civil War (1861-1865) and the Civil War in Russia (1918-1920) and more recent civil conflicts. From clearcut victory and defeat, to negotiated settlement, partition, and international intervention, I identify the various ways that civil wars are resolved. I also indicate when (before, during or after a given war) the peaceful strategy of co-option might have been implemented, and why.

1.3 General Theory of Civil War

War isn't the acceptance of risk,
It's the pure and simple acceptance of death.

Antoine de Saint-Exupéry

These are good times for civil war. Over one hundred fifty civil wars have occurred since World War II; and the twenty-odd civil wars raging around the world - from Peru to Tajikistan to Zaire to Papa New Guinea - constitute the main feature of global conflict in today's unipolar world. My general theory makes sense of the diversity of small civil wars and should increase consciousness of the distinction between civil and international wars, as blurred as that distinction is given that civil wars are often funded by external powers: the Spanish Civil War (1936-1938) is the best example and worth examining in detail.

1.3.1 *The Spanish Civil War* The nascent Spanish Second Republic, established in 1931, faced numerous obstacles - the Great Depression, differences within the regime and high expectations that proved hard to meet. The Right was demoralized by the fall of the monarchy and the fact that the constitution represented a victory for the Republican Left and Socialists. An effort was made to depoliticize the officer corps, but this antagonized the armed forces. Meanwhile anti-clerical measures rallied support around the Church. Land reform was slow, largely because of resistance from landowners and the Civil

227

Guard. Government repression did nothing to win over the sizeable anarcho-syndicalist movement.

The general election of November-December 1933 fostered an alliance between the right-wing CEDA and the Radical Party, to the dismay of Socialists and Left Republicans. The Radicals wanted a new conservative regime and the CEDA wanted a corporate state - reforms were demolished by CEDA, which led to a split in the Radical party in May 1934. The CNT (*Confederación Nacional de Trabajo*) went on strike in Saragossa; an agricultural stoppage took place around the same time. Three events in October 1934 - a massive general strike, the declaration of Catalan independence and an armed rising in Asturias - polarized the Republic.

In 1935, the left-wing parties, with the exception of the Socialists, unified in the Popular Front. The 1936 elections were hotly contested, and the Popular Front managed a narrow victory over the Nationalists. The situation was chaotic, with landless peasants occupying land while the Socialists increased their revolutionary propaganda. The monarchists (Carlists) and the Falangists (Spanish fascists) turned up the volume of their propaganda and provoked street violence while a faction in the military planned a coup d'etat. It was the intransigence of the Socialist leader Largo Caballero in not allowing his moderate comrade Indalecio Prieto to become prime minister in May 1936 that deprived the Republic of its best chance of containing the conflict. The failure of the attempted military coup on July 17-18, 1936, led to full-scale civil war.

The actual conduct of the war pitted the insurgent Nationalists - operating out of Spanish Morocco and the north, but also controlling southern cities - against the Republicans in Madrid, Catalonia and the Basque region, and most of the south and east. The Republic retained the navy, army, air force and Civil Guard, but faced the intervention of Nazi Germany and Fascist Italy. These countries airlifted Nationalist troops from Morocco to mainland Spain and provided considerable support, including a hundred thousand Italian troops and the German Condor Legion. Britain and France failed to support the

Republic; however, the USSR did provide conditional assistance to the Republicans. Mexico gave unconditional, if limited, support to the Republican side. The legendary International Brigades - volunteers organized by Comintern but including people of various political stripes - gave crucial support in the early defense of Madrid and more.

The revolution that took place within the confines of the Spanish Civil War was unprecedented in both its scope and anti-hierarchical character. Agrarian and industrial collectives spontaneously transformed the Republic, which inspired the anarcho-syndicalist CNT and dissident Marxist POUM to view revolution as the means to win the war. Unfortunately, Communists, Republicans and moderate Socialists took suppression of revolution as their strategy to win the war. Again, it was the socialist leader Largo Caballero, now in power, who contained the revolution and tried to fight Franco on his own terms with a conventional army. In the view of the British anarchist Vernon Richards and his Spanish sources on the issue, anarchists were wrong to join the Socialist-led cabinet and not simply because it set a bad precedent of anarchists entering a government - they joined a counter-revolutionary government during a revolution! Others, such as the American anarchist Sam Dolgoff, disagree with this anti-participationist view on the grounds that the anarchists were doing what they could to save the Republic. I'd like to think I'd've gone down swinging, but I probably would've retreated to France with many others.

With material aid from the Soviet Union, the Spanish Communist Party (PCE) was also in a position to suppress the revolution in accordance with Soviet policy goals. After the PCE and CNT fought it out in the streets of Barcelona in May 1937, Largo Caballero stepped down. His successor, Juan Negrin, foolishly worked with the PCE in suppressing the POUM and marginalizing the CNT. In the spring of 1938, Franco divided the country in half militarily and rejected Negrin's talking points. Negrin made the additional error of unilaterally withdrawing the International Brigades in October 1938 in the midst of the battle of Ebro - the most devastating conflict of the war - in the false hope that the Italians and Germans would follow suit. Negrin thought

that the imminent collapse of appeasement and the generalization of the conflict across Europe would save the day. It did not. Catalonia fell in early 1939 and Madrid followed soon afterward. In hindsight, it seems that the position of the POUM and CNT made more strategic sense. The revolution corresponded to real and profoundly felt popular needs and ideals - had these ends been pursued, more of the population could have been won over to the Republican side. Nationalist victories would have been met with so much local opposition that they would have been very short-lived as guerrilla revolutionaries ambushed their occupiers at every turn.

It seems clear that the Socialists must take the most blame for the Spanish Second Republic's demise, although Communists in the service of Moscow comported themselves like lap dogs, albeit vicious ones. Prior to the start of the war, the Socialists made no concessions to the Popular Front government with whom they could reasonably have been expected to be allied, and thus played into the hands of the Nationalists by weakening the Republic. During the war, Socialists and Communists made no concessions to the revolutionary forces of the country and violently opposed them, weakening what would have been a natural alliance had the Socialists and Communists been more conscious of the need to win the support of the population and not fight Moscow's war. The concessions offered by the Socialists to the Nationalists at the end of the war were made out of desperation. Contemporary observers mention that in the midst of total war, such as the battle of Ebro, everyone knew Franco would stop at nothing less than total victory. The time for Socialist concessions was earlier and should've been made to opposition forces on the Left, not the Right.

Furthermore, the Spanish Civil War is indicative of the way revolution and civil war are intertwined, and of the way Socialist Party and Communist Party members have been, in plain historical fact, counter-revolutionary. For this reason, the issue of anarchist participation in the government is such a touchy subject. The heroic example of the Nestor Makhno anarchist guerrilla movement during the Russian Revolution might have served as model for the CNT-FAI - there are

moments in history when a highly honorable defeat is preferable to a dishonorable alliance. In a revolutionary situation, the true partisans of revolution must find allies and support in the population, not with party politicians. The Marxist-Leninist party types of the PCE can never wash the blood of anarchists and partisans of POUM from their hands because they were directly responsible for their deaths. Robert Michels' *Political Parties* (1911) is the standard reference for a critique of the inherent hierarchy in party structures and the problems posed by these hierarchies, but I would like to refer the reader to pointed remarks made in the Forties by the Dutch council communist Anton Pannekoek:

> Many workers already realize that the rule of the Socialist or Communist party will only be the concealed rule of the bourgeois class in which the exploitation and suppression of the working class remains. Instead of these parties, they urge the formation of a "revolutionary party" that will really aim at the rule of the workers and the realization of communism. Not a party in the new sense as described above, but a party like those today, that fight for power as the "vanguard" of the class, as the organization of conscious, revolutionary minorities that seize power in order to use it for the emancipation of the class.
>
> We claim that there is an internal contradiction in the term "revolutionary party." Such a party cannot be revolutionary. It is no more revolutionary than the creators of the Third Reich. When we speak of revolution, we speak of the proletarian revolution, the seizure of power by the working class itself.

If the latter point is somehow in doubt, I remind the reader of the history of parties and unions overtaking bottom-up revolutions: in 1917 Russia, when the discredited Bolsheviks took power to the deceitful cry "all power to the soviets"; in Germany in 1918, when leftist party politicians again swindled the worker and soldier council movement; and again in Italy in 1920, when the Socialist Party and unions opposed the workers' council occupation of factories. Most people don't know much about council communism; I'd like to give a brief sketch

231

of its historic moments, which stand out as the greatest expression of political intelligence in the XXth-century, for several reasons: (1) because they illustrate what can happen when workers come together outside of the influence of corrupt unions and party politicians, and (2) because they are precursors to the rise of zeroworker councils mentioned in the zerowork theory of civil war. In these two respects, councilism responds to the question: What, in contemporary terms, is the best strategy to oppose tyranny?

1.3.2 *The Historic Moments of Councilism* In every truly revolutionary situation, such as Russia in 1905 and again in 1917, as well as in Germany and Austria in 1918, workers' and soldiers' councils arose spontaneously and attempted to organize economic and political life by extending the council system to a national scale. Proponents of councilism hold that the principles of workers' councils attract the most rebellious sectors of the proletariat - those willing to impose the dictatorship of the proletariat. We know that councils formed spontaneously at the beginning of the 1905 General Strike in Russia by printers in Moscow, and that as a form of organization, the council was discovered by the workers themselves. The famous St. Petersburg Council of Workers' Deputies represented 200,000 workers during the strike with 562 delegates. Unfortunately, the executive committee was composed of twenty-two workers and nine representatives from the three revolutionary parties who had a consultative status and weren't entitled to vote, but who exerted an enormous influence on the committee.

In February 1917, another spontaneous general strike shook Russia and the Czar's government fell. Worker's councils sprang up in factories all across the country. When their demands were refused, the workers took over administration of factories by decrees that banished management from the workplace. By October, the revolutionary moment had arrived - the Bolshevik Party seized state power in the name of the workers, peasants, and soldiers as the populace called for workers' control, land, and peace. Lenin wanted syndicalization to facilitate nationalization, but the workers themselves took possession of facto-

232

ries and drove out their employers.

Lenin prevented the convocation of a planned All-Russian Congress of Factory Councils and set up his Supreme Soviet of National Economy that effectively thwarted inter-council relations at the grassroots level. The result was a Bolshevik dictatorship of a capitalist state monopoly. By crushing the Kronstadt uprising, whose credo was "All power to the soviets, not to the parties," Lenin emasculated the soviets in Russia to the point where we no longer think of workers' councils when we hear the word *soviet*. As for the international communist movement, Lenin wanted all power for his party, the Russian party. The upshot was fierce opposition between party communists and anti-parliamentarian, anti-trade union council communists like Anton Pannekoek to whom Lenin addressed his *"Left-wing" Communism: An Infantile Disorder.*

Elsewhere, by October 1918, the war effort of Germany and Austria-Hungary collapsed. Soldiers were deserting left and right, and Emperor William II was forced to rely on the powerful Social Democratic party to hold the centralized state together. The left wing of the party, composed of the likes of Karl Liebknecht and Rosa Luxemburg, the Spartacists, were closest to the workers and soldiers in the uprising, but in reality, the shop stewards and sailors organized their own takeovers and mutinies through their spontaneously formed councils. The worker and soldier councils attempted to extend economic and political organization around the council system to the nation as a whole, but only belatedly recognized the difficulty of realizing social revolution that excluded most of those removed from the point of production. The councils eventually voted themselves out of existence by supporting the National Assembly, where they were dominated by the Social Democratic bureaucracy that defied several council decrees.

In Italy, in 1920, the Italian workers who had been organizing for two years into factory councils (some 150,000 Turinese, and hundreds of thousands more in Milan and other parts of the country), occupied thousands of factories, took over management and started up production under their own direction while protecting the plants from

counter-attack. The revolution was opposed by the unions and by the Socialist Party; they effectively crushed the movement by keeping it in isolation. The Socialists, for example, refused to print the appeal of the Turin workers who were under siege by troops. Mussolini immediately rose to power following these events with the promise to clamp down on worker autonomy - a promise that he kept.

The Hungarian Revolution of 1956 reveals how workers' councils became the natural organizational form in revolutionary situations, because they take shape with the speed required to match the accelerated pace of events. What began as a students' and writers' protest movement became a proletarian revolution overnight. The students' protest was joined by workers in the march to Parliament on the night of October 23, and even more workers joined in as they marched together to the radio station to broadcast their demands. After a night of fighting sparked by the security police massacre of protesters outside the radio station, the Revolutionary Council of Workers and Students went into permanent session and called for a general strike.

While the reversal of allegiances by Russian tank drivers showed how easily the military can be co-opted, the speed with which councils spread to all industrial centers of the country and to the countryside was the most incredible fact of the Hungarian revolution. The councils immediately began to link up. As a United Nations representative noted: "Workers councils are the only real authority in the country." With the exception of medical, electric and transportation industries, the strike continued; and councils in the countryside began to redistribute land. Like all revolutions from below, there was lots of arguing and agitation as to what was to be done, but when it was discovered that the Red Army was not withdrawing as the government promised (it was massing its forces for another intervention), the councils were united in maintaining the strike. During the second Red Army assault, workers' council members fought to the death in what became one of the most poignant massacres of the XXth-century.

It is often overlooked that a workers' council movement rose up during the 1968 Prague Spring:

The major development affecting industrial labor was the workers' councils movement, sketched out in the Action Program and endorsed in principle by the cabinet in June, despite foot-dragging by the old official trade-unions who saw their power threatened. Prior to the Soviet intervention, actual councils were formed at the Skoda works in Pilsen and a few other large enterprises, though they had no legally defined role. Interestingly enough, the intervention did not stop the spread of the council movement up until early 1969, when the government actually published a draft law on enterprise autonomy empowering enterprise councils to elect the director and approve plans and policies. This was the high-water mark. The new law was never put in force, and Soviet-style "normalization" soon crushed the experiment in industrial democracy. (from Robert Daniels' *Year of the Heroic Guerrilla*)

*

The threat of revolution from below, if it reappears on the stage of world history, may again take council form, or else something like the Spanish CNT (although one would hope it would be militarily less timid and theoretically more astute). Only in its more anarchistic moments, which is to say prior to November 1936 when four anarchists were duped into joining the Socialist-led Cabinet, does the CNT offer much inspiration. The popular assemblies of the Portuguese Revolution of 1974-1975 may, likewise, offer some inspiration to those who would contest the current order.

As with the Spanish Civil War, which was one of the most atrocious wars of the XXth-century, the great civil wars of world history - the Peloponnesian Wars, the Arabic religious civil wars of the VIIth-century, the French wars of religion (1559-1589), the Thirty Years' War (1618-1648), the US Civil War (1861-1865) and the Civil War in Russia (1918-1920) - were all fought over big ideas, but were inordinately costly. In his typology of wars, Gérard Chaliand calls civil wars "wars of no quarter" because of the incredible loss of life. Hence, the best strategy

for the established order is to avoid civil war, if possible, because peaceful rule by means of law and order is the best way to sustain rule. Failure to govern this way runs the risk of dangerous civil wars that, by their deadly nature, offer no acceptable solutions.

While current headlines mention civil wars resulting from the revindications and irredentism of ethnic, tribal or religious groups, these conflicts tend to be local or regional. In their isolation or when viewed collectively, conventional civil wars don't pose a significant threat to the established world order. Once in power, the former opposition forces tend to immediately, or at least eventually, accommodate the global financial and industrial elite. The Zairean rebel Laurent Kabila, for example, gives every indication of following suit even though he was once a radical comrade of Che Guevara. The reluctance shown by the dominant nations to intervene in these conventional civil wars demonstrates that there is a realization everywhere that these wars aren't worth fighting. As Hans Enzensberger puts it, civil war "has become bad business."

Right-wing revolutionary civil wars, such as the Iranian Revolution, appear to pose a more significant threat. Although Iranian religious rulers and other Islamic fundamentalists often behave as rogues with their assassination-level wars and efforts to export revolution, they have no real qualms about maintaining business as usual with the global financial and industrial elite. The opposition to the occidental paradigm is cultural, not commercial.

The real threat to the existing world order is much the same threat that has been bad for business in every industrialized country over the last two centuries: class war. For Marxists, civil war is an acute expression of class war, which is called class struggle in Lenin's lexicon. In my estimation, the world may be approaching a moment akin to the European revolutions of 1848, when governments were blamed for the misery and anxiety that affected most of the population. These historic episodes merit closer inspection because they reflect the development of mass politicization during a moment of accelerated economic and social change.

236

1.3.3 *The Revolutions of 1848* In France, a banned demonstration for electoral reform and the use of the army to disperse crowds led to violence in the streets. Although calls for broader political participation were made by those already in the political sphere, it was tradesmen, workshop owners and skilled workers who manned the barricades. They wanted more money, more respect and, in general, a better life. They resented the employers who exploited them and excluded them from political debate. The news of the Paris riots in late February spread the expression of discontent to Vienna, Milan, Venice and Berlin.

The Austrian and Prussian monarchies quickly promised constitutional reform. In France, a small group of bourgeois republicans took power and introduced electoral reform and the right to work. Yet this participation didn't prevent much of the previous regime from remaining intact, as was the case in Austria and Prussia. Those who had new-found power were moderates who wanted to avoid more violence; they compromised with the existing elites. Germany was faced with both reforming individual states and achieving greater national unity, while coming to grips with massive unemployment caused by revolution. Talk spread of cooperatives and communal use of common land. The last remnants of serfdom were called into question, but once a few concessions were made, the economic elites retrenched and did their best to avoid social change.

In France, the Church and other traditional elites swayed the electorate away from radical reform. When the government announced the closure of national workshops, riots ensued. The government's military victory against the masses gave considerable ammunition to Marxists, who saw it as the first great battle between the bourgeoisie and the proletariat. Meanwhile, the Austrian army regained control of Prague; likewise in Berlin and Vienna, where thousands were killed. Eventually, northern Italy and Hungary were subdued by the Austrians.

As the story goes, a proud Fredereick-William IV would not

237

accept his crown from the elected Frankfurt Parliament because its members were bourgeois jurists and officials who wouldn't resist the monarchy. They wouldn't risk radical rebellion, they simply gave in and dissolved their assembly. The protests in south-west Germany and Dresden, where anarchists such as Bakunin manned the barricades, were easily suppressed. Nonetheless, the spirit of democracy gained ground, and the conservatives did their best to modify the electoral systems to prevent democrats and socialists from gaining power. In France, Louis Napoleon was elected in December 1848 and would go on to stage a "Brumaire" comically modeled on that of his more illustrious ancestor. In Austria, Prince Felix Schwarzenberg became chancellor under the banner of modernization and Germanization of the monarchy. Mass discontent was quickly reduced by (1) improvements in the standard of living, (2) the conservative socialization of the masses through education and the mass media, and (3) limited political reform. The demise of this new social order wasn't engendered so much by the limited democratization that took place during the revolutions, but rather by the nationalism that was the unfortunate legacy of these events. The reactionary force of nationalism eventually precipitated World War I, destroying the XIXth-century world altogether. The established order's policy of concession-retrenchment-good government was relatively successful. Those fighting for social-economic justice, on the other hand, made relatively minor gains and were unable to attain the total change called for by their most radical theoreticians.

1.3.4 *Conclusion* Civil war is the most primal form of conflict and the perfect expression of ungovernability, to use political science jargon. By definition, the nation-state possesses a monopoly on violence, but this essential aspect of the nation-state is being challenged in numerous parts of the world by so-called non-state actors. Today's civil wars are found primarily in Africa, the Middle East and Asia, but the potential for civil strife is present in most societies. When these separatists or racists or rebels or religious zealots raise the flag of civil war, judge their actions in reference to their strategic goals.

The goal of the established order should be to maintain peace using either counter-insurgency measures or by making concessions to the opposition, or a combination of both, to avoid the disastrous consequences of civil war. Concessions and co-option of opposition forces have the advantage of lending a sense of legitimacy to the established regime, whereas counter-insurgency measures can easily alienate the population as a whole, while the military engages in the process of fighting rebels. Opposition forces can either work within the existing system or try to subvert it - concessions can be accepted with ulterior motives in mind, or rejected in favor of excessive demands designed to provoke more conflict.

During conventional civil wars of the single-issue type, concessions may be more in order than repression. Granted, these issues can present insurmountable obstacles, but it seems that extensive efforts should be made to overcome them and thus avoid the high and always bloody costs of civil war. If, however, these conventional wars involve a secessionist strategy, limited autonomy might be granted - what is now referred to as devolution - but each state must decide if it can afford to lose a region of its territory. Given its immensity, Russia should have conceded much more quickly in Chechnya; Spain, to cite another variant, might be remiss in granting complete independence to the Basque region, and thereby lose what some would argue is an essential aspect of its national unity.

As for revolutionary civil wars, the history of the XXth-century teaches us that socialist and communist party leaders can be easily co-opted; they are too easily impressed by lunch with this or that member of parliament to remain loyal to their worker base. Although one would have difficulty imagining sub-comandante Marcos attending a party at the presidential palace in Mexico City, most party and union leaders are susceptible to these overtures, especially in advanced industrialized countries. Authentic left-wing revolutionaries should avoid party politics and expose the true nature of power-hungry Leninists, whether they are dressed like Mao, Che or Abbie Hoffman. Beyond that, left-wing revolutionaries should do what they can to win

the support of the masses and prepare for revolutionary moments that call for going all the way. Right-wing revolutionaries pose greater problems for republics and parliamentary democracies because they tend to be able to forge close ties with industrialists and the military. Once in power, or close to power, they use these alliances to brush aside any democratic checks on their domination.

One must be much more careful when dealing with right-wing revolutionaries than with the current breed of left-wing revolutionary leaders. Civil wars erupting over the seizure or attempted seizure of state power must be opposed with force, because force only responds to force. As for the molecules of civil war, much of this essay has argued in favor of the use of concession to appease disgruntled groups, who would contest the totality of social relations to such a violent degree. Policymakers, when confronted with a non-state actor using a flawed strategy (such as terrorism), might allow the protagonist to continue his erroneous terrorist campaign, shooting himself in the foot. The jobless movement in France (1988) gives some indication of both the success and possible limits of verbal violence and a strategy of occupations.

In a more commonplace sense, these strategic considerations can also be applied to governing. Administrative authorities should try to create a society that the population is willing to defend. Here poll numbers and a subjective reading of the degree of consent of the governed remain vital indicators. I'm reminded of the way President Clinton has worked with the representatives of his opposition and adapted his policies accordingly. This tactic is a better way to win over the support of the population than severe counter-insurgency tactics, such as arrests and temporary detention, overt use of defensive terrorism (bombings, death squads) and the overturning of elections as in Cuba 1921, Guatemala 1954 and Chile 1973. Overtly unjust counter-insurgency techniques on the side of domestic defense, security forces or the civil guard do not mount as good a defense for the established order as convincing the political elite to share its power, and to placate the masses with the illusion of reform.

To turn again to Italy, while Prime Minister Prodi had problems governing with old-guard communists who claimed to have refounded the Communist Party as part-time allies of his coalition, it was much harder for him to govern without them because he was forced to turn to his conservative rivals for votes. Prodi's Olive Tree coalition, in which his party was a weak member, lasted longer than anyone thought. He was succeeded in fall 1998 by an ex-communist in a coalition with communists.

Whereas Peruvian President Fujimori's commando raid on the Tupac Amaru rebels holding hostages in the Japanese embassy in Lima was tactically successful, exemplifying the dictum never negotiate with terrorists, Fujimori could easily lose this war. His poll approval numbers were up to sixty-seven percent after the hostage affair in April 1997, but he continued his tough guy stance against the insurgents, while offering no concessions to the poor and continuing to suspend Peru's constitution. By stripping his rival, Baruch Ivcher, of Peruvian citizenship, for broadcasting news about widespread telephone-tapping of journalists, businessmen, politicians and ministers, Fujimori created more problems than he appeared to be fixing. By July 1997 his approval in the polls had plummeted to twenty percent. The drug-running military with whom he shares dominion - who most Peruvians know are really in control - has a long history of brutality and corruption. The officers have no interest in solving the nation's dire problems of poverty, racism and other forms of injustice.

The best defense of the established order is the offense of creating a fair justice system, rooting out governmental corruption, having an orderly succession of government, limiting the scope of black markets, regulating commerce, providing secure banking within a sound financial structure, and granting considerable autonomy to ethno-nationalists who want to foster an open and diverse democratic culture. The government must provide basic services - roads, schools, hospitals, waste management and health care - and it must do what it can to influence social health in a positive way.

Good examples of this are the land reform concessions granted

by Brazilian president Fernando Henrique Cardoso to the Movimento Sem Terra (MST), family farmers who have won huge public support through their demonstrations and land invasions. The question is whether these reforms are enough, as was not the case with the belated land and promised constitutional reforms granted by the czar on the eve of the Russian revolution. For those who would wage war to attain social justice and economic equality, the same sense of fair play is at stake in winning over the population to long-term support for a revolution. Revolutionary movements should nonetheless be ready to cross the line of legality - in occupations, sabotage, illegal strikes - so long as they have popular morality and support behind them. Concessions should only generate increasingly radical demands (to be taken up with care at times and audacity at other moments in the struggle) until the day, should it ever arise, that a just, non-hierarchical society is fully realized.

The main examples that I have given so far - the English civil war, the Spanish civil war, the historic moments of councilism and the revolutions of 1848 - support my general theory of civil war. More proof appears in the expanded typology in part three.

Part II Kill Your Inner Cop

2.1 Definitions

2.1.1 *Strategy* is the general's art of directing troops, but it's more than that, it's part of war itself - the evolving conduct of war and the organization of defense. Strategy always involves logistics and geographic considerations, but this essay is primarily concerned with broad strategic objectives involving basic political and diplomatic situations. Yet these global strategies are dependent on military strategic objectives, both of which are limited by operational strategies. Indeed, operational strategies involving the use of repressive, terroristic tactics often negate the broad strategic goal of both sides, to win over the support of the population. Too often politicians confuse a sound strat-

egy with a stratagem: a trick designed to deceive the enemy.

Since the era of Pericles, strategy has been the key link between civilian and military resources available to those with political power. Pericles ran the foreign affairs and military campaigns of Athens for fifteen consecutive years, hence his influence as a strategist was immense. Students of strategy understand that, for the Greeks, strategy entailed forming alliances and collecting contributions from allies, conscripting soldiers and implementing war taxes. For the Romans, a strategist was the commander of a large military unit, which may have involved acting as governor of a region.

Civil wars pose strategic questions about the legitimate use of violence both for State and non-State actors (private armies, paramilitary groups, rebel forces, parallel operations, guerrillas, terrorists, gangs, warlords, Mafiosi, rioters, arsonists, etc.). But for experts such as the French strategist Foch, strategy implies an intelligent understanding of the situation while making a decision, a sort of strategic intelligence in a war of wills that gives rise to many questions:

1. What is the mission? For whom? When? Where?
2. Where do we stand in regard to the more important elements in play in the overall situation? in regard to the mission?
3. What is the terrain?
4. What are the adversary's military capabilities? What are ours?
5. What are the strengths and weaknesses of both sides?
6. What sort of maneuvers can we make?
7. What methods of action do we have? what are the possible modes of action of the enemy? how do the two compare?
8. What are the phases of our action plan?
9. Who will do what?
10. What are the secondary aspects of our plan and the possible consequences?
11. What decision should we make? Is it executable?

acceptable?

12. Should other options be reconsidered? should the plan be rejected?

Betrayals and treason are potential events that can't always be predicted by strategic reasoning, but in the case of civil wars, the strategic objective of winning over the support of the population makes intangibles, such as loyalty and trust, much more important than they would be in the case of a military operation in a foreign country.

Clausewitz writes of the *Zweck*, the situation one wants to engender, and the *Ziel*, the goals of the conquest. For the established order, the *Zweck* is a long peaceful rule and the *Ziel* increases its powers of domination. For opposition forces, the *Zweck* is to replace the existing order with a new one; its *Ziel* is to destroy the existing regime and pursue conquests in all sectors: diplomatic, economic, military, industrial, commercial and, above all, culture where the seeds of a new civilization grow. Other objectives, such as the creation of riches with little wage labor, and the institution of social income for the population, are weighed into the calculus of operations and tactics. To preserve the status quo, the existing order will try to dissuade its rivals and simultaneously intimidate or interdict them. All strategies - attrition, salami, dominos, genetic - have their military rationale, even the notorious scorched earth strategy, which, in the case of civil wars, is disastrous for either side.

2.1.2 *Logistics* comes from the word *logis*, or the housing and feeding of troops. It's now defined as the procurement, distribution, maintenance and replacement of materiel and personnel.

2.1.3 *Tactics* is the science of calculating and choosing where, when and how to strike. Tactics always involve considerations of the immediate situation in each specific theater of conflict. The established order has a plethora of means at its disposal, but the primary tactics I am concerned with are terrorism, offensive and defensive, and co-optation. The old Haitian model of overtly terrorizing the civilian popu-

lation corresponds to the offensive use of state terror and highlights its link with corruption. The defensive use of terror corresponds to the Italian model of covert use of artificial terror by agent provocateurs in the strategy of tension (the creation of enough social tension using artificial terror to justify a military *coup d'état*). Special operations tactics include the use of sabotage, assassination and psychological warfare. Naturally, non-state terrorist groups engage exclusively in the offensive use of terror, unless they have been co-opted by the state for the purposes of defensive terrorism.

The alternative tactic of co-option, that is the absorbtion of opposition representatives into the established order, may involve real concessions, or may simply require personal persuasion.

2.1.4 *War* is the large-scale and deliberate destruction of fellow humans: what Clausewitz called "a duel on an extensive scale." In modern warfare, the main goal of hostilities involves destroying enemy military facilities and armed forces, followed by its economic base and State system. Ultimately, it's a judgment call as to whether a war is more or less civil (between fellow citizens) or international (between nations with professional militaries).

2.1.5 *Civil* Given the meaning of the word *civil* - of civilians, as distinct from military or religious groups - one might falsely assume that civil wars do not involve a nation's military or religions. This is not the case. The military of the established regime is likely to be involved in most civil wars, and rival military factions might engage in civil war, as General Franco did in the Spanish Civil War. The civil war in Lebanon among Christians, Muslims and Druze in 1975, demonstrates the way religious groups can become involved in civil wars.

War is the apogee of politics. International wars can be used to forestall social revolt, but as history reminds us, these wars can be turned into civil war.

2.1.6 *Psychological warfare* is political and ideological violence

245

carried out by various civil, military and opposition elements targeting its people or those of another country, or vice versa. The use of this sort of propaganda (disinformation aimed at the masses) was used extensively in the name of nationalism during World War I. The Nazis and Bolsheviks improved on these techniques before and during World War II, an ideological war par excellence. As with the Cold War, blaming the adversary is the most common tactic - this was also the case during the Sixties and Seventies when the Occidental nations were the object of an intense psychological war by anti-imperialist groups and peoples who waged a propaganda war of their own. Psychological warfare was attempted by the Carter administration, using human rights as the main thrust. Reagan, with his considerable acting abilities and virulent anti-communism, made an able psychological warrior. Bush and Clinton clearly registered the importance of public opinion and did what they could to gain public support for their military operations in the Persian Gulf.

2.1.7 *Urban insurrections* The classic examples of urban insurrections are found in France in 1830, 1848, 1871 and 1968, where the decisive role was played by the proletariat. In my opinion, the strategy of fomenting urban insurrections is now invariably fatal in advanced industrialized nations, due to the degree to which cities can be surrounded and isolated. Electronic weaponry makes these conflicts even more one-sided; they're only viable in less developed countries, or, potentially, in developed countries when there is overwhelming mass support for the operation. In practice, this support isn't forthcoming, in part because those who would effect this operation work in secret, and therefore cannot very well cultivate mass support.

2.1.8 *Guerrilla warfare* (from *guérilla*, or little war in Spanish) is the euphemism, coined during the Spanish resistance to Napoleon's occupation (1807-1812), to describe operations of irregular troops, generally the weaker side in the conflict, against a stronger regular army. This form of war includes surprise, mobility as well as being a menace

246

to a regular army, and shares traits with wars dating to ancient China and Greece. Guerilla warfare is often the preferred method of at least one side in civil wars. Its importance is illustrated by post-World War II maps of the world that were transformed by guerrilla struggles: China, Cuba, Nicaragua, Algeria, Angola, Mozambique, etc. Vietnam was, likewise, a guerrilla war where the long duration of the conflict played into the hands of the North. Quite often these conflicts end in negotiated settlements, but this is hardly ever the case when the established power is a dictatorship. The goal of a guerrilla force is to be strong enough to ceaselessly bother the enemy, little by little, so as to weaken its supply routes by attacking convoys, intercepting its communications and surprising its forces that happen to be isolated. As in an occupied city or village, the regular army should feel as if it could be attacked at any moment and thus only travels in groups. Under these conditions, the regulars become tired, frightened and vulnerable to defeat, even if they have numerical and logistical superiority.

2.1.9 *Terrorism*: bombings, kidnapping, hijacking (with and without taking hostages), assassinations - terrorism is a substitute form of guerrilla warfare used by movements that either have limited political support, or, more rarely, by movements having a large social base. Terrorism derives its name from the Terror of the French Revolution when, in the name of popular sovereignty, the revolution justified the use of State terror.

Terrorism is largely an aspect of psychological warfare, because its psychological impact far exceeds the actual physical effects of the violence used in the operation - the watershed case is the hijacking, in 1968, of an Israeli El Al airliner in Rome by the Popular Front for the Liberation of Palestine. The classical equivalent of terrorism is the tyrannicide lauded by Cicero in his rhetoric, but acted upon by the great defender of republican virtue, Marcus Junius Brutus. If there is a historical antecedent to the ideological purity of today's terrorists, it is the infamous Assassins of the XIIth and XIIIth centuries, the secret band of hashish-eating Moslems who killed Christian leaders during the

Crusades.

The modern conception of terrorism dates to the Russian populists, the Narodniki (1878-1881), whose assassination attempts against the Czar were an expression of a general social crisis, namely the last resort of those facing a despotic regime. The Narodniki condemned the use of terrorism in the democratic United States (President James Garfield was assassinated in 1881), when they read about the event back in Russia. The Narodniki and the anarchist ideologues of terrorism recognized that these operations were highly risky; they thought of terrorist operations (the "propaganda of the deed") as a way to spark the revolutionary spirit of the masses. The Anarchist International was formed in London in 1881 as the number of terrorist attacks in France increased: Ravachol was the Carlos the Jackal of the period, as the street song La Ravanchole attests: "It will come, it will come. Every bourgeois will have his bomb."

Terrorism in a modern democratic society is less risky, and arguably more cowardly than guerrilla warfare, and amounts to a deadly means of expression given the media's fascination with spectacular displays of violence. Note that for Marxists, terrorism is eschewed in favor of the collective violence of civil wars, such as the Paris Commune, that spread to other cities (see Marx's *The Civil War in France*). In a remarkable way, the terrorist act of assassinating Archduke Ferdinand precipitated World War I. In the post-war period, terrorism became more localized, with the Irish using all forms of violence at their disposal to fight the British, and the Macedonians using terrorism to contest Ottoman domination, while the Armenian Dachnak party used it to seize the Ottoman bank in Constantinople in 1896. In the Twenties and Thirties, terrorism was used increasingly by the Right - Romania's Iron Guard, Croatia's Ustashi, and the Zionist Stern Group (the latter, ironically, in the form of bus and market bombings during the Arab revolt of 1938-1939).

The next proponents of terrorism were the liberation movements of the Sixties and Seventies who used it, and then only rarely, as a special branch of their armed forces. The exceptions to the limited

248

use of terrorism by liberation movements were the Kurds in Iraq, the Eritrians, the IRA, the PLO and the FLN in Algeria. The latter were notorious for their use of terror to liquidate the agents of colonialism and rival movements and to intimidate and control the population - as I describe below, this legacy is alive and well in the outskirts of Algiers. The example of the PLO demonstrates that terror can make a movement well-known and keep its existence in the minds of people worldwide, but this success is in marked contrast to actual damage and limited military gains.

Most terrorist groups tend to be progressively liquidated by their foes and then, due to internal crises and a weak social base, they self-destruct. This is often the case with revolutionary groups in Latin American or emigrant nationalist groups who use terrorism as the primary weapon in armed struggle, as well as with revolutionary sects in advanced industrial societies who have no social base to speak of - the Weathermen in the United States, the Red Army Faction in Germany and the Red Brigades in Italy, all of which attempted to use violence to show the masses the coercion of the system, and gain adherents by means of the consciousness said to be developed in the spiral of violence and repression that these groups blamed on the State.

In reality, these groups gain little more than passive support from the populace and the groups themselves tend to break up in faction disputes. The spectacle of violence may engender a euphoric phase of operations whereby, for example, a lack of victims may elicit support from the population. But this popular sympathy is bound to diminish as long as violence is used as a substitute for winning over popular support, which is difficult given the limited room to maneuver afforded clandestine military organizations.

These organizations want to make a spectacular media impact more than, say, distribute food to the poor, generate mass-oriented propaganda or organize the young. In fact, these risky military operations render potential sympathizers mere spectators, hence even the most selective terrorism ends up being counter-productive.

History demonstrates that the failed efforts of terrorists to de-

stabilize the politics of democratic countries lead to forms of counter-terrorism that are themselves tyrannical. For example, during the so-called German Autumn of 1977, every house was searched and an unexpected level of repression was directed at the Left.

In the final analysis, the media extends privileges to violent actions that are disproportionate to the political importance of the terrorist act, thereby playing into the hands of terrorists who are gratified to see their handiwork on television. The methods of one group are then mimicked by others, even when there is no contact between groups. Other than gaining media exposure, and here terrorism is effective, terrorist operations rarely succeed in achieving serious political gains. The failures of terrorism can usually be foreseen; terrorism, as in Uruguay, Argentina and Turkey, acts as a provocation that leads to the replacement of more or less democratic regimes with dictatorships. Terrorists are often victims of their own propaganda; they overestimate the impact of their actions and tend to lose contact with reality. The Unabomber exemplifies many of these negative aspects of terrorism.

2.1.10 *Counter-insurgency techniques* are forms of anti-revolutionary or anti-nationalist or ethnic insurgency violence perpetrated by the established order - arrests, detention, death squads, etc. They may also include the corruption of electoral systems and psychological warfare techniques, such as spreading rumors. The established power wants to destroy the insurrectionary movement while it is still in its developmental phase, but subversion can sometimes be difficult to identify. Governments have the advantage, because this form of counter-insurgency terror makes freedom appear to be much more difficult to attain than continuing to submit to tyranny; governments have the army, police, administration and greater financial resources in their favor. Counter-insurgency operations are likely to have a strategy that coordinates the police, military and political administration in a determined way. This form of state terrorism has more victims than media-driven terrorism, because the goal is usually to liquidate all potential

250

opposition.

Despite all I've said about popular support, it is a mistake to think that the State absolutely needs the support of the population to obtain a short-term victory; so long as the insurgents don't have the support of a large part of the population, the State can wage a military war on one front and grant a few concessions to the most needy sectors of society on another. Repression may produce the most immediate results, but reforms have a more lasting effect in preserving the interests of the ruling class.

The police are the first line of defense in any counter-insurgency operation, particularly in the beginning of an operation when the use of the military would be viewed as excessive to the public. Infiltration of opposition movements is difficult when they're just beginning to gain ground. Later, infiltration becomes easier, and one informer at the right level may be all that is needed to divide and conquer, a major goal of all counter-insurgency operations. This is true even at the level of society as a whole; ethnic, religious, linguistic, regional, sexual and any other differences are routinely exploited by the forces of law and order. Note, for example, the way the Soviets in Afghanistan exploited ethnic rivalries (and countless other examples).

Insurgency operations should be aimed at the terrain the adversary wants to conserve at all costs; for this reason, I view the workplace as an important battlefield. Insurgents might, on the other hand, want to adopt a flexible strategy of not risking frontal confrontation and conceding territory without a fight at certain moments, only to launch a later surprise attack. Counter-insurgency strategies may involve the production of refugees as a means of evacuating partisans or potential partisans from a contested zone. The main goal is to destroy the clandestine political infrastructure of the insurrection by identifying and eliminating the agents of the insurrection, thereby controlling the population and creating viable conditions for it to live quality lives. This puts the insurrection on the defensive and gets it to submit to authority. Soldiers shouldn't steal and pillage, otherwise all reforms - medical, scholastic, economic - can easily fail.

251

The State's day-to-day response to terrorism may range from prevention and infiltration to manipulation, torture and liquidation. The instrument of law was used by Germany in the Seventies to forbid association with, or propagandizing in favor of, terrorist groups - these laws were abused by applying them against any undesirables. No one technique is universally effective because all insurgencies are historically specific. We don't have a universally applicable way for those in power to handle terrorist situations, but we can point to the "ideal" model in the Israeli raid on a hijacked plane on the tarmac in Entebbe (1976), because of its military effectiveness. More often than not, this sort of military resolution of a terrorist situation fails, for a plethora of reasons. The United States and Israel are the classic protagonists of the categorical refusal to negotiate with terrorists, although they have softened up in regard to Arafat after his long struggle for legitimacy based on popular support, or because they believe in Arafat's manageability.

2.2 Classical Examples of Civil War

2.2.1 *Greece* Thucydides' *History of the Peloponnesian War* is the classic account of civil war, the chronicle of war when arrows and javelins were missiles, when phalanx maneuvers and cavalry without stirrups fought at close range. The war that ultimately ended in Athenian defeat was won by Sparta in alliance with Persia, and paid for with the freedom of the Asia Minor Greeks. Nonetheless, the war was in fact a civil war between Greeks in the realm of Hellas.

As the story of what was actually many wars comes down to us, Athens won the Archidamian War, rebuffing Sparta, the aggressor. Athens' strength came in retaliatory naval raids under Pericles and the aggressive strategy of Demosthenes. After the Peace of Nicias, both sides smelled blood and engaged in a series of raids that ended in Alcibiades' disastrous raid on Sicily. The Ionian War witnessed Spartans and Boeotians systematically pillaging Attica - an area under Athens' immediate jurisdiction. But Athens had its victories, such as the naval battle at Cyzicus that forced Sparta into peace negotiations. At

252

this juncture, Cleophon convinced the Athenians to fight on. Cyrus the Younger and Lysander ultimately ensured Spartan victory through their ability to starve Athens into total submission.

If I were to venture any judgments about these events, so distant from us in time, it would be to point out the folly of adventurism exemplified by Alcibiadies' raid on Sicily, and the inability of Attica to form alliances with, or otherwise divide, the Spartan alliance of the geographically dispersed states of Macedonia, Boeotia and Arcadia. Reforms, diplomatic overtures or refraining from initiating raids may have saved the day, for what eventually became a beleaguered city-state that was handed its head in its hands.

2.2.2 *Rome* The Roman Civil Wars under the republic (78-27 BC) provide an even more poignant example of civil war phenomena, because they, more than anything else, destroyed the republic and engendered empire.

The innovative Gaius Marius, an Italian new man who became a consul at the time of the war with Jugurtha, the Numidian king, allowed the landless to serve in his legions and promised them land after the war. To *all* the victors he promised the spoils of war. When Marius proposed a bill to grant land to his veterans, the senate refused him and, in effect, turned its back on the soldiers of Rome. The legionaries fully expected their commanders to protect their interests - this expectation and the brief but bitter war between Romans and their Italian allies (91-88 BC) set the stage for military rebellion.

In 88 BC, the Roman general and conqueror, Sulla - deprived of his command by Marius and Sulpicus - marched on Rome. Constant fighting between Sulla and other generals exhausted Sulla and he was eventually driven from Rome. But he returned in 83 and dubbed himself dictator. His scorched earth policy put enemies to death and confiscated their land. In this bloody process the constitution was effectively destroyed, although it was restored with pomp and circumstance. When Sulla voluntarily abdicated as dictator, he continued to cast a long, ominous shadow over the late Republic. Civil war raged for the next fifty years as Caesar drove Pompey from Italy; when Caesar was

assassinated, civil wars began again with greater ferocity. Octavian, the future emperor Augustus, waged war with numerous rivals until the republican constitution gave way to his Empire in 27 BC. The secret of military dominion, as opposed to authority residing in the constitution, was kept until AD 69, the year of the four emperors fighting for the throne. I don't want to dwell on the more sporadic Roman civil wars in the IInd and IIIrd centuries, nor those of the late Empire, except to say that nothing posed as great a threat to the Empire as these wars.

Part III War as a Science of Possible Solutions

3.1 Typology of Civil Wars

I distinguish *six types of civil war and three categories,* mindful that such models are fluid because wars often combine attributes. These are not ideal types that abstract the characteristic factors of all civil wars; rather, they are broad classificatory types used to organize specific examples from history to test my concession-repression hypothesis and otherwise assess a civil war. With many wars, the précis or chronicle mimics the unfolding of the moment in its context or, in other ways, avoids a structuralist, archetype analysis.

3.2 Category I: Conventional Civil Wars

I break conventional civil wars into two basic types, single-issue wars and wars of secession, because secession has significant strategic implications that distinguish it from other conventional civil wars. The image of contemporary civil war that comes most readily to mind - the Zapatista insurrection - has aspects of revolutionary war. Descriptively imperfect as such a single-issue civil war may be, it forces the

strategist to characterize a conflict according to its dominant issue, and act accordingly. If peasants are reclaiming land, then that is their issue, even though these peasants may be fighting colonial enclosures on other fronts. If these fronts open up and land ceases to be the burning issue, the conflict might become an anti-colonial war. If single-issue wars develop along separatist lines, always consider the implications of wars of secession.

Writing from the mountains of southeast Mexico, Subcomandante Marcos addresses national and international civil society on the day of the massacre of forty-five civilians in Acteal, Chenalhó (December 22, 1997).

Brothers and Sisters:

Why?

How many more?

Until when?

3.3 Type A: Single-Issue Wars

Single-issue wars, such as ethnic wars and religious wars, are usually based on the strategy of identification and the simple use of superior force. I'm reminded of the recent wars in Rwanda and Tanzania, where the perpetrators of genocide had no real strategy. That said, many of these single-issues, particularly religious issues, quickly become weighty.

3.3.1 *Islamic Holy Wars* Civil war broke out following Muhammad's death in AD 632. The Muslim community, or *umma*, that he created was in danger of disintegrating into potentially rival tribal groups who would carry the faith to the rest of the world. But neither the *Qur'an* nor the *Sunna*, the account of the Prophet's sayings on con-

255

duct in particular situations, offered guidance on succession. In this crisis, Muhammad's followers elected Abu Bakr and hailed him as the *khalifa*, or 'caliph,' meaning leader and successor as well as deputy of the exalted Prophet. This process expressed the goals of the Muslim community to promote its faith and use it as the cornerstone of Muslim law, government and personal behavior. Abu Bakr governed on the basis of personal prestige, gained by leading the community in prayer. With the help of a small group of advisors and scribes he collected taxes, waged war and conducted diplomatic relations with other tribes on behalf of the community. Yet Abu Bakr never established the caliphate as an institution.

These events set the stage for the emergence of the caliphate as an institution by expanding Abu Bakr's policies. Umar, Bakr's first successor, exerted his authority over rival tribes by military conquest. The second successor, Uthman, asserted the right of the caliph to protect the economic interests of the entire community and published the definitive text of the *Qur'an* to ensure a degree of unity in the community. Yet Uthman's opponents accused him of nepotism and unnecessary cruelty. Opposition coalesced around Ali, and when Uthman was assassinated in 656, Ali succeeded him.

This assassination threw the legitimacy of Ali's accession into question. Uthman's cousin Mu'awiya, based in Syria, refused to recognize Ali as caliph and civil war ensued. To make a long story short, Ali was assassinated, Mu'awiya assumed the caliphate and founded the Umayyad dynasty, which moved the capital of the Islamic state from Medina to Damascus. The first four caliphs were elected by their peers, and the theory of an elected caliphate was established as an Islamic legal ideal, but three of the first four patriarchs, as they were called, were assassinated, and civil war ended the elective caliphate. Beginning with Mu'awiya, the caliphal office was *de facto*, if not *de jure*, dynastic. In addition to ending the elective caliphate, the assassination of Ali and ensuing civil war also precipitated the split between Shi'ites, meaning supporters of Ali, and Sunnis, a term derived from the Sunna, mentioned above, signifying religious orthodoxy. Today, as in the VIIth

and VIIIth centuries, the Shi'ites are a dangerous minority that expresses its religious opposition in political terms. Because of the depth of the division between the two sides, it is doubtful that concession on the part of the Sunnis would have had the desired effect. Moreover, history has shown the remarkable, indeed obsessive way in which the Shi'ites have pursued their objectives, notably in the establishment of an Islamic state in Iran in 1979 (see right-wing revolutionary wars).

3.3.2 *French Wars of Religion* The resolution of the preceding example is in marked contrast with the religious riots and civil war in France from 1559 to 1589. A sizable minority of the French nobility took advantage of the weaknesses of the monarchy by converting to Calvinism to demonstrate their independence. At that time, no one believed that peoples of different faiths could live peacefully in the same territory, and the clashes between Calvinist anti-monarchist lords and Catholic royalist lords in many parts of France seemingly proved this point. Meanwhile, working-class crowds were easily incited by priests and preachers, who fomented violence during baptisms, marriages and funerals. French Calvinists, or Huguenots, attacked the symbols of Catholic piety and were in turn tortured and massacred, as on Saint Bartholomew's Day in 1572.

The Saint Bartholomew's Day massacre led to fighting that launched the War of the Three Henrys, a civil conflict among factions led by the Catholic Henry of Guise, the Protestant Henry of Navarre, and King Henry III. Though he remained Catholic, King Henry realized that the Catholic Guise group represented his greatest danger. The Guises, through an alliance of Catholic nobles called the Holy League, wanted both to destroy Calvinism and to replace King Henry with a member of the Guise family. For this ambition, France suffered fifteen more years of religious rioting and domestic anarchy; agriculture in many areas was destroyed and many starved.

A group of Catholic moderates called Politiques sought to restore the monarchy, and reverse the trend toward collapse through religious tolerance. For them, no religious creed was worth so much death

and destruction. When Catherine de Medici died and Henry of Guise and King Henry III were assassinated, Henry of Navarre assumed the throne as Henry IV. Although he was a Protestant, he knew that a majority of French people were Roman Catholics and therefore joined the Roman Catholic Church. He readily sacrificed his religious principles for a political reconciliation that enabled him to publish the Edict of Nantes in 1598. The edict granted Huguenots liberty of worship in two hundred towns and restored peace to France. Yet it was precisely this peace that paved the way for the absolutism of Louis the XIV and the eventual revocation of the Edict of Nantes. The haunting mass exodus of Huguenots from France is consistent with the thesis that the concession on the part of Henry IV led to peace, which strengthened the hand of the established order. After the anti-monarchist, class-driven skirmishes of the Fronde (see chapter one) there would be no real threat to the legendary Sun King.

3.3.3 *Thirty Years War* This civil war is a much more complicated affair than the religious conflicts described above - it merits treatment here as a religious civil war and as an indicator of the degree to which civil wars are the motors of change. This war arguably signifies the beginning of modernity.

A series of accidents and unexpected deaths bequeathed to Charles V, the last medieval emperor, Spain and its dominions in Italy, the Habsburg lands in Austria, southern Germany, the Low Countries and the Franche-Comté in east-central France. But the Church, with which Charles intended to maintain the unity of Western Christendom, was in shambles and already the butt of dirty jokes; many are catalogued in Martin Luther's famous Ninety-Five Theses and confirmed by the massive peasant revolts that swept through Swabia, Thuringia, Rhineland and Saxony.

The religious turmoil launched by Luther clashed with the officially determined religion of Germany. A vast anti-Roman sentiment was sparked by Luther's appeals to German national pride and his denunciation of the papacy's financial exploitation. The Edict of Worms

(1521) condemning Luther wasn't enforced by many German princes who backed the new faith for numerous reasons, not the least of which was financial self-interest. Charles V was preoccupied with the Valois kings of France who, although Catholic, were happy to support the Protestant cause to further divide the German states.

Charles finally agreed to the Peace of Augsburg in 1555, which allowed each prince to choose the religion, Lutheran or Catholic, of his territory. Most of northern and central Germany became Lutheran whereas the south remained Roman Catholic. The effort at reconciliation by Pope Paul IV at the Council of Trent (1545-1563) may have strengthened the Catholic Church, but it didn't win over any Protestants, for whom the Inquisition was a recent memory. The advent of Calvinism further confused the issue, because Calvinism wasn't part of the Augsburg peace agreement. Meanwhile, militant Jesuits were reconverting Lutheran princes back to Catholicism. As the situation became increasingly tense, Lutheran princes formed the Protestant Union in 1608; Catholics formed the Catholic League the following year.

To fully set the stage for the conflict, when Charles V abdicated in 1556, he divided his possessions between his son Philip II and his brother Ferdinand I, effectively partitioning the Habsburg family into Spanish and Austrian branches, respectively. Ferdinand's grandson became Ferdinand of Styria in 1617 and then king of Bohemia, ruling Silesia and Moravia too. When Ferdinand closed Protestant churches, Protestants, true to their name, protested. On May 23, 1618, Protestants threw a few of the king's officials out a castle window into the muddy streets of Prague. They fell over seventy feet, but survived. Catholics claimed that angels had saved them; Protestants said they'd fallen into a heap of soft horse manure. As improbable as it sounds, the event started the Thirty Years War. It seems to me that Ferdinand of Styria would have been better served by a policy that respected the religious freedom his various peoples had enjoyed prior to his ascension. What was intolerable about a situation whereby Lutherans, Calvinists, Catholics and Hussites lived in relative peace and harmony?

His insane desire to unify Habsburg dominions under Catholicism overruled better judgment.

The Bohemian phase (1618-1625) of the civil war between the Catholic League and the Protestant Union resulted in the Bohemian Estates deposing Ferdinand of Styria and giving the crown to Frederick of the Palatinate. Catholic forces behind the recently elected Holy Roman emperor Ferdinand II fought back, as if inspired from above, and deposed Frederick. They proceeded to virtually wipe out Protestantism in Bohemia with militant Jesuit missionaries playing a significant role in this process.

The Danish phase (1625-1629) of the Thirty Years War witnessed additional Catholic victories, won thanks to the ineffective leadership of King Christian IV of Denmark and the superior military acumen of the Catholic warrior Albert of Wallenstein. Wallenstein was hungry for power and clashed with the Catholic League, thus dividing Catholic forces, although he would soon be appeased by the riches dangled before his eyes. The Jesuits persuaded the emperor to issue the Edict of Restitution, whereby all Catholic properties lost to Protestantism since 1552 would be restored and only Catholics and Lutherans - not Calvinists, Hussites, or other sects - allowed to practice their faiths. Wallenstein relished enforcing this edict as ruthlessly as possible. Protestants throughout Europe feared collapse of the balance of power in the north-central region as their brothers and sisters perished in droves. The Swedish king Gustavus Adolphus, a Lutheran, intervened in the German conflict; first with material support from France, and then in person. Swedish victories drew the Habsburg ambition of uniting the German states under imperial authority to a close.

Following the death of the great warrior Gustavus Adolphus, France, under Louis XIII, intervened directly by declaring war on Spain and sending more material support to the Protestant cause in Germany. As the war dragged on, German agriculture and commerce were utterly destroyed. The Peace of Westphalia was finally achieved in 1648 and marked a turning point in European history. The treaty recognized the sovereignty of the German princes; with power in the hands of

over three hundred princes and no central government, the Holy Roman Empire was destroyed and the papacy was denied the right to participate in German religious affairs. The independence of the Netherlands was also recognized. France grew in size and prestige; the skinflint religion of Calvinism was legalized. North German states remained Protestant; south German states remained Catholic. Hence, the war thoroughly undermined the established authority that had been so imprudent as to try to force its religion on all peoples under its dominion. The Thirty Years War was the most destructive event in German history prior to the XXth-century.

3.3.4 *Recent Examples* Nationalism is fundamental to civil wars - the alienating concept dates to the French Revolution when, for the first time, the idea was formulated that a nation had natural rights and could legitimize a State. Many wars of independence and civil wars are based on the idea, fundamental to the concept of the nation-state, that any non-self-governing system is a system of servitude. This sentiment in favor of self-determination found its champion in American President Wilson at the end of World War I, and was made explicit in the Charter of the United Nations.

The current Bosnia conflict can be categorized as a single-issue war (the issue being nationalism), even if it has multiple focal points. Even a complicated region such as the Sahel, with all its problems of territorial disputes and famine, can trace the roots of its conflicts to single, dominant issues. In Somalia, for example, the conflict is essentially based on tribal rivalry - the Issaks against the Marehan.

Sri Lanka's fourteen-year-old civil war clearly shows that a single-issue war can have a multiplicity of moments. These moments present themselves or remain latent as a conflict unfolds. The native Sinhalese are Buddhists with a long tradition of pacifism. The Marxist government came to power with promises of peace that it shattered when it waged all-out war in 1995 against the separatist Hindu Tamil Tigers. Ethnic war? Religious war? Separatist war? Undoubtedly, all of the above. The leftist People's Alliance party is at pains to share power

or grant concessions to the Tamils because it has to contend with the United National Party to its right.

The situation in Myanmar is such that the Karen ethnic group - at war with the Burmese since 1949 - is split into two rival religious factions: Christian and Buddhist.

Perhaps the best current example of a religious civil war is the Taliban Islamic movement's three-year struggle "to cleanse the country of the enemies of Islam." The Taliban forces have captured most of Afghanistan, including the major cities of Kabul, Kandahar and Herat, and appear to have taken Mazar-i-Sharif. Once a city comes under Taliban control, women are no longer allowed to work or attend school, and have to be veiled in public. Murderers are hanged; thieves have their hands amputated. Adulterous couples are buried to the waist and stoned to death and young women report having their pubic hair checked to make sure it's shaved. This is as much an ethnic conflict as a religious one; the Taliban are Pashtuns from the south and northwest of Pakistan, whereas the Dari-speaking north of Afghanistan is a mix of Uzbeks, Tajiks, Aimaq, Hazaras, Turkmen, Mongols and Baluch.

Thanks to the Shi'ite revolution in Iran, the concept of the *jihad*, or 'holy war,' regained considerable force that finds renewed expression with the Hezbollah, who have over a million partisans in Iran and have established branches throughout the Arab world. Debates that date to the crusades have been dusted off and classic writers have been reinterpreted on the meaning of *jihad*. It so happens that the *jihad* appears when Mohammed is in Medina, not in Mecca - the Prophet and his followers fought the polytheistic Bedouins with violence because the Bedouins were violent. It's crucial to understand that *jihad* corresponds to the core of Islam in the sense that for a Muslim, the natural order of things is that one is Muslim. When the world is not in order, one can engage in a major *jihad* against the spiritual enemy within oneself; or a minor internal *jihad* waged against renegade Muslims and apostates; or a minor external *jihad* against infidels. Those who fight on the road to god, the *mujaheddin*, take on the obligation of fighting the *jihad* for the rest of the believers and never turn their back on the

262

enemy. They seem to be inspired by the belief that the sins of martyrs are said to be forgiven.

In these multi-factor, but ultimately single-issue wars, the strategic goal of the State is two-fold. First, to have the citizenry, including partisans behind a given issue, identify with the State rather than with an ethnic or rival national group. This is sometimes accomplished with great difficulty and may involve bringing the rival groups into all-party talks or into a government of national reconciliation. Second, the State must maintain superior force. This is true even if the State must ultimately transfer power to its rival, to maintain its essential integrity.

Tactical considerations play an important role here. The genocidal tactics used in Rwanda and Burundi may have led to short-term gains, but they ultimately cost those that practiced such tactics so much in legitimacy, that they engendered strategic losses. The tactics of the Bosnian Serbs, to cite another recent example, were precisely the justification for the intervention of foreign powers, to their rivals' advantage. The supreme injustice of the strong-arm police tactics of the former South African regime probably only encouraged greater resistance, and these same tactics remain the biggest sticking points to national reconciliation. Although war is, by definition, harsh business, one should not underestimate the social power of its moral aspects. As Clausewitz points out, the results of war are never absolute.

The inadvisability of extra-legal tactics by the established power is illustrated by the Algerian government's likely efforts to terrorize its population in the name of the Armed Islamic Group (GIA), which in the past engaged in terror. Now the nightly killings take place in Islamic strongholds surrounded by military installations. Why would the GIA kill its own? Why wouldn't the government send in troops to protect the innocent? Meanwhile, opposition leaders calling for peace are put under house arrest. We know that the international community has lost faith in the government and we can safely assume that once the word gets out the civilian population will follow suit. In an October 30, 1997, *Independent* story Robert Fisk reported on Algeria's terror, claiming that the Military Secret Police was responsible for this

torture and for the demise of more than twelve thousand so-called disappeared citizens.

3.4 Type B: Wars of Secession

Wars of secession embrace such a significant strategic perspective that they constitute a type unto themselves. This is the case even if these wars mirror single-issue wars in every other respect. Hence we have ethnic and national wars of secession, or secessionist wars caused by slavery or apartheid or other issues. Wars of secession have the breast-beating strategic goal of obtaining space and establishing a separate state. Depending on the disposition of forces, protagonists of either side tend to rely on defense of the space in question, which recalls Clausewitz's comment that one rarely wins by remaining on the defensive.

3.4.1 *US Civil War* Although the US Civil War was centered around the single-issue of slavery, it was, from a strategic perspective, a war of secession. The staggering loss of life in this clash of brothers reiterates how costly and irrational civil wars can be. Southern leaders decided to secede from the Union when a Republican president was elected, and these gents elected Jeff Davis as their president at the sun-drenched Confederate capital of Richmond. The exceptional Virginian general Robert E. Lee triumphed at Bull Run, Sharpsburg and Chancellorsville, his most brilliant victory, but would lose the great battle of the war, Gettysburg, and never take the offensive again. Meanwhile, the drunken general Grant nabbed Vicksburg and Chattanooga and gained control of the Mississippi for the North. Lee fought his defensive battles against Grant as Sherman captured Atlanta in September 1864 and split the Confederacy yet again. Grant then pinned Lee down and compelled surrender from him at Appomattox in southern Virginia, much to the chagrin of those who still sing about the death of Dixie. The remaining Confederates surrendered to Sherman on April 26, just days after Lincoln's assassination. It seems that the South might

264

have been advised to accept some reforms and thus maintain greater autonomy, until such time that it could have overtaken the North. Faced with a belligerent South that simultaneously threatened the sanctity of the union and insisted on maintaining slaves, the North had no choice but to fight despite the inevitable and devastating loss of life - the paradox of being uncivil so as to civilize.

In the general strategy of wars of secession, the separatist questions the legitimacy of the regime on all possible grounds and claims to represent the general will of a strategic minority. The nation-state in question wants to maintains its territorial integrity and its monopoly on the use of force. To accomplish these strategic goals, the State destroys or disarms the non-State actors opposed to it. But as with all civil wars, a large degree of psychological warfare is involved - the regime uses all means of communication to discredit the rebel forces and maintain its own legitimacy. Unifying themes such as nationalism and patriotism are stressed in these communications. Daniel Webster:

> And, now, Mr. President, instead of speaking of the possibility or utility of groping with those ideas so full of all that is horrid and horrible, let us come out into the light of the day; let us enjoy the fresh air of Liberty and Union; let us cherish those hopes which belong to us; let us devote ourselves to those great objects that are fit for our consideration and our action; let us raise our conceptions to the magnitude and the importance of the duties that devolve upon us; let our comprehension be as broad as the country for which we act, our aspirations as high as its certain destiny; let us not be pygmies in a case that calls for men.

3.4.2 *Diverse Examples* If separatist forces operate with the backing of the citizenry, the State is at a serious disadvantage. And although the State might win militarily, it could lose strategically because the State then faces a hostile population. Here, as with most types of civil war, the State needs the support of the population to attain its ultimate strategic goal of governing a unified citizenry. If this support appears

to be impossible to obtain in any foreseeable future, then one should consider retreat before the trump card of public opinion is played by rival forces.

The history of Quebec separatism demonstrates how the terrorist bombings of the Quebec Liberation Front in the Sixties floundered and generated no real political support from the population. The masses can, however, come to support separatist partisans engaged in legitimate warfare, as was the case in Chechnya.

Russia's big debacle, hastily invading Chechnya in 1994, pushed Moscow into declaring peace four times in 1996-1997. As of this writing, Chechnya's constitutional status has been left in limbo until 2001. Chechnya still uses Russian currency and is subject to Russian economic pressures, but it legitimately claims to have bashed the Russian bear and attained greater independence. It appears that Yeltsin should have conceded a degree of autonomy to the Chechens at the start and then fought peacefully and economically to regain full dominion over the territory.

France, incidentally, faces separatists on numerous fronts: Basque, Breton, Corsican, Spanish anti-Basque and West Indian separatists. The French government might be advised to grant still greater cultural and social recognition to these groups while insisting on the sanctity of its political institutions and territorial integrity.

In the conduct of its twenty-nine year, dirty war against ETA Basque separatists, the Spanish government has used what are sometimes called parallel forces, or forces that operate covertly and outside the direct operational control of the Spanish government. The harsh paramilitary tactics of these parallel forces, and the disclosure of their existence, has caused a scandal that lowers the prestige of the government in the eyes of the population. Despite limited tactical gains, this sort of low-intensity warfare is once again tallied as a strategic loss. This loss may have been partially reversed when, in July 1997, the ETA killed a hostage, prompting widespread protests in Spain against the ETA. After these events, ETA offices were attacked, which demonstrates how these tactics siphon off public support, even in Basque country.

Unlike Spain's willingness to give the Basques a degree of autonomy, Turkey has been unwilling to grant any autonomy to the Kurds waging war against it. The supreme governor of the south-eastern provinces of Turkey instituted emergency rule in 1997 and rejected even minor concessions. Unsolved murders thought to be perpetrated by Turkish security forces, the jailing of Kurdish politicians and the eviction of three million subsistence farmers suspected of being sympathizers - these tactics have shunted more sympathy to the opposition Kurdish Workers Party (PKK) than they would have otherwise attained.

While the on-going Bougainville secessionist movement in Papua New Guinea (PNG) is something of an anomaly, given its strong environmental aspect, the PNG government received the scorn of its Pacific neighbors when it hired a South African mercenary company to help fight the Bougainville rebels. Australia and multilateral donors to PNG were reportedly reassessing their aid policies in light of this sinister development, and PNG's prime minister was deposed in disgrace. His successor saw fit to renegotiate mining deals with Bougainville and appeal for a negotiated settlement.

3.5 Category II: Revolutionary Civil Wars

The strategic goal of revolutionary movements is to win the favor of the population and subvert the established order. The Great French Revolution engendered citizens, not subjects, who no longer approved of the political organization of their society and claimed the right to replace it with a system based on natural rights, such as *equality* before the law. The established order wants to maintain its power and seeks adherence from the population, but the heritage of despotism is often difficult to relinquish: for a traditional society, even those in our times, *inequality* is part of human nature. Questions of justice, seemingly so abstract, are usually wedded to economic injustice despite the protestations of those who profess to know the will of god. Alas, a religious ideology, or even traditional morals, can provide the impetus for a right-wing revolutionary war, just as the idea of a repub-

267

lic or party-controlled state can be the motivating factor behind a left-wing revolutionary war.

The primary goal of revolutionary wars isn't simply to advance to a victorious position that avoids battle (for example, in the case of the anti-work movement, to entice managers to quit their jobs the way England essentially quit its side in the American Revolution), or to a position that assures easy victory to attain space and the systematic destruction of the adversary's army. The goal is to conquer the population ideologically. To win the endorsement, solidarity and defense of their fellow citizens, the revolutionary movement tries to inspire the population to detach itself from the established regime and implicate itself in the fight. Revolutionaries speak of the regime in power in the most unhoneyed terms, inseminating a widespread cynicism that blossoms in anger or even revolt. Although he didn't fully live up to his words, Lenin, a follower of Clausewitz like Marx before him, wrote of the need to retain moral superiority in the conduct of war so as to be "assured of the utmost sympathy and unreserved support of all the working and exploited people."

In subverting the equilibrium of a polity, revolutionary agitators create doubt about traditional loyalties and try to bring institutions belonging to the State and other social institutions into conflict, while adapting their tactics to local and circumstantial exigencies. In a guerrilla warfare situation, revolutionaries often use rudimentary arms, augmented by a highly evolved strategic vision involving political, military and organizational aspects of their struggle. Mao was able to combine irregular and regular units in his irregular operations, before finally mounting a classic frontal assault.

DeFronzo finds five phenomena of crucial importance to the success of a revolutionary movement:

1. the growth of frustration among the majority of a population;

2. the existence of elite elements alienated from the current government who support the concept of revolution;

3. the development of unifying motivations that bring together

members of different social classes in support of revolution;

4. The occurrence of a crisis that severely weakens government administrative and coercive capabilities, in a society experiencing the development of a revolutionary movement;

5. The choice on the part of other nations not to intervene, or their inability to do so, to prevent the success of a revolutionary movement in a particular society.

Both types of revolutionary civil wars, right-wing and left-wing, may have characteristics of the other, and both aim for mass participation. They use the same tactics - legal protest, nonviolent disobedience, strikes and violence (terrorism, people's war, guerrilla warfare). Obviously the most immediate danger for any regime is posed by groups with a capacity for extra-legal action: those prepared to "go all the way" as Lenin put it. Yet the indirect strategy of revolutionary propagandists and the steps taken by legal protesters and strikers can also have long-term effects. It may be in the interest of the established order to muddle, even misrepresent, the issues at stake. Both sides are likely to make use of atrocity accusation, hyperbolic inflation of the stakes, demonization and dehumanization of the opponent, polarization and propaganda against the propaganda of their rivals.

3.6 Type C: Left-Wing Revolution

The strategic goal of left-wing revolutionaries is to change or alter dominant economic, social and political relationships in a society. Lefties press for equal access to educational opportunities and medical services, higher wage levels and land reform. In most cases, the established regime pursues reforms that amount to too little too late, that might have garnered praise from the population if they had constituted timely and real social change. Left-wing revolutions are at least ostensibly based on the class warfare concepts developed by Marx and Engels, even if they invariably engender a new first class.

3.6.1 *Chinese Revolution* In strategic terms, Mao - both before

and after the Long March - remains the classic thinker of revolutionary civil war. He always stressed the fact that the Chinese Red Army was as much a propaganda organ as it was a military organization. He was against adventurist offensive operations and never dogmatically held his ground at all costs. In addition to using the army as a way to organize and teach the peasantry, Mao stressed the need to choose a favorable time and place to fight. He preferred to constantly torment and pester his adversary, thus demoralizing the enemy and creating the conditions for victory prior to the battle itself.

Mao, contrary to Lenin, relied on the peasantry to surround the towns and then conquer them. The remoteness of the peasant population placed them in sanctuaries where Mao could establish rural bases. He used these areas to win over the peasantry, by redistributing land and promising the moon. The Red Army was discouraged from raping and pillaging those in its path - in addition to being a fighting machine, it was simultaneously an expression of agit-prop and mass organization that would carry revolution "From the masses to the masses," as Mao put it.

Like today's political pollsters, communists were sent into communities where they listened to the desires of the people, and when they returned, it was to present proposals that were certain to appeal to the people. By 1945, Mao and his comrades had reached out and touched over one hundred million people, and the party had a million members. Fierce opposition to the Japanese imperialists, strident criticism of Koumintang corruption and Mao's rural reform program - these points struck a responsive chord with the masses. In choosing between total disruption of Chinese society or a more gradualist approach, Mao chose the latter, took his time, and won mass support for the revolution.

That said, the early transition from Kuomintang to Communist rule was accomplished by gentle persuasion and retaining experts and managers from the old regime, when necessary. When persuasion didn't succeed, terror was the rule and reforms were made in the teeth of opposition. A wide coalition of political forces under the leadership

of the party, excluding only Kuomintang members, took control of the country as the people's democratic dictatorship. The peasants continued to own land and the same gradualist approach was followed with industry - China experienced far less disruption and far more adherence than would have been the case had a purist revolutionary line been taken.

Compare the example set by Mao with that of the communist offensive during the Greek Civil War (1947-1949). Popular support was limited and the strategy of frontal attacks fatal. British forces influenced the KKE (Communist Party) decision, on February 12, 1945, to disband and surrender its weapons. And it didn't help the Communist cause that Stalin had conceded Greece to Churchill in exchange for control over Bulgaria and Romania. The fatal last battle of the guerrilla war occurred in the northern area adjacent to the Yugoslav-Albanian-Bulgarian borders where the KKE had formed a provisional government. When Yugoslavia closed the border, the guerillas lost their supply depot and fled into exile in Albania.

Compare, once again, the example set by Mao with the Cuban model of the *foco* strategy. The *foco* calls for armed struggle without any political preparation of the population. The futility of this strategy is exemplified in a spectacular way in the person of Che Guevara. His campaign to raise a guerrilla force among Boliva's rural poor didn't amount to a hill of beans; the suspicious local population betrayed Che to the army that captured and executed him. The success of the Cuban revolution was due in large part to widespread anti-Batista sentiment, which isolated the dictator. Revolutionaries wisely depicted their operation not in Marxist-Leninist terms, but colored it in humanist revolutionary hues.

3.6.2 *1905 Russian Revolution* This revolution can be blamed on the Czarist inaction, in the form of a lack of reforms, and events such as Bloody Sunday - a massacre on January 9, 1905, of peaceful petitioners that sparked the 1905 revolution. Strikes and demonstrations spread from city to city. The crew of the battleship *Potemkin* mutinied at Odessa

in June and hundreds of peasant disturbances swept the countryside. On the same day that Nicholas II published his October Manifesto of reforms and promised to grant a constitution, the central strike committee proclaimed itself the St. Petersburg Soviet of Workers' Deputies: for the next two months the capital was under two authorities - the government and the soviet, or council, movement. The reforms in the October Manifesto did, however, manage to split the opposition and weaken the spirit of resistance: arrests and the shelling of working-class districts crushed the 1905 revolution.

3.6.3 *October Revolution* Now we fast-forward to the events preceding the 1917 October Revolution. In early 1917, as fighting spread through the streets of Petrograd, the chairman of the Duma sent wire after wire to the Czar beseeching him to form a new government. Nicholas refused to grant concessions. I take it for granted that readers are familiar with the February Revolution or can find it standard histories, and I will instead highlight the inter-revolutionary period when the Petrograd soviet could have taken over the State but chose not to do so. Why? Because it would have led to civil war. As Voline observes in *The Unknown Revolution*, real power resided with the workers in the soviets or workers' councils that demanded and gained numerous concessions from industrialists. When, in May, some members of the soviet joined the government, workers shifted their support from the Mensheviks and Socialist Revolutionary Party to the Bolshevik Party. By September, the Bolsheviks had majorities in the Petrograd and Moscow soviets. Meanwhile, General Kornilov failed in his venture to set up a military dictatorship, the sort of extra-legal paramilitary tactics detrimental to the established order, the wisdom of which is refuted in fact and in the general theory of civil war. It was precisely this affair that diverted attention and enabled the Bolsheviks to recover from Czarist persecution. Lenin, in hiding in Finland, called for the seizure of power on September 12. His Central Committee feared a failure akin to that of the July Days, when the Bolsheviks feared a failed attempt to seize power due to half-valid accusations that Lenin was a

German agent. The coup was finally planned for October 10, 1917. A day earlier, the Petrograd Soviet set up a Military Revolutionary Committee to organize the defense of the capital against a possible military coup, under the control of Trotsky. The Bolsheviks knew that if they launched an action in the name of their party, they would have limited support; they deceptively used the slogan "All Power to the Soviets."

Rumors that the Provisional Government was moving from Petrograd to Moscow to dodge advancing Germans created a vacuum, filled by Trotsky's Military Revolutionary Committee a week before the rising on October 24. On the night of October 24-25, the Military Revolutionary Committee occupied key points in the city. By the time the Congress of Soviets met on the evening of the 25th, only the Winter Palace was holding out, guarded by a women's battalion and some officer cadets. It fell that night. Unlike the February Revolution, when hundreds of thousands went on strike, the October Revolution was a palace revolution and mass participation would have to wait for the civil war.

More importantly, the Petrograd Soviet and the Congress of Soviets hadn't taken part in the October Revolution. Kamenev and Zinoviev seemed ready to give power to the soviets and govern in a coalition of socialist parties, but Lenin had other ideas, namely the creation of the Council of People's Commissars, composed of Bolsheviks, to take over the government. There were dissidents and resignations, but Lenin maintained his authority.

After their seizure of state power in the October Revolution, the Bolsheviks effectively insisted on ruling alone rather than in cooperation with other socialist parties, which was their major mistake. Concessions to these parties might have created such a powerful front that rivals to power would have conceded victory without a fight. Instead, the Bolsheviks closed down the Constituent Assembly, and Lenin prevented the convocation of the All-Russian Congress of Factory Councils - the councils, or soviets in Russian, having been the real force behind the revolution - and set up his Supreme Soviet of National Economy. These events, along with the Treaty of Brest-Litovsk that

ceded large areas of Russia to Germany, prompted opponents to take up arms.

In May 1918, a Czech legion, prisoners of war who had declared their support for the allies when Czech independence was established, traveled back to the western front to fight Germany via Vladivostok. The legion clashed with Bolsheviks and then took control of the Trans-Siberian Railway and large parts of the Ural and Volga regions. These Czechs lent their considerable military support to the Socialist Revolutionary Party, then governing at Samara on the Volga. Siberia was in Bolshevik hands. In August 1918, the Czechs and White forces took Kazan, only to have their victory reversed by forces led by Trotsky, the Commissar for War of the Red Army, known for his program of War Communism that took central control through expropriation and later nationalization.

To complicate matters, the Whites were confronted with the anarchist army of Makhno in the Ukraine. White resistance in Siberia found itself at odds with the socialist policies of the democratic government in the region. British troops were in Murmansk and Archangel; the French were in Odessa and the Americans and Japanese at Vladivostok (although allied troops allegedly didn't take part in the civil conflict except by supplying the White cause with arms and equipment). But the Whites had no real political unity with their Social Revolutionary allies, and the White General Denikin's aristocratic land policies buried support from the peasants.

The Bolsheviks had Moscow and Petrograd, and although they were preoccupied with the Russo-Polish War in 1920, they had, by 1921, gone on to conquer the independent republics that had been set up in Georgia and Central Asia. An estimated eight hundred thousand troops died in the conflict that, more than anything else, accustomed the Bolsheviks to ruling through coercion. The Cheka, or Extraordinary Commission for Combating Counter-Revolution, Sabotage and Speculation, set up shop in December 1917. Extra-legal in nature, and more powerful than the Czar's Okhrana, the commission sought to exterminate the bourgeoisie as a class and to suppress peasant risings through a

program of Red Terror. The Cheka was succeeded by GPU, OGPU, NKVD and finally by the infamous KGB - the names may have changed, but the rule by terror remained the same. This terror contributed, in a highly significant way, to the eventual demise of the Soviet Union, because the unresolved crises of legitimacy associated with terror engender crises of sovereignty.

3.6.4 *Considerations on Revolution* Today, the class war conflict is expressed in the media by Marxists such as the Shining Path's Abimael Guzman, who treats the failures of Eastern European and Chinese communism with contempt. The Shining Path's flawed strategy involved brutalizing its potential ally, the Indian peasants and the poor who now lend their support to Fujimori. I predict failure for Fujimori, however, because of his brutal tactics, such as the kidnapping of his rival, the retired General Rodolfo Robles, who had exposed the murderous operations of the army intelligence unit known as the Grupo Colina, and who sought a referendum opposing Fujimori's ability to run for re-election in 2000. Prior to storming the Japanese Embassy in 1997, where the Tupac Amaru were holding hostages, the Peruvian intelligence services were bombing left-wing politicians and journalists; they now have the blood of an unarmed revolutionary girl on their hands.

Contrary to the Peruvian method, where the army found a like-minded authoritarian in Fujimori, in moments of impending revolutionary crisis, politicians of an established regime may find it to their long-term advantage to bring representatives of the Communist Party or unions into the government. This occurred in Italy in the mid-Seventies with the historic compromise. Party and union representatives carry more weight with the Left, and could be convinced that it is to their advantage to work with the established industrial and financial aristocracy. For example, the Social Democrats thwarted the workers' and soldiers' councils in Germany in 1919; the Social Democrats went so far as to deploy the notorious Free Corps against the Spartacists. The 1968-1969 protests in Italy were actually far more serious than in

275

any other European country, because they spawned a remarkable up-surge in militancy among industrial workers. Indeed, the lack of a simi-lar response in the United States may make the Italian situation the most far-reaching of all, especially considering the way, as in France but to an even greater extent in Italy, the trade union movement was threatened by the development of factory councils. As Grenvile says:

> The hot autumn of 1969 saw the spread of many strikes, sup-porting demands for higher pay and better working conditions. The Italian people could no longer be easily led; there was a loss of respect for institutions and for the political leadership which extended through all parties and traditions. Labor legislation the following year, in 1970, gave the trade unionist more power.

To restate the strategy favorable to the established order in Peru, the army might actually have been better served by the Opera party, or even by a pseudo-Marxist like Alan Garcia, rather than an autocrat like Fujimori, who is perceived to be dominated by Japan. He could eventually face a united front of Opera, socialists, communists and those further to the left who want to be rid of the whole corrupt system. Peruvian opposition forces may be justified in using terrorism, in view of severe repression that has quashed other means of dissent. No fo-rums are open; any attempt to strike and create *ollas populares*, the popu-lar assemblies created amid nationwide strikes in Argentina during the summer of 1996, would probably be met with inordinate state vio-lence in Fujimori's Peru.

Rather than following the Napoleonic strategy of the complete rout, victors and losers alike, as with the two Germanies in the post-Cold War era, should prepare to win over their enemies. The elite never forgets that the population is the target, as if the people were a military force, and is happy to assist the misdirection of its opposition as it loses itself in identity politics. The regime knows that psychological warfare should serve as a substitute for actual war when it can. In what ap-pears to be a protracted conflict, psychological warfare at least has the

merit of possibly avoiding actual warfare. Psychologically, citizens feel part of the conflict and tend to choose sides. Hence, it's vital that political messages be credible. These messages should be followed up with action that adds meaning to the messages; the established power will inevitably try to manage news, neutralize rival claims by refuting them as quickly as possible, and reach the most people possible.

Mao was perhaps the greatest master of Leninist propaganda, which aims, in the words of Jacques Ellul, to "modify the whole human being by giving him a totally new view of the world and awakening in him a range of feelings, reactions, thoughts, and attitudes entirely different from those to which he was accustomed." Slogans were disseminated and explained in large discussion groups called Peasant Unions that polarized the population. People were simultaneously brought into party organization activities that created a hierarchy parallel to the existing order. The goal of propaganda was to teach and inspire people to fight, and as Ellul makes abundantly clear, terror was used by Mao to reinforce his propaganda messages.

When calculating a response to the threat of left-wing revolution, the established power should never appear to be manipulating the worker representatives that it co-opts. The regime might, on occasion, offer public concessions to workers to give these representatives the appearance of strength, because this appearance might generate favor from their base. Party and union representatives should be constantly evaluated to help predict ways workers would disobey their representatives with a wildcat strike. A general strike poses the greatest risk to any financial and industrial elite; as Clausewitz says, "because of their consequences, events that are merely possible should be judged as real."

Counter-insurgency measures, often special or covert operations, pose more problems. If they are to be used at all, these measures should be carried out within the spirit and letter of the law so that the established regime has the force of justice on its side. For example, one should not discount the role that the Okhrana, the czar's secret police, played in his loss of prestige within his own government and with the

population. Recall that, on the eve of the 1905 revolution, Okhrana agents operating in the name of the revolutionaries carried out the assassinations of the Minister of Interior and Grand Duke Serge, the czar's uncle and the head of the Moscow military district. These sorts of provocations are frequently disclosed and the regime loses prestige.

Another, more recent, example is the oppression perpetrated by Guatemalan dictators since Colonel Jacobo Arbenz Guzman was toppled in a CIA-aided Army coup in 1954. Why? Because Guzman had granted the Guatemalan Labor Party legal status. Civil war ensued with only minor breaks for the next thirty-odd years. General Efrain Rios Montt took power in March 1982. By then one hundred and twenty thousand had been killed in the war and forty thousand disappeared. Montt denounced death-squads while continuing to massacre peasants and set up populist programs. But these actions were actually designed to gain Indian help in fighting leftist guerrillas among groups that might be allies, if not for the traditional skepticism with which Mayan Indians view those of Spanish ancestry. The extreme torture, executions without trial and disappearances continued right up to the peace negotiations, signed on December 29, 1996. It remains to be seen if exploitation, discrimination, union repression and extreme poverty can be reversed, because they are as responsible for the civil war as the initial coup. In the end, the military and the United States have thoroughly discredited themselves, making it difficult to restore peace and order. Narco-terrorism, threats of another coup, gunfights between peasant squatters and police - this is the immediate legacy of civil war.

While Marxists everywhere remind us of the economic motivation of their strategy, the heirs of Trotsky present their rivals with the worst case threat by couching their arguments in terms of staggering totalities, such as "total world income" and an equally global vision of revolution. One already hears rumblings in the mainstream about how, in terms of global income distribution, the 20 percent of the world's population that lives in the top fifth wealthiest countries receives 82.7 percent of total world income. The bottom fifth countries,

where an equal number, 20 percent, of the world's population live, obtain a mere 1.4 percent of total world income.

The excess populations proliferating around the world are increasingly perceived to be the regrettable result of the current economic system and its on-going globalization. Given advances in industrial capacity and efficiency, the managers of production have been able to afford to revalue and demean human work. Alas, for the bottom four-fifths of the world, there is no sense of universal solidarity. This lack of unity reduces the threat, but isolated revolutionary civil wars are quite likely given current conditions. One particularly pointed reaction to the South Korean government's new laws, promulgated in the name of globalization to increase employers' rights to fire, was the incredible surge of strikes at the beginning of 1997 and the armed occupation of factories in 1998.

Despite its apparently omnipotent position, the established order might find its interest in reforms that share wealth, clean up industrial methods of production and consumption, and encourage a rich cultural life. Failure of these reforms risks the situation of having to defend a civilization that is indefensible. Note well, at the end of our tumultuous century the statesmen of the last forty-odd years have wound up delivering to their corporate clients the free markets they have always wanted, along with aspects of economic globalization and privatization of government industries. The tremendous growth in the power of the always strong financial interests when they applied their speculative trade to revolutions in communications technology and global deregulation is incalculable. But the Bedouin with a satellite dish who may not know what is going on in Frankfurt and Tokyo begins to get an idea from what he sees on the TV screen, turning away in disgust or envy for the greed of the movie *Wall Street*.

On the other hand, revolutions rarely succeed. Once the masses vent their spleen, a military or military faction that has, early on, presented itself as favorable to the demands of the masses can take over in a moment of crisis. A fairly recent example of this is the 1975 takeover of the Nine during the Portuguese Revolution. A précis of this event

appears in *Guy Debord - Revolutionary*, but I don't have the last word on it. In his highly recommended autobiography *Beware Anarchist!*, Augustin Souchy writes about his investigations in Portugal, and concludes that the political revolution from above "smoothed the way for incisive changes in the socio-economic structure below and corresponded to the postulates of the former anarcho-syndicalist labor movement in Portugal."

In the course of two years the center of gravity of the Portuguese revolution shifted from the officer's mess and Parliament to the workbench and the land. The revolution was comparatively bloodless due to the fact that the army was in the revolutionary camp. The generals themselves triggered it off. As usual there were radical and moderate groups among the revolutionaries. After the crushing of the parachutists' revolt the revolutionary élan was spent. The period of street fighting ended. The political activity was reduced to the preparation of the parliamentary and presidential elections. The elections went on in orderly fashion and the powers of moderation won a majority. The president-elect was also a man of the middle. Now it was time to appraise the situation and find out what the revolution had really achieved.

On the credit side of the balance sheet was the abolition of the dictatorship and the establishment of political democracy, so long awaited by the people of Portugal. But this was not all. Added should be the beginning of economic democracy with its objective of social justice. Many private enterprises were changed into collectives. After establishment of hundreds of collectives, an agrarian reform bill was enacted on July 29, 1975 permitting expropriations of estates of more than seven hundred acres. Later the permissible maximum of private ownership was set at fifty acres. By August 31, 1975, 426 agricultural collectives - formerly in private ownership - were officially registered. In Baja, province of Alentejo, sixty percent of formerly private estates were

under collective administration; in the province of Evora, two hundred thirty thousand acres were estimated to have been expropriated.

Souchy points out other ways that Portuguese society opened up over the two years of the carnation revolution - the budding of economic democracy, or so it seemed at the time. Likewise it's worth recalling that although the revolutions of 1848 were unsuccessful, the concepts of democracy and nationalism did take hold. Likewise, the revolutions of 1968 - Prague, Paris, China and the United States, with eruptions on every continent - left a profound cultural legacy, part of which is the idea that revolution is possible.

Conservatives blame the breakdown of the world on these emancipation movements and on the decline of authority. They advocate a return to the past (see right-wing revolutions, below). The current Left is reformist, not revolutionary, and proposes social work and the welfare State. Meanwhile the world market produces more losers who destroy themselves in civil wars, as capital retreats from every battle against united workers in the defensive strategy of constant retreat. A prolonged general strike in one country where workers occupy factories can easily be defeated by corporations shifting production elsewhere, although sympathy strikes would reverse that trend. The unlikely but real threat is that these revolutions could spread from continent to continent as they did in 1968.

In a more general sense, the established order often finds it useful to promote divisions in society using the strategy of separation. For example, to the extent that your loyalty is to your sex or race, such loyalty displaces class solidarity. However, the forces of modernization may be so torturous that no psychological warfare strategy can prevent people from assembling in protest to widespread poverty, corruption and ecological disasters - I'm thinking of events such as the general strikes in Venezuela and Russia in spring 1997, and the partial liberation of the lower castes in India in recent years. Those who doubt the existence of spectacular domination as I present it in part IV might

consider the fact that every poster in Britain now has a rating indicating how many eyeballs will see it, to go along with something called POSTAR, whereby lasers pinpoint where people look when they pass a billboard. Illusions produce ignorance, but passion sometimes finds ways to supersede images, even images of itself.

The established order seems to be preparing to go on the offensive to conserve the world it has created - seen in the special forces operations in American cities, and in an increasingly propagandistic mass media. While I would agree that the powerful may have to go on the offensive tactically even when they are on the defensive strategically, they would be advised to avoid heavy-handed operations and concentrate their offensive efforts on the promotion of social well-being.

As mentioned above, citing the work of André Gorz, well-being is directly related to the degree in which people feel overworked. For those looking for the rationale of a future left-wing revolutionary civil war, look no further than Juliet Schor's *The Overworked American*. Moreover, 1997 statistics cited in *The Economist* confirm her thesis; the United States remains the country that works its citizens longer hours than any other industrialized country, over one thousand nine hundred hours per worker per year.

Some of the most strident opposition to this inordinate amount of work draws on the theories of the Situationist International (SI), particularly its leading theorists, Guy Debord and Raoul Vaneigem. Debord amplified the Never Work slogan of Rimbaud and the surrealists; Vaneigem was somewhat less excessive in his call for a ten hour work week. As historian Luisa Passerini points out in her first hand account of the period, *Autobiography of a Generation: Italy, 1968*, the Situationist International's tactics found practical expression in Italy during this revolutionary period, although the SI's caustic propaganda was difficult to translate into a mass movement. The situationists were council communists, in the tradition of the workers' councils in Russia prior to the Bolshevik seizure of state power, and the workers and sol-

282

diers' councils in Germany in 1918. Henry Jacoby hails 1918 Germany as one of the few XXth-century examples of the democratic ideals of Periclean Athens. Jacoby could have mentioned as well the council movement in Turin, which prompted the industrialists to support Mussolini out of fear; the councils in Poland in 1955 that were the inspiration for those in Hungary in 1956, or the 1968 Prague Spring.

The current anti-work movement apparently draws on the work of the Italian economist Antonio Negri, particularly his 1978 book *Marx Beyond Marx: Lessons of the Grundrisse,* a best-seller in Italy when it was first published there, but described, accurately, as opaque by Doug Henwood in *Wall Street.* My Internet search on this subject has revealed a fairly widespread movement, and turned up a remarkable document originating in India called *The Ballad Against Work.* This extraordinary document is by a group called Kamunist Kranti, from the dusty industrial zone of Faridabad, where the group sustains the Majdoor Library and publishes an entirely worker-written newspaper. In the *Ballad Against Work,* Kranti deplores the increased intensity of work, the increased rate of exploitation and the increased duration of the workday. According to the group the basic premise of management manuals is that wage workers are against work, against discipline and against productivity. They observe that the increased surveillance of the workplace is proof that resistance is taking place, and they see workplace skirmishes as seeds of non-hierarchical production relations and non-wage-labor based social formation. They don't put much faith in strikes and other big events, but feel that routine resistance is the best means to oppose the system.

Groups such as this turn the conceptual tools of management against the managerial class by holding them up to the light of Marxist theory. For sophisticated groups like Kranti, and a vast left-wing movement drawing on anarchist, syndicalist and councilist traditions, the humiliation of wage work is imposed by the powerful weapon of the commodity - the commodity force of labor that one must sell in order to buy the commodities to sustain one's life. You should take what I or anyone else says about Kranti with a grain of salt, and read them for

yourself.

> ...the characterization of capital as wage-labor-based-commodity-pro-
> duction clarifies the real meaning of the dissolution of capital which
> can only be seen as global dissolution of all commodity production.

and again:

> The critique of political economy, of Marxian political economy, may
> appear to be dry stuff, but it needs to be grappled with if a meaningful
> intervention in the present is intended to make a non-market, non-coer-
> cive, non-hierarchical and free society. Humanity today may appear to
> be a bit dazed by reality and drowned in hopelessness. But we are not
> lost and shall invent if we have not unlearned how to learn.

Whereas the commodity is one of the keys of power of the lending class and its managers, the engine of infinite progress is class war. And when one reads works like Martin Sprouse's *Sabotage in the American Workplace*, it isn't difficult to imagine the workplace becoming a war zone and more people becoming aware of the glorious past of anti-work and anti-discipline struggles.

This history will eventually be written by professional historians like Michael Seidman, author of *Workers Against Work: Labor in Paris and Barcelona During the Popular Fronts*. Perhaps Bob Black, the soon-to-be PhD. in history and author of the influential essay "The Abolition of Work," will do it. For now, I will sketch some of the dimensions of the struggle.

In my preface I mentioned the slave revolts in the Roman Republic, but I could've gone back to slave insurrections in Greece and, with a little imagination, beyond. The situationist Gianfranco Sanguinetti likes to point to the Ciampi and Communards as historical examples of the refusal of work. Tuli Kupferberg, whose Sixties contribution to the movement, *1001 Ways to Live Without Working*, still elicits laughs, talks about the St. Monday tradition of calling in sick and the

great hobo legends of adventurous lives lived without work. The aesthetic perspective on the subject is presented by Russian painter Kazimir Malevitch in his *Laziness As the Effective Truth of Man,* and again by Dada poet Clément Pansaers in *The Apology for Laziness.* In terms of depth and scope, André Gorz's *Critique of Economic Reason (Métamorphoses du travail, Quête du sens)* is perhaps the academic best book on the subject, rivaled only by his latest tome *Misères du présent, richesses du possible*:

> We're leaving the society of work without replacing it with another.... We all sense a precarious sense of power. But what each of us know will no longer become... a common consciousness for all of our common condition.... The central aspect of an apparently normal condition is no longer that of worker but of a person in a precarious position who works as much as doesn't work in a discontinuous way at several trades, none of which are real trades... people who consider their real activity what they do between wage work.

Gorz rejects the notion that creators or theorists or artists work. The act of creation is a refusal-of-work gesture when it can't be socialized or codified - the gestures of a non-submissive culture, a rebel culture of free debate, solidarity and dissidence. He pokes wicked fun at what he calls the "administrated ones" that we've all become by watching capitalists use less work and pay less for it to create immense wealth. Bankers use capital to prey on society. In these conditions, Gorz makes something of an overstatement to justify his research on the consequences of a post-work society; more than a decadent intellectual luxury, wage-based societies offer less real hope to poor countries than ones in which people assume the production of their society in solidarity and common action.

In Gorz, the refusal-of-work movement currently finds its most forceful and convincing advocate; he takes on Friedman and the Chicago School's arguments about unemployment and makes it clear that he knows that work isn't lacking so much as the distribution of wealth.

Big companies like Siemens make more profit on financial moves than on industrial production. Prepare the population from school on, Gorz argues, to live with periods of non-professional work. Integrate work into a multi-activity life in cooperation with others, whose excellence is in your interest. Work and play activities could complement one another once technology is used to maximize free time instead of production. Gorz challenges the fundamental assumption about the consequences of economizing work time, and paraphrases Marx on the need for the distribution of the means to pay correspond to the volume of socially produced wealth, and not to the volume of work supplied. In other words, the national product is a collective good that justifies what the French call social revenue. No longer advocating a minimal social income for all, Gorz now calls for a sufficient social income, as is now the case for citizens of Geneva.

Numerous individuals and groups have kept this opposition alive: from Jim Haynes, author of *Workers of the World, Unite and Stop Working!* to Dominique Méda, the philosopher who penned *Work: A Disappearing Value*, which I discuss at length in *Liquid Zinc*; or the Echanges et Mouvement group and their pamphlet *The Refusal of Work* that so eloquently describes the "new movement of all types of struggles carried on by those directly involved *themselves* for their own emancipation" and offers suggestions for "bringing the debate out of the rut" such as highlighting the difference between a capitalist and socialist refusal of work; and the Processed World collective's eponymous journal that circulated revolt-against-work ideas far and wide in the Eighties and early Nineties. To quote the New York-based *Zerowork*, which first appeared in 1975, from the introduction to the first issue:

> The political strategy of the working class in the last cycle of struggles upset the Keynesian plan for development. It is in this cycle that the struggle for income through work changes to a struggle for income independent of work. The working class strategy for full employment that had provoked the Keynesian solution of the 1930s became in the last cycle of struggle a general

strategy of the refusal of work. The strategy that pits income against work is the main characteristic of struggle in all the articulations of the social factory. This transformation marks a new level of working class power and must be the starting point of any revolutionary organization. The strategy of refusal of work overturns previous conceptions of where the power of the working class lies and junks all the organizational formulae appropriate to the previous phases of the class relation.

The winds of change suddenly shift direction again and again. Those whose daily lives are colonized by work and by the work of specialists, may one day exalt in a world of their own creation in which autonomous activity, not work, occupies their time. For many, the arrogance of corporate power is felt as a constant humiliation in a daily life filled with tension and anxiety. After such a long period of subjugation, in conditions of being tense and tired, depressed, an inferiority complex is almost inevitable. But this doesn't mean that workers will always continue to be forced to do what they're ordered to do and pretend they like it. I can imagine a scenario in which assemblies form and elect delegates who are revocable at any time by the base, while bandits operating out of sanctuaries and with the assistance of employees who have infiltrated the workplace move in to sabotage business operations. The political power of these assemblies may be limited, but they will play an important psychological role in bringing the masses into a resistance movement. Those who resist the resistance to work will be revealed. Traitors will be liquidated. All of these elements will be constantly under review by resistance forces so as to make adjustments in accord with shifting conditions. Various economic and social sectors become active in the resistance at different moments in the struggle. Those currently excluded from the economy, such as the jobless in France, find themselves in the van when they overcome their shame about being unemployed and demand increased social income payments. Minimum-wage workers in advanced industrial countries could easily realize what a raw deal they're getting from McDonald's

and from unions alike.

The weaknesses and strengths of the adversary will be under continuous reassessment, both locally and internationally. At present, it seems that the group most likely to mobilize is the semi-intellectual youth who are marginalized by current work conditions; they bring to the struggle considerable, if latent, discontent. The hopelessly poor are more difficult to mobilize because they have little hope of change and little taste for risk. Nonetheless, the homeless person who consciously refuses to work under current conditions and spends his or her days living the anti-work ethic may, in fact, constitute the avant-garde. These are the people who might enjoy making anti-work propaganda and encouraging others to join them. This minority can conceivably provide the masses with the motivation to act against the established power by howling drunken shouts about kicking the work habit to passersby, and practicing self-sufficiency through shoplifting as advocated in *An Appeal to the Homeless*. While those who work are forced to be somewhat clandestine about their anti-work activities, those external to the economy can intimidate managerial types on the street and otherwise engage in agitation that could build mass support for the anti-work movement.

Once this propaganda and agitation reaches a certain threshold, and a certain portion of the population adheres to the anti-work platform, strikes and street protests are likely. Yet it is the duty of the strategists to lessen the expectation of the masses in regard to these forms of protest as they tend to wind up in negotiated settlements promising mild reforms. Even seemingly minor psychological losses can unravel the most patient work and induce a sense of despair. But this rule applies to the adversary as well. It's often best to recognize that a guerrilla war such as this can last decades and focus on infiltration and sabotage (well-planned and executed and therefore assured of success) over a long duration. Such a movement might strive for the erosion of the authority of managers, the agents of the State and those who collaborate with it. Every attack should be designed to break the will of the adversary and convert potential adherents, who can instantly

288

identify with the vision of a post-wage work world.

The anti-work movement shouldn't necessarily seek a purely military victory (very rare in the history of guerrilla war), but instead try to weaken the will and control of those who impose the system of wage slavery on the masses. The anti-work movement, rising up as new life from the ruins of the revolutions of the past, focuses on the fundamental inadequacies of the work-based system that doesn't correspond to the needs and aspirations of the masses. The passive support of the population for an objective such as the ten-hour work week should not be underestimated, because at certain junctures, this passive support could become active.

A massive refusal of work could be decisive. The passive support of those who support the managers must be fought with a seductive propaganda campaign that extols the virtues of idleness and rest. At the same time, agitation and propaganda should demonstrate the vulnerability of managers who might otherwise seem invulnerable. Sabotage on a global scale may be all it takes to demonstrate the effectiveness of the movement and quickly win over the population. Disorder will reign - both administrative and economic. At this stage the partisans of the anti-work movement must keep the initiative and press on, teaching the population to distrust anyone who positions him or herself as a leader or a boss.

This does not engender a complete absence of organization; on the contrary, what is required is organization on such a large scale that independent individuals can readily come together and disperse without being tied to a small, easily liquidated party apparatus. This organization must be completely democratic so as to refute the hierarchic structure of the adversary's military and police - not a parallel hierarchy that will take over at the moment of victory, rather an anti-bureaucratic council movement that uses force only as the last resort. This reluctance to use force shouldn't be interpreted as a lack of determination, which is the most decisive factor in any war, rather as recognition of the fact that the population desires peace and security. Violence can either encourage or discourage partisans, or even be com-

pletely counter-productive, and that goes for both sides. State repression often elicits resentments that play into partisan hands. Terrorism demonstrates weakness.

Today's techno-peasants - like the traditional peasants of yesteryear - are not ready to seize state power: they remain regionalized to a certain extent, or localized, even though they are linked globally on the basis of styles, trends and tastes. The zeroworker who would decolonize everyday life for him or herself and for fellow zeroworkers, should take heed of the Japanese victories against the Americans in the Philippines, and the indigenous victories over the Dutch in Indonesia, the French in Vietnam, the British in Malaysia - they showed the world that the unthinkable is possible, that the white man could be beaten. The examples of Czechoslovakia's 1968 revolution and its subsequent "velvet revolution" in the early Nineties are of interest because they affected profound changes in public values vis-à-vis authority, without much civic disorder or violence.

The revolutionary forces of the Sixties went through the classic rise, peak, divide and fall cycle. Revolutionaries must ask themselves how this can be avoided in the next revolutionary period of history. The apparent answer to this question is to keep the focus of the revolution against hierarchical relations of dominance-submission, power, bureaucracy and experts of all types; commodification (of labor and goods); inequalities (especially economic inequalities); and, above all, on alienated labor (a unifying principle par excellence). The revolution fails when participants instead focus on the spectacles of power, the co-option of ideology without real change and the pursuit of personal power. The idea of interpersonal dominance based on a job or some specialty needs to be challenged at every turn. This is not as extreme as it sounds. Unlike militant extremism, this type of psychological warfare can be sustained.

The extremism of the Red Brigades and Red Army Faction should be avoided, in favor of sustained anti-work struggles that foresee the possibility that workplace rules may change to appear more tolerant even as they become more bureaucratic, and adjust to the new

290

conditions. Bureaucrats adapted to the challenge of 1968 and became even more entrenched. Those who focus on overthrowing national governments, especially constitutional systems, are misguided, because these systems are the products of past revolutions and, as such, usually have enough flexibility built into them to thwart a new revolutionary threat. There may be millions, perhaps tens of millions of Clark Kent anti-workers who would be ready to fight the eight-to-six routine, given the right circumstances and armed with visions of societies featuring social income and distributive money for consumption, as outlined in Marie-Louise Duboin's *La Grande relève* journal, to mention an early vision among many more recent contributions.

Once this struggle begins on a mass scale, the revolution will already have been won to a certain extent. In the United States, there is now so much abundance that the model of free meals and free goods given away by the Diggers in San Francisco in the mid-to-late Sixties is in practice in Washington, DC, and could, quite conceivably, be emulated elsewhere.

If you want a rationale to wage civil war, it is to oppose the corporate bureaucratic system of production and consumption that imposes inordinate work on the peoples of the world. The pseudocyclical reproduction of daily life is the real moment of contemporary history; for any civil war or other historical intervention to succeed, it must break this pseudo-cycle. When looking back at the history of the XXth-century, the only organizational model that offers the possibility of supplanting the existing corporate system is councilism. With a little imagination one can envisage a day when managers are forced, through the psychological persuasion of verbal violence, to abandon their posts: A moment when workers occupy factories and tell the shareholders that their illusions of ownership are over. Self-organized councils could render the nefarious professions illicit and otherwise alter the face of the earth by acting in their own interests. Zeroworker councilism might abolish forms of work such as financial speculation, and otherwise place limits - minimums and maximums - on many forms of work. Of course, autonomous activity and domestic labor would be free from constraints

291

unless decisions on these issues have been made democratically in open assemblies.

3.7 Type D: Right-Wing Revolution

Whereas certain right-wing revolutions harken back to a mythical past and involve a charismatic leader, conservative revolutionaries often want to restore traditional institutions that were perhaps more real, as a way to maintain social order and traditional authority. I'm thinking here of Iran and the repression that followed 1979. This type of revolutionary civil war reminds us that established regimes must heed religious opposition, paying special attention to opposition guerrilla forces. I happen to hear the spirit of revolution, however shrill and ugly, in this instance, because Iran makes no secret of the fact that it would like to spread its revolution throughout the Persian Gulf region and beyond. A look at this revolution's success might indicate what a prince might *not* do in the way of counter-insurgency measures.

Muhammad Reza Shah Pahlavi lost the population's support because of his US backing and single-party system, and also because of the tactics of his secret police, the legendary SAVAK. The shah's government squandered oil income on advanced weapons rather than on civil services - services that the population would want to defend in a state of crisis. Simply put, the shah's White Revolution didn't do enough to correct economic injustice. The shah's economic austerity program was perceived to be unjust given his monarchical patronage system, and slandering the exiled Ayatollah Khomeini and his tape-recorded speeches didn't sit well with a population well informed about the shah's subservient relationship with the United States.

Rumors spread that the 1977 murder of Khomeini's forty-five-year-old son, Mustapha, was a SAVAK assassination operation. His death provoked large, angry demonstrations.

These lessons of mass revolt were apparently lost on Turkey's secular generals, who pushed an Islamist government from office in July 1997, and who may be splitting their own ranks by persecuting

pro-Islamist soldiers. What had Prime Minister Erbakan's Welfare Party done to enrage the generals of this once-stable Muslim democracy? The only concrete charges against the Welfare Party are (1) that it encouraged the wearing of scarves in public buildings, and (2) that it proposed building a mosque in Istanbul's Taksim Square. What the generals have apparently failed to recognize is that Erbakan and his Welfare Party are not Afghani Taliban, or the radical Islamists of Algeria, Egypt and Pakistan. The Welfare Party has more in common with moderate revivalist parties in Tunisia, Egypt and Jordan who appear willing to operate in a democratic system. Although I recognize that this is purely anecdotal, it seems relevant that my secular Turkish friends believe that the failed effort to ban the Welfare Party was wrong-headed. If they go too far in denying the population a degree of representation, the generals may find themselves facing a generalized civil war akin to the one now being waged in Algeria. Turkey is currently waging a civil war with rebel Kurds; in such unstable times, popular support is essential.

The Egyptian example merits investigation because this is where the first modern Islamist movement, the Muslim Brotherhood, was born in 1928, and encouraged by the government as a tool against the Left through the Seventies. The Eighties ushered in an era of Islamic dress for women, and of Islamists in parliament. Violence by the radical fringe of this movement served as a justification for government counter-insurgency - mass arrests, military trials and death sentences. Most of the violent Islamists now live in exile. The government is beginning to give better services to the urban poor where the Islamists had made inroads, and the state broadcasting monopoly has tried to project a more moderate and tolerant version of Islam that kept veiled women off the airwaves. The tourist massacre in Luxor gives the impression that anything could happen.

3.7.1 *Mussolini* The future *Il Duce*, Benito Mussolini was first a leader of the revolutionary wing of the Italian Socialist Party, who broke with his party over the issue of Italy's involvement in World War I.

After the war, he founded the Combat Group with a socialist program, namely the abolition of private property and the principle that workers should run their factories.

Initially Mussolini supported Gabriele D'Annunzio, the poet and nationalist who wanted Italy to acquire territory populated by Italians in the Austro-Hungarian Empire; he railed against the Treaty of Versailles because the cities of Fiume and Dalmatia hadn't been acquired. In September 1919, D'Annunzio and his band of war veterans occupied Fiume. The city was held for over a year. Mussolini's support for this operation lost him electoral support, and his movement was saved from collapse only by financial support from large landowners and industrialists, who used his Blackshirts to terrorize the countryside and destroy trade-union and peasant organizations in the *biennio rosso*, the 'two red years' (1918-1920) of industrial and agrarian unrest in Italy following the First World War. The climax of this *biennio rosso* came in August 1920 when workers occupied factories in Milan, Turin and Genoa. Industrialists feared a Bolshevik revolution, but socialists and trade-union leaders were unwilling to start a revolution because it seemed, so they said, doubtful that the workers would support it.

Prime Minister Giolitti negotiated a settlement, but the large landowners and industrialists turned to the Fascist Blackshirts. These paramilitary Fascist groups or action squads were recruited from war veterans, students and lower-middle-class youth that remind us of those who perpetrated the ruthless massacre in Acteal, Mexico, for the PRI on December 22, 1997. In Italy, the police and army, amazingly, did nothing to stop the Blackshirts, who were burning down the offices of left-wing newspapers and parties, trade unions and Catholic peasant leagues. These actions effectively destroyed most of the organizational structure of the socialist and Catholic trade unions. In much of central and northern Italy, their membership fell dramatically, while Fascist membership increased dramatically. Mussolini abandoned his socialist beliefs and made a political pact with Giolitti, who thought he could constitutionalize and absorb Fascism. As a result the Fascists won thirty-

five seats in the 1921 election and joined Giolitti's so-called national bloc.

Mussolini came to power a year later, following his March on Rome and King Victor Emanuel III's unwillingness to oppose the Fascists. In 1922, inspired by the occupation of Fiume by D'Annunzio, the Blackshirts occupied public buildings in the towns of north and central Italy. Mussolini threatened to follow these operations with three columns of Blackshirts marching on Rome. Although the Blackshirts were no match for the army, and the Prime Minister, Facta, had decided to oppose the Blackshirts, the King wavered - fearing civil war and army loyalty - and ultimately he refused to sign a declaration of martial law. Facta immediately resigned, the ultimate concession in an excessive string of concessions. The King appointed Mussolini, who refused to join any government he did not lead, prime minister. Defeat for Mussolini would have marked the end of Fascism, but his bluff worked - the Chamber of Deputies gave Mussolini's government a huge vote of confidence and his followers paraded through the streets of Rome on October 31, 1922. During the 1924 elections, the Blackshirts used violence and intimidation to gain sixty-six percent of the votes and to gain a majority of the seats. Critics of these tactics, such as the Socialist deputy Matteotti, were murdered by Fascists. This precipitated the Matteotti crisis and its demonstrations and demands for Mussolini's resignation. It looked to everyone as though the Fascist government would fall, but fearing a communist revival, the King did not ask Mussolini to resign; the Aventine Secession was the response of many socialist, liberal and Catholic deputies, who withdrew from parliament in protest. Local Fascist party bosses demanded that Mussolini set up a dictatorship or step aside. Mussolini declared, on January 3, 1925, that he didn't intend to become dictator (without making the slightest admission of involvement in Matteotti's murder), but by December of that year new laws gave him total power. He used these new laws to ban political opposition and trade unions, censor the press, purge the administration of anti-Fascists, replace elected mayors in local governments with appointed officials and set up secret

295

police and special courts to arrest and try political offences.

As with Mussolini, Hitler's rise to power was effected by a similar mix of extra-legal violence and electoral claims to power that were ultimately rewarded the same way: power was granted from above. I considered these to be civil wars in the sense that both Mussolini and Hitler sought power through paramilitary force and only resorted to the ballot as an additional tactic. These dictatorships imposed the state of pure war that Sun Tzu writes of in *The Art of War*, a moment when no opposition is possible. This was the case to an even greater extent in Nazi Germany than it was in Mussolini's Italy.

3.7.2 *Hitler* Like Mussolini, Hitler had originally joined the Socialist camp, namely the German Workers' Party, which changed its name in 1920 to the Nazi Party. Its basic program was the rejection of the Versailles Treaty, unification of all Germans and attainment of increased living space. The platform was blatantly racist, stating that no Jew could be a German.

Hitler took over the party in 1921 with ex-soldiers and middle-class youth supporting him. These groups were organized as a paramilitary force in the SA, *Sturm Abteilung*, or 'stormtroopers.' Dressed in brown uniforms, they protected Nazi meetings, broke up the meetings of other parties and disseminated Nazi propaganda. The SA played a large part in bringing Hitler to power by street fighting and otherwise intimidating opponents, although the first real attempt to seize power, the Munich Putsch in 1923, was a failure.

The tactics of this putsch are illuminating. Hitler and his SA surrounded a Munich beer hall where a meeting of right-wing politicians was being held. When he burst inside, Hitler declared that the Bavarian and Reich governments were dissolved and that he was the leader of the national government. In the process, he named General Ludendorff as his new army chief, and the next morning three thousand Nazis marched through the streets. Police fired on the marchers, killing sixteen Nazi and effectively ending the putsch. Hitler fled as soon as the police opened fire, but Ludendorff marched right through

the police lines. Had Hitler marched on red Berlin, he would have been crushed; as it was, he was only arrested.

After his release from a brief stint in prison, Hitler reformed the Nazi Party and sought power without the nationalist Right who were too weak to be trusted. Although much too strong to be seized by force, the Weimar regime was vulnerable to attack by vicious propaganda. In the process of this psychological warfare, the Nazi Party attracted lower-middle-class white-collar workers and rural voters, yet the party grew slowly prior to 1928. The depression and an alliance with the nationalists against reparation payments helped Nazis win more seats and become a mass party, especially in the small towns of the north and east of Germany inhabited by peasants, self-employed artisans and small traders who resented trade union power. Hitler's charismatic call for a German renaissance was the ticket for the Nazi Party to win thirty-seven percent of the vote in the 1932 elections.

Then, on February 27, 1933, a night that will live as one of the most infamous nights of the XXth-century, the Reichstag was burned down. A mentally disturbed Dutch communist by the name of van der Lubbe was found on the scene and arrested, and later excuted. The Nazis claimed that the fire was a signal for a communist rising. Nonetheless, rumors spread that the Reichstag had been set on fire by Nazis to give them an excuse to attack their opponents and declare a state of emergency. An international commission under a Swiss, Walter Hofer, found that the fire was started by an SS-SA group under the direction of Himmler's assistant, Reinhard Heydrich (the SS being the brutal *Schutz-Staffel* or 'protective squadron' under Himmler).

Hitler used the fire to obtain President Hindenburg's agreement to issue a decree suspending most civil and political liberties, as a temporary measure. Hundreds of communists and socialists were arrested, their meetings were disrupted and many were killed in street clashes with Nazi stormtroopers. The electoral campaign was under way, and Nazis appeared as saviors who were delivering Germany from communism.

Lest anyone doubt that this was a civil war, consider the roles

of the SS and SA. The SS was founded in 1925 as part of the SA. Himmler was put in charge of the SS in 1929 and built it into a carefully selected elite to identify and destroy all of Hitler's enemies. By 1933 it had fifty-thousand members and rose to two hundred and forty thousand by 1939. The SA, meanwhile, was anti-capitalist in the sense that it was hostile to big business. Ernst Röhm became Chief of Staff in 1931, and the SA grew rapidly; by 1934, it had over four and a half million members at a time when the army numbered one hundred thousand troops. After Hitler became Chancellor in 1933, the SA expected to be rewarded lucrative posts, but they were disappointed and became increasingly radical and spoke of a second revolution.

The old elites and the army feared that their property and positions were in jeopardy, particularly when Röhm suggested that the army should merge with the SA under his command. Hitler needed the support of the army to become president when Hindenburg died. On the Night of the Long Knives (June 30, 1934), Hitler and his SS echelon executed SA leaders, effectively eviscerating the group. This is how the SS gained its independence from the SA and went on to command the first full-scale concentration camps. Equally ominous was the Gestapo hunt for communists and socialists. Resistance was suicidal. When Hindenburg died, Hitler became both president and chancellor.

These last two examples illustrate a limitation of my theory. When faced with would-be dictators such as Mussolini and Hitler, and would-be Ayatollahs for that matter, no negotiation or concessions should be used that don't fit into an overall counter-insurgency strategy. Make no mistake about it, agents of death wage civil war. The attentive reader who argues that the same can be said about left-wing revolutions is correct and might recall that I argued against concessions for fascists draped in red (socialist and communist party types) in my discussion of the Spanish Civil War. In today's world, it seems as though the fascist politicians have been in such successful alliances with the wealthy and military for so long that the Left is less worrisome than the Right.

3.8 Category III: Unidentified Civil Wars

Unidentified civil wars do not constitute a pure type, rather an infinite number of possible scenarios. Many of these wars have limited objectives, but they can have mass implications given the media culture in which we live. These scenarios unfold in two fundamental ways: the seizure of state power (and the imposition of dictatorial controls and structural violence); or the riotous molecules of a race war, or any other essentially anti-social eruption of civil conflict.

3.9 Type E: The Seizure of State Power

Here, scenarios such as a palace revolution (Algeria, 1962), come to mind, or a coup d'état that imposes a situation of pure war on the population whereby no real retaliation is possible (as in Argentina's long dirty war against the left that followed the 1976 military coup). As with the dynastic disputes of the past, the strategy is simply to seize state power, preferably in a way that allows the coup leaders to effectively govern.

The coup attempt on May 25, 1997, in Sierra Leone witnessed a young army major stage a failed attempt to take Freetown. This event can be read as a recent development in the civil war that began in 1991 between rival army factions and the local self-defense forces of the wealthy class. A 1992 military coup resulted in promises of elections, but as the fighting continued, South African mercenaries were deployed to tame the rebels.

The 1977 Sierra Leone coup was crushed by the intervention of the Nigerian military. As we all know, big fish eat little fish, but eagles don't catch flies. In other words, the seizure of state power is so obvious and such an obviously flawed revolutionary strategy that I won't waste time on it, except to remind the reader that even the purportedly anti-Gorbachev coup-plotters knew that they couldn't use force because it wouldn't be politically viable in their last attempt, in

1991, to hold on to power. The Communist Party was soon banned, but many of its members are still in the hunt for power.

3.10 Type F: The Molecules of Civil War

To my mind, undeclared civil wars can be virtually *any riotous situation that resembles civil war*. Enzensberger calls this molecular civil war, or the basic molecules of civil war. A recent example would be Albania in the spring of 1997, when army barracks were overrun and raided for light weapons and the country went berserk. Many current conflicts resembling civil war actually have no strategy at work other than looting and weak-willed crowd control. Enzensberger reminds us, in this light, of what Freud called "destrudo" or destructive impulse, which is often self-destructive. Albania's president Sali Berisha appeared ready to deal with opposition parties after the moment of chaos had more or less passed. But after agreeing to rules, he changed his mind and then changed it back again. Not exactly the sort of behavior that inspires confidence and loyalty in the population - Berisha appears willing to rule with little more than his presidential police force.

Another recent example of the molecules of civil war would be the rioting in Nairobi, Kenya (July 1997). In support of my thesis that repressive measures tend to backfire, recall that in 1990, when the pro-reform lobby held a rally for democracy, it was violently opposed by the corrupt president, Daniel arap Moi - an act that marked the beginning of the end of peace in Kenya. Now Moi's soldiers rage throughout the capital, brutally terrorizing innocent citizens. Moi painted himself into a corner by being intransigent and corrupt.

Indonesia's elections in May 1997 took on characteristics of a molecular civil war when riot police faced off with stone-throwing youth who were using an occupation strategy to demand and receive concessions; the currency crash precipitated still more riots in 1998.

Unidentified civil wars might also include the assassination-level wars by Iran, Iraq and Libya against their exiled dissidents. Although they take place internationally, these are usually undeclared

civil wars or the embers of past civil conflicts.

<center>*</center>

The category of unidentified civil wars is important because many civil wars involve these types of threats to, or seizures of, State power. Recall, for example, the way Spaniards went to war after a failed coup.

The strategic goal of Laurent Kabila and his Alliance of Democratic Forces for the Liberation of Congo-Zaire (ADFL) appears to be nothing more than to depose Mobutu. Most of the various tribes went along for a while. As a Tutsi, Kabila doesn't have support from the Babembe, Bahunde and Baluba tribes, and he isn't doing much in his long march from the east across Zaire to gain their support. Kabila is likely to liberate Zaire, but he may not be able to govern it. Hence, Kabila's civil war might be unidentified or simply a single-issue tribal war.

Many of today's undeclared civil wars, notably those of the molecular type, have traits (riots, arson, looting, strikes, occupations) that can be traced to prejudicial causes. For example, the urban gang wars in the United States result from underlying factors related to poverty and generations of families sharing a profound sense of social alienation. The greatest threat to the established order is that these molecules attach themselves to atoms of ideas about solidarity and then become precursors of a more generalized civil war.

An excellent example of this was brought to light by Curtis Price. At a Baltimore recycling plant in the early Nineties non-union workers set up an informal organization, what might be called a zeroworker council. Guerrilla warfare became a fact of everyday life, with loafing and getting high as the initial objectives. The theft of lumber and copper and other examples of non-political work resistance continued for years.

<center>301</center>

Part IV Chaos Never Dies: A Zerowork Theory of Revolution

4.1 Generalized Revolution

The revolutions of 1848, the last major example in the general theory of civil war, were anomalous but not without precedent - namely the revolutions of 1830-1832. Pannekoek's assessment of these revolutions is painfully accurate:

> Always, when the masses overthrow a government and then allow a new party to take power, we have a bourgeois revolution - the substitution of a ruling caste by a new ruling caste. It was so in Paris in 1830 when the finance bourgeoisie supplanted the landed proprietors, and in 1848 when the industrial bourgeoisie took over the reins.

The successors to these revolutions are (1) the revolutions in Russia and Germany in 1917-1919 (destroyed by the dishonest machinations of Social Democrat party politicians), and (2) the global revolutions of 1968, most notably these events: the student occupations in Paris and subsequent national general strike (ended by union acceptance of an agreement that most workers found unacceptable); the Prague Spring with its councilism component (the full realization of which was again thwarted by the Communist Party); the peak of the Chinese Cultural Revolution (albeit a revolution stage-managed by the Communist Party); and sporadic riots and protests in the United States. The example of Paris in 1968 was repeated in scores of cities, with occupations taking place on every continent, and revivified with renewed force in Italy in 1969. What is interesting about the French and Italian examples is that they took place at a time of economic prosperity and involved matters beyond pay, namely quality of life issues; they can be viewed as a reaction to the rapid modernization that took place during the Fifties and Sixties (see Kristin Ross' *Fast Cars, Clean Bodies*). Robert V. Daniels makes much the same point in his book, *Year of the Heroic Guerrilla: World Revolution and Counterrevolution in 1968*,

here comically bopping bureaucrats on their heads:

> Common circumstances - the widening urbanization, education, and technological impersonality of modern society; rising expectations for economic progress and personal freedom; and the perception of oppressive authority in school, street, and work place whether in the hands of one's own rulers or of alien races and governments - readied potential rebels for action.

And again:

> Most striking in many cases was the revolutionaries' perception that technology, extolled by the dominant ideologies as the salvation of humanity, could be the accomplice of bureaucracy and the bane of a free and equal society. The technocrats, for their part, from French cabinet ministers and American generals to Soviet and Chinese party bosses, proved themselves consistently unable to understand what their adversaries were agitated about.

These quotes lend credence to the notion that the 1968 experience, when the world was ablaze with revolution, corresponds to the modernization theory of revolution:

> The experience of technological and economic change tends to mobilize new or previously apathetic groups by raising both their economic aspirations and their demands for political participation. Revolution is likely to occur when those holding state power are unable or unwilling to meet the demands of groups mobilized by modernization. (from James DeFonzo's *Revolutions and Revolutionary Movements*)

As unlikely as a revival of these savage protests seems at present, consider a few facts: technological unemployment is a reality - one-fifth of the world's population is unemployed, half of the population of Latin America is in poverty and the miserable effects of glo-

303

balization of management strictures are being felt by workers of all nations (greater job insecurity, worse conditions, lower wages, longer hours). A recent report by the United Nations Conference on Trade and Development finds that from 1965 to 1995 the difference in income per capita between the seven richest and seven poorest countries nearly doubled, from twenty times to thirty-nine times.

What is ominous is that poor people everywhere are aware of the lifestyles of the rich and famous. The lower classes in advanced industrialized countries now compete with those in less developed countries on the basis of so-called free trade. As the figures of the 1996 US census point out, even in the current US economic boom, prosperity is lopsided - the rich are getting richer as the poor continue to slip downward, while the middle class makes modest gains in income, often with the sacrifice of more work. We find verification of Marx's theory of immiseration in still more statistics: from 1980 to 1996 the richest 5 percent of households in the United States have increased their share of the wealth from 15.3 percent to 20.3 percent while the poorest 60 percent have experienced a decline in their share of total household income from 34.2 percent to 30 percent.

Half the financial assets of the country are in the hands of the richest 1 percent and three-fourths of all financial assets are controlled by the richest 10 percent of the population. Perhaps nothing exemplifies wage inequities the way the compensation of chief executives has risen from sixty times that of the average worker in 1978, to one hundred and seventy times that of the average worker in 1995. As for the inequities of sheer, over-all wealth, we now know that Bill Gates owns as much as the bottom 40 percent of the population. Capitalism has had an amazing ability to cope with demographic challenges, but the present predicament will test even the best response capital can muster.

As was the case with both the fallout from the industrial revolution in 1848 and with the mass media and automated production revolutions of the Sixties, the civil wars and riots around the world today originate in restless populations who are rendered surplus by

technological and managerial innovations. The economic system now fails to adjust fast enough to compensate for the fact that less labor power is needed to create the glut of commodities that pollute the planet. Pressures build as unemployment rises and millions struggle to survive. If deprivation reaches new, unforeseen levels, these surplus populations may resort to the sort of occupations and wildcat strikes experienced in 1968. To the skeptical reader, I should mention that I too believe that the threat of a generalized left-wing revolution is unlikely to happen tomorrow, but the outlook over the next decade is far less promising for the existing order.

To think strategically is to examine the worst-case scenario. For the existing powers, the generalization of left-wing revolutionary civil wars remains the worst-case scenario, because the ultimate strategic goal of these wars remains to radically alter the existing global financial and industrial arrangements. The fact that these sweeping revolutions have happened in the past, with greater or lesser success, means that they are a possibility. This revolution may not come from the elite industrial workers, such as skilled union members, but from the growing sub-proletariat of unemployed and marginally attached and discouraged workers. History has shown, as in the civil war in France (the Paris Commune of 1871), that workers without leaders (Blanqui was in prison, Marx in London), without means and without any real coordination constitute a perilous threat to the existing social order.

Such an informal mass might not be much of a match for today's well-armed nation-state, but the State has severe moral and strategic constraints that populations, when they get to a certain point, can readily override. When public opinion goes against the established power, this social force harms the regime; this negativity should never be underestimated because it represents a latent capacity for uprising. Imagine a moment when even overworked executives and professionals support the idea of a revolution to reduce their work hours, because many consider themselves well-paid slaves working more than sixty hours a week.

Depression and hopelessness are spawned by the supreme self-denial demanded of these workers. But these psychic ailments must be masked with courage and decisive action if one is to succeed in the modern office environment. Doctors and lawyers suffer panic attacks because of the immense responsibilities demanded of them. Teachers assume positions of powerlessness that require them to follow untenable orders. Dentists have high suicide rates and often project their problems onto the people around them. Government workers trying to stay out of trouble turn into automatons. And all those middle managers working for large corporations no longer have the security they need, because of downsizing and other hazards of current working conditions.

Much-admired celebrities who chase success by burning the candle at both ends find that success isn't all it's cracked up to be; like politicians, they can't separate their public and private personas. As the sex scandals of 1998 and 1999 show, they can never really escape their work-place roles. Office politics has become increasingly harsh; every artifice of deceit comes into play: spreading rumors, stealing ideas, working to show others up, being a stickler for details, stabbing colleagues in the back.

Of course those imprisoned by child labor (recall that the United States is a non-signatory to the International Labor Organization's child labor laws), prison labor and other forms of hard, under-compensated labor have even more reason to revolt. It is merely a matter of time before books such as Emile Pouget's *Sabotage* or Walker Smith's *Sabotage: Its History, Philosophy and Function,* or yet again, Thorstein Veblen's *On the Nature and Uses of Sabotage* are reread and put to use. As the title of a more recent book on the subject put it, people are *Fighting Back on the Job.*

The author of this savage tome, Victor Santor, tells you how to assess your boss' vulnerability, such as his financial position or client lists. All delicate equipment, communications and transportation is vulnerable. And Martin Sprouse's *Sabotage in the American Workplace,* one of the great books in the refusal-of-work library, provides scores of

tales of "dissatisfaction, mischief and revenge." I particularly liked Jason's story - a bank teller jerked around by the bosses, let it be known to his friends that he cashed forged checks and then didn't show up on the busiest day of the year.

Although the experience has been fraught with difficulties, work is undergoing a revaluation here in the United States. For example, Scott Adams' comic *Dilbert* gently skewers corporate bosses. Is Dilbert so tame that he's a safety valve, as its critics allege, and actually thwarts resistance to work? Or does Dilbert give popular expression to the very real dissent and subversion found in the American workplace?

What else comes to mind? The television sit-com *Working*, the film *American Job* (1997), the radio contests to see who has the worst boss or who has the best excuse to take the day off, and the whole so-called slacker phenomenon reflected in Richard Linklater's film *Slacker*. Management experts are finding it difficult to deal with a generation of people who talk back and don't respond to yelling. These twenty somethings detest the surveillance systems that management uses to monitor their productivity, such as new software that monitors employee use of computers and puts an end to high-tech coffee breaks in cyberspace. The superior-subordinate and command-control system is being tested by these bad workers who demand access to management to express their grievances as a major condition of employment. A majority of employers add that today's teenagers are even worse - they demand creative expression in the workplace, such as the ability to choose books that go on display or no limits on facial piercings. As André Gorz puts it, the new office space holds the possibilities that workers to reclaim their work or become totally enslaved. He adds that three conditions must be met to supersede the alienation of work:

1. self-management of work by workers as subjects of their productivity and cooperations;

2. a way of work that develops the faculties of workers so that they can put them into practice outside of work;

3. objectification of work as a product that is recognizable by

the workers as the meaning and goal of their activity.

Gorz sees indications that youth identify with these ends. Teenagers and young adults frequently don't define themselves by their relationship to their job, and they're motivated by ethics and social utility. They're not ruled by money and commonly reject the work ethic's values of sacrifice, servitude, saving and putting their lives on hold. Given the choice, most of this generation would opt for part time work and the sort of multi-activity life that Gorz envisions. Successful work-refusal operations could serve as examples for others, and if the pressure is universal, sudden and forceful enough, a generalized revolution surpassing the revolutions of 1848 and 1968 could happen. No other form of civil war even claims to challenge the historical moment that is charaterized by the capitalist reproduction of daily life, the production-consumption cycle that is the focus of the vast majority of global social energy.

4.1.1 *Non-Work Activities* Gorz points out that most people view non-work activities that develop human relations as contributing much more to well-being than commodity relations. Autonomy, self-esteem, a happy family life, friendship - these are the expressions of life that make people happy. I would debate whether contemporary capitalism provides adequate opportunities for these autonomous activities and this lack puts the legitimacy of the system in question, although the autonomous activities that it does allow are palliatives that mask the undeclared civil war. A lack of autonomy is impossible to measure, especially in our media-saturated age. But if the masses revolt against the alienation and separation from life of global corporate bureaucratization and commodification, by carving out new slices of autonomy for themselves in non-work activities, we know that they are responding to a significant lack of autonomy and free time.

People sense that they lack the time to develop themselves, to engage in arts, sports, science, philosophy, because of the socially determined need to work. But socially necessary paid labor has been declining for decades, precipitating a serious crisis for our work-based

societies; individuals no longer find their identities in work and often resent the fact that their social lives are limited to their workmates, because they spend most of their time at work.

As work becomes less economically important and people become more detached from their work, a profound revolution could take place. A radical shift in values could make economically related activities seem disgraceful and other interests fill the void - popular participation in physical culture, philosophy, science and art. These can become strictly extra-economic realms that transform work-based civilization into a love-based one that values a more diverse range of values, zerowork values that supersede economic values. Make love not work.

Here, the global DIY (do it yourself) movement is crucial because these cultural projects - recording, publishing, broadcasting - run the risk of transforming the sub-proletariat with plenty of free time on their hands into a sort of new aristocracy that finds its glory in expression of alternative values.

In the midst of the growing diversity of individual political critiques, a few simple, radical ideas surface, simple ideas that many people can accept and put into practice - the idea that the economy is a tyrant that needs to be fought on every front through gifts, barter and boycotts, or the idea that there are two classes: the *interns* (integrated in the economy through work and conspicuous consumption) and the *externs* (excluded from the economy by their rejection of work and prioritizing of the free self-realization of their individuality through self-education aimed at countering the dominant culture).

As hard as it is for us to imagine now, there may come a time when the trend toward turning every activity from home cleaning to comforting into wage work is reversed.

The most serious threat to the present triumphalism of capitalism comes in the form of a generalization of civil war based on a critique of the ideology of work - a verbal assault against the work ethic whereby work is a social duty, a moral obligation and the path to personal success, an assault that coincided with the way the work ethic

309

has been undermined by employers who create precarious conditions or downsize experienced employees.

With so much indirectly productive and unproductive labor going on, the idea that the more each individual works, the better the society, is coming into question.

People are asking, what is the justification for this overproduction that ruins the air we breathe and the water we drink?

The connection between more work and a better society tears as overproduction is becoming the most obvious and pressing problem facing the planet. Once the demographic numbers become too significant to ignore (although the measure of unemployment is as ambiguous as its many causes - all ultimately tied to the accumulation of capital), it will become clear to everyone that those who work little or not at all are not necessarily acting against society. Less should be produced to ensure the continued satisfaction of basic needs such as air, water, space and time. This useless and harmful production creates pollution and social unrest, as if obscene profits weren't, in themselves, enough incitation to revolt. The mere revaluing of the value of work, which is already well under way, could engender the self-destruction of a great many economic phenomena.

4.1.2 *More Strategic Considerations* In the face of this threat to the control of the population through work and consumerism, the obvious strategic goal of the established order is to maintain its monopoly on military force, to maintain its institutions and to further secure its territorial integrity. On a deeper level, however, the established order wants the support of the population because the population may be strategically decisive. Mao wrote that the active support of the population was the first condition for the success of his Red Army, and he proved himself correct by enlisting the support of the masses of Chinese peasants. The weight of popular support in all civil conflict is seen here in Washington in the seriousness with which politicians regard public opinion polls (the same is true of politicians everywhere). The US Army highlights the importance of popular support for the

conduct of war in its recent field manuals, and found itself facing considerable popular opposition to the US Army Special Operations exercises carried out in Atlanta, Chicago, Los Angeles and other major cities.

With a hostile population ready to express its distaste or displeasure, a given regime can only rule in a high-handed way, and this is always difficult to sustain. The best way to obtain the support of the population is to govern fairly - no corruption, a just legal system, a good banking system and health care for everyone. The existing order might itself try to take the offensive and reform work - make it less standardized and bureaucratic, for example. These reforms might come too and late and not go far enough at time when everyone knows that capitalists make more money with less work and pay less for the work they do use. New production techniques enable capital to dominate workers like never before because in rich and poor countries alike, joblessness is increasing, and this fact forces millions to work in harsh conditions and, what is worse, to pretend to like it.

The established order might want to get ahead of the curve and advocate a smooth transition into a post-work society. The commodity economy as a whole is most vulnerable on the point of work because humans naturally resent being a commodity that works. For the established order, it might make sense to encourage externs, those external to the economy, to see themselves as independent by granting them a social revenue at a time when stable, full-time work is increasingly hard to find and when wealth no longer depends on human work. Value might be granted to people willing to work discontinuously on various projects, when needed, but otherwise live lives filled with free time. In other words, the existing order finds its interest in modifying the oppressive conditions that prevail everywhere work is treated as a cheap commodity, and where those who don't work are denied human dignity.

In a civil war situation, such as a zerowork revolution, the established order wants the population to defend the status quo and should therefore conduct its war according to the same fair-minded

311

principles with which it governs. In many cases, extra-legal or otherwise excessive counter-insurgency tactics backfire because in using them, the established order loses the popular support of the population.

Whether it's Spain's dirty war with the Basque separatists, the genocidal tactics used in Rwanda and Bosnia, the Czar's provocative use of his Okhrana for assassinations, or the Shah's use of SAVAK, morally reprehensible tactics actually tend to work against the established order. Why? Because the population is unlikely to lend its moral support to the use of these cowardly tactics. Of course, many regimes successfully hide their use of these tactics for many years and populations don't necessarily turn against these brutal regimes. Nonetheless, a regime should show that it can save itself by better means; force should only be used within strict rules of engagement. The proof of this axiom is seen in the way the population abhors terrorism, especially state-sponsored terrorism, such as that executed in the name of the Left in the strategy of tension in Italy - not a pure civil war, rather an undeclared civil war. These tactics either exacerbate disorder, or create it.

An alternative tactic is to engage representatives of the opposition in peace talks or encourage other dialogues and possibly share a degree of representative power with rivals. Aside from the obvious delaying aspect of this tactic, these concessions are in the interest of those who recognize their interest in maintaining the present system of production and consumption. The example here is Aldo Moro's historic compromise with the representatives of the Italian Communist Party (PCI) during the Seventies. For the economic elite, this concession to the PCI made perfect sense because it gave the representatives of the workers a stake in the existing order. But rival right-wing forces in Italy associated with military intelligence personnel, linked with NATO, disagreed with Moro on intensely held ideological views. These forces perpetrated attempted coups, kidnappings and bombings that caused the population to regard subsequent regimes with deep-seated contempt (see chapters eight and nine). Governing Italy is now more impossible than ever; an ex-communist holds the prime minister's post

and communists form part of the ruling coalition.

This example conforms to the axiom that cruelty and corruption tend to go hand in hand. At least since the XVIIIth-century, shrewd state-builders and political thinkers have recognized that governments should govern with the consent of the governed; since the XIXth-century, people have held the conviction that the government should represent the nation. As a general rule, representatives of opposition groups - separatists, rival ethnic or religious groups, unions or left-wing parties - can often be co-opted into the service of the established order by being brought into the ranks of the political class. For example, in spring 1998, Moroccan King Hassan II included opposition personalities, such as Economics and Finance Minister Fathallah Oualalou, in his cabinet. This power-sharing gives the impression of change when in fact the monarch rules. An apparent willingness to invite all the estates to the banquet corresponds to the loftiest ideals of the middle class. Such liberalism dates from the slogan Liberty, Equality, Fraternity of the French Revolution, which wasn't without its incredibly bloody counter-revolutionary civil war in the Vendée. Although never completely suppressed, the struggle was quelled by a combination of repression and conciliation, including the freedom of worship and amnesty in the Treaty of La Jaunaye, February 17, 1795.

Of course, concessions to representatives of the lower classes must be limited, lest they over-embolden upstarts who might press for still more radical demands, demands that reactionary elements would find unacceptable and fight to prevent. Danger arises when these representatives of proletarian elements lose control of their base of support; the dominant class forfeits its best ally, and workers who have no union representatives can suddenly decide to strike - without representation they represent an unpredictable mass of social energy. Naturally, this threat extends to union workers who engage in wildcat strikes.

To govern in a strategic way, it is in the long-term interest of the existing powers to co-opt and offer limited support to union representation and communist parties to obviate the worst-case threat of revolutionary civil war. It makes strategic sense for authentic revolu-

313

tionary movements to expose the bureaucratic structure of unions and the class character of party politicians. Again, the Italian example is illustrative. Opposed to the policy of conciliation practiced by the PCI, the workers' council movement of 1969 constituted an extra-union, extra-party takeover, albeit momentary, of a noteworthy portion of Italian industry.

To take this lesson a step further, the strategic interest of the established order finds itself preventing workers and other groups from meeting in extra-union and extra-party forums. The principle of representation is the ruling principle of the current hyper-media age. Direct social contact, and even a degree of direct contact with life's miseries, have been relegated to the realm of representation. The battlefield of civil war, extended to the mass media at the latter's inception, has been almost entirely taken over by the media.

A recent, obvious example of this psychological warfare appeared after the bombing in the Xinjiang province's capital city, Urumqi, on the day of Deng Xiaoping's funeral (February 25, 1997) in Beijing. A large minority of increasingly militant Muslim Uighurs share Xinjiang with the Han, the dominant ethnic group in China. Following the explosions in Beijing during the annual session of China's parliament, the National People's Congress in March, China's leaders cracked down on all Uighurs - the threat reportedly being from Uighur dissidents in Turkey and Kazakhstan. On the cover of the *People's Daily* - next to articles on the importance of ethnic unity and others on the regime's resolve to ensure law and order - readers found the picture of Jiang Zemin wearing a Muslim cap and shaking hands with a famous Uighur singer.

Those who conduct guerrilla-style civil wars have attempted to join in this psychological warfare, using terrorism and other media-oriented events, in what usually amounts to a fatal strategy on their part. They are no match for the likes of the military regime in Myanmar, which, with the stroke of a pen, can change its name from the State Law and Order Restoration Council to the State Peace and Development Council. As Machiavelli put it in *The Discourses*: "The great ma-

jority of mankind is satisfied with appearances as though they were realities, and is often even more influenced by the things that seem, than by those that are."

4.2 The Science of Spectacular Domination

In his time, Guy Debord understood that not only was the commodity the universal category of society as a whole, but that the commodity and society existed in a world of representation composed of many spectacles. To describe this new stage of capitalism in 1967, Debord opens his *Society of the Spectacle* with this paraphrase of Marx: "In societies where modern conditions of production prevail, all life appears as an immense accumulation of *spectacles*."

The society of the spectacle exists in opposition to an authentically lived daily existence. But the situation is now so desperate that, during the XXth-century, the globe has become a massive, lurid spectacle of the consumption of commodities and their images, as created by the military-industrial-entertainment complex. Spy satellites easily confirm that the brutal vaudeville of commodity-spectacles blots the landscape. We all deserve a break today from Ronald McDonald's reality, but authentic experience is pitifully rare, because most acts involve a distracting product or listless contemplation at a distance, separating us from each other.

The person in the street simply can't escape the annoying poetry of roadside billboards and its broken promises of independence and pleasure. The spectacle is the scientific development of commodity fetishism via the continuous monopolization of all appearances everywhere. Moreover, throughout this century, the development of imaging systems has gone hand in hand with war, with their subsequent use in psychological warfare, and finally as the spin-off commodities of warrior-idols from movies like *Total Recall* and *Rambo*.

From the recon flight films of World War I that made cinematographers feel they were looking at men on a microscope slide, to the propaganda newsreels; from Goebbels' stage-managed call for total

315

war before a fanatical crowd at the Berlin Palace of Sports, to the sub-
sequent defeat at Stalingrad; from the atrocities of Vietnam to falsifica-
tions in the US war with Iraq, the spectacle brings us the thrill of vic-
tory and the agony of defeat - at a safe distance. As the Cold War proved,
we no longer need to have a war to be at war.

The spectacle is the mechanism that has shifted social life from
having to *appearing*, in a world that is seen via specialized mediations
originating in the fantasies of military engineers. The spectacle is the
bad dream of modern society enchained by Mickey Mouseketeers
marching across the screen in *Full Metal Jacket*.

We root like fanatics for teleguided cruise missiles, and get the
vicarious thrill of using the equivalent of the army's Multiple Integrated
Laser Engagement System in the local video arcade. The result of sub-
mitting to this unnatural world-apart is that we find nothing other than
empty promises and blank despair on our passionless adventures back
to the future.

Couch potatoes aren't conscious of this division between the
world and its self-representation because they speak and think in the
language of spectacle. With this language, the spectacle pervades all
consciousness with the commodities, images and celebrities who've
slipped under reality and are worshiped like religious idols. The de-
nial of life by means of a fallacious paradise is no longer projected into
the heavens, but onto the material plane of Walmart and MTV. The
commodity and its spectacle, the commodity-spectacle, has become
the very hub of our universe; it's how the scopic regime rules. Never-
theless, submission to the spectacle is known to most of us, usually as
a vague moral problem couched as materialism or in a religious sense
as idolatry.

Money is a primary facet of the spectacle. With its staggering
debt, the capital wealth of this society of the spectacle is yet another
unconvincing illusion - a ledger entry credit system, legally used and
controlled by domination for its own purposes through the exploita-
tion of the general population. Debt is how the powers of spectacular
domination have consolidated their wealth; debt reconstitutes feudal-

316

ism in a high-tech form. Money is created out of thin air, which leads to the debt that crushes the poor and often leads to war.

War is a primary dimension of war, and vice versa. We have the now familiar war that's presented to spectators by the new breed of producer-generals, or the psychological war directed against civilian populations that effects a highly disorienting spatialization of time. At this spectacular stage of capitalism, techniques are in use to erase memory and foster the illusion of a perpetual present. From the footlights of the theater stage to the global theater of operations (by way of the Nazi congress at Nuremberg in 1938, where Hitler tried to build the crystal castles imagined by medieval poets using lighting effects), the logistics of perception remain fundamental to the battle for consciousness - what the US military called "worldview warfare."

Everything we think of as communication theory, as taught in universities and practiced throughout this culture - public opinion research, voter surveys, advertising, worker morale, corporate image propaganda - are extensions of post-World War II psychological warfare research. These quantitative social science studies with titles like *Are We Hitting the Target?* give the technocrats the information they need to make us believe whatever they want.

Researchers like Christopher Simpson have followed the money trail from the communications departments of major universities and think tanks back to the big foundations and then back to the CIA and Pentagon. Consumer dissatisfaction? Feminism? Black nationalism? The powers of spectacular domination fund any idea that will separate people, knowing that at other steps in the communication process, the information will be increasingly deformed in ways that have nothing to do with social justice, much less authentic liberation. As the social scientists of the Forties, Fifties and Sixties who were active in psychological warfare knew, the people who granted the research contracts followed up their communication, as an instrument of domination, with violent coups or civil wars in Greece, Iran, Guatemala, Laos, and Congo.

The rule is that coercive propaganda must be tied to physical

317

coercion. The United States strategy for developing Third World nations was to destroy all destabilizing influences, using mass media, aid, arms and counterinsurgency support to ensure the following conclusion: "communications can lead to adjustive behavior." The rain of bullets that soldiers in Korea felt are now the imperceptible reverberations of radio and television waves that fan out like concentric circles of water to encompass the globe. Most ominously, continuing technological innovation, and the fusion of nation-state and economy, bring virtual reality barreling down the information superhighway. Fill the space between your years with the zeitgeist of the military-industrial-entertainment complex, submit to this domination without a fight, even willingly, and become a civilization of warheads.

We live in the state of Pure War that Sun Tzu so highly praised as the apogee of military strategy. In other words, *the state of war has dissolved and completely infiltrated daily life*. In the same way that the spectacle sells time as an object (the commodity of leisure), or as it turns humans into things (consumers), the spectacle is a militarized vision of the world that has been actualized in the material realm.

Decolonization of the Third World revealed something interesting - entire cultures had disappeared. In other words, Third World countries remain colonized in daily life. The spectacle extends its boundaries by the destruction of geographical distance using speed to export its militarized culture - the spectacle made in America, its war machine, corporate bureaucracies and consumer trash. If humanity were to decolonize daily life it would need to disabuse itself of the idea that a state of peace means the absence of open warfare, or that the military somehow helps society.

With 40 percent of all US scientists doing defense-related work, and defense budgets remaining at historically high levels, we must realize that we're still in a permanent state of war. We're told that roughly a quarter of the US federal budget goes to defense, although that figure excludes the vast amounts of money spent on defense-related NASA and Energy Department projects, veterans affairs, military pensions and the debt on past wars. A quarter of the US gross

domestic product is military oriented, but this doesn't factor in secret sales, heavy subsidies and artificial inflations or deflations that are justified by everything from local employment to national security. To give one incriminating example, when the Pentagon distributes surplus attack helicopters to Third World allies, only the shipping costs are calculated in the deal.

As for the weapons actually sold to foreign countries - and we should remember that the United States is the number one arms exporter in the world - the American taxpayer usually ends up paying for them too, through foreign aid and give-away loans. According to John Ralston Saul in *Voltaire's Bastards*, the stockpiles of military supplies are so vast that the Pentagon loses track of a billion dollars' worth of arms and equipment every year.

Better than anyone else, Saul describes how this disastrous waste is justified as make-work projects and technological developments that trickle down to civilian sectors of the economy like crumbs from a rich man's table. The biggest misrepresentation that must be corrected in the minds of the citizens who pay for these weapons with their sweat is that arms are capital goods that lead to growth and consumption. Arms are really extravagant consumer goods that can either be stockpiled or blown up.

Arms production is now the heart whose beat controls the speed and direction of Western research and development, industrial production, high-tech production and make-work programs. The Commerce Department's figures on orders for manufactured goods for the economy as a whole - month after month - are directly linked to the military figures. The United States spends as much it did for Reagan's Star Wars as for Clinton's renamed Ballistic Missile Defense Organization in a vast make-work project with no hope of doing any good for humans. People like Robert McNamara came to Washington from Detroit to sell weapons like cars under the erroneous conception that weapons could be profitable - McNamara's gone but not forgotten, his idea continues to be misapplied by countries like France, Britain, China and newcomers like Brazil who now sell more military equipment than

319

coffee. The real costs of defense spending are buried in the enormous infrastructures required to keep the military machine running, and these expenditures of money, time and work could otherwise be going to benefit humanity.

The spectacle doesn't have to be believed to be powerful. On the contrary, the spectacle does all it can to promote distrust and mutual suspicion, and the cult of secrecy plays a big part in this. Because everyone feels that they're in on their little secret, they're sure that they're never getting an accurate story on any event outside their realm of experience. They're quite right to do so. A look at this season's political ads, where the photograph of one candidate is morphed into another, and other blatantly negative means of persuasion should be enough to convince spectators that they're the intended targets of manipulation. Less obvious, and more ominous, is the black propaganda of the Christian Coalition, the network of secret rumors that spreads from smoky rooms to churches to newsletters to talk shows until the desired prejudices fully crystallize: violent hatred of abortion, the inferiority of non-whites, an irrational and shallow nationalism - in short, the whole stew of lies cooked up by the chefs of American conservatism.

The powers of illusion of the spectacle are so great that it constantly reproduces the world - its history, time and space - in the language and imagery of separation so dear to domination. This illusory world of the spectacle dominates the real. Separation flies in the face of the fact that everyone is united in the same alienated, fragmented existence. We live in the same seemingly inescapable economy and ecology as everyone else, but separation is what we feel. The social scientists, engineers and producers have conspired with the statesmen, arms dealers and financiers to advance the military-industrial-entertainment complex's cause of spectacular domination. The results are seen everywhere, and most importantly within ourselves - every time you imagine an enemy, the enemy is in you. With techniques such as demonization, science has fabricated a society whose members are sleepwalkers living illusory days at peace with the status quo. At the

320

moment, the existing regime is winning this psychological warfare operation hands down by painting a happy face on the misery of daily life.

4.3 The Decolonization of Daily Life

Because hierarchies enclose lives in an imperialist way, think of opposition in terms of the decolonization of daily life. The struggle for decolonization must be more profound and radical than the national liberation movements of the Sixties and Seventies that tended to effect the transfer of power from a foreign elite to a local one. The struggle must destroy old errors without making new ones. In the broadest sense, the ends are merely the beginnings of conscious access to history and the free construction of life. Any coherent strategy of decolonization can only be provisional and evolutionary, a dialectic between foresight and continuous adaptation to the immediate situation.

The regimes of spectacular capitalism allow for some political debate and occasional riots to mollify social polarization. These debates and riots are followed by a period of muddling compromise that is played out at a distance from the population, and represented using the distortions of the spectacle. The population is hidden behind opinion polls, and any strategic consciousness is lost to the masses during the muddling process, because the conflict is no longer seen in the light of well-defined polarities, such as *what is seen* and *what is lived*. State-sponsored strategists refer to disputes in North America as "controlled anarchy."

The ongoing history of agent provocateurs in the United States and the strategy of tension in Italy prompts us to rethink the return of social revolution. Terrorism tends to support conservatism and can be a bomb aimed at the proletariat. Open battles, barricades and arrests are often what fascists want. Means and ends must be reconciled if anyone wants to convince the population of the historical necessity of revolutionary change, and of their good intentions. The population is

321

the central factor at the heart of any subversive war; potentially all the panracial populations of the world are ready to liquidate national borders and appropriate the means of production.

By highlighting the humiliations of the past, the humiliations experienced at work or within this mind-numbing culture, we can begin to demonstrate the need for a civilization of continuous revolution. We know from Vietnam that the authorities can't withstand a protracted war. A long, popular struggle will lend character to the emerging revolutionary civilization, and create a sense of suspense that can only be released in a total social revolution on the scale of 1848 and 1968. This isn't as far-fetched as it sounds - there are operational tactics within everyone's reach that enable everyone to reclaim their rights to their lives, cities, farms and beaches.

In the battle over loyalties, use Caesar's method of recruitment during the civil war ("if they're not against me, they're with me") rather than Pompey's ("if they're not with me, they're against me"). By looking at the enemy, you see that all those not locked into a predetermined socio-economic group are potential allies, and even these people might be won over with humor and prospects for a quality life. The diverse struggles of autonomous groups and communities can be unified, radicalized and federalized. Once this process begins, more and more people around the world will experiment with democratic forms of organization. Imagine the day when extranationalists take over their cities and implement the project of zeroworker councils that decide what must be done and must no longer be done.

While waiting for the revolutionary moment of intense and rapid reversal of spectacular capitalism, rebels wage a long-term struggle where the fundamental form of coercion is that which one exercises is on oneself... coercion to have the self-discipline to avoid tactics that would prompt the State to take the offensive. During this long march, use horizontal and indirect strategies to cut down conservative ideologies and social classes on a philosophical-moral basis. The inevitable alternations of egoist and collectivist strategies cut across these conflicts; welcome them, so as to both reflect and encourage the

322

pluralism of the human condition.

This indirect strategy of moral persuasion at first relies entirely on the secret power of negation in the realms of ethics and politics, only to be followed up by the practical negation of spectacular domination. Bring subversive agitation to power by creating a psychological vision that the masses can easily and willfully assimilate, one that also incites them to act. For example, history can be depicted simply as Antiquity, the Germano-Christian Era, and an age of revolutionary praxis that begins right now. Negation should be applied internally to all beliefs that support the regime - its bosses, values and traditions. For example, we can cultivate sub-proletarians by dividing classes into interns and externs (those integrated in the economy and those excluded from it) and by trumpeting the refusal of the externs who use or waste their lives without serving the economy.

Negation must always anticipate reaction by the adversary and gauge its capacity to respond with moral force or collective spontaneity. Moral and intimate conflicts of faith will eventually be followed by coercive acts that unite us even more. One can radically separate from separation by going into the fray on the side of life, and accept conflict as part of life. The powerful spirit of negation is the best way to whip up the present and become part of it. Using a little exaggeration, cast doubt on all established loyalties, then follow up with acts that electrify the world like a negative current - offensive acts such as occupying disputed territory, or the transformation of race conflict into class conflict and creating a new civilization at the same time. A moment when all that was previously introverted bursts out, takes hold of the world, and transforms it.

*

History shows that moral force succeeds when rationality submits to the irrationality of basic axioms, such as:

1. negation has been suppressed for so long that life itself has been suppressed;

2. the accumulation of capital leads to the accumulation of the proletariat;

3. historical consciousness is the consciousness of daily life.

These and other axioms of life must be held to be irreducible and true, even if they're unproven, if one wants to win a psychological war. The latent irrationalities in the existing social structure exist for rebels to exploit and extend. Don't inspire fear, but intimacy, and adhesion to axioms. As the new loyalties spread and take hold of conquered space, lessen the use of negation, and appear to identify with ex-adversaries. Politics becomes so generalized that it will be suppressed. Work becomes unified into a full life in such a way that the word *work* becomes an anachronism. Commodities are appropriated and distributed according to need. Property is abolished and a universal tribunal judges everything that exists.

Rather than opposing revolutionary excess, we know that revolution must be extra-legislative, extra-scientific, extra-artistic, extra-rational and above all, extra-economic in the prevailing, restricted sense of economics. The return of social revolution signals the refusal of the society of the spectacle as a totality. This means the liquidation of old habits and illusions and the destruction of authority. Reclaim the right to a morality of happiness, happiness derived from revolutionary pleasures.

4.3.1 *Changing the Prevailing Concept of Time* The abolition of work, be it wage-slavery or shopping, is the most fundamental means of changing the prevailing concept of time. Without jobs people can't purchase the commodities that propel the system of mass consumption, but decent jobs are becoming increasingly scarce. This sordid economic system's reliance on increases in consumption is in obvious contradiction to the efforts by management to eliminate work and cut wages. Meanwhile, women have doubled the labor pool, while robotics and other forms of automation continually eliminate jobs.

Those who trumpet high-tech industries for job creation should bear in mind that they're highly automated industries employing few

workers. Governments and private industry alike are downsizing their work forces, and squeezing more productivity out of their employees. Deceptively glowing unemployment statistics aside, there aren't enough socially necessary jobs to go around. This fact puts those who have jobs at a disadvantage vis-à-vis the boss, who doesn't hesitate to exploit the precarious situation of the employees by scheduling longer hours. The same logic of labor still applies to the salaried service sector and the so-called intellectual professions. Salaried work sometimes pays maximum dollars for minimum work, but it always reproduces work to the nth degree by increasing the time spent at work.

Americans have added nine hours of work each year for the last twenty years. Not only do Americans spend more time on the job than Germans and French workers, but they shop more too. I'm not going to debate the point that shopping is work; nor will I insist that the consumption of images is work. Simply bear in mind that the only nation that watches more television than the United States is also the only country that works more, namely Japan.

The global tourist industry is the world's largest employer, which creates the absurd situation of some people paying to consume their time, and others losing their time working for these tourists. Meanwhile, children lack care and people get sick or hurt at work and the ranks of the time-poor continue to grow.

It's easy to reject the work-leisure dichotomy because so many leisure activities have taken on the characteristics of work. What do people do with their leisure time? They assign themselves irrelevant tasks, and once those goals are achieved, they find new ones so that they can experience the same pleasure they derive from work - overcoming obstacles and self-mastery. The work mode has invaded daily life to the point where life becomes a constant state of dubious exigencies. The passive leisure of trite shopping malls, sterile amusement parks and tourist cruises are the rest stops that augment the usual television-induced hypnosis. These periods of total rest allow the human machine to recuperate the energy that will go back into some intense, work-like activity, or into work itself.

The powers of spectacular domination seem to have created the perfect system to continually regenerate voluntary servitude. In a classic act of doublethink, work is mistaken for self-fulfillment and personal growth. Rather than this misconception of work as an end in itself, many reclaim the right not to work or to work no more than ten hours per week. This isn't a childish desire based on the pleasure principle, but a rejection of the post-modern equation of maturity with ambiguity tolerance that has allowed the reality principle to take on Orwellian proportions.

A quick look at the enormous waste in the military-industrial-entertainment complex's production and distribution of arms and commodities should be enough to convince us that people don't work to produce and consume, but to work more and more and harder and harder. Over-achievement and personal advancement have eclipsed any actual ends - the completed task is erased by the next task at hand in a vicious cycle of progress or power or an abstract notion of production that is far removed from the work ethic. Money is merely the measure, not the goal, which is actually to create more and more work for yourself until the day you die.

As Debord notes: "Everywhere the same formidable question is asked, the question that has haunted the world for two centuries: how to make poor people work where illusion is deceived and force is defeated?" A simple comparison with other eras prompts us to recognize the facts. Athenians had fifty-odd holidays a year; Romans had even more. The calendar in medieval Spain comprised five months of vacations. The vague consciousness of time in the Middle Ages where the workday was regulated by the sun and punctuated by numerous breaks and rest periods, was replaced by the work clock - with it, the hours and the pace of work have continuously increased. Holidays began to disappear and life became regularized and regimented. By the XIXth-century, the life of wage earners was pretty much the same as those formally enslaved. The clock is one of many devices that prove the point that technology makes more work - not less, as is often assumed. Time first took on the spatialized form of hands sweeping

326

around the face of a clock, then became the measure of identical fragments of production in industries around the world - a process that monetarized and inflated the price of time.

Most Americans are caught in the work and spend cycle designed by the likes of Charles Kettering, the general director of General Motors' Research Labs, who once said that the mission of business was the "organized creation of dissatisfaction" to snare people in consumption traps. Kettering was referring to the dissatisfaction with one's way of life, with the dismal products that occupy one's material world and the urge to live in the luxury of TV reality. Dissatisfaction with this shallow, consumer society and its traps is at the base of revolutionary morality.

Should we serve the economy by being good workers and consumers? We work ourselves into debt and put our fellow workers in debt with our work. Work is the most decisive activity in the world because everyone - rich and poor - works. While workers create the wealth of civilization, they usually don't have the time or strength to cultivate their faculties, formulate their own opinions or develop coherent moral positions. Despite the fact that work is tiresome, debilitating and dangerous, underprivileged workers sometimes have greater moral vigor than the privileged classes.

It remains to be seen if these proletarians - people who no longer have control of their lives by being forced into inordinate production - will have the moral fortitude to resist the military-industrial-entertainment complex. As Orwell said, the essence of war is the "destruction of the products of human labor by shattering to pieces, pouring into the stratosphere, and sinking in the depths of the sea, materials which might otherwise make the masses too comfortable, and hence, in the long run, too intelligent." Even when the weapons of war aren't actually destroyed, their production is still a convenient way of expending labor power without producing anything that can be consumed in total affirmation of life. Without the consumption of the war machine, it's easy to imagine a world in which everyone worked very short hours, had enough to eat, lived in a house with a bathroom and a refrigerator,

and had means of transport - a world where the most important forms of inequality had disappeared.

In 1953, when Guy Debord wrote the words NEVER WORK in chalk on a wall on the Rue de Seine, a photographer shot the inscription to make a humorous postcard. Despite protestations about not embellishing "this attitude by some ethical justification" in reality, Debord was articulating a very serious moral position - the shame of work, which dates at least as far back as Greece and Rome. This NEVER WORK inscription was called the "preliminary program of the situationist movement," and "the most important trace ever revealed on the site of Saint-Germain-des-Pres, as testimony of a particular lifestyle that attempted to affirm itself there." Of course this NEVER WORK inscription appeared on the walls of Paris with renewed force during the month of May 1968. And as Sanguinetti noted, "... in February 1977, this same watchword reappeared on the walls of Rome, greatly enhanced by the simple fact that in the meantime it had been translated into Polish by the workers of Stettin, Gdansk, Ursus and Radom, in 1970 and 1976, and equally into Portuguese by the workers of Lisbon in 1974."

Kamunist Kranti ran this text on the back cover of *Reflections on Marx's Critique of Political Economy*, instead of a blurb:

What is Useful Social Labor?

If a person can find employment with corporations, States or other frightful entities, then he/she is deemed to be doing useful social labor. This useful social labor might be making light pistols or bullet-proof jackets; atom bombs or nuclear shelters; fertilizers or junk food; garments or movies; books or television sets.... This is hardly a definitive list; please feel free to add your own list of useful social labor.

In our times, labor becomes useful and social only when it, or its product, can be sold to the State, to corporations, to academia, to production houses or publishing groups, to hospitals, schools, ancillary production units or large happy families. If one has qualities and one desires to

328

do things for oneself or others but is unwilling to sell that ability to do labor, then one forfeits one's right to survive. And one is then deemed unemployable, that is, useless. This man or woman becomes an embodiment of useless social labor, fit to be humiliated and abused, but also feared.

What is termed useful social labor is basically the system's demand on labor to perpetuate the rule of surplus produce extractors and their hierarchical social structures.

Capitalism is also a social system and so it must fulfil certain human needs. Our scrutiny and investigation of the balance-sheet of total human production has produced some startling findings and obvious inferences.

Findings:

1. Ninety-four percent of total human production is used for the maintenance and perpetuation of hierarchies.

2. More importantly, six percent of global production presently suffices for the nourishment and sustenance of humanity.

Inferences:

1. If we are able to remove hierarchies, we just won't need ninety-four percent of the production that takes place today. Consider anything anywhere, from medicine to steel, paper to police-stations, elections to Olympics, and erase what is required for the maintenance and perpetuation of hierarchies and we're left with six percent.

2. With the erasure of hierarchies, our work-load will be reduced to one-sixteenth of the present load. This by itself will enormously enrich human life and open up diverse arenas of creativity and freedom. Festivals with month-long festivities will be resurrected.

329

3. When ninety-four percent of the production is eradicated, environmental degradation will dramatically diminish and give humanity enough breathing space to recast and recreate its production processes to sustain a harmonious human-nature relationship.

While rebels wait for the return of social revolution, they discover and develop extra-economic lifestyles. They don't have any general solutions, or even any permanent solutions for themselves to avoid work; they take victories over work where they can and grant concessions to it from time to time. The consumption side of the equation isn't as hard to solve as it seems; the consumption of true wealth is the extra-economic consumption of other people who've taken the time to develop their faculties, and the extra-economic consumption of ourselves. Rebels cultivate a sense of alienation with consumer culture because they know what commodities are, and where they come from. They're not what we freely choose, but what's offered to us to choose by those who have already made the choice for us by deciding what to produce. What may at first appear to be unattractive, difficult or demanding can be just the thing that corresponds to our cultivated tastes.

Consumption has become a duty that insures economic demand and maximum profits, not the hedonistic pleasure or the defining act of individualism as we're led to believe. People identify themselves as what they do for work, and as what they consume. They idolize media heros and react to every whim of fashion, such as the current preoccupation with combat boots and crew cuts. The modern individual may be free from religious determinations, but he or she is rarely free from the consumer propaganda of the military-industrial-entertainment complex.

Time takes on new aspects when we're liberated from work, and the days stretch out before us free from any real obligations or worries - the refusal to survive for work and the negation of the obligation to work to survive. With a maximum of no more than ten hours per week of ludic chores, the individual has the time to expend on him

330

or herself. The myth of the necessity of huge amounts of labor is what generates so much surplus wealth for the military and upper classes, and what generates the ugly commodities that occupy virtually all social space. Revolutionary freedom is found in the emancipation of life time - time in rhythmic flow with the expanding moments of a new civilization.

4.3.2 *The Zeroworker Council Environment* Let's say we've been working together for a few weeks. Like most jobs, our's stink. We agree on ways that we could do our jobs more easily so we can relax on the job or work on projects for our homes. It follows that the boss is our enemy because the boss wants us to work for him or her, not *for ourselves*.

We now have the courage that comes with solidarity to express how we feel about workplace authorities. Our social ethic spreads to other employees and is acted on - for example the above-mentioned government work, where one takes the fruits of one's labor directly home - but this social ethic is foremost psychological. It's the ethic that has caused hundreds to simultaneously go on strike without anyone even saying the word *strike*.

The mutual trust and understanding at the base of this social ethic are key elements in creating an environment suited to the needs of workers' councils. Informal councils threaten the spectacle's powers of separation and unite workers and non-workers in the struggle going from the mass withdrawal of obedience to an entirely new society.

It begins in episodes like those in the film *Office Space* when workers conspire against the company. A more realistic scenario might be when a new employee comes to the office and the council asks her to stand guard while we photocopy our zines, shoot our videos or play a hand of gin. The council encourages her to steal something from work to accustom her to challenging the property rights of the workplace authorities. On the other hand, if she tries to work us under the table to impress the boss, the council lets her know that she's taking big risks

with us. The council shows her how to get a little pleasure on the job by sabotaging the office, and gradually brings her into the informal secret organization. As councils grow in numbers and make contact with other groups, they begin to sense what can be done.

The history of groups like this goes back at least as far as the history of workers' councils, which may be the best way to consciously organize against corporations, unions and political parties. By stopping production at the point of production through the refusal of work, these groups are in reality zeroworkers' councils that change the world by resuming production at much lower levels. Capitalist managers are too naive to suspect how easily their Total Quality Management Programs can be subverted by new social ethics, and how much their cross-training programs will ease the appropriation of the means of production by zeroworkers' councils.

The refusal of work is the force that can create mass disobedience that moves toward the complete transformation of society. Zeroworkers' councils could coordinate production so that no-one is forced to do more than ten hours of wage-like labor per week. Zeroworkers' councils might administer monthly income for everyone. Other people and groups will try to step in and run things, but only by keeping vital decisions in the realm of zeroworkers' councils that account for the devastation caused by work can activity be self-directed and not subject to dehumanizing forces. Zeroworkers' councils could provide a way for the phantom proletariat to manifest itself, to make decisions for itself and to federate with each other by means of delegates responsible to the base of workers and revocable at any moment.

When the polarization of Third World capitals hits the citadels of too-late capitalism, the earth could quake with revolution. And as the revolution spreads from the city to suburbia to country and back again, reassess old ideas like the *polis* and city-state, because they're all we really have to oppose the modern nation-state. Unlike the classical model, envision an extranational city-state devoid of slaves and foreign merchants of death. Complete freedom of immigration will ren-

der the word *foreign* incomprehensible. Given wealth as other people and democracy as a conversation, find true wealth and democracy in all the hundreds of thousands of extranational city-state assemblies of zeroworkers who debate and vote on issues concerning their daily lives in a rough and tumble way. In the extranational worldview, one could be a citizen of several cities and live life as an adventure of nomadic roaming from city to city.

Anticipate the possibilities for life in the post-revolutionary world and act accordingly by acquiring historical knowledge to build on what is freest and best in the human past, such as the chaos of the classical agora. Even if absolute freedom is impossible, we can surely govern ourselves and rebuild something like the agora as quickly as Athens after the Persian invasion. Should anyone try to move the seat of power from the zeroworker councils of the agora to the citadel, as Pericles did, put the would-be king or queen in the right place.

4.3.3 *The Negation of Culture as Separate from Daily Life* With Brancusi and the Bauhaus and many other minimalist examples, culture is defined as the absence of ornament. Envision a day when everyone wakes up and the entire world is changed by ornamentation. Seemingly meaningless graffiti occupies this transformed world and announces the return of the repressed and the negation of culture in a festival of iconoclasm where the roles of spectator-spectacle are erased - the experience of art and history as lived events.

During a revolution, what would otherwise take ages to change changes overnight because everyone participates. This is how the spectacle took over. Everyone simply woke up with the feeling that there'd been some rapid invasion, like foggy weather, that suddenly forced everyone to live differently. Ask yourselves why your lives are the way they are, and why the world is the way it is. The answers to these questions inform your theory and theory guides a practice of realizing art in daily life.

We, the extranational hordes, eschew the role of philosopher or poet and their specialization of knowledge and creativity, and put

333

language in the service of life. We once made use of genitive inversions such as *the love of life in a life of love*, but this is the propaganda of life, not poetry. Even diversions like "Life is a journey, I seek my passage on the death ship of fools," which is traced to Debord's rediscovery of the fluidity of preexisting concepts, is only the subversion of poetry, not the poetry of subversion. Rather than a sonnet or art song, I prefer the extra-artistic everyday genre of the list of authentic desires, or a personal letter, or a chat over a fence and their place in literature is the novel.

Another tactic is assimilation, which is appropriation and transmission with greater or lesser gaps between the original and new-found meaning. Another favorite is reification, which strips a word (such as *work*) of its normal context and exhibits it for all to see. We sometimes use simple recontextualization of authoritative discourses in satiric ways, a method that goes back at least to Greeks like Mennipus. The greatest modern practitioner of recontexualization is Lumumba; to write contemplative poetry after his assassination is somewhat barbaric.

I use the novel because it's grounded in a situation, like a good psychogeographic report. In the hands of the masters who inspired me, the novel is already theory and much more - not simply the dialectics of imagination, but the dialogics of imagination that includes dialectics. The novel is a way to incorporate other points of view and explore emotions that don't lend themselves to theory. And nowhere else but the novel does one find the same clash of linguistic consciousness. The novel's openness to possibilities may point the way out of the XXth-century before our minds become petrified there. But I don't place the novel in too high regard, I laugh at it in a way that makes it a vehicle for the propaganda of life.

Everyone can make rudimentary posters, books, zines, cassettes and videos, but the real negation of culture means to supersede separation. The lost unity of social life that we seek in so-called culture can be found in romantic behavior. We'll survive the drama of sedition and civil war in style if we create a new romantic culture that seeks

solar revolution from the shadows of the night.

The countercurrent to the love of life is art. Artists have turned on themselves to the point that we no longer recognize the meaning and value of the human world in art. The realization and suppression of art will fulfill our aspirations for cruelty and thereby overcome art. Like the Viking invaders' vandal aesthetic, we waste and consume everything in the world in extravagant orgies of destruction, all the while covering this concrete world with graffiti to our glory. Carve out identities in blocks of history, and in the creativity released in making history collectively: history as the force that intensifies daily life into a comprehensive and comprehensible symbol; history as the revolution of daily life through the passageways of situations with new experiences - foods, drinks, sounds, sensations, interactions, epiphanies. Instead of art, we propose the creation of treatises that contest the totality of existence and point to the end of cultural history in its supersession in total history, and the subsequent realization and supersession of these treatises.

When the masses become nomads in their own communities - everyone living on the fringe - history will be putty in our hands. The fringe is the real historical community on which art and culture depends for its praxis as a direct activity and language. The fringe as the terrain for the multiplication of poetic subjects and objects; the fringe as games of poetic objects among poetic subjects. When Debord writes that, "The problem is to actually possess the community of dialogue and the game with time which have been *represented* by poetico-artistic works," he's talking about living poetically or artistically, which is only possible on the fringe and other realms of sovereignty.

Only those on the fringe can map out the positions and movement of the hostile forces of authority in the terrain of language. They can destroy the language of the spectacle by venturing sorties into the battlefield of revolutionary dialogue and destroy the encrusted meanings attached to words and objects by stripping them of their normal contexts (and reaccentuating the meaning to create a new unity - the unity of armed dialogue). This can be a malevolent slang that's not

meant to be understood by any class other than the proletariat: a language made by and for this class in a playful and creative way using inventive synonyms, especially homonymic ones. Deprecating denominations and the extension of negative adjectives are likely places to start. Another easy mode to encode might be the inversion of syllables or the transposition of phonemes in anagrams. We should contaminate English as much as possible with foreign words, and advance these languages the way Burgess did in *Clockwork Orange*.

We live under the weight of the ideology of visibility, which we can shrug off with an ideology of invisibility - games of disappearance that lend us the clandestine cover we need to mount our struggle, and games of appearance that force secrets into the public consciousness. The negation of secrets using the secret of negation. Ideology is the essential symbolic medium of social relations - not simply the distorted representation of reality as many revolutionaries claim, but also the basic material force of social practice most connected with class conflict.

The ruling ideology of visibility privileges the eye over the entire remaining geography of the body - it masks blatant lies with pretty pictures. Ideology is a material force that can be deflected to other organs so that we hear one another's voices and touch one another. If we exploit the gaze, it's looking into the other's eyes and blending hearing, touching and seeing in the psychogeography of situations that destroy separation. We've gone from having to appearing and back to being together.

The society of the spectacle and its "cascade of hierarchic signals" can only be negated by the resumption of a romantic culture that infuses class struggle with the passion to love and hate. For now, we can only look back on the past's exaltation in revolution, and hope that we will know the happiness of this rite of spring. Meanwhile, we must try to dissolve the dominant consciousness of separation fostered by the science of spectacular domination, the separation that separates revolution from daily life and daily life from the poetry made by everyone under the sun. "I would continue to walk and talk with you,"

as Dante says, "but we've gone too far and smoke is rising from the sand."

STRATEGIC PLAN

	short term	mid term	long term
Goals	Cultivate anti-work consciousness Demoralize bosses into giving up their role.	Cancellation of debt and institution of the ten-hour work week. Abolition of many positions.	Transform work-based society into a multidimensional society.
Methods	Propaganda Sabotage	Global rise of zeroworker councils that cancel debt, abolish positions, and police the ten-hour work week.	Training to live without work. Planning ways around work. Support for popular arts, athletics, science, and so on.
Results	Rufusal-of-work movement grows in size and force.	The movement wages and wins revolutionary civil wars that become a generalized revolution.	Work is remembered with contempt and then forgotten by future generations.

Bibliography of Chapter Fourteen

Akann, Robert *A History of the Habsburg Empire 1526-1918*(Berkeley: California, 1974)

Anderson, Andy *Hungary '56* (London: Pheonix Press, 1964)

Appian *The Civil Wars* (London: Penguin, 1996) Assefa, Hizkias *Mediation of Civil War* (Boulder: Westview, 1987)

Aston, Trevor *Crisis in Europe 1560-1660* (London:Routhledge, 1965)

Bond, James *The Rules of Riot: Internal Conflict and the Law of War* (Princeton: Princeton, 1974)

Caesar *The Civil War* (London: Penguin, 1967)

Chaliand, Gerard *The Art of War in World History* (California: Berkeley, 1994)

____ *Guerrilla Stratetgy* (Berkeley: California, 1982)

____ *Terrorism and Guerrilla Warfare* (London: Saqi, 1987)

Chan, Stephen *Renegade States* (Manchester: Manchester, 1994)

Clogg, Richard *A Concise History of Greece* (Cambridge: Cambridge, 1992)

Correlates of War Project *Political Units in the Interstate System 1816-1989* (Ann Arbor: University of Michigan)

____ *Military Capabilities of Nations 1816-1986* (Ann Arbor: University of Michigan)

Current, Williams, Freidel and Brown-Lee *The Essentials of American History* (New York: Knopf, 1980)

Daniels, Robert *Year of the Heroic Guerrilla* (Cambridge: Harvard, 1996)

Debord, Guy *Society of the Spectacle* (Detroit: Black and Red, 1981)

DeFronzo, James *Revolutions & Revolutionary Movements* (Boulder: Westview, 1996)

Duggan, Christopher *A Concise History of Italy* (Cambrige: Cambridge, 1994)

Dunér, Bertil *Military Intervention in Civil Wars: the 1970s* (New York: St. Martin's Press, 1985)

Dunnigan, James and Bay, Austin *A Quick and Dirty Guide to War* (New York: Quill, 1991)

Ebrey, P.B. ed. *Chinese Civilization and Society* (New York: The Free Press, 1981)

Ehrenreich, Barbara *Blood Rites* (New York: Metropolitan Books, 1997)

Enzensberger, Hans *Civil Wars: From L.A. to Bosnia* (New York: New Press, 1994)

Fejto, Francios, ed. *The Opening of an Era: 1848* (New York: Grosset, 1973)

Figes, Orlando *A Peoples Tragedy: A History of the Russian Revolution* (New York: Viking, 1996)

Foerstel, Lenora *Creating Surplus Populations* (Washington, DC : Maisonneuve, 1996)

Fraser, Ronald *Blood of Spain* (New York: Princeton, 1979)

Friedrich, Otto *Before the Deluge* (New York: Collins, 1972)

Fulbrook, Mary *A Concise History of Germany* (Cambridge: Cambridge, 1990)

Gallo, Max *The Night of the Long Knives* (New York: Da Capo, 1997)

Gardiner, Juliet and Wenborn, Niel *The Columbia Companion to British History* (New York: Columbia, 1995)

Goldschmidt, Authur *A Concise History of the Middle East* (Boulder: Westview, 1979)

Gorz, Andre *Capitalism, Socialism, Ecology* (London:Verso, 1994)

Grenville, J.A.S. *A History of the World in the Twentieth Century* (Harvard: Cambridge, 1994)

Gurr, Ted *Minorities at Risk* (Washington, DC: Institute of Peace Press, 1993)

Hart, Liddell *Strategy* (New York: Paeger, 1960)

Hashim, Ahmed and Cordeshan, Anthony *Iran* (Boulder: Westview, 1997)

Henwood, Doug *Wall Street* (London: Verso, 1991)

Hobbes, Thomas *Leviathan* (London: Penguin, 1985)

Holmes, George *The Oxford History of Italy* (New York: Oxford, 1997)

Holsti, K.J. *The State, War, and the State of War* (New York: Cambridge University Press, 1996)

Horowitz, Donald *Ethnic Groups in Conflict* (Berkeley: California, 1985)

_____ "Irredentas and Secessions: Adjacent Phenomena, Neglected Con nections" in Naomi Chazan, ed. *Irredentism and International Politics* (Boulder: Lynne Reinner) pp 9-22

Hume, David *The History of England Vol. II* (Indianapolis: Liberty Fund, 1983)

Humphreys, R. Stephen *Islamic History* (Princeton: Princeton, 1991)

Hurani, Albert *A History of the Arab Peoples* (New York: Warner, 1991)

Jacoby, Henry *The Bureaucratization of the World* (Berkeley: California, 1973)

Jones, Archer *The Art of War in the Western World* (Oxford: Oxford, 1987)

Keddie, Nikki *Roots of Revolution: An Interpretive History of Modern Iran* (New Haven: Yale, 1981)

Kutner, Luis *Due Process of Rebellion* (Chicago: Bardian, 1974)

Livy *The Early History of Rome* (London: Penguin, 1960)

Locke, John *Two Treatises of Government* (Cambridge: Cambridge, 1960)

Luard, Evan *The International Regulation of Civil Wars* (New York: NYU, 1972)

Mailer, Phil *Portugal: The Impossible Revolution?* (Quebec: Black Rose, 1991)

Maoz, Zeev *Domestic Sources of Global Change* (Ann Arbor: University of Michigan Press, 1996)

_____ *Paradoxes of War* (Boston: Unwin Hyman, 1990)

Marx, Karl *The 18th Brumaire of Louis Bonaparte* (New York: International, 1966)

McCoubrey and White, *International Organizations and Civil Wars* (Brookfield: Dartmouth Publishing Company, 1993)

n.a. *A Ballad Against Work* (Faridabad: Majdoor Library, 1997)

Negri, Antonio *Marx Beyond Marx* (Brooklyn: Autonomedia, 1991)

Passerini, Luisa *Autobiography of a Generation: Italy, 1968* (Hanover: Wesleyan, 1996)

Peirats, *Anarchists in the Spanish Revolution* (Detriot: Black & Red, n.d.)

341

Pipes, Richard *The Russian Revolution* (New York: Vintage, 1990)

Price, Roger *A Concise History of France* (Cambridge: Cambridge, 1993)

Rachleff, Peter *Marxism and Council Communism* (New York: Revisionist Press, 1976)

Rupesinghe, Kumar *Conflict Transformation* (New York: St. Martin's, 1995)

Sanguinetti, Gianfranco *On Terrorism and the State* (London: Chronos, 1991)

Schama, Simon *Citizens: A Chronicle of the French Revolution*(New York: Vintage, 1989)

Schor, Juliet *The Overworked American* (New York: Basic Books, 1991)

Schram, Stuart *Mao Tse-tung* (New York: Simon and Schuster, 1996)

Souchy, Augustin *With the Peasants of Aragon* (Minneapolis: Soil of Liberty, 1982)

_____ and others *The May Days: Barcelona, 1937* (London: Freedom, 1987)

Sprouse, Martin, ed. *Sabotage in the American Workplace* (San Francisco: Pressure Drop, 1992)

Strauss, Barry and Ober, Josiah *The Anatomy of Error: Ancient Military Disasters and Their Lessons for Modern Strategists* (New York: St. Martin's, 1990)

Thomson, Janice *Mercenaries, Pirates, & Sovereigns* (Princeton: Princeton University, 1994)

Toffler, Alvin and Heidi *War and Anti-War* (Warner: NY, 1993)

Richards, Vernon *Lessons of the Spanish Revolution*(London: Freedom, 1983)

Thucydides *The Peloponnesian War* (London: Penguin, 1954)

Vaneigem, Raoul *The Revolution of Everyday Life* (Seattle: Left Bank, 1991)

Wilkinson, David *Revolutionary Civil War* (New York: Page-Ficklin, 1975)

Willan, Philip *Puppet Masters: The Political Use of Terrorism in Italy* (London, Constable, 1991)

World Bank *Annual Report 1996* (Washington, DC: World Bank, 1996)

Zartman, William, ed. *Elusive Peace: Negotiating An End to Civil War* (Washington, DC: Brookings Institution, 1995)

PATH OF THE POLE
Cataclysmic Pole Shift Geology
by Charles Hapgood

Maps of the Ancient Sea Kings author Hapgood's classic book *Path of the Pole* is back in print! Hapgood researched Antarctica, ancient maps and the geological record to conclude that the Earth's crust has slipped in the inner core many times in the past, changing the position of the pole. *Path of the Pole* discusses the various "pole shifts" in Earth's past, giving evidence for each one, and moves on to possible future pole shifts. Packed with illustrations, this is the sourcebook for many other books on cataclysms and pole shifts such as *5-5-2000: Ice the Ultimate Disaster* by Richard Noone. A planetary alignment on May 5, 2000 is predicted to cause the next pole shift—a date that is less than a year away! With Millennium Madness in full swing, this is sure to be a popular book.

356 PAGES. 6X9 PAPERBACK. ILLUSTRATED. $16.95. CODE: POP.

THE TIME TRAVEL HANDBOOK
A Manual of Practical Teleportation & Time Travel
edited by David Hatcher Childress

In the tradition of *The Anti-Gravity Handbook* and *The Free-Energy Device Handbook*, science and UFO author David Hatcher Childress takes us into the weird world of time travel and teleportation. Not just a whacked-out look at science fiction, this book is an authoritative chronicling of real-life time travel experiments, teleportation devices and more. *The Time Travel Handbook* takes the reader beyond the government experiments and deep into the uncharted territory of early time travellers such as Nikola Tesla and Guglielmo Marconi and their alleged time travel experiments, as well as the Wilson Brothers of EMI and their connection to the Philadelphia Experiment—the U.S. Navy's forays into invisibility, time travel, and teleportation. Childress looks into the claims of time travelling individuals, and investigates the unusual claim that the pyramids on Mars were built in the future and sent back in time. A highly visual, large format book, with patents, photos and schematics. Be the first on your block to build your own time travel device!

316 PAGES. 7X10 PAPERBACK. ILLUSTRATED. $16.95. CODE: TTH.

THE CHRIST CONSPIRACY
The Greatest Story Ever Sold
by Acharya S.

In this highly controversial and explosive book, archaeologist, historian, mythologist and linguist Acharya S. marshals an enormous amount of startling evidence to demonstrate that Christianity and the story of Jesus Christ were created by members of various secret societies, mystery schools and religions in order to unify the Roman Empire under one state religion. In developing such a fabrication, this multinational cabal drew upon a multitude of myths and rituals that existed long before the Christian era, and reworked them for centuries into the religion passed down to us today. Contrary to popular belief, there was no single man who was at the genesis of Christianity; Jesus was many characters rolled into one. These characters personified the ubiquitous solar myth, and their exploits were well known, as reflected by such popular deities as Mithras, Heracles/Hercules, Dionysos and many others throughout the Roman Empire and beyond. The story of Jesus as portrayed in the Gospels is revealed to be nearly identical in detail to that of the earlier savior-gods Krishna and Horus, who for millennia preceding Christianity held great favor with the people. *The Christ Conspiracy* shows the Jesus character as neither unique nor original, not "divine revelation." Christianity re-interprets the same extremely ancient body of knowledge that revolved around the celestial bodies and natural forces.

256 PAGES. 6X9 PAPERBACK. ILLUSTRATED. $14.95. CODE: CHRC.

ECCENTRIC LIVES AND PECULIAR NOTIONS
by John Michell

Michell's fascinating study of the lives and beliefs of over 20 eccentric people: the bizarre and often humorous lives of such people as Lady Blount, who was sure that the earth is flat; Cyrus Teed, who believed that the earth is a hollow shell with us on the inside; Edward Hine, who believed that the British are the lost Tribes of Israel; and Baron de Guldenstubbe, who was sure that statues wrote him letters. British writer and housewife Nesta Webster devoted her life to exposing international conspiracies, and Father O'Callaghan devoted his to opposing interest on loans. The extraordinary characters in this book were—and in some cases still are—wholehearted enthusiasts for the various causes and outrageous notions they adopted, and John Michell describes their adventures with spirit and compassion. Some of them prospered and lived happily with their obsessions, while others failed dismally. We read of the hapless inventor of a giant battleship made of ice who died alone and neglected, and of the London couple who achieved peace and prosperity by drilling holes in their heads. Other chapters on the Last of the Welsh Druids; Congressman Ignacius Donnelly, the Great Heretic and Atlantis; Shakespearean Decoders and the Baconian Treasure Hunt; Early Ufologists; Jerusalem in Scotland; Bibliomaniacs; more.

248 PAGES. 6X9 PAPERBACK. ILLUSTRATED. $14.95. CODE: ELPN.

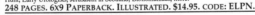

THE ARCHCONSPIRATOR
Essays and Actions
by Len Bracken

Veteran conspiracy author Len Bracken's witty essays and articles lead us down the dark corridors of conspiracy, politics, murder and mayhem. In 12 chapters Bracken takes us through a maze of interwoven tales from the Russian Conspiracy (and a few "extra notes" on conspiracies) to his interview with Costa Rican novelist Joaquin Gutierrez and his Psychogeographic Map into the Third Millennium. Other chapters in the book are A General Theory of Civil War; A False Report Exposes the Dirty Truth About South African Intelligence Services; The New-Catiline Conspiracy for the Cancellation of Debt; Anti-Labor Day; 1997 with selected Aphorisms Against Work; Solar Economics; and more. Bracken's work has appeared in such pop-conspiracy publications as *Paranoia*, *Steamshovel Press* and the *Village Voice*. Len Bracken lives in Arlington, Virginia and haunts the back alleys of Washington D.C., keeping an eye on the predators who run our country. With a gun to his head, he cranks out his rants for fringe publications and is the editor of *Extraphile*, described by *New Yorker Magazine* as "fusion conspiracy theory."

256 PAGES. 6X9 PAPERBACK. ILLUSTRATED. BIBLIOGRAPHY. $14.95. CODE: ACON. JUNE PUBLICATION

LOST CONTINENTS & THE HOLLOW EARTH
I Remember Lemuria and the Shaver Mystery
by David Hatcher Childress & Richard Shaver

Lost Continents & the Hollow Earth is Childress' thorough examination of the early hollow earth stories of Richard Shaver and the fascination that lost continents and the hollow earth have had for the American public. Shaver's rare 1948 book *I Remember Lemuria* is reprinted in its entirety, and the book is packed with illustrations from Ray Palmer's *Amazing Stories* magazine of the 1940s. Palmer and Shaver told of tunnels running through the earth—tunnels inhabited by the Deros and Teros, humanoids from an ancient spacefaring race that had inhabited the earth, eventually going underground, hundreds of thousands of years ago. Childress discusses the famous hollow earth books and delves deep into whatever reality may be behind the stories of tunnels in the earth. Operation High Jump to Antarctica in 1947 and Admiral Byrd's bizarre statements, tunnel systems in South America and Tibet, the underground world of Agartha, UFOs coming from the South Pole, more.
344 PAGES. 6x9 PAPERBACK. ILLUSTRATED. $16.95. CODE: LCHE

INSIDE THE GEMSTONE FILE
Howard Hughes, Onassis & JFK
by Kenn Thomas & David Hatcher Childress

Steamshovel Press editor Thomas takes on the Gemstone File in this run-up and run-down of the most famous underground document ever circulated. Photocopied and distributed for over 20 years, the Gemstone File is the story of Bruce Roberts, the inventor of the synthetic ruby widely used in laser technology today, and his relationship with the Howard Hughes Company and ultimately with Aristotle Onassis, the Mafia, and the CIA. Hughes kidnapped and held a drugged-up prisoner for 10 years; Onassis and his role in the Kennedy Assassination; how the Mafia ran corporate America in the 1960s; more.
320 PAGES. 6x9 PAPERBACK. ILLUSTRATED. $16.00. CODE: IGF

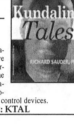

KUNDALINI TALES
by Richard Sauder, Ph.D.

Underground Bases and Tunnels author Richard Sauder on his personal experiences and provocative research into spontaneous spiritual awakening, out-of-body journeys, encounters with secretive governmental powers, daylight sightings of UFOs, and more. Sauder continues his studies of underground bases with new information on the occult underpinnings of the U.S. space program. The book also contains a breakthrough section that examines actual U.S. patents for devices that manipulate minds and thoughts from a remote distance. Included are chapters on the secret space program and a 130-page appendix of patents and schematic diagrams of secret technology and mind control devices.
296 PAGES. 7x10 PAPERBACK. ILLUSTRATED. BIBLIOGRAPHY. $14.95. CODE: KTAL

LIQUID CONSPIRACY
JFK, LSD, the CIA, Area 51 & UFOs
by George Piccard

Underground author George Piccard on the politics of LSD, mind control, and Kennedy's involvement with Area 51 and UFOs. Reveals JFK's LSD experiences with Mary Pinchot-Meyer. The plot thickens with an ever expanding web of CIA involvement, from underground bases with UFOs seen by JFK and Marilyn Monroe (among others) to a vaster conspiracy that affects every government agency from NASA to the Justice Department. This may have been the reason that Marilyn Monroe and actress-columnist Dorothy Killgallen were both murdered. Focusing on the bizarre side of history, *Liquid Conspiracy* takes the reader on a psychedelic tour de force.
264 PAGES. 6x9 PAPERBACK. ILLUSTRATED. $14.95. CODE: LIQC

ATLANTIS: MOTHER OF EMPIRES
Atlantis Reprint Series
by Robert Stacy-Judd

Robert Stacy-Judd's classic 1939 book on Atlantis. Stacy-Judd was a California architect and an expert on the Mayas and their relationship to Atlantis. Stacy-Judd was an excellent artist and his book is lavishly illustrated. The eighteen comprehensive chapters in the book are: The Mayas and the Lost Atlantis; Conjectures and Opinions; The Atlantean Theory; Cro-Magnon Man; East Is West; And West Is East; The Mormons and the Mayas; Astrology in Two Hemispheres; The Language of Architecture; The American Indian; Pre-Panamanians and Pre-Incas; Columns and City Planning; Comparisons and Mayan Art; The Iberian Link; The Maya Tongue; Quetzalcoatl; Summing Up the Evidence; The Mayas in Yucatan.
340 PAGES. 8x11 PAPERBACK. ILLUSTRATED. INDEX. $19.95. CODE: AMOE

COSMIC MATRIX
Piece for a Jig-Saw, Part Two
by Leonard G. Cramp

Leonard G. Cramp, a British aerospace engineer, wrote his first book *Space Gravity and the Flying Saucer* in 1954. *Cosmic Matrix* is the long-awaited sequel to his 1966 book *UFOs & Anti-Gravity: Piece for a Jig-Saw*. Cramp has had a long history of examining UFO phenomena and has concluded that UFOs use the highest possible aeronautic science to move in the way they do. Cramp examines anti-gravity effects and theorizes that this super-science used by the craft—described in detail in the book—can lift mankind into a new level of technology, transportation and understanding of the universe. The book takes a close look at gravity control, time travel, and the interlocking web of energy between all planets in our solar system with Leonard's unique technical diagrams. A fantastic voyage into the present and future!
364 PAGES. 6x9 PAPERBACK. ILLUSTRATED. BIBLIOGRAPHY. $16.00. CODE: CMX

24 hour credit card orders—call: 815-253-6390 fax: 815-253-6300

email: auphq@frontiernet.net http://www.adventuresunlimited.co.nz

CONSPIRACY & HISTORY

HAARP
The Ultimate Weapon of the Conspiracy
by Jerry Smith
The HAARP project in Alaska is one of the most controversial projects ever undertaken by the U.S. Government. Jerry Smith gives us the history of the HAARP project and explains how it can be used as an awesome weapon of destruction. Smith exposes a covert military project and the web of conspiracies behind it. HAARP has many possible scientific and military applications, from raising a planetary defense shield to peering deep into the earth. Smith leads the reader down a trail of solid evidence into ever deeper and scarier conspiracy theories in an attempt to discover the "whos" and "whys" behind HAARP, and discloses a possible plan to rule the world. At best, HAARP is science out-of-control; at worst, HAARP could be the most dangerous device ever created, a futuristic technology that is everything from super-beam weapon to world-wide mind control device. The Star Wars future is now! Topics include Over-the-Horizon Radar and HAARP, Mind Control, ELF and HAARP, The Telsa Connection, The Russian Woodpecker, GWEN & HAARP, Earth Penetrating Tomography, Weather Modification, Secret Science of the Conspiracy, more. Includes the complete 1987 Bernard Eastlund patent for his pulsed super-weapon that he claims was stolen by the HAARP Project.
256 PAGES. 6x9 PAPERBACK. ILLUSTRATED. $14.95. CODE: HARP

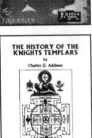

MIND CONTROL, OSWALD & JFK:
Were We Controlled?
introduction by Kenn Thomas
Steamshovel Press editor Kenn Thomas examines the little-known book *Were We Controlled?*, first published in 1968. The book maintained that Lee Harvey Oswald was a special agent who was a mind control subject, having received an implant in 1960 at a Russian hospital. Thomas examines the evidence for implant technology and the role it could have played in the Kennedy Assassination. Thomas also looks at the mind control aspects of the RFK assassination and details the history of implant technology. A growing number of people are interested in CIA experiments and its "Silent Weapons for Quiet Wars."
256 PAGES. 6x9 PAPERBACK. ILLUSTRATED. NOTES. $16.00. CODE: MCOJ

MIND CONTROL, WORLD CONTROL
by Jim Keith
Veteran author and investigator Jim Keith uncovers a surprising amount of information on the technology, experimentation and implementation of mind control. Various chapters in this shocking book are on early CIA experiments such as Project Artichoke and Project R.H.I.C.-EDOM, the methodology and technology of implants, mind control assassins and couriers, various famous Mind Control victims such as Sirhan Sirhan and Candy Jones. Also featured in this book are chapters on how mind control technology may be linked to some UFO activity and "UFO abductions."
256 PAGES. 6x9 PAPERBACK. ILLUSTRATED. FOOTNOTES. $14.95. CODE: MCWC

PROJECT SEEK
Onassis, Kennedy and the Gemstone Thesis
by Gerald A. Carroll
This book reprints the famous Gemstone File, a document circulated in 1974 concerning the Mafia, Onassis and the Kennedy assassination. With the passing of Jackie Kennedy-Onassis, this information on the Mafia and the CIA, the formerly "Hughes" controlled defense industry, and the violent string of assassinations can at last be told. Also includes new information on the Nugan Hand Bank, the BCCI scandal, "the Octopus," and the Paul Wilcher Transcripts.
388 PAGES. 6x9 PAPERBACK. ILLUSTRATED. $16.95. CODE: PJS

NASA, NAZIS & JFK:
The Torbitt Document & the JFK Assassination
introduction by Kenn Thomas
This book emphasizes the links between "Operation Paper Clip" Nazi scientists working for NASA, the assassination of JFK, and the secret Nevada air base Area 51. The Torbitt Document also talks about the roles played in the assassination by Division Five of the FBI, the Defense Industrial Security Command (DISC), the Las Vegas mob, and the shadow corporate entities Permindex and Centro-Mondiale Commerciale. The Torbitt Document claims that the same players planned the 1962 assassination attempt on Charles de Gaul, who ultimately pulled out of NATO because he traced the "Assassination Cabal" to Permindex in Switzerland and to NATO headquarters in Brussels. The Torbitt Document paints a dark picture of NASA, the military industrial complex, and the connections to Mercury, Nevada which headquarters the "secret space program."
258 PAGES. 5x8. PAPERBACK. ILLUSTRATED. $16.00. CODE: NNJ

THE HISTORY OF THE KNIGHTS TEMPLARS
The Temple Church and the Temple
by Charles G. Addison, introduction by David Hatcher Childress
Chapters on the origin of the Templars, their popularity in Europe and their rivalry with the Knights of St. John, later to be known as the Knights of Malta. Detailed information on the activities of the Templars in the Holy Land, and the 1312 AD suppression of the Templars in France and other countries, which culminated in the execution of Jacques de Molay and the continuation of the Knights Templars in England and Scotland; the formation of the society of Knights Templars in London; and the rebuilding of the Temple in 1816. Plus a lengthy intro about the lost Templar fleet and its connections to the ancient North American sea routes.
395 PAGES. 6x9 PAPERBACK. ILLUSTRATED. $16.95. CODE: HKT

24 HOUR CREDIT CARD ORDERS—CALL: 815-253-6390 FAX: 815-253-6300
EMAIL: AUPHO@FRONTIERNET.NET HTTP://WWW.ADVENTURESUNLIMITED.CO.NZ

THE LOST CITIES SERIES

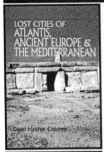

LOST CITIES OF ATLANTIS, ANCIENT EUROPE & THE MEDITERRANEAN
by David Hatcher Childress

Atlantis! The legendary lost continent comes under the close scrutiny of maverick archaeologist David Hatcher Childress in this sixth book in the internationally popular *Lost Cities* series. Childress takes the reader in search of sunken cities in the Mediterranean; across the Atlas Mountains in search of Atlantean ruins; to remote islands in search of megalithic ruins; to meet living legends and secret societies. From Ireland to Turkey, Morocco to Eastern Europe, and around the remote islands of the Mediterranean and Atlantic, Childress takes the reader on an astonishing quest for mankind's past. Ancient technology, cataclysms, megalithic construction, lost civilizations and devastating wars of the past are all explored in this book. Childress challenges the skeptics and proves that great civilizations not only existed in the past, but the modern world and its problems are reflections of the ancient world of Atlantis.

524 PAGES. 6x9 PAPERBACK. ILLUSTRATED WITH 100S OF MAPS, PHOTOS AND DIAGRAMS. BIBLIOGRAPHY & INDEX. $16.95. CODE: MED

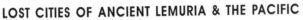

LOST CITIES OF CHINA, CENTRAL INDIA & ASIA
by David Hatcher Childress

Like a real life "Indiana Jones," maverick archaeologist David Childress takes the reader on an incredible adventure across some of the world's oldest and most remote countries in search of lost cities and ancient mysteries. Discover ancient cities in the Gobi Desert; hear fantastic tales of lost continents, vanished civilizations and secret societies bent on ruling the world; visit forgotten monasteries in forbidding snow-capped mountains with strange tunnels to mysterious subterranean cities! A unique combination of far-out exploration and practical travel advice, it will astound and delight the experienced traveler or the armchair voyager.

429 PAGES. 6x9 PAPERBACK. ILLUSTRATED. FOOTNOTES & BIBLIOGRAPHY. $14.95. CODE: CHI

LOST CITIES OF ANCIENT LEMURIA & THE PACIFIC
by David Hatcher Childress

Was there once a continent in the Pacific? Called Lemuria or Pacifica by geologists, Mu or Pan by the mystics, there is now ample mythological, geological and archaeological evidence that an advanced and ancient civilization once lived in the central Pacific. Maverick archaeologist and explorer David Hatcher Childress combs the Indian Ocean, Australia and the Pacific in search of the surprising truth about mankind's past. Contains photos of the underwater city on Pohnpei; explanations on how the statues were levitated around Easter Island in a clockwise vortex movement; tales of disappearing islands; Egyptians in Australia; and more.

379 PAGES. 6x9 PAPERBACK. ILLUSTRATED. FOOTNOTES & BIBLIOGRAPHY. $14.95. CODE: LEM

ANCIENT TONGA
& the Lost City of Mu'a
by David Hatcher Childress

Lost Cities series author Childress takes us to the south sea islands of Tonga, Rarotonga, Samoa and Fiji to investigate the megalithic ruins on these beautiful islands. The great empire of the Polynesians, centered on Tonga and the ancient city of Mu'a, is revealed with old photos, drawings and maps. Chapters in this book are on the Lost City of Mu'a and its many megalithic pyramids, the Ha'amonga Trilithon and ancient Polynesian astronomy, Samoa and the search for the lost land of Havai'iki, Fiji and its wars with Tonga, Rarotonga's megalithic road, and Polynesian cosmology. Material on Egyptians in the Pacific, earth changes, the fortified moat around Mu'a, lost roads, more.

218 PAGES. 6x9 PAPERBACK. ILLUSTRATED. COLOR PHOTOS. BIBLIOGRAPHY. $15.95. CODE: TONG

ANCIENT MICRONESIA
& the Lost City of Nan Madol
by David Hatcher Childress

Micronesia, a vast archipelago of islands west of Hawaii and south of Japan, contains some of the most amazing megalithic ruins in the world. Part of our *Lost Cities* series, this volume explores the incredible conformations on various Micronesian islands, especially the fantastic and little-known ruins of Nan Madol on Pohnpei Island. The huge canal city of Nan Madol contains over 250 million tons of basalt columns over an 11 square-mile area of artificial islands. Much of the huge city is submerged, and underwater structures can be found to an estimated 80 feet. Islanders' legends claim that the basalt rocks, weighing up to 50 tons, were magically levitated into place by the powerful forefathers. Other ruins in Micronesia that are profiled include the Latte Stones of the Marianas, the menhirs of Palau, the megalithic canal city on Kosrae Island, megaliths on Guam, and more.

256 PAGES. 6x9 PAPERBACK. ILLUSTRATED. INCLUDES A COLOR PHOTO SECTION. BIBLIOGRAPHY. $16.95. CODE: AMIC

VIMANA AIRCRAFT OF ANCIENT INDIA & ATLANTIS
by David Hatcher Childress
introduction by Ivan T. Sanderson

Did the ancients have the technology of flight? In this incredible volume on ancient India, authentic Indian texts such as the *Ramayana* and the *Mahabharata* are used to prove that ancient aircraft were in use more than four thousand years ago. Included in this book is the entire Fourth Century BC manuscript *Vimaanika Shastra* by the ancient author Maharishi Bharadwaaja, translated into English by the Mysore Sanskrit professor G.R. Josyer. Also included are chapters on Atlantean technology, the incredible Rama Empire of India and the devastating wars that destroyed it. Also an entire chapter on mercury vortex propulsion and mercury gyros, the power source described in the ancient Indian texts. Not to be missed by those interested in ancient civilizations or the UFO enigma.
334 PAGES. 6x9 PAPERBACK. RARE PHOTOGRAPHS, MAPS AND DRAWINGS. $15.95. CODE: VAA

LOST CONTINENTS & THE HOLLOW EARTH
I Remember Lemuria and the Shaver Mystery
by David Hatcher Childress & Richard Shaver

Lost Continents & the Hollow Earth is Childress' thorough examination of the early hollow earth stories of Richard Shaver and the fascination that fringe fantasy subjects such as lost continents and the hollow earth have had for the American public. Shaver's rare 1948 book *I Remember Lemuria* is reprinted in its entirety, and the book is packed with illustrations from Ray Palmer's *Amazing Stories* magazine of the 1940s. Palmer and Shaver told of tunnels running through the earth—tunnels inhabited by the Deros and Teros, humanoids from an ancient spacefaring race that had inhabited the earth, eventually going underground, hundreds of thousands of years ago. Childress discusses the famous hollow earth books and delves deep into whatever reality may be behind the stories of tunnels in the earth. Operation High Jump to Antarctica in 1947 and Admiral Byrd's bizarre statements, tunnel systems in South America and Tibet, the underground world of Agartha, the belief of UFOs coming from the South Pole, more.
344 PAGES. 6x9 PAPERBACK. ILLUSTRATED. $16.95. CODE: LCHE

LOST CITIES OF NORTH & CENTRAL AMERICA
by David Hatcher Childress

Down the back roads from coast to coast, maverick archaeologist and adventurer David Hatcher Childress goes deep into unknown America. With this incredible book, you will search for lost Mayan cities and books of gold, discover an ancient canal system in Arizona, climb gigantic pyramids in the Midwest, explore megalithic monuments in New England, and join the astonishing quest for lost cities throughout North America. From the war-torn jungles of Guatemala, Nicaragua and Honduras to the deserts, mountains and fields of Mexico, Canada, and the U.S.A., Childress takes the reader in search of sunken ruins, Viking forts, strange tunnel systems, living dinosaurs, early Chinese explorers, and fantastic lost treasure. Packed with both early and current maps, photos and illustrations.
590 PAGES. 6x9 PAPERBACK. PHOTOS, MAPS, AND ILLUSTRATIONS. FOOTNOTES & BIBLIOGRAPHY. $14.95. CODE: NCA

LOST CITIES & ANCIENT MYSTERIES OF SOUTH AMERICA
by David Hatcher Childress

Rogue adventurer and maverick archaeologist David Hatcher Childress takes the reader on unforgettable journeys deep into deadly jungles, high up on windswept mountains and across scorching deserts in search of lost civilizations and ancient mysteries. Travel with David and explore stone cities high in mountain forests and hear fantastic tales of Inca treasure, living dinosaurs, and a mysterious tunnel system. Whether he is hopping freight trains, searching for secret cities, or just dealing with the daily problems of food, money, and romance, the author keeps the reader spellbound. Includes both early and current maps, photos, and illustrations, and plenty of advice for the explorer planning his or her own journey of discovery.
381 PAGES. 6x9 PAPERBACK. PHOTOS, MAPS, AND ILLUSTRATIONS. FOOTNOTES & BIBLIOGRAPHY. $14.95. CODE: SAM

LOST CITIES & ANCIENT MYSTERIES OF AFRICA & ARABIA
by David Hatcher Childress

Across ancient deserts, dusty plains and steaming jungles, maverick archaeologist David Childress continues his world-wide quest for lost cities and ancient mysteries. Join him as he discovers forbidden cities in the Empty Quarter of Arabia; "Atlantean" ruins in Egypt and the Kalahari desert; a mysterious, ancient empire in the Sahara; and more. This is the tale of an extraordinary life on the road: across war-torn countries, Childress searches for King Solomon's Mines, living dinosaurs, the Ark of the Covenant and the solutions to some of the fantastic mysteries of the past.
423 PAGES. 6x9 PAPERBACK. PHOTOS, MAPS, AND ILLUSTRATIONS. FOOTNOTES & BIBLIOGRAPHY. $14.95. CODE: AFA

ANTI-GRAVITY

THE ANTI-GRAVITY HANDBOOK

edited by David Hatcher Childress, with Nikola Tesla, T.B. Paulicki, Bruce Cathie, Albert Einstein and others

The new expanded compilation of material on Anti-Gravity, Free Energy, Flying Saucer Propulsion, UFOs, Suppressed Technology, NASA Cover-ups and more. Highly illustrated with patents, technical illustrations and photos. This revised and expanded edition has more material, including photos of Area 51, Nevada, the government's secret testing facility. This classic on weird science is back in a 90s format!
• How to build a flying saucer.
• Crystals and their role in levitation.
• Secret government research and development.
• Nikola Tesla on how anti-gravity airships could
 draw power from the atmosphere.
• Bruce Cathie's Anti-Gravity Equation.
• NASA, the Moon and Anti-Gravity.
230 PAGES. 7X10 PAPERBACK. BIBLIOGRAPHY. APPENDIX. ILLUSTRATED. $14.95. CODE: AGH

ANTI-GRAVITY & THE WORLD GRID

edited by David Hatcher Childress

Is the earth surrounded by an intricate electromagnetic grid network offering free energy? This compilation of material on ley lines and world power points contains chapters on the geography, mathematics, and light harmonics of the earth grid. Learn the purpose of ley lines and ancient megalithic structures located on the grid. Discover how the grid made the Philadelphia Experiment possible. Explore the Coral Castle and many other mysteries, including acoustic levitation, Tesla Shields and scalar wave weaponry. Browse through the section on anti-gravity patents, and research resources.
274 PAGES. 7X10 PAPERBACK. ILLUSTRATED. $14.95. CODE: AGW

ANTI-GRAVITY & THE UNIFIED FIELD

edited by David Hatcher Childress

Is Einstein's Unified Field Theory the answer to all of our energy problems? Explored in this compilation of material is how gravity, electricity and magnetism manifest from a unified field around us. Why artificial gravity is possible; secrets of UFO propulsion; free energy; Nikola Tesla and anti-gravity airships of the 20s and 30s; flying saucers as superconducting whirls of plasma; anti-mass generators; vortex propulsion; suppressed technology; government cover-ups; gravitational pulse drive; spacecraft & more.
240 PAGES. 7X10 PAPERBACK. ILLUSTRATED. $14.95. CODE: AGU

ETHER TECHNOLOGY

A Rational Approach to Gravity Control

by Rho Sigma

This classic book on anti-gravity and free energy is back in print. Written by a well-known American scientist under the pseudonym of "Rho Sigma," this book delves into international efforts at gravity control and discoid craft propulsion. Before the Quantum Field, there was "Ether." This small, but informative book has chapters on John Searle and "Searle discs;" T. Townsend Brown and his work on anti-gravity and ether-vortex turbines. Includes a forward by former NASA astronaut Edgar Mitchell.
108 PAGES. 6X9 PAPERBACK. ILLUSTRATED. $12.95. CODE: ETT

MAN-MADE UFOS 1944—1994

Fifty Years of Suppression

by Renato Vesco & David Hatcher Childress

A comprehensive look at the early "flying saucer" technology of Nazi Germany and the genesis of man-made UFOs. This book takes us from the work of captured German scientists to escaped battalions of Germans, secret communities in South America and Antarctica to today's state-of-the-art "Dreamland" flying machines. Heavily illustrated, this astonishing book blows the lid off the "government UFO conspiracy" and explains with technical diagrams the technology involved. Examined in detail are secret underground airfields and factories; German secret weapons; "suction" aircraft; the origin of NASA; gyroscopic stabilizers and engines; the secret Marconi aircraft factory in South America; and more. Not to be missed by students of technology suppression, secret societies, anti-gravity, free energy, conspiracy and World War II! Introduction by W.A. Harbinson, author of the Dell novels *GENESIS* and *REVELATION*.
318 PAGES. 6X9 PAPERBACK. ILLUSTRATED. INDEX & FOOTNOTES. $18.95. CODE: MMU

One Adventure Place
P.O. Box 74
Kempton, Illinois 60946
United States of America
Tel.: 815-253-6390 • Fax: 815-253-6300
Email: auphq@frontiernet.net
http://www.adventuresunlimited.co.nz

ORDERING INSTRUCTIONS

✓ Remit by USD$ Check, Money Order or Credit Card

✓ Visa, Master Card, Discover & AmEx Accepted

✓ Prices May Change Without Notice

✓ 10% Discount for 3 or more Items

SHIPPING CHARGES

United States

✓ Postal Book Rate { $2.50 First Item
50¢ Each Additional Item

✓ Priority Mail { $3.50 First Item
$2.00 Each Additional Item

✓ UPS { $5.00 First Item
$1.50 Each Additional Item

NOTE: UPS Delivery Available to Mainland USA Only

Canada

✓ Postal Book Rate { $3.00 First Item
$1.00 Each Additional Item

✓ Postal Air Mail { $5.00 First Item
$2.00 Each Additional Item

✓ Personal Checks or Bank Drafts MUST BE
USD$ and Drawn on a US Bank

✓ Canadian Postal Money Orders OK

✓ Payment MUST BE USD$

All Other Countries

✓ Surface Delivery { $6.00 First Item
$2.00 Each Additional Item

✓ Postal Air Mail { $12.00 First Item
$8.00 Each Additional Item

✓ Payment MUST BE USD$

✓ Checks and Money Orders MUST BE USD$
and Drawn on a US Bank or branch.

✓ Add $5.00 for Air Mail Subscription to
Future *Adventures Unlimited* Catalogs

SPECIAL NOTES

✓ RETAILERS: Standard Discounts Available

✓ BACKORDERS: We Backorder all Out-of-
Stock Items Unless Otherwise Requested

✓ PRO FORMA INVOICES: Available on Request

✓ VIDEOS: NTSC Mode Only. Replacement only.

✓ For PAL mode videos contact our other offices:

European Office:
Adventures Unlimited, PO Box 372,
Dronten, 8250 AJ, The Netherlands
South Pacific Office
Adventures Unlimited Pacifica
221 Symonds Street, Box 8199
Auckland, New Zealand

Please check: ✓

☐ This is my first order ☐ I have ordered before ☐ This is a new address

Name				
Address				
City				
State/Province		Postal Code		
Country				
Phone day		Evening		
Fax				

Item Code	Item Description	Price	Qty	Total

Please check: ✓

☐ Postal-Surface

☐ Postal-Air Mail
(Priority in USA)

☐ UPS
(Mainland USA only)

Subtotal ➡
Less Discount-10% for 3 or more items ➡
Balance ➡
Illinois Residents 6.25% Sales Tax ➡
Previous Credit ➡
Shipping ➡
Total (check/MO in USD$ only)➡

☐ Visa/MasterCard/Discover/Amex

Card Number

Expiration Date

10% Discount When You Order 3 or More Items!

Comments & Suggestions	Share Our Catalog with a Friend